CU00802989

STUDIES IN COMICS AND CARTOONS
Lucy Shelton Caswell and Jared Gardner, Series Editors

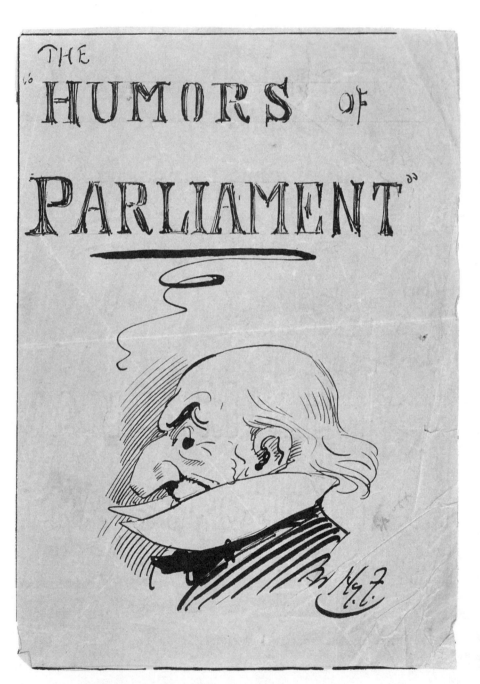

"The Humours of Parliament" (PA HC/LB/1/112/112). The original image, now in the Parliamentary Archives, upon which the cover of this book is based. Discussed further on p. 90.

THE HUMOURS OF PARLIAMENT

Harry Furniss's View of Late-Victorian Political Culture

Edited
and with an Introduction by

GARETH CORDERY
and
JOSEPH S. MEISEL

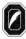

THE OHIO STATE UNIVERSITY PRESS • COLUMBUS

Copyright © 2014 by The Ohio State University.
All rights reserved.
Library of Congress Cataloging-in-Publication data available online at catalog.loc.gov.

Cover design by Laurence J. Nozik
Text design by Juliet Williams
Type set in Adobe Caslon
Printed by Thomson-Shore, Inc.

∞ The paper used in this publication meets the minimum requirements of the American National
Standard for Information Sciences—Permanence of Paper for Printed Library Materials. ANSI
Z39.48–1992.

9 8 7 6 5 4 3 2 1

CONTENTS

ACKNOWLEDGMENTS

*T*HIS BOOK had its genesis in Chicago in April 2005 when the two authors met at the 29th Annual Conference of the Midwest Victorian Studies Association on the theme of "Victorians in Sight and Sound." The subsequent collaboration between literature specialist and historian has involved work, occasionally together, in Australia, Canada, New Zealand, the United Kingdom, and the United States. The tyranny of distance was conquered by streams of emails and attachments. But this book would not have been possible without the help of numerous institutions and individuals.

First thanks must go to Harry Furniss, the artist's grandson, who supplied the original manuscript of "The Humours of Parliament" presented here. For permission to quote from or reproduce materials (as specified in the Bibliography and List of Illustrations), we are grateful to the British Library; the Research Library of the Getty Research Institute, Los Angeles; Mr. Selwyn Goodacre; the University Librarian and Director, The John Rylands University Library, The University of Manchester; the National Portrait Gallery, London; the Parliamentary Archives, London; the Speaker of the House of Commons; and Mrs. Rosemary Wood.

We are particularly grateful to the staffs at the above-mentioned institutions, as well as at the British Library's Newspaper Library, Colindale, London; the Canterbury Public Library, Christchurch, New Zealand (especially Guy Field); Columbia University Libraries; the House of Commons Information Office; the Newberry Library (especially James Grossman); the New York Public Library; and the University of Canterbury Library, Christchurch, New Zealand (especially Bronwen Matthews and Robin Stevens).

Critical research assistance was provided by Dr. Robert Dingley, who trawled the National Library of Australia for evidence of Furniss's tour Down Under, and also made indispensible contributions to our account of that episode. Tawney Gowan similarly tracked down Furniss's movements in Canada. David Francis, authority on the Magic Lantern, former Curator of the National Film Archive, and co-founder of the British Film Institute, helped clarify various issues and generously supplied a copy of one of the "Humours" programs. Douglas Horrell, Visual Resources Technician of the School of Humanities at the University of Canterbury, scanned more than 150 images and recreated the "No Politics Umbrella." Jennifer Middendorf, of the English department at the University of Canterbury, transcribed the original manuscript. Susanne Pichler and Lisa Bonifacic of the Andrew W. Mellon Foundation Library provided exceptional research support and arranged for copious inter-library loans. David Cannadine and Martin Meisel offered customarily insightful readings of early drafts.

At The Ohio State University Press, we have been gratified by the enthusiasm with which this project has been received by Sandy Crooms; Lucy Shelton Caswell and Jared Gardner, the editors of the Studies in Comics and Cartoons series; and the editorial board. We also thank the anonymous readers for their helpful thoughts on the manuscript.

On a more personal note, Gareth would like to thank his colleagues, friends and family, especially Mike and Marlene Cordery, for their generous hospitality while conducting his research in London, and his wife Donna for her unstinting support and love. Joe thanks his colleagues at Mellon and latterly at Brown University, but most especially his wife Felice Ramella and son Luke Meisel for their love and always eager encouragement.

GC & JSM
Christchurch and Providence
December 2013

ABBREVIATIONS IN NOTES

AH	Harry Furniss. *Harry Furniss at Home.* London: Unwin, 1904.
B&W	*Black and White.*
BAA	*A Brief & Authentic Account of Harry Furniss. Complied By Those Who Know Him,* 1896. [Pamphlet, 16pp. No publisher.]
BL	British Library, London.
"Carnival"	Anonymous biographical sketch accompanying Harry Furniss, *The Carnival.* Unpublished typescript, n.d. In possession of Gareth Cordery.
"Cartoon"	Harry Furniss. "Cartoon (Lecture)." Unpublished annotated typescript, c. 1914–18. In possession of Gareth Cordery.
*CC*I, *CC*II	Harry Furniss. *The Confessions of a Caricaturist.* 2 vols. London: T. Fisher Unwin, 1901.
Diary SP	Henry W. Lucy. *A Diary of the Salisbury Parliament, 1886–1892.* London: Cassell, 1892.
EH	William Makepeace Thackeray. *The English Humourists of the Eighteenth Century.* London: Macmillan, 1911.
EML	David Robinson, Stephen Herbert, and Richard Crangle, eds. *Encyclopedia of the Magic Lantern.* London: Magic Lantern Society, 2001.
EP	Norman Wilding and Philip Laundy. *An Encyclopedia of Parliament,* 4th ed. London: Cassell, 1971.
F	Furniss (e.g., daughter "Dorothy F").
FV	Harry Furniss. *Flying Visits.* London: Simpkin, Marshall, 1892.

Getty Archive J. Paul Getty Trust, Getty Research Institute, Special Collections, Los Angeles. Harry Furniss Letters. Access No. 861048.

HF Harry Furniss.

How Harry How. *Illustrated Interviews.* London: George Newnes, 1893.

HTD Harry Furniss. *How to Draw in Pen and Ink.* London: Chapman and Hall, 1914.

ILN *Illustrated London News.*

JRL John Rylands Library, Manchester. Spielmann Collection.

M&B William Flavelle Monypenny and George Earle Buckle. *The Life of Benjamin Disraeli, Earl of Beaconsfield.* 6 vols. London: Murray, 1910–20.

MAHTD Harry Furniss. *More about How to Draw in Pen and Ink.* London: Chapman and Hall, 1915.

MBD Harry Furniss. *My Bohemian Days.* London: Hurst & Blackett, 1919.

MPS Harry Furniss. *M.P.'s In Session: From Mr. Punch's Parliamentary Portrait Gallery.* London: Bradbury Agnew, 1889.

NPG National Portrait Gallery, London.

NYT *New York Times.*

OED *Oxford English Dictionary.*

ODNB *Oxford Dictionary of National Biography.*

PA Parliamentary Archives, London.

PPP Harry Furniss. *Pen and Pencil in Parliament.* London: Sampson Low & Co., 1897.

SVM Harry Furniss. *Some Victorian Men.* London: John Lane, [1924].

SVW Harry Furniss. *Some Victorian Women: Good, Bad, and Indifferent.* London: John Lane, 1923.

TPC Harry Furniss. *The Two Pins Club.* London: John Murray, 1925.

TT *The Times* (London).

ILLUSTRATIONS

INTRODUCTION

*I*N 1891, THE NOTED CARTOONIST, journalist, and author Harry Furniss (1854–1925) took to the stage with his hugely successful lecture-entertainment "The Humours of Parliament," with which he subsequently toured throughout the United Kingdom and later brought to audiences in North America and Australia. While a magic lantern projected image after image from the large supply of drawings of London's Westminster and caricatures of its inhabitants that had made him famous in *Punch* and other periodicals, Furniss delivered a copiously illustrated evening of narrative, commentary, anecdote, mimicry, and jokes. Normally, the only records of such ephemeral entertainments are press reports and occasional reminiscences of audience members, so it is comparatively rare for the text of an unpublished oral performance (especially from the 1890s) to survive. But an annotated typescript of "The Humours of Parliament" remained in the possession of Harry Furniss's grandson, and that rather compli-

cated document, together with a reconstruction of the more than one hundred images that accompanied it, form the core of this book.[1] Publication of the extant text and images of "Humours" brings to light a significant work by a major, if idiosyncratic, witness to an era that would otherwise be unavailable to historians of late Victorian culture. The introductory matter, appendices, and other apparatus that surround the presentation of "Humours" serve to position Furniss and his lecture-entertainment within the overlapping political and artistic milieux of his time.

As a long-time close observer of Parliament, Furniss spoke with considerable authority about his favorite subject. Along with the generally light, though occasionally broad, comedy of his words and pictures, "Humours" offered its audiences a well-informed look inside the Houses of Parliament, the better to understand their mysterious workings and the character of the leading political personalities of the day. Furniss was arguably the most significant and prolific political cartoonist and illustrator of his time. Although his work was widely celebrated by contemporaries, his career and his place in late Victorian and Edwardian public culture are now almost entirely neglected, especially when compared to the attention that has been given to his illustrious predecessors from the late-eighteenth- and early-nineteenth-century "golden age" of caricature and visual satire: William Hogarth (1697-1764), Thomas Rowlandson (1756–1827), James Gillray (1757–1815), and George Cruikshank (1792–1878). Indeed, the same may be said in relation to Furniss's contemporary John Tenniel (1820–1914), much of whose enduring fame derives from his illustrations for Lewis Carroll's *Alice* books, and to later figures like David Low (1891–1963), whose cartoons have enjoyed a long life thanks in part to the continuing fascination with the Second World War era and Winston Churchill. This volume is part of an ongoing project to call renewed attention to Furniss's art, both on its own merits and within its broader historical context.[2]

As the following sections of this introduction will make clear, Furniss approached his vocation with exceptional energy and entrepreneurial spirit. Studying "The Humours of Parliament" in particular affords an excellent opportunity to take a new look at Furniss's historical and cultural significance beyond simply his ability to craft iconic images of notable contemporaries. Professionally neutral in politics (though hardly so in private), Furniss

1. For background on the papers left by Furniss and their subsequent disposition, see the account by his grandson and namesake: Harry Furniss, *Family & Friends: Memoirs: Three* (Victoria, BC: Trafford, 2003), esp. pp. 13–18. The editorial approach to converting the original typescript and images for presentation in the present work is described below in Section VI.

2. See Gareth Cordery's series of publications on Furniss, listed in the bibliography.

was a keen-eyed observer who enjoyed exceptional access to the institutions and people that his illustrations helped define in the public mind. With "Humours," Furniss presented Parliament and its leading personalities in an amusing but informative manner, both entertaining and edifying the large number of people who attended his performances. For students of late Victorian politics and culture, the text of "Humours" provides an opportunity to examine in some detail several interrelated aspects of the political phenomenology of that pivotal moment in British history. At the same time, reconstructing the details of "Humours" as a touring illustrated lecture-entertainment presents a case study for understanding in greater depth this important and internationally popular nineteenth-century performance genre.

The purpose of this introduction is to provide necessary background information for the text, images, and performance of "Humours" while also setting the form and substance of the entertainment in a broader historical context. It begins with an account of Furniss's career and place within the artistic traditions of British cartooning and visual satire. This is followed by an effort to broaden the frame and situate "Humours" at the intersection of several notable trends in nineteenth-century British public culture. After a brief discussion of some of the key political developments of the 1880s and 1890s which formed the immediate backdrop for "Humours," the focus then returns to the performance of "Humours" itself with a description of how Furniss developed the entertainment and presented it to audiences throughout the UK and subsequently in North America and Australia. Finally, we describe the properties of the "Humours" document transcribed here and the editorial principles which have informed the selection of illustrations.

I

HARRY FURNISS

Life in Art

•

ORN IN WEXFORD, IRELAND on 26 March 1854, Harry Furniss was the son of James Furniss, a civil engineer from Hathersage, Derbyshire, and his second wife, Isabella Cornelia Mackenzie, daughter of a Newcastle publisher. When Harry was ten, the family moved to Dublin where he was educated at the Wesleyan Connexional School alongside fellow pupils Edward Carson and George Bernard Shaw.[3] He began working as a caricaturist at the tender age of twelve and his earliest published sketches, of three of his schoolmasters, appeared in the school magazine. By the time he was sixteen, in prophetic anticipation of his later work for *Punch*, Furniss was contributing to *Zozimus*, the Irish equivalent of the famous English weekly, edited by A. M. Sullivan, a politically active journalist who helped form the Home Rule party (see section III.2 for more background on political developments in Ireland).

While he was no Irish Nationalist—in fact in later years he denied his Irishness and became fiercely Anglophile—Furniss was involved from the start with politics and political caricaturing. With an energy and output that was to typify his working life, he also simultaneously contributed illustrations to "religious books, medical works, scientific treatises, scholastic primers and story books."[4] Before turning to the political context within which Furniss plied his art and his extension of the cartoonist's trade through "Humours," it is important to place his career and body of work within the larger history of political caricature in Britain.

3. Although HF and Shaw had at least one stiff exchange (see note 23), the two appear to have been on generally cordial terms. See HF to G. B. Shaw, 9 April 1895, BL Add MSS 63183, f. 1. Shaw later contributed to *Harry Furniss's Christmas Annual* (1905) and HF caricatured him several times.

4. *CCI*, p. 15.

1. Furniss and the Tradition of British Political Caricature

The crucial moment in Furniss's early career came in the summer of 1873 when, at the age of nineteen, he arrived in London with letters of introduction, money to last him a year, and a portfolio of sketches under his arm. Mrs. J. H. Riddell, a fashionable author of the period, introduced him to Bohemian London. He joined the Savage and other clubs and quickly established himself as an up and coming caricaturist and illustrator. The first reputable weekly that he began working for on a regular basis (in April 1874) was the *Illustrated Sporting and Dramatic News*. Then he became a "special artist" (the equivalent of a latter-day news photographer) for the *Illustrated London News*. His "Election Sketches" (February–April 1880) for this prestigious publication caught the eye of Henry Lucy who, as the recent replacement to Shirley Brooks as *Punch*'s parliamentary reporter, was looking for an illustrator for his "Essence of Parliament" column. For over a year after his first contribution in October 1880, Furniss had to be satisfied with providing smaller sketches of individual MPs (some two to four per week on average) while Linley Sambourne's large, elaborate decorations continued to grace Lucy's text. Furniss took over completely in February 1882 and the Lucy-Furniss collaboration flourished for nearly thirteen years.

Between October 1880 and March 1894, Furniss contributed by his own estimate "over two thousand six hundred designs" to the pages of *Punch*—a prolific output even by *Punch* standards.[5] He wrote that "my first efforts in *Punch* were confined to the three Ps—Parliament, Pictures and the Playhouse,"[6] but it was the first that was his special forte, especially as the illustrator of Lucy's light-hearted weekly "Diary of Toby, M. P.," the satirical *Hansard* that chronicled the toings and froings of parliamentarians. Furniss's independent, stand-alone political caricatures (to be distinguished from the weekly full-page "cartoon" for which *Punch* was famous) made his reputation. Parliament, though the center of national life, still remained something of a mystery to the majority of those whose lives were governed by its laws.[7] As

5. HF, "My Reminiscences," *The Strand Magazine*, vol. 38, no. 223 (1909), p. 189. Furniss's 2,600 *Punch* cartoons produced between 1880 and 1894 yield an average of 185 per year. Compare his output with some of the other major *Punch* contributors: Keene produced 5,000 to 6,000 (1851–90); Sambourne 4,000 (1867–95); Tenniel over 2,000 (1851–1901). See Stanley Applebaum and Richard Kelley, eds., *Great Drawings and Illustrations from Punch, 1841–1901*, (New York: Dover, 1981), pp. xvi, xviii, and xix.

6. *MBD*, p. 176.

7. On the shift in the public meanings of Parliament, as embodied by, and within, its Houses beginning around the 1880s, see David Cannadine, "Parliament: The Palace of Westminster as a Palace of Varieties," *In Churchill's Shadow: Confronting the Past in Modern Britain* (London: Penguin, 2002), esp. pp. 12–19.

discussed in greater detail below, Furniss's sketches for *Punch* and for other magazines and newspapers played an important part in publicizing Parliament—its architecture, its procedures, its private spaces, and above all its inhabitants—to an expanding and increasingly educated electorate.

By Furniss's time, the social context in which caricature functioned had changed considerably from that of the late eighteenth and early nineteenth centuries. The Victorian era was marked by increasing emphasis on *respectability* across the social spectrum. The sources and extent of this movement have been much debated (particularly its influence among the lower classes); in general, however, great stress is laid on the general permeation of evangelical mores and the related efforts to tame working-class culture that were undertaken by both the state and private charities.[8]

In art, this shift in tone imposed constraints on how people were depicted, as Thackeray, who began as a would-be caricaturist-illustrator and worked for *Punch* in its early days, noted in his preface to *Pendennis* (1850): "Even the gentlemen of our age—this is an attempt to describe one of them, no better nor worse than most educated men—even these we cannot show as they are, with the notorious foibles and selfishness of their lives and their education."[9] In the visual field, Charles Baudelaire described the early-nineteenth-century English caricaturists' work as being distinguished by "violence, a love of the excessive, and a simple, ultra-brutal and direct manner of stating [their] subject; when it comes to caricature, the English are extremists."[10] By Furniss's time, however, the grossness, vulgarity, and viciousness associated with Gillray and Rowlandson had given way to the "kindly gaiety" of the *Punch* cartoonists like Tenniel, "whose cartoons never had enough bite to hurt and were not intended to do so."[11]

In his writings on art, Furniss frequently discussed the ways in which the "wings of the caricaturist have been clipped."[12] In 1894, for example, he wrote:

8. One provocative argument suggests that different classes produced different notions of respectability that were largely independent of one another. See F. M. L. Thompson, *The Rise of Respectable Society: A Social History of Victorian Britain, 1830–1900* (Cambridge, MA: Harvard University Press, 1988). Thompson's account, however, pays little attention to the influence of religion on which many other scholars have focused. Cf., for example, Ian Bradley, *The Call to Seriousness: The Evangelical Impact on the Victorians* (London: Cape, 1976).

9. William Makepeace Thackeray, *The History of Pendennis*, 2 vols. (London: Smith, Elder, & Co., 1898), vol. I, p. xi.

10. Charles Baudelaire, *The Painter of Modern Life and Other Essays*, trans. and ed. Jonathan Mayne (London and New York: Phaidon, 1965), p. 188. The essay from which this quote is taken, "Some Foreign Caricaturists," originally appeared in *Le Présent*, 15 October 1857.

11. H. C. G. Matthew, "Portraits of Men: Millais and Victorian Public Life," in Peter Funnell et al., *Millais: Portraits* (London: National Portrait Gallery, 1999), p. 146. See also Martha Banta, *Barbaric Intercourse: Caricature and the Culture of Conduct, 1841–1936* (Chicago: University of Chicago Press, 2003), p. 64.

12. *PPP*, p. vi.

We don't caricature nowadays as the old caricaturists did; if we did, I don't know what pains and penalties we should court. Caricaturing in the savage, bitter sense has been killed more or less by the development of art . . . John Leech, as an unknown man, would not now get one of his drawings accepted by an editor. No one admires John Leech more than I do, and in the sense of humour and caricature, his work was perfect. But since Leech things have altered very much.[13]

Similarly, he claimed in 1902 that "nine tenths" of Gillray's work would not today have been published "for although members of Parliament can be, even in full dress debate, as coarsely satirical and as grossly personal as they like, the caricaturist nowadays is suppressed altogether."[14] He bemoaned the fact that "an honest satirist has no chance nowadays. He must not draw what he sees, or write what he really thinks about it. Pleasing wishy-washiness is idolised, whilst Hogarth is voted coarse. Great Scott! How this age of cigarettes and lemon squash would have stirred the pulse and nerved the brush of the greatest of English caricaturists!"[15]

From these lamentations over "the decadence of English satirical art,"[16] it might be said that Furniss was born in the wrong century, or at least in the wrong part of the century. Throughout his later magic lantern entertainment, "A Sketch of Boz" (1905–7), Furniss in effect traced the fate of caricature in the nineteenth century and, through his survey of Dickens's illustrators, located his own place in the tradition of graphic satire.[17] His satirical instincts were far closer to those of Gillray and Rowlandson (he owned several originals of the latter) than to those of his contemporaries Tenniel and Sambourne. As a cartoonist, he clearly felt constrained by the proprieties of late Victorian society. Writing in 1889, George Bernard Shaw attributed "the change from the old order of caricature to the new" (which he did not think was for the better) to "a change in the social status of the artists." He identified his former schoolmate Furniss as a prime example of a caricaturist whose powers of satirical criticism were limited by respectability and middle-class careerism. "Mr.

13. *The Sketch*, 21 February 1894, p. 165. Leech (1817–1864), one of the great English caricaturists and illustrators, contributed to *Punch* from 1841 to his death. Furniss described him as a "genius." Gareth Cordery, *An Edwardian's View of Dickens and His Illustrators: Harry Furniss's 'A Sketch of Boz'* (Greensboro, NC: ELT Press, 2005), p. 67. Leech's illustrations for Dickens's *A Christmas Carol*, especially, have ensured a broader and enduring legacy. Furniss's 1910 re-illustrated edition of Dickens has been seen as "affirming and modernizing the graphic satire tradition of the original illustrators." Paul Davis, *The Lives and Times of Ebenezer Scrooge* (New Haven: Yale University Press, 1990), p. 121.
14. *Weekly Scotsman*, 27 September 1902.
15. *CCI*, pp. 150–51.
16. *CCI*, p. 151.
17. See Cordery, *Edwardian's View of Dickens*, pp. 10–11.

Furniss . . . tries in all directions for new subject-matter; worries and overdoes
the old in his attempts to get something funny out of it; and yet cannot, with
all his efforts, get a true Homeric laugh anywhere." At the same time, Shaw
did not give up hope for the energetic Furniss: "the more he struggles, the
more likely he is to break his bonds asunder some day."[18]

While acknowledging that caricature can be cruel and that "there is
undoubtedly considerable justification for the belief" that "the root of all
comedy is cruelty," he also conceded that, in keeping with the supposedly
more refined sensibilities of his age, the impulse towards savage laughter
needed to be counteracted by "feelings of kindly sympathy."[19] In other words
Juvenalian satire required a compensating Horatian amiableness and Furniss
claimed to be "funny without being vulgar."[20] Thus, he defended himself
against accusations of being hurtful to those who were his subjects: "I have
always striven, during my career in Parliament, to avoid giving offence to any
member, whom I might light upon for a satiric sketch. And my sketches are
not so satirical after all. They are, I think I may say, fairly true to nature; and
if I slightly exaggerate any one point or feature, I endeavour to refrain from
anything like malicious suggestion."[21]

Yet some of his caricatures undoubtedly did cause offence: "I was at times
necessarily 'ugly,' and therefore to some unpopular. I confess I felt it my duty
not to shrink from being 'ugly,' although whenever I could I introduced
some redeeming element into my designs . . . but in some of my *Punch* draw-
ings this relief was impossible."[22] Reviewing Furniss's exhibition of drawings
at the Gainsborough Gallery, Shaw wrote that the Parliamentary sketches
displayed "knowledge as well as fancy," but he was much less taken with
the artist's book illustrations and other works. In particular, Shaw thought
Furniss's "repulsive and unsympathetic caricatures of working-class human-
ity" overstepped "the line between ridicule and insult which divides the satirist
from the street-boy."[23] For statesmen at least, Furniss prided himself on not
exploiting physical infirmities, such as with the missing finger on Gladstone's
left hand: "compared with those [caricaturists] of other countries . . . it was
a credit to those in this country that they did not seize upon the deformities

18.*The World*, 12 June 1889; in *Bernard Shaw on the London Art Scene, 1885–1950*, ed. Stanley Weintraub
(University Park and London: Pennsylvania State University Press, 1989), pp. 285–86.

19. *MAHTD*, p. 69.
20. *MAHTD*, p. 70.
21. *AH*, p. 34.
22. *CCI*, pp. 252–53.
23. *The World*, 19 Oct 1887. Some months later, HF sent an indignant letter to Shaw disparaging
his socialist approach to art criticism. HF to G. B. Shaw, 28 April 1888, BL Add MSS 50512, f. 31.

of public men for ridicule."[24] Despite these protestations, when an exhibition of "Drawings Political and Pictorial by Harry Furniss" opened at the Fine Arts Society Gallery in Bond Street in 1894, the author of the catalogue's introduction, *Punch* writer E. J. Milliken, placed him squarely in the tradition of graphic satire: "Mr. Furniss has nevertheless all the equipment of a true caricaturist, after the old Gillray and Rowlandson fashion. . . . He can smite and spare not, when native kindliness, or the exigencies of journalistic conventions, social amenities, and current taste do not bid him hold his hand."[25] Similarly, his friend and *Punch* historian M. H. Spielmann detected in his work the "resurrection of Gillray's spirit."[26]

As a popular entertainment for late Victorian audiences, "Humours" could ill-afford to be "ugly," though a few of the slides might be construed as such. For example, Furniss expressed his strong objection to bluestockings and the women's suffrage movement (images 83 and 85).[27] His penchant for Rowlandsonian caricature may be seen in his sketch of the Irish MP Swift MacNeill (image 20). (See sections III.3 and III.2 for more about Furniss's views on, respectively, the women's suffrage and Irish questions.) In the Irish case, however, what gave greatest offence were not the slides but Furniss's broad mimicry of Irish MPs. In a widely reported incident (though accounts vary), MacNeill grabbed Furniss by the lapels in the Lobby of the House of Commons, and then by the ear, and said he ought to be horsewhipped. This "technical assault," according to Furniss, "was the outcome of my imitations of the Irish members in my entertainment, 'The Humours of Parliament,' which I have given for two seasons all over the country. This was my offence; my caricature of Mr. Swift MacNeill [in *Punch*, 26 August 1893] the excuse for the attack."[28]

When he launched "Humours" in London, Furniss was criticized for the show's length, for lamenting that the good old days of Gillray and Rowlandson had passed, and for including "one or two representations which ridicule the consequences of physical infirmity."[29] When he toured the provinces, Furniss heeded the advice to shorten and refine his entertainment. The extant text

24. *PPP*, p. 73. Gladstone accidentally shot off his left forefinger in 1842. See image 21.

25. *Catalogue of a Collection of Drawings, Political and Pictorial by Harry Furniss* (London: Fine Art Society, 1894), p. 13.

26. M. H. Spielmann, "Our Graphic Humorists: Harry Furniss," *Magazine of Art*, vol. 23 (1899), p. 346.

27. The term "image" is used throughout this introduction to refer to the pictures HF used as slides for "Humours" and here accompany the extant text. "Figure" refers to background illustrations accompanying this introduction.

28. *St. James's Budget*, 1 September 1893, p. 7.

29. *Saturday Review*, 9 May 1891, p. 556.

contains no references to the good old days, nor indications of slides depicting
MPs with physical disabilities.

The touchiness of some reviewers over his stage imitations of politicians
may to some degree reflect the concern by conservative, bourgeois Victorians
for what they perceived as an increasing immorality that had pervaded the
arts, especially the music hall. Furniss had had a long association with the
theater and he was on stage during the so-called naughty nineties, a decade
when the social purity movement headed by the appropriately named
National Vigilance Association (formed in 1885) was in full cry.[30] NVA mem-
bers vigorously campaigned against prostitution and the current state of the
music halls (closely connected in the minds of these purity crusaders) and
a Select Committee on Theatre and Places of Entertainment was set up in
March 1892 (shortly after the end of the first "Humours" tour) to investigate
the issuing of licenses for stage performances.[31] Although Furniss performed
"Humours" at a variety of venues, including holiday pavilions, concert rooms,
and music halls, his show was never in any danger of falling foul of the over-
lapping licensing powers granted to the Lord Chamberlain's office and the
London County Council,[32] or of disturbing the delicate moral sensibilities of
the NVA, but he was not encouraged to give full rein to his talent for imitat-
ing on stage highly respectable and respected parliamentarians and ministers
of the Crown.

Thus, the performance, like the art on which it was based, generally oper-
ated within conventional notions of genteel respectability. If Furniss was
more temperamentally suited to the kind of robust caricature of his golden
age predecessors, he also knew that to make a living with his pen (and its
derivatives) required that he take account of the tastes of the times. By 1915
he was advising budding caricaturists to ignore the models of "Gillray, Row-
landson and other old masters of the art" since "one's artistic system becomes
in due course saturated with the ugly, the repulsive and the grotesque: and
this ends with a fever for raging monstrosities, which may take such a hold on

30. Furniss responded with a series of magnificent, satirical drawings, with titles like "A Meeting
of the Purity League" and "The Puritan on the Stage," which remain unpublished. These are housed
at the Hastings Museum and Art Gallery, England.

31. Dagmar Kift, *The Victorian Music Hall: Culture, Class, and Conflict*, trans. Roy Kift (Cam-
bridge: Cambridge University Press, 1996), pp. 144–45.

32. The allocation of licenses to different kinds of stage performances was complex. Under the
Theatres Act of 1843, the Lord Chamberlain's Office could issue licenses for "every Tragedy, Com-
edy, Farce, Opera, Burletta, Interlude, Melodrama, Pantomime, or other entertainment of the stage,
or any part thereof." The London County Council, formed in 1888, was granted the power to issue
licenses to music halls for "public dancing, music, or other entertainments of the like kind." Kift,
The Victorian Music Hall, ch. 7.

the system as to make eradication impossible."[33] One suspects that Furniss is thinking of himself here. The subjects of George V had no taste for the kind of caricature that had flourished under his earlier royal namesakes. As Furniss concluded, "the old caricaturists were coarse, because the period in which they worked was coarse."[34]

2. Art and Craft

While regretting the less savage form of caricature required by the times, Furniss sought not only fame and fortune, but also respectability. Accordingly, he made a virtue of necessity and became a consistent advocate for the artistic significance and legitimacy of the gentler variety of caricature as an art form worthy of serious consideration and study: "The art of caricature is not easy. It requires more training to make a caricaturist than a serious artist; for no one can turn the sublime into the ridiculous without first understanding the sublime."[35] It was on this basis that he pressed the Royal Academy to include artists who did "black-and-white work—by that I mean drawing for periodicals"[36] but without success.

So long as he enjoyed the patronage of *Punch* and hence access to the Press Gallery in Parliament, Furniss championed caricature and caricaturists. But after he lost his reporter's ticket in 1894 when he left *Punch* (over a pecuniary dispute), and following the rapid failure and associated financial losses of his own satirical magazines *Lika Joko* (1894–95) and *Fair Game* (1898–99), he changed his tune. Downplaying his years with *Punch*, he instead talked up his non-caricatured work such as book illustration: "*Punch* required 'funny little figures,' and I supplied them; but my *métier*, I must confess, was work requiring more demand upon direct draughtsmanship and power. I am a funny man, a caricaturist, by force of circumstances; an artist . . . by nature and training."[37]

Artists, however, are not always the best judges of their own work and Furniss's "funny little figures" are more incisive and memorable than even his underrated illustrations for Lewis Carroll's *Sylvie and Bruno* (1889) and certainly more than, say, a series of conventional portraits of the leading clergy of the day he did for non-satirical magazines like the *British Weekly*. Even while attacking the Royal Academy (most famously in his 1887 exhibition of

33. *MAHTD*, pp. 75–76.
34. *MAHTD*, p. 76.
35. *MAHTD*, p. 68.
36. *MAHTD*, p. 37.
37. *CCI*, p. 91.

87 parodies of RA artists dubbed "An Artistic Joke"), he nevertheless wished "to be able to paint a picture which shall be worthy of a place on the walls of the National Gallery."[38] In his *Punch* days, he revealed to one interviewer that, although the magazine paid well and a man had to eat, his secret ambition was to be a serious artist: "He told me that he looked forward to the time when he should consign to the rag-basket the famous Gladstone collar and cease to play with Goschen's eye-glass. He is striving to accomplish something more—he would do it now, but it isn't marketable. Mr. Furniss is a sensible man. He caricatures to live; and, if the laughs follow, well, so much the better."[39] In the evaluation of the great cartoonist of a later era, David Low, Furniss was "an unusually accomplished caricaturist," but one who "galloped too fast for his horse. . . . Had Furniss produced less he would have been accounted a better artist."[40] But this assessment fails to properly appreciate the scale and range of Furniss's achievements.

The two aspects of Furniss's art, the satirical and the serious, the funny little figures and the portraits, the caricatured and the representational, are found in his work for *Punch* and *Black and White* respectively, both of which he contributed to regularly during his tour with "Humours." That he was by inclination and instinct a satirist and caricaturist—a *Punch* man rather than a *Black and White* man—is to be seen in the latter magazine's editorial injunction that he curb those instincts for his column "The Week in Parliament: Illustrated and Described by Harry Furniss" (which ran from February to August 1891) and in Furniss's reaction, remarkable for its outspoken and public nature.

> The reader may accept the accompanying portrait of Sir William [Harcourt (fig. 1)] as fairly true to the original, and as, in compliance with the request of the editor of this paper, I avoid caricature as well as I can in my drawings, I feel that I cannot sign this sketch of Sir William without some explanation of the contrast it presents with the figures of the same politician in 'in another place.' The fact is simply this, that I do not always represent a man after the manner of a tailor by inch measurements, or with automatic accuracy like a photographer. It is my aim, to go further, and endeavour to embody in my sketch something of the character of my subject, and this I attempt to achieve by exaggerating any physical peculiarities which I think may elucidate my object.[41]

38. *CCI*, p. 91.
39. How, p. 306.
40. David Low, *British Cartoonists: Caricaturists and Comic Artists* (London: William Collins, 1942), pp. 34–35.
41. *B&W*, 28 March 1891, p. 254.

THE RIGHT HON. SIR WILLIAM HARCOURT SPEAKING

Figure 1. "The Right Hon. Sir William Harcourt Speaking" (*B&W*, 28 March 1891, p. 254)

In "Humours," hamstrung by neither the nature nor the editorial policies of any magazine Furniss was able to "elucidate" Sir William, as in images 30 and 31, though whether the latter is, as Furniss himself avers, not a caricature but a "thumbnail character sketch, without any attempt whatever to elaborate or . . . caricature"[42] is a moot point.

For the sake of variety and to appeal to the eclectic tastes of his audiences, Furniss included both formal portraits and caricatures in his entertainment, as in the case of Gladstone leaning over the despatch box (image 21) followed by eight sketches. The former set up the audience for the latter: "I spoke night after night from the platform, and the laugh always came with the collars."[43] This division between the serious and the satiric informed the dual purpose of the performance, namely to instruct and amuse, a combination reviewers immediately recognized and praised. By and large those slides that are representational are also the most informative while the caricatures obviously got the laughs.

But this simple division obscures the fact that Furniss worked in at least three different styles based upon different forms of publication. Apart from the opening slide, almost all the other images in "Humours" appeared in newspapers, magazines or, as with the architectural drawings that were done specially for the show, published later in book form (*Pen and Pencil in Parliament,* 1897). In his drawing manual for aspiring artists Furniss distinguishes

> three classes of printing:—the careful high-class work on the best paper; that of cheaper magazines, printing with cheaper ink, on cheaper paper; and the quick printing in newspapers and in the cheapest periodicals, printed on rotary machines. Therefore it must be evident that there ought to be three distinct styles of drawing to suit these methods of printing. Finish as much as you like for the first. For the second, shade less and keep the work more open. For the third, the requirements are: strong, clear outline, and practically no shading whatever, certainly no cross-hatching.[44]

"Humours" includes all three styles: "finished" architectural drawings (such as images 2, 9, 10, 45, and 106) and portraits (images 49 and 67); pictures of intermediate refinement (such as images 6a–c, 11–18, 36, 50, 78, 92, 107, and 108); and clear, unadorned drawings (such as images 31, 83, 85 and 97).

Some slides, such as the Gladstone series (images 21–29), combine all three styles, and these outstanding sketches demonstrate Furniss's belief that the

42. *Daily Graphic,* 10 July 1890, p. 4.
43. *CCI,* p. 164.
44. *HTD,* pp. 45–46.

caricaturist must also be a capable portraitist. He pinpoints the essentials of a
good caricaturist:

> concentration of effect, good strong black and white, with careful elimination
> of artistic frillings, and directness. The mind not the model should be the
> prominent factor. Secondly he must be a master of drawing and yet preserve
> his sense of caricature. In other words he must be capable of getting more than
> merely photographic resemblances. The facial expression must not merely be
> a mask, but express the essence of the man.[45]

The Gladstone sketches are exemplary displays of Furniss's combination of
technical skill, eye for detail, and sense of the absurd. In an interview from
1894 he explained his method: "you pick out the prominent characteristics: the
eyebrows, the curve of the nostril, the contour of the chin, the shape of the
forehead. Accuracy and the closest observation—a sort of observation every
man might not be capable of—are needed by the caricaturist."[46]

Direct and detailed observation of his subjects goes some way to explain-
ing the success of his caricatures. Apart from identifying "the prominent facial
features of the man" and exaggerating them (such as Gladstone's nose or Har-
court's chins), or an item characteristically associated with an MP (such as
Chamberlain's eye-glass), "it is absolutely necessary to find out his peculiari-
ties of habit or manner" and thus "settle his identity."[47] Hence, we see, as one
advertisement for "Humours" declared, "Mr Gladstone in his various Atti-
tudes—Serious, Comic, Vehement, Persuasive, Defiant, Eloquent, Excited
and Taking Egg Flip!!"[48] This "familiarity with the subject is only arrived
at by continually watching and sketching a Member."[49] Furniss claims to
"have frequently sat for many, many hours watching [Gladstone's] every ges-
ture, every change of expression. I have watched his colour leave his cheeks,
and his hair his head, marked Time contract his mouth by degrees, and noted
the development of an additional wrinkle. I have mused under the shade of
his collars and wondered at the cut of his clothes . . ." (fig. 2).[50]

Significantly, the quotation is from a section of his 1888 lecture on "Por-
traiture" subtitled "The Unpaintability of Mr. Gladstone." Furniss goes on
to assert that "a man like this, who can electrify a crammed House of Com-

45. "Cartoon," p. 9.
46. *Sketch,* 21 February 1894, p. 165.
47. *MAHTD,* pp. 30, 73.
48. *Dundee Advertiser,* 26 November 1891.
49. *CCI,* p. 148.
50. *Pall Mall Budget,* 11 October 1888, p. 13.

" I HAVE MUSED UNDER THE SHADE OF HIS COLLARS."

Figure 2. "I Have Mused Under The Shade Of His Collars"
(*Pall Mall Gazette*, 11 November 1888, p. 11)

mons, is too mercurial, too impressionist, for the nerves of a modest portrait-painter alone in a studio, and a portrait of the orator at his best has yet to be painted." Thus posterity will not look to portraits or to photographs (where "the pose is the pose the sitter takes before the camera") for the essence of the Grand Old Man but "it will be the caricatures, or, to be correct, the character sketches, that will leave the best impressions of Mr. Gladstone's extraordinary individuality."[51] Furniss makes a fair claim on behalf of the "black and white" artists, and he was among the most successful at depicting Gladstone's dynamism, which was the key, for, as Colin Matthew has noted, "Gladstone's features posed problems for cartoonists."[52]

51. *CCI*, pp. 166–67.
52. H. C. G. Matthew, *Gladstone, 1809–1874* (Oxford: Clarendon Press, 1986), caption to illustration 6.

3. Image-Making: From Observation to Publication

Furniss enjoyed exceptional access to his subjects. While associated with *Punch,* he not only had a ticket to the Press Gallery, but was also granted the even more select privilege of entering the Lobby, where reporters and members could mingle. While other reporters gathered information for their columns, Furniss "transfers upon a few strokes upon a piece of cardboard in the palm of his hand those striking caricatures that adorn the 'Essence of Parliament.'"[53] Yet, for the highly detailed, carefully sketched drawings, taken from a corner under the Press Gallery that would be incorporated into "Humours," Furniss had to seek special (and possibly unprecedented) permission. This was granted by the Lord Great Chamberlain's Office in July 1888: "Admit Mr. H. Furniss to take sketches in the Palace of Westminster."[54]

With this license, unimaginable today, to wander freely throughout Parliament, Furniss "made full use of [this] unique opportunity" to gather "material invaluable for my Parliamentary work."[55] He made friends with Dr. Percy, the "official engineer of the Palace of Westminster" who invited him "behind the scenes and under the stage of Parliament" (images 87–89).[56] For his architectural drawings of Parliament, Furniss would create a template by "tak[ing] a point of sight and draw[ing] lines converging on it. . . . For interiors such as I show . . . of the House of Commons (fig. 3), one can provide himself with several pages marked out in this way, but with different points of sight to suit any view one wants to sketch"[57] with figures added later as the occasion required (images 2 and 9 are cases in point).

When the House was sitting, his procedure for sketching the MPs themselves was somewhat different. Furniss "was the first artist on *Punch* to attend St. Stephens and study the members from life instead of relying—as all the other artists had hitherto done—on photographs and prints."[58] He wanted to catch his subjects unawares and in characteristic poses—for when a man "thinks he is unobserved . . . all his peculiarities are then evident."[59] Here is his summary of the stages from observation to publication:

53. John Pendleton, *Newspaper Reporting in Olden Time and To-Day* (London: Elliot Stock, 1890), p. 113. The author makes an interesting comparison between Furniss's method in the Lobby and that of other cartoonists: "In this respect he resembles Mr. Leslie Ward, 'Spy,' and differs from the late Mr. Pellegrini, the 'Ape,' of *Vanity Fair,* who would study a member in the lobby for an hour or two, and then go home to draw those marvelous likenesses" (pp. 113–14).

54. *CCI,* p. 246.

55. *CCI,* pp. 246, 249.

56. *CCI,* p. 249.

57. *HTD,* p. 62.

58. Anonymous prefatory biographical sketch, "Carnival," p. 9.

59. *CCI,* p. 137.

Figure 3. Initial Sketch of House of Commons (*HTD*, p. 63)

My system of work is to go down to the House of Parliament, taking little cards along. Then I watch a member and make sketches of him with a pencil in his different attitudes, and fill them in afterward in ink. Then they are photographed on wood and engraved—the old style, for they've never adapted new processes on *Punch*. I keep all these figures and use them when a member makes an important speech. When they get old I sketch them over again.[60]

Furniss's method of surreptitiously drawing his subjects on little cards was necessary in order to evade standing parliamentary prohibitions.[61] Initially "he

60. *NYT*, 7 April 1891, p. 3.

61. The standing orders of both houses of Parliament prohibited the admission of strangers. In practice, strangers were admitted, but the orders could be enforced at any time. Reporting of speeches by accredited journalists began to be permitted in the nineteenth century, though members of the public were forbidden to take notes. Each House relaxed its rules in different ways. To this day, the House of Lords' Rules for Admissions of Visitors states that visitors are not permitted to draw or write, except in the South-West Gallery. See Thomas Erskine May, *A Treatise on the Law, Privileges,*

used to make a rapid note on his shirt-cuff" but soon "trained himself to make sketches with his hand in his pocket," working away with "a pencil not more than three inches in length" rounded at one end "to prevent catching against the lining of the pocket" on cards "about the size of a square ordinary envelope," all the time "looking straight into the face of his victim."[62]

Then it was back to the studio in St. John's Wood to "fill in the details from memory" with the aid of his model, "the same model [who] has stood for all his principal people for the last ten years."[63] He also had "a wardrobe of artistic 'props' big enough to fit out every member of the House of Commons."[64] The process is described in detail in his drawing manual for aspiring artists and is relevant specifically to image 49 of Lord Salisbury:

> First, with a few hieroglyphics, I mark the size of the figure, its position, whether sitting or standing; long or short coat; style of tie, collar, etc. . . . (fig. 4), and then I draw in the head completely and carefully in pen and ink . . . (fig. 5). Having got so far, in every case I have a model and pose him as nearly as possible in the position I want. I never allow myself to think I have a model before me, but carefully keep my mind on the figure I imagine I see on the paper, still undrawn . . . (fig. 6).[65]

A constant stream of political caricatures arrived on Lucy's desk from which he could choose to illustrate his tongue-in-cheek account of individual MPs. "These single portraits were supplied in advance, and engraved proofs sent in a book to Mr. Lucy to select from week by week."[66] For the daily newspapers there was no time for the initial sketches to be touched up with the help of a model so that stage was bypassed. Furniss's sketches for the *Daily News* (1896), for example, were "drawn in an open style to suit rapid newspaper printing, and are perhaps interesting from the fact that they were actually drawn in the Press gallery of the House during the debates, and sent from the gallery to the engravers, not afterwards being improved upon or touched. These are probably the only Parliamentary sketches ever made direct in pen-and-ink in the House during a sitting and printed a few hours after being drawn from life."[67]

Proceedings and Usage of Parliament, 9th ed. (London: Butterworths, 1883), pp. 92–93, 265–69; *Parliamentary Debates,* 6th series (Lords), vol. 675, col. 952 (15 November 2005); House of Lords, *Companion to the Standing Orders and Guide to the Proceedings of the House of Lords* (2007), Appendix D, p. 213.

62. *CCI*, pp. 145–46; *MAHTD*, pp. 24–25. See sketch in *MBD*, p. 270.
63. *MAHTD*, pp. 24–25.
64. How, p. 300.
65. *HTD*, pp. 19–21.
66. *CCI*, p. 258.
67. *PPP*, p. 173.

Figure 4 "The Rough Sketch" (*HTD*, p. 19) Figure 5. "Sketch With Head Carefully Drawn"
 (*HTD*, p. 20)

Figure 6. "The Finished Portrait" (*HTD*, p. 21)

Furniss described the technical process whereby his drawings finally appeared in newspapers in his essay "Preparing to Lecture" (reproduced in full as Appendix I): "The original sketch has first to be made . . . it then has to be redrawn, then photographed, afterwards transformed into a relief block, then to be mounted, subsequently electrotyped upon a forme for the press, from which a papier-mâché impression has to be taken again, which in its turn has to be re-electrotyped before ink or paper must touch it."[68]

While touring with "Humours" Furniss continued to contribute to *Punch* and *Black and White*. He did not, of course, have access to his home studio. By that time, however, he had created a repertoire of features of the most famous politicians—Gladstone's collars, Harcourt's chins, Chamberlain's eye-glass, and so on—and no longer needed to sketch them "direct from life."[69] He also carried with him "a portable studio, about 3 feet by 1½ feet, which contains all my drawing materials, and when open forms a desk, so that I can get to work the moment I arrive at a hotel."[70] In this way, Furniss was able to keep up with his cartooning work (and income) in the few hours before presenting his evening show. From his traveling studio he sent to London by train his impressions of the places he visited that then appeared in *Black and White* magazine (later collected as *Flying Visits*) and in the parallel series for *Punch* "Mr Punch on Tour" (19 September 1891 through 23 January 1892).

Trains and station platforms also acted as his studio at times. On one occasion Francis Burnand, the *Punch* editor (1880–1906), telegraphed Furniss at Tunbridge Wells that he needed a sketch of Randolph Churchill hunting lions in South Africa to be on his desk that night. Furniss met the deadline by working on the train and at the stations on the way to Southampton, the next stop on his tour. "Our Special Artist on Tour" (fig. 7) shows the "Effect of Sketching in the Train." Furniss was proud to own that "all the time I have been on tour I have never allowed anything to interfere with my keeping pace with my Press work."[71]

68. This so-called "process" method was not used until 1900 for the full-page political cartoons, such a feature of *Punch,* which during the nineteenth century were printed from woodblocks engraved by the skilled craftsmen at Swain & Co. In 1900 HF became a director of Carl Hentschel & Co., a leading firm of "Photo Engravers, Electrotypers, and Designers," and his response to Hentschel's paper "Process Engraving," given to the Society of Arts on 3 April 1900, was published in the *Journal of the Society of Arts,* 20 April 1900, p. 472. For "a social history of photomechanical reproduction in Victorian London" (the book's subtitle) in the 1890s see Gerry Beegan, *The Mass Image* (Basingstoke & New York: Palgrave Macmillan, 2008). The method by which caricatures were transferred onto magic lantern slides is described in section IV.2.

69. *CCI*, p. 148.

70. *FV*, p. 156. See also *CC*II, p. 187.

71. *FV,* p. 157.

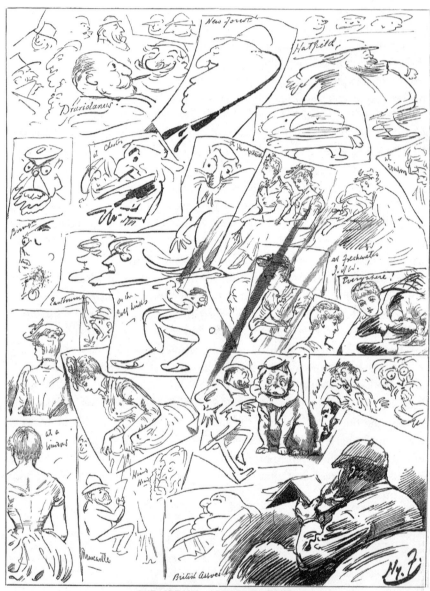

OUR SPECIAL ARTIST ON TOUR.
Effect of Sketching in the Train. (The Ladies were drawn at the Stations.)

Figure 7. "Our Special Artist On Tour" (*Punch*, 23 January 1892, p. 46)

II

POLITICAL CULTURE IN THE LATER NINETEENTH CENTURY

*A*S AN ILLUSTRATED LECTURE-PERFORMANCE about the center of national politics and its most notable inhabitants, "The Humours of Parliament" must be situated and understood, not only in relation to the development of caricature and graphic satire, but also within the larger frame of changes in political culture—in word and in image, in public acts and in print. "Humours" was first presented at the end of a century during which the relationship between politics and the people had altered in fundamental ways. Evolving modes of political communication were both instrumental to, and products of, processes of political modernization. The aim here is not to provide a comprehensive account of these developments. Rather, in light of the preceding discussion of Furniss's career and place within the history of British political art, this section attempts to outline a set of key contexts for appreciating "Humours," as contemporaries did, in relation to the political conditions that obtained when the caricaturist, commentator, and showman took the stage.

1. Political Participation and Electoral Display

Britain's political modernization occurred in a piecemeal, idiosyncratic, and sometimes paradoxical fashion over the course of the nineteenth century and well into the twentieth. This process went in tandem with notable transformations in the cultures and practices of political display, as well as in the nature of political audiences. The history of British political modernization is almost inevitably structured around a series of major legislative acts that revised the parameters for voting privileges, electoral practices, and the distribution of

parliamentary seats. When speaking of political display, however, there are few clear-cut cases of before-and-after. Traditional electioneering activities of the "unreformed" constitution carried on well past the "Great" Reform Act of 1832.[1] Indeed, supposedly older practices and conventions associated with political participation persisted across the formal divisions between electoral regimes, and their life-span varied by locality in a political culture that was still far from homogenized at the time of the Second World War.[2]

With "Humours," however, Furniss addressed not the persistence of older electoral forms, but rather the newer realities of political culture that had emerged in the second half of the nineteenth century. The franchise reforms of 1867–68 and 1884 created a mass (albeit still limited) electorate that included large numbers of artisans, urban laborers, and agricultural workers who either owned or rented a home.[3] Eligibility for the vote was still defined largely in terms of "fitness" and respectability. With the introduction of the secret ballot in 1872, voting itself ceased officially to be a matter of public display. This helped alleviate some (though hardly all) of the coercive pressures and social disciplines around which voting behavior had traditionally been structured. The Corrupt and Illegal Practices Act of 1883 (building on a series of previous measures) went further by attempting to regulate the uses (and abuses) of money at elections and other forms of swaying votes.

Taken together, these developments placed an increased premium on the ability of politicians to appeal to the expanded electorate at both the local and (for leading figures) national levels. At the same time, following a period of party fractures, weak coalitions, and minority governments, the 1850s saw the coalescing of two stable national parties and the beginning of a period of durable ministries alternating terms in office. New central party organizations were established in the 1860s and 1870s by both the Conservatives and Liberals to help with the coordination and financial management of campaigns nationwide.

Alongside these developments on the national scene, local politics had emerged from the 1830s onwards as a major arena of activity. Over the course

1. Frank O'Gorman, "Campaign Rituals and Ceremonies: The Social Meaning of Elections in England 1780–1860," *Past and Present*, no. 135 (1992), pp. 79–115; James Vernon, *Politics and the People: A Study in English Political Culture c. 1815–1867* (Cambridge: Cambridge University Press, 1993).

2. See, e.g., Jon Lawrence, "The Transformation of British Public Politics after the First World War," *Past and Present*, no. 190 (2006), pp. 185–216. The 1948 Representation of the People Act finally placed the system on a one-person-one-vote basis while also (among other things) bringing the parliamentary and local franchises into conformity.

3. Following the 1884 Reform Act, roughly six adult males in ten had the vote, with the franchise for the most part standardized across the United Kingdom. John Garrard, *Democratisation in Britain: Elites, Civil Society and Reform Since 1800* (Houndmills: Palgrave, 2002), p. xiii.

of the century, but increasingly so in the latter decades, responsibility for a range of sub-national or devolved functions—including municipal and county governance, poor relief, and elementary education—came to be vested in a host of deliberative voting bodies, the structure and procedures of which were modeled on the House of Commons. By the end of the century, links between local and parliamentary politics were considerable. One major difference between the national and the local, however, was that from around 1870 qualified women began to be able to vote for, and in some cases be elected to, a range of local official bodies (see section III.3). Local politics thus served as an important field for the emergence of cadres of both non-elite and female political leaders, and as a kind of apprenticeship for participation at the national level. The growing importance, sophistication, and machinery of local politics also stimulated a desire for greater knowledge of Westminster.

It is not necessary to deny the persistence of older traditions in order to say that the expansion of the electorate, the efforts to take influence out of voting, the establishment of national party organizations, and the growth of local politics had created by the late 1880s a political world quite different from the one into which Furniss had been born. Under these conditions, certain means of political communication assumed greater importance.

2. Political Communication

In "Humours," Furniss states that "The House itself is the stage, and whatever is said or done in it, is political acting for public effect" (p. 254). Later, he would write that "Parliament is the theatre of politics, and no theatre will ever succeed if the cast of the play is uninteresting."[4] A significant dimension of Britain's political modernization in the nineteenth century was the increasing need for politicians to make themselves more interesting to their audiences.[5] Speech, in a variety of forms, was the primary medium. In the words of Colin Matthew: "Victorian public life was linked by what seemed an ever-growing flow of words, spoken and printed."[6] In politics, those who were most successful at producing words and embodying speech were advantaged. As constituency contests became more competitive as a result of electoral reform,

4. HF, "The Caricaturist and the Politicians," *Weekly Scotsman*, 7 January 1905, p. 7.

5. Unless cited otherwise, much of this section draws upon Joseph S. Meisel, *Public Speech and the Culture of Public Life in the Age of Gladstone* (New York: Columbia University Press, 2001), esp. chs. 2 and 5.

6. Colin Matthew, *The Nineteenth Century* (Oxford: Oxford University Press, 2000), p. 106; see also H. C. G. Matthew, "Rhetoric and Politics in Great Britain, 1860–1950," in *Politics and Social Change in Britain: Essays Presented to A. F. Thompson*, ed. P. J. Waller (Hassocks: Harvester, 1987).

extensions of the franchise, and party organization, an increasing proportion of ordinary MPs participated in parliamentary debates. Politicians aspiring to a larger regional or national profile did much more than that, in some cases assisted by the emergence of local party machines.

At the upper reaches of political life, the century witnessed the creation of a politics of personality that relied on various forms of performative appeal. Although it is always possible to point to antecedents, the cultivation of a public persona for mass consumption was arguably pioneered by Lord Palmerston and subsequently carried further by Gladstone.[7] Disraeli's theatrical effects achieved similar results in a somewhat different key.[8] Other leading figures to which Furniss paid attention in his cartooning work and in "Humours"—like Chamberlain, Harcourt, and Balfour—all drew on these examples. For politicians, cultivating this kind of standing became especially important toward the end of the century. The introduction of new rules for parliamentary procedure in 1882 substantially increased time set aside for government business and introduced new powers for closing debates.[9] These changes had the effect of focusing what happened in the Commons on the major figures seated on the government and opposition front benches. Further, where once politicians made their name within the parliamentary context alone, by the 1890s political personae were projected before the mass public through their activities "out-of-doors."

The three great and interlinked mainstays of the politics of personality in the nineteenth century were the extra-parliamentary platform, the railways, and the press.[10] Previously the hallmark of the leaders of Radical mass protest movements from the first half of the century, extra-parliamentary speechmaking outside the electoral calendar and not necessarily in one's own constituency became an increasingly common practice for leading politicians by the century's end. These speaking appearances enabled politicians to organize public displays of (and thereby bolster) their own popularity, to appeal to the public directly over the heads of Parliament and local political caucuses, and to carry on a debate with their opponents outside of the Commons chamber.

7. On Palmerston, see Antony Taylor, "Palmerston and Radicalism, 1847–1865," *Journal of British Studies*, vol. 33, no. 2 (1994), pp. 157–79; Joseph S. Meisel, "Palmerston as Public Speaker," in *Palmerston Studies*, ed. David Brown and Miles Taylor, 2 vols. (Southampton: Hartley Institute, University of Southampton, 2007), vol. 1, pp. 39–67. On Gladstone, see Matthew, *Gladstone, 1875–1898*, pp. 49–51; Eugenio F. Biagini, *Gladstone* (Houndmills: Macmillan, 2000), pp. 57–74.

8. On Disraeli's debt to Palmerston, see Robert Blake, *Disraeli* (London: Eyre & Spottiswode, 1966), pp. 535, 567–68.

9. See Edward Hughes, "The Changes in Parliamentary Procedure, 1880–1882," in *Essays Presented to Sir Lewis Namier*, ed. Richard Pares and A. J. P. Taylor (London: Macmillan, 1956), pp. 289–319.

10. See Meisel, *Public Speech*, pp. 268–72.

The spread of the railway network throughout Britain enabled speakers to travel around the country quickly and inexpensively, and also made it possible for larger numbers of people to come greater distances to hear their speeches.[11]

Railways also carried the newspaper reporters who covered these events. The press experienced a major expansion in the second half of the century thanks in part to Gladstone's elimination while Chancellor of the Exchequer of the so-called "taxes on knowledge": the duty on advertisements (1852), the stamp duty (1855), and the paper duty (1861). The total number of newspapers in the United Kingdom grew from 795 in 1856 to 2,093 in 1886,[12] while circulation figures also increased substantially. In addition to printing extensive coverage of parliamentary sessions, the enlarged newspaper media carried the words spoken at platform events to reading audiences throughout the nation. The capacity for disseminating platform oratory increased further with the nationalization of the telegraph lines under the Post Office in 1870. This provided the technological and economic infrastructure for a veritable "trade in great men's speeches" organized by the new news agencies.[13]

At one level, therefore, "Humours," as a series of spectacular speaking events delivered across the country, was of a piece with this broader platform culture in which speech-making, performance, and politics were so closely linked. At the same time, however, "Humours" can also be seen to occupy an interesting transitional position in the history of visual political communication. Certainly, Rowlandson, Gillray, Cruikshank and other notable predecessors used the technology of their times (single-sheet etched copperplate prints) to circulate their images through printshops and in special portfolios to a wide, but typically fashionable audience.[14] By Furniss's time, however, the technological, communications, and political contexts had evolved considerably. Illustrations in newspapers and periodicals were prevalent by the 1840s, but became far easier to produce by the last two decades of the century with

11. In 1850, approximately 67 million passengers traveled on 6,000 miles of track. By 1880, when the practice of "platforming" began to take off, the expanded 15,500 miles of track carried an annual ridership of nearly 597 million. B. R. Mitchell, *Abstract of British Historical Statistics* (Cambridge: Cambridge University Press, 1962), pp. 255–56.

12. H. Whorlow, *The Provincial Newspaper Society, 1836–1886* (London: Page, Pratt, & Turner, 1886), p. 38.

13. Alfred Kinnear, "The Trade in Great Men's Speeches," *The Contemporary Review*, vol. 75 (March 1889), pp. 439–44.

14. The economy of illustration during the "golden age of caricature" (conventionally, c. 1770–1815) enabled printsellers to keep their professional caricaturists dependent and underpaid in ways that would have been anathema to Furniss's entrepreneurial spirit. George Cruikshank remarked that, as with Gillray and Rowlandson, the most profitable work of his career had been etching the work of fashionable amateurs. Draper Hill, ed., *The Satirical Etchings of James Gillray* (New York: Dover, 1976), p. xv.

the advent of more sophisticated techniques for halftone prints and photo-
graphic processing.[15]

In politics, visual media generally became far more prominent toward
the end of the century. Although banners, placards, bills, and hoardings were
long-established forms of political communication, the emergence and refine-
ment of new lithographic printing techniques toward the end of the nine-
teenth century made possible the large-scale production of pictorial posters
and their widespread use as a political medium.[16] The new national party
organizations, barred from more traditional forms of voter persuasion by the
1883 Corrupt Practices Act, turned to visual propaganda to reach the elector-
ate, particularly in urban constituencies. Non-party political organizations
also took advantage of the new postering technologies to advance their causes,
as did the political press which tended to be closely aligned with the parties.
Not that the art of the political poster matched these improvements in tech-
nology in Furniss's opinion: "Political posters are, as a rule, in as poor a taste
and as bad art as the posters puffing the cheapest melodramas. The cheapest
periodicals nowadays aim at being artistic; advertisements have improved by
leaps and bounds; shop windows are pleasing and refined, and almost every
hoarding is equal artistically to a wall in a picture gallery. Why, then, should
our legislators, and their satellites, all conspire at election time to bring back
our people to the worst art, degrade the public taste, and offend the public
eye?"[17]

Furniss may have been especially critical in this regard because the use of
pictorial posters in politics was strongly connected to the tradition of political
cartooning. Cartoons were the most important source for posters before 1914,
and many posters were essentially scaled-up reprints of cartoons. Some of the
major cartoonists were especially prominent in the poster realm, although, as
with their work for newspapers, the images these professional graphic artists
produced did not always correspond to their own political allegiances. In the
context of the emergence of pictorial political posters, then, "Humours" may
be seen as Furniss's own version of (literally) projecting via magic lantern
slides scaled-up versions of his cartoons for the purpose of conveying political
information to large audiences around the country.[18]

15. Patricia Anderson, "Illustration," in *Victorian Periodicals and Victorian Society*, ed. J. Don
Vann and Rosemary T. VanArsdel (Toronto: University of Toronto Press, 1994), pp. 128–30.

16. This paragraph and the next draw on James Thompson, "'Pictorial Lies'?—Posters and Poli-
tics in Britain c. 1880–1914," *Past and Present*, no. 197 (2007), pp. 177–210.

17. HF, "Standing for Parliament: Its Humours and Toils," *Cassell's Magazine*, vol. 45 (May
1908), p. 586.

18. Furniss cartoons were also used for political posters, although his "Unionist Empire Team" of
1900 was an unusual example of positive appeal in this medium. Thompson, "'Pictorial Lies'?" p. 185.

The magic lantern itself was employed as a form of political media. It had been used as early as 1872 to announce electoral results in New York while "at the presidential elections of 1896 [which Furniss attended and sketched] the results of the contest between Bryan and McKinley were projected at seven sites throughout the city, including a vast screen 170 x 60 feet, which displayed pictures of the candidates, news of the election, and the progressive results."[19] In Britain, parties quickly saw the lantern's propaganda potential. Slides with portraits and cartoons bearing on the major domestic and foreign issues were made available during the July 1892 general election, and the anti-Tory candidates in the 1895 London County Council elections also campaigned with slides.[20]

Because it had concluded a few months before the general election of July 1892, the first "Humours" tour cannot be said to have played any direct role in the campaign. Furniss was back in England following a voyage to the United States for a period of "rest and recreation"—during which he sketched all the time, of course (see section V.1). In the press, Furniss commented on the election, touting his accurate prediction that Gladstone would form a fourth ministry, but with a narrow majority, then further (and erroneously) predicting that the new government would soon fall and give way to a Unionist ministry.[21] But whether "Humours" exerted any residual influence on the political disposition of electors who saw the entertainment cannot be known.

What is reasonably certain is that the contentious election presented Furniss with a new opportunity to cash in on the political excitement. While no documentation has come to light describing Furniss's motives for launching a second tour of "Humours" in the fall of 1892, several factors in particular could be seen to have favored a revival of the entertainment. Perhaps most important was the return of Furniss's principal subject, Gladstone, to the head of government and the forefront of public life. Further, Ireland was to be at the top of the agenda as it was well known that Gladstone would attempt to reverse the defeat of his bill for Irish Home Rule in 1886 (see section III.2).

During World War I Furniss produced for the government posters such as "Better Than The VC," depicting a soldier back from the front, baby in arms, accompanied by his wife, and "Peace and War Pencillings," which ran for six weeks at the Coliseum, London, in August and September of 1914, and was described by Furniss himself as "lightning-sketching for the cinematograph." HF, "The Magic Hand," *Strand Magazine,* vol. 48, no. 278 (1914), p. 667. Political figures also appeared on postcards with increasing frequency from 1902 onwards when the Post Office allowed one side of the card to be divided between the message and the name and address, thus making the reverse side available for pictures, including political cartoons. In 1904–5 a series of twelve postcards with caricatures by Furniss of Joseph Chamberlain during the tariff reform era became available.

19. *EML,* p. 237.
20. *EML,* p. 237.
21. See *CCI,* pp. 206–12 for this letter, responses to it, and Furniss's own musings about his attempt at parliamentary prophecy.

In this light, the extended characterizations of Irish MPs and their grievances in "Humours" would have had a new topicality. With anticipation high, but before Parliament was back in session to start making news, it may well have seemed a good moment to capitalize on the political suspense.

In addition to these factors, the face of British politics was changing and there was a new crop of notable MPs to be incorporated. These were a boon to Furniss who was ever aware of the dangers of reproducing the same old figures: "To the Parliamentary artist there is nothing more welcome than a General Election and the change of Government which is thereby usually implied. For after five or six years his stock-in-trade begins to grow stale, and he, as well as the public for whom he works, begins to long for something new."[22] The advertisement for the 5 December performance at Brighton specified that "Humours" was "up to date" and the programme included "The Latest Additions to the Westminster Show: Mr. John Burns, Mr. Keir Hardie, Mr. Naoroji, Mr. Asquith, Mr. Field, and Others." Burns and Hardie were two of the three working-class members elected under the banner of the Independent Labour Party (though Burns would subsequently join the Liberals); Dadabhai Naoroji was the first Indian member; and William Field was a notable Irish nationalist. Herbert Henry Asquith, first elected in 1886 but given the prominent post of Home Secretary in 1892, was marked out as the coming man. All of these would have been figures of interest or curiosity to Furniss's audiences.

Unlike the posters and lantern slides that were deployed explicitly for party political purposes, Furniss claimed that his intentions with "Humours" were not propagandistic or partisan:

> It is a funny thing, which I fail to understand, and of which I cannot get any explanation, that my "Humours of Parliament," which is in no way a Party picture, and which, as you know, is accepted equally by the Radical, Tory, Liberal, and Unionist press, should be chiefly patronised by one party—the Tories. Any stranger travelling with me might well suppose that 99 per cent. of the people of Great Britain are Conservatives, were he to judge only from my audiences. As you know, I hold the scales of political feeling as equally as I can: if one side goes down at any time, the other follows suit the next moment.[23]

Political communication is generally discussed in terms of its partisanship, but as Furniss and "Humours" illustrate, there was also a role for neu-

22. HF, "Parliamentary Illustration," *B&W*, 29 August 1891, p. 312.
23. *FV*, p. 103.

trality. In general (his antipathy to all things Irish aside), Furniss claimed to be "unprejudiced by party feeling"[24] and seized opportunities to broadcast his non-partisan status. When, for example, he declined the invitation to become chairman of a local Liberal and Radical association, he sent a letter to *The Times* declaring that "I myself take no sides in politics, and am glad to say that I have numerous friends in all parties."[25] Given his profession, this made good economic sense. Overt partisan leanings would have narrowed the approbation of his audiences and compromised his free and easy access to the full range of national political life: "I had the tremendous advantage of being in it [Parliament], not of it. And I could survey its actions with impartiality."[26]

Consistent with this general approach, Furniss wanted "Humours" to appeal across the political spectrum, to be "in no way a Party picture" and "accepted equally by the Radical, Tory, Liberal, and Unionist press."[27] He appears to have succeeded in this objective for, as one reviewer noted, "we are sure that the most violent partisan could have found no fault with his good-natured and amusing sketches."[28] Furniss made it crystal clear in his opening remarks that the stage he stood on was no party platform. The forthcoming entertainment, he would say, was to be a "purely artistic and unpolitical occasion" and he took "no side in politics" (p. 141). The very first slide was of a large umbrella inscribed with the words "No Politics," something he urged his audience to "keep an eye on" for the rest of the evening.

Furniss possibly learned the advantages of political neutrality from his employment with *Punch,* which claimed from the start to have no political preferences and had on its staff men of all political persuasions.[29] But perceptions could differ. Furniss wrote that *"Punch* is supposed to be non-political" and "its present editor [Burnand] is impartial," yet it is also true that the very nature of caricature provokes partisan reactions, as did "The New Cabinet" (fig. 8).[30] This 1892 cartoon depicted the despair of the ministers gathered around a table on which Gladstone has unfurled his agenda for the government. It is a blank sheet, and Gladstone holds a large quill not yet dipped in ink. Underscoring the Grand Old Man's perceived failure to have produced (or permit others to produce) a substantial program of needed reforms that would help strengthen the Liberal party internally and with the electorate, a

24. *PPP,* p. 73.

25. *CCI,* pp. 205, 207.

26. *TPC,* p. 227.

27. *FV,* p. 103.

28. *Dundee Advertiser,* 26 November 1891.

29. For a discussion of *Punch*'s politics see Frankie Morris, *Artist of Wonderland: The Life, Political Cartoons, and Illustrations of Tenniel* (Charlottesville: University of Virginia Press, 2005), pp. 248–49.

30. *Punch,* 27 August 1892, p. 95. Reproduced, along with commentary, in *CCI,* p. 255.

candle representing the government's majority of 40 burns down while the current cabinet is reproached by a picture of its 1880 predecessor. Meanwhile, the shadow of Lord Salisbury, the Conservative leader, looms in the background. As Furniss later wrote:

> It is impossible to treat a strong political subject . . . without offending some readers by amusing others, unless, as I say, the subject is treated in a colourless manner. . . . My readers will sympathise with me. I am to draw political cartoons without being political; I am to draw caricatures without being personal; I am to be funny without holding my subject up to ridicule; I am to be effective without being strong—in fact, I am to be a caricaturist without caricature!"[31]

But the objectives of *Punch* and "Humours" were different, even though Furniss drew on his published *oeuvre* for his performance. *Punch* responded to the latest political events week by week. While many of its cartoons endure as brilliant encapsulations of particular historical situations, they were intended to be of the moment. "Humours" aimed instead to present a more general picture of Parliament and its proceedings in that era. Although, for example, Furniss claimed that his highly topical and controversial "The New Cabinet" was the most popular cartoon he "ever drew for *Punch*,"[32] he did not add it to "Humours" after it was published (which would have been in time for inclusion in his second tour in 1892). Instead, Furniss relied on generic incidents, such as the debate over taxes on periwinkles or silly discussions over army horses, and on generic MPs (the MP for Boredom, the MP for Ballyhooley, the Official Windbag) for many of his satiric thrusts. Named MPs like Gladstone or Harcourt were portrayed in an amusing but not offensive manner as larger-than-life figures. Ultimately, political neutrality was the most appropriate position for "Humours," which set out to instruct as well as entertain the broadest possible (albeit respectable) audience.

3. Caricature and the Politics of Personality

Along with the "rise of the platform," visual political communication also played a central role in the creation of celebrity politicians in the new democratizing era. The first *OED* citation for "celebrity" in its modern sense of a

31. *CCI*, p. 254.
32. *CCI*, p. 254.

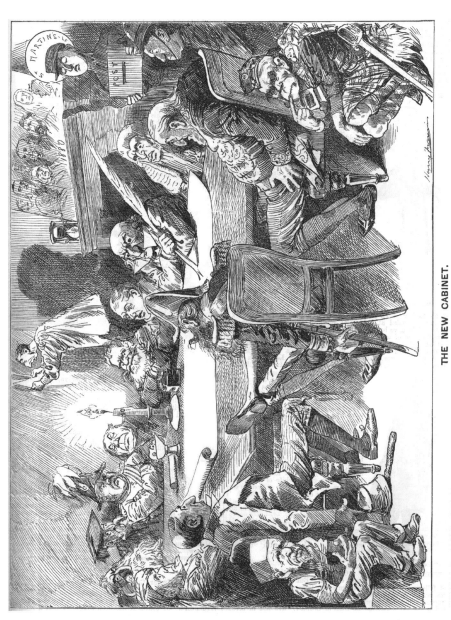

THE NEW CABINET.

Figure 8. "The New Cabinet" (*Punch*, 27 August 1892, p. 95)

public personality dates from 1849, and Thackeray, *Punch*'s most famous contributor, certainly helped to establish this meaning. As historians of the term have noted, it was a concept made possible by the rise of market capitalism and the emergence of a sophisticated consumer culture in which public figures were marketed as commodities to be circulated and consumed.[33] Literary and artistic celebrities were already well established by the 1880s, and Dickens (who died in 1870) has been seen as "the first true celebrity of the popular arts."[34] In politics, the forces already discussed—new technologies, the mass electorate, changes in the nature and conduct of politics, a symbiotic relationship between press and Parliament—all came together in the later nineteenth century to produce the true celebrity (as distinct from the merely famous) politician.

If "immediate physical recognizability" became a vital component in the construction of the celebrity,[35] then caricatures disseminated through the expanding press presented politicians to the people through the constant repetition of a set of simplified, accentuated, and instantly recognizable features. Repetition is critical in this respect. According to theater historian Joseph Roach, the celebrity quality of "It"

> arises not merely from the singularity of the original, as Walter Benjamin supposed, but also from the fabulous success of its reproducibility in the imaginations of many others, charmed exponentially by the number of its copies. The one-of-a-kind item must become a type, a replicable role-icon of itself . . . in order to unleash the Pygmalion effect in the hearts and minds of the fans, making the idea of him or her theirs. . . .[36]

As a result of promoting this kind of visibility, caricature has always been a double edged genre: at once puncturing and exalting its subject in a dual gesture of trivialization and veneration.[37]

33. See, e.g., Leo Braudy, *The Frenzy of Renown: Fame and its History* (Oxford: Oxford University Press, 1986); David P. Marshall, *Celebrity and Power: Fame in Contemporary Culture* (Minneapolis and London: University of Minnesota Press, 1997). For the general notion of style and performance in politics, see John Street, "The Celebrity Politician: Political Style and Popular Culture," in *Media and the Restyling of Politics: Consumerism, Celebrity and Cynicism,* ed. John Corner and Dick Pels (London: Sage, 2003), pp. 85–98.

34. Jane Smiley, *Charles Dickens* (New York: Viking, 2002), p. 26.

35. Lisa Hamilton, "The Importance of Recognizing Oscar: The Dandy and the Culture of Celebrity," *The Center & Clark Newsletter,* no. 33 (Spring 1999), p. 4.

36. Joseph Roach, *It* (Ann Arbor: University of Michigan Press, 2007), p. 177.

37. See Nicholas Dames, "Brushes with Fame: Thackeray and the Work of Celebrity," *Nineteenth-Century Literature,* vol. 56, no. 1 (2001), p. 42. We have drawn more generally on Dames's excellent discussion of caricature and celebrity.

Not surprisingly, Furniss had a good deal to say about the caricaturist's role in the production of political reputations. In 1905, lamenting the current lack of politicians whom he thought good subjects for caricature, he wrote: "It is not the politician that makes the caricaturist, but the caricaturist that makes the politician."[38] Elsewhere, he observed that "Public men have, more often had their reputations enhanced, than retarded, by being chosen as [the caricaturist's] subjects. It is not too much to say that some men have been made, solely by these flattering attentions of the lampooner." On first seeing a caricature of himself, Disraeli (according to Furniss in a possibly apocryphal anecdote) "jumped up with joy, and exclaimed: 'Now my reputation is made!'"[39]

Furniss was thus acutely aware of the importance of the visual element in the symbiosis (some would say Faustian pact) between modern politics and the media that developed over the nineteenth century. Caricaturists mediated between politicians and their audiences, depicting the contradictory qualities that underlie modern public fascination with celebrity: "vulnerability in strength, profanity in sanctity, intimacy in public."[40] In an era of speech, words, both spoken and printed, were the principal means through which politicians cultivated importance. By creating and repeating readily identifiable images of politicians that often accompanied accounts of oral performance if not depicting them outright, cartoons were a visual cognate to verbal communication that gave embodiment to the words.

Perhaps the truest indication of the power of caricature (especially of the gently satiric variety) was not simply how cartoons became a critical means by which leading politicians' identities were established for the public, but rather the way that they could also confer distinction on the undistinguished: "In the House of Commons, as we all know, a pushing and incompetent person who happens to catch the draftsman's eye becomes a far more important man in the public imagination than men of real power and intellect."[41] Once a politician is caricatured, "it is a sign that he is being taken notice of, and that he is rapidly making his mark." Lord Randolph Churchill, according to one report, "had quite an extensive collection of caricatures of himself which had been published in the public prints, and takes great delight in looking over the lot, and showing them to his intimates."[42] This kind of repetition of imagery that the medium of cartooning was so well suited to provide was

38. HF, "The Caricaturists and the Politicians," *Weekly Scotsman*, 7 January 1905, p. 7.
39. *AH*, p. 28.
40. Roach, *It*, p. 175.
41. *AH*, p. 42.
42. Quoted in *AH*, p. 32.

a critical means by which people were conditioned to know what to expect from politicians, and at the same time the means by which those expectations were established.

By the time he launched "Humours," Furniss had worked for *Punch* for ten years and his repertoire of features of the most famous MPs—the seventy or so that he thought worth caricaturing[43]—was well established in the public mind. If his "recipe for the making of caricatures" was "to find out the chief points and exaggerate them," it was also important to "invent a type for a public man and stick to it. The man then grows, in the public eye, to look like his own caricature."[44] Thus, Furniss "invented" the famous Gladstone collars which first appeared in *Punch* on 8 April 1882 (fig. 9), and "by ceaseless repetition made it impossible for Gladstone to appear in cartoons without his collars being exaggerated."[45] (Perhaps the only similar cartooning achievement in identifying a prime minister with an article of clothing was Steve Bell's "invention" of John Major's underpants.) By 1905, however, Furniss lamented that, Balfour and Chamberlain apart, "the present batch of leading politicians are not good subjects for caricature." Disraeli, Gladstone, Salisbury, and Harcourt "became known to the man in the street not so much by reason of their diplomacy or by their public works, but by their caricatures. Alas! At the present time there is a dearth, not so much of clever men, but of comic-looking men. We will pass over Mr. Balfour and Mr. Chamberlain; where are the others?"[46]

According to Colin Matthew, "cartoonists have always been much more influential than painters" in British public life, and that by the 1880s, "cartoonists were almost as respectable as artists, and the sharp disjunction of the early years of the century—between, for example, Rowlandson and Lawrence—had disappeared."[47] Matthew attributes this to the high quality of British cartoonists' work compared to that, generally, of mid-Victorian portrait painters, but other factors were also surely responsible for the diminishing status gap between painters and cartoonists. *Punch*, for instance, developed into a national institution, while periodicals like the *Illustrated London News* (launched in 1842) and the *Graphic* (1896) were not only distinguished by the

43. *B&W*, 29 August 1891.

44. *CCI*, p. 139; *MAHTD*, p. 31.

45. "Cartoon," pp. 38–39. Gladstone clearly took note of the collar device. When Furniss drew a cartoon to announce his intention to retire the collars—"Serious Announcement. Mr. Gladstone's collars are worn out. No more after today. Last appearance!"—the statesman pasted it into his diary. Reproduced with the illustrations in H. C. G. Matthew, *Gladstone, 1875–1898* (Oxford: Clarendon, 1995).

46. HF, "The Caricaturists and the Politicians."

47. Matthew, "Portraits," pp. 145–46.

Figure 9. "Getting Gladstone's Collar Up" (*Punch*, 8 April 1882, p. 160)

quality and realism of their engravings, but also employed rising artists like Frank Holl and Luke Fildes.[48] At the same time, established painters began to work in a variety of graphic media: Whistler produced noted series of lithographs and etchings, and Millais drew illustrations for books. The same robust market for prints that contributed to the easing of rigid distinctions among categories of artists also enabled enterprising cartoonists like Furniss to prosper, and therefore cultivate respectability.

In the context of an emerging mass political culture, formal portrait paintings of public figures were to be found for the most part in spaces which the general public did not frequent or to which it had little or no access: art galleries, private homes (like the "Statesmen's Gallery" assembled by Sir Robert Peel at Drayton Manor), and institutional spaces (e.g., clubs and societies).[49] The National Portrait Gallery was founded in 1856 expressly to place such images on public view, but in its early years access was doubly constrained by limited opening hours and the lack of a permanent purpose-built home before 1896. In addition, although "the celebrity [here meaning the enduring significance] of the person represented rather than the merit of the artist" was the key criterion for inclusion, the Gallery did not begin to collect images of living persons for more than a century after its establishment.[50]

More significantly, formal portraiture was a medium in which the potential benefits of repetition for establishing a public image were limited in both quantitative and qualitative terms. Although painted portraits were duplicated on canvas in very small numbers if at all, engravings of these works were widely circulated in illustrated weeklies and as commercially marketed prints. But Furniss, for one, was critical of these images' capacity to represent their subjects. They were drawn, he stated, "in a purely conventional tailor's advertisement fashion."[51] "The mass of Gladstone portraits published," for example, "are idealised, perfunctory, stereotyped, and worthless."[52] No doubt, such comments reflect, at least in part, Furniss's unceasing attention to his own self-interest. At the same time, however, it is important not simply to

48. Van Gogh for one greatly admired this new generation of English black-and-white artists, including Furniss himself, whose drawing "A Midsummer Night's Dream: A Sketch in a London Park" (*ILN*, 8 July 1882, p. 37) he praised "as beautiful as the most beautiful Daumier." Vincent van Gogh, *Complete Letters of Vincent van Gogh: With Reproductions of All the Drawings in the Correspondence*, 3 vols. (Greenwich, CT: New York Graphic Society, 1958), vol. 3, p. 340.

49. Matthew, "Portraits," pp. 141–43.

50. David Cannadine, *National Portrait Gallery: A Brief History* (London: National Portrait Gallery, 2007), pp. 20, 36–37. Lara Perry, "The National Gallery and Its Constituencies, 1858–96," in *Governing Cultures: Art Institutions in Victorian London,* ed. Paul Barlow and Colin Trodd (Aldershot: Ashgate, 2000), pp. 145–55.

51. *CCI*, p. 167.

52. *CCI*, p. 164.

dismiss his artistic judgments, especially with respect to his stock-in-trade, the representation of people.

For Furniss, "Portraiture, meaning by that the true reflection of a personality, is a first essential of present-day caricature."[53] Indeed, he asserted that caricature better captured the reality of politicians than "serious drawing." The latter made politicians look all alike in order to "avoid giving offence":

> They do not represent the truth, and if the artist draws the member as he sees him, the sketch is at once pronounced a caricature! All men are not dressed like "mashers," nor are all six feet high, nor do they all wear black coats, light trousers, boots of the newest, and spats; but I cannot deny the fact that they are better pleased to see themselves drawn so all the same. It is not these conventional and frequently untrustworthy "serious" drawings of public men that give any idea of the real man.[54]

For example "in serious portraiture . . . Mr Balfour would be represented with his hand uplifted in the usual oratorical style. In caricature, however, the artist must be more true to life in his treatment of such details."[55] Accordingly, Furniss depicted (images 32 and 33) Balfour's lackadaisical manner, effeminate address and "aesthetic attitude" (p. 178).

As with Balfour, "Many members have some characteristic action which assists you materially . . . Lord Randolph Churchill likes to indulge in a little acrobatic exercise and balance himself on one foot. . . . All these 'mark' the man for the caricaturist. I invented Gladstone's collars and made Churchill small."[56] Accused of misrepresenting Lord Randolph's height, Furniss defended himself in the following way (once more displaying some animus toward tailors): "I do not profess to supply photographs of members, and I am not in the habit of measuring them like a tailor, but I endeavour to give something more than a mere portrait, and seek in their physical delineation to reflect something of their political character. Thus from the first I have inflated the figure of Sir William Harcourt in my Parliamentary sketches, and minimised that of Lord Randolph Churchill."[57] In short, caricatures give "a much better impression of Mr. Gladstone, and other politicians, than can ever be gathered from the conventional portraits manufactured merely from photographs."[58] Compare, for

53. *Sketch,* 21 February 1894, p. 165.
54. *Fair Game,* April 1899, p. 22.
55. *MAHTD,* p. 30. Cf. John Singer Sargent's portrait of Balfour in the National Portrait Gallery.
56. How, p. 305.
57. *ILN,* 25 April, 1891, p. 535.
58. *PPP,* p. 74.

example, the conventional portrait of Joseph Chamberlain, "drawn from life" for *The Graphic* of 1889 (fig. 10), with Furniss's caricatures of the same politician for "Humours" (image 34a).

No. XXVIII.
CELEBRITIES OF THE DAY—THE RIGHT HON. JOSEPH CHAMBERLAIN, M.P.
DRAWN FROM LIFE

Figure 10. "Celebrities of the Day—The Right Honourable Joseph Chamberlain, M. P."
(supplement to *The Graphic*, 26 January 1889, facing p. 92)

Photographic portraits of major public figures became available from the 1850s onwards in costly upmarket portfolios, and in the 1860s in the form of inexpensive *cartes de visite*. Photographs also reached a wider audience as frontispieces in cheap popular biographies. (Indeed, the commercial availability of print and photographic images of famous contemporaries may have justified the National Portrait Gallery's decision to devote its state-granted resources to figures from the past.[59]) With no fewer than 366 copyrighted images between 1862 and 1901, Gladstone was probably the century's most photographed politician (although there were considerably more registered photographs of Royal Family members and the actress Ellen Terry in circulation).[60] This was hardly accidental, for, as Matthew noted, "Gladstone latched on quickly to the importance of this new form of political communication, by which the voter might have a visual image of the party leader in mind."[61] Gladstone worked consistently, and with increasing success, to exert control over his photographic images—their content, pricing, and distribution—as an essential component of the mass politics he helped to pioneer.[62]

But photography also had limitations as a mass circulation medium at the time that Furniss launched "Humours." The popularity of *cartes de visite* had largely subsided by the close of the 1860s.[63] And although the technology for printing halftone images in newspapers and magazines had been perfected by the 1880s, British periodicals did not make extensive use of photographs for illustration until the 1890s. *Punch,* for its part, stubbornly resisted technical innovation, refusing to use process reproduction "until the end of 1892" while "the sacred chief 'cartoon' was still printed by wood block until 1900!"[64] For Furniss, the "secret of the art of all caricature, is to seize upon the peculiarities of a subject and exaggerate them, and this process often gives a far truer idea of the real man or woman than the most slavishly perfect photograph."[65]

In Furniss's view, then, photography, like portrait painting, failed to capture the subject's essence: "a photograph as a rule is devoid of all character."[66]

59. Cannadine, *National Portrait Gallery,* p. 15.

60. John Plunkett, "Celebrity and Community: The Poetics of the *Carte-de-Visite,*" *Journal of Victorian Culture,* vol. 8, no. 1 (2003), pp. 65–68. The Copyright Act that came into effect in 1862 required photographs to be registered at Stationer's Hall (for a fee of one shilling) in order to qualify for protection.

61. Matthew, "Portraits," p. 147.

62. Ruth Clayton Windsheffel, "Politics, Portraiture and Power: Reassessing the Public Image of William Ewart Gladstone," in *Public Men: Masculinity and Politics in Modern Britain,* ed. Matthew McCormack (Basingstoke: Palgrave Macmillan, 2007), esp. pp. 107–14.

63. Plunkett, "Celebrity and Community," p. 76.

64. Applebaum and Kelley, eds., *Great Drawings and Illustrations from Punch,* p. xi.

65. HF, "Parliamentary Illustration," p. 312.

66. *MAHTD,* p. 79.

As a major practitioner of the art of illustrated journalism, however, he was all too well aware of the challenge posed by photography. By 1905 he could write of how "the outbreak of the present snap-shot craze" threatened the art of black-and-white illustration, and that "photography is to a large extent taking the place of the illustrator."[67] He lamented the increase in the number of photographs in newspapers and magazines at the expense of artistic sketches: "it is quite evident that these mechanical snap-shots have . . . atrophied, and practically destroyed the artistic perception of the draughtsman."[68]

All this is to argue that, when "Humours" opened in 1891, notwithstanding the increasing availability of other kinds of images taken from life, the caricature was still instrumental—indeed crucial—in fashioning and sustaining public careers. As Furniss wrote, "it will be the caricatures, or, to be correct, the character sketches, that will leave the best impressions of Mr. Gladstone's extraordinary individuality" and not the portrait or even the photograph, which, while it "cannot alter the cut of the clothes, can alter, and does alter, everything else."[69] As Pierre Bourdieu has argued, caricature played a leading part in that multiplication of media images essential to the "consecration" of the cultural celebrity.[70] He also observed that "the 'great' are perceived as physically greater than they are . . . [which] is why political contestation has always made use of caricature."[71] But, as already discussed, caricature was not a static medium. The diminishing visual acerbity of caricature paralleled, on the one hand, the greater emphasis on parliamentary decorum and political probity, and, on the other, the rise of celebrity culture.

Furniss's entertainments were praised for their "essential good humour" and for departing from "the more Rabelaisian features of the early caricaturists."[72] This style of cartooning was especially well-suited to the kind of polite entertainment Furniss sought to provide with "Humours." It was also appropriate in another respect since the lecture aimed not only to give account of great figures and their mannerisms, but also to describe how the often mysterious, exclusive, and even secretive Parliament itself functioned. Beyond playing to (and fueling) celebrity culture, Furniss tapped into a widespread interest in the workings of Parliament—in effect, treating Parliament as a celebrity in its own right.[73]

67. *HTD*, p. 7.

68. *HTD*, p. 54.

69. *CCI*, p. 167.

70. Pierre Bordieu, *The Field of Cultural Production: Essays on Art and Literature*, ed. R. Johnson (New York: Columbia University Press, 1993).

71. Pierre Bordieu, *Distinction: A Social Critique of the Judgment of Taste*, trans. Richard Nice (Cambridge, MA: Harvard University Press, 1985), p. 208.

72. *B&W*, 9 May 1891, p. 439.

73. In this connection, it is worth noting the figure of Miss Parliamentina, who appeared in

4. Political Education

Just as the increasing extent and variety of political display served to intensify interest in the personalities and processes of public life, so the broadening of opportunities for political inclusion at both national and local levels stimulated the earnest desire of people to become better informed about these matters. In the absence of a general European war between 1815 and 1914, a great deal of the public drama of nineteenth-century Britain centered in one way or another on Westminster.[74] As political life incorporated aspects of entertainment, political education in one form or another became a kind of serious recreational activity. "Humours" must also be seen in light of these trends, for reviewers praised the performance not only for the "loud laughter" prompted by its humor and mimicry, but also for providing "a liberal education in itself."[75]

At one level, "Humours" can with considerable justification be seen as an extension of *Punch*, and its illustrations as "the *Punch* designs greatly improved upon."[76] Like *Punch*, it represented "to the people that personal side of Parliamentary life, the familiar aspect and the *vie intime* of the House of Commons, not to be found elsewhere."[77] Known as "Parliamentary Harry," Furniss was second only to Lucy in his knowledge of the workings of Westminster: "I do not think there has been an artist so conversant as he with parliamentary procedure and personalities" wrote Charles Harper in 1892.[78] Furniss's special license to roam its corridors for six years gave him unique access to Westminster's "personal side" such that, according to the editor J. A. Hammerton, he was "the first to show our legislators as they are . . . stripped of the glamour of debates." His satires became "a vital factor in the political life of the time,"[79] not just because they made known more widely than ever before

Furniss's cartoons from the 1880s. Unlike the more common representations of nations (e.g., Britannia and Marianne) or civic ideals (e.g., Justice) as chaste female figures, Miss Parliamentina is possibly a unique instance of a legislature personified and—notwithstanding her being garbed in a long black robe and periwig—strangely eroticized.

74. Consistent with the general interest in parliamentary activity, it is worth observing that Parliament and the parliamentary milieu were brought before the public in various ways through the theater during the latter part of this period: Gilbert and Sullivan, *Iolanthe* (1882); Oscar Wilde, *An Ideal Husband* (1895); Elizabeth Robbins, *Votes for Women* (1907); Harley Granville-Barker, *Waste* (1907); and J. M. Barrie, *What Every Woman Knows* (1918).

75. *Era*, 2 May 1891, p. 15; *Daily News*, 1 May 1891, p. 3.

76. *Irish Times*, 25 August 1891.

77. M. H. Spielmann, *The History of "Punch"* (London: Cassell, 1895), p. 551.

78. Charles G. Harper, *English Pen Artists of To-Day* (London: Percival, 1892), p. 172.

79. J. A. Hammerton, "The Art of Mr. Harry Furniss," *The Charles Dickens Library, Vol. 17: The Dickens Picture Book: A Record of the Dickens Illustrators* (London: Educational Book Company, 1910), p. 36.

parliamentary life but because they made it known in a particular way: both *Punch* and "Humours" removed from Parliament its august aura and humanized its Members, showing them to be "just like other men, with weaknesses, eccentricities, strong points, hobbies, and crotchets."[80]

Along with Lucy's pioneering work in developing the parliamentary sketch, Furniss helped to establish this new way of reporting parliament, one that became increasingly influential in the way it was represented. *The Graphic* placed its review of "Humours" in the context of the history of Parliamentary journalism:

> More than a century ago, the debates of Parliament were regarded as too choice and sacred to be reported by stenographic pencils. When Dr. Johnson undertook to inform the public concerning Parliamentary discussions, the debates were professedly those of the Senate of Laputa. Even quite lately, long after the privilege of reporting the speeches had been conceded, it was held to be a serious breach of decorum for a stranger to be sketching. Gradually, however, the caricaturist, as well as the short-hand writer, has seen his way to freedom in this respect, and nowadays, when Parliament is sitting, the sensation-loving public would be quite disappointed if they did not find in the pages of *Punch* and the *Daily Graphic,* as well as various other publications, a complete pictorial record of the most notable scenes and actors in the Parliamentary arena. Of these chroniclers Mr. Harry Furniss confessedly occupies the first place.[81]

In a 1921 article titled "Reporting Parliament and Congress," the British political journalist and author Philip Whitwell Wilson lamented that "except in Hansard, there is now no verbatim and hardly any 'full' report of Parliament . . . newspapers depend on agencies like the Associated Press or the Central News." Wilson looked back to *Punch* of the 1880s and 1890s for a possible solution to "the problem of reporting" since

> the most hopeful experiment in England was conducted by Sir Henry Lucy as 'Toby, M. P.' in *Punch.* His diaries of Parliament, published also as books, made Parliament live. Newly enfranchised voters became as familiar with Lords and Commons as they were with the boatraces or the Derby. Lucy's work gained much from association with the cartoonists of British politics— Sir Francis Gould, . . . Sir [sic] Harry Furniss, and Sir John Tenniel.[82]

80. *Liverpool Echo,* 29 October 1891.
81. *Graphic,* 9 May 1891, p. 515.
82. P. W. Wilson, "Reporting Parliament and Congress," *North American Review,* vol. 214 (1921),

For those thirteen years (1881–94) that Lucy and Furniss worked together their names, along with *Punch* and Parliament, were inseparable in the public mind and Furniss was quick to exploit the prestige of *Punch*'s name in promoting "Humours" both at home and abroad. He was inevitably advertised as "the inimitable caricaturist of *Punch*" or welcomed in America as "the well-known caricaturist of London *Punch*,"[83] and at one show was even introduced as "Toby, M. P."[84] Thus, "Humours" carried Parliament beyond the pages of *Punch,* retaining the latter's visual and verbal format but re-working it into a popular and influential performance.

While "Humours" thus bore all the hallmarks of *Punch*'s special influence on and association with Furniss, in other ways the performance aimed to reach beyond the magazine's readership and embrace a wider, less exclusive audience. In these ways, therefore, "Humours" can also be seen as part of a long-term, and progressively more popular, vein of civic culture that was deeply committed to explication and exercise of parliamentary practices.[85] Debating societies proliferated, first at the great public schools and Oxbridge in the century's early decades, and subsequently throughout the expanding realm of secondary, higher, and professional education. Oratorical training and display also spread throughout British society via the establishment of literary and philosophical societies in towns throughout the United Kingdom—venues in which the early promise and local reputations of individuals from middle-class and artisanal backgrounds were established. Working-class mutual improvement societies also became a notable locus of political discussion and more formalized debate.[86] Toward the end of the century, the "Local Parliament" movement saw the establishment of mock legislatures across the country in which people from most social strata participated and obtained a practical training in the procedures of the House of Commons. While some of these debating societies were more serious and successful than others, taken as a whole, this wide range of organizations manifested not only the nineteenth-century penchant for "improving" recreation, but also a deep and widespread direct engagement of people from across the social spectrum with parliamentary forms and practices.

Public lectures were another important form of improving recreation. In 1900, recalling his own efforts with "Humours" and other performances,

p. 329. Lucy's *A Diary of the Salisbury Parliament, 1886–1892* (London: Cassell, 1892) was illustrated by Furniss.

83. *NYT,* 7 April 1892, p. 3.

84. *CC* II, p. 177.

85. This paragraph draws upon Meisel, *Public Speech,* pp. 46–49.

86. Jonathan Rose, *The Intellectual Life of the British Working Classes* (New Haven and London: Yale University Press, 2001) pp. 73–75.

Furniss wrote that "Anyone nowadays thirsting for notoriety jumps on to the platform as a lecturer," though he also noted the declining quality of and demand for lectures and readings compared with the late 1880s.[87] Although they were not parliamentary exercises of the kind experienced in debating societies, lectures could nevertheless offer directly or indirectly a kind of political education. Platform lecturing on political issues had been sufficiently common in the late eighteenth century to be viewed as a threat by the authorities. Following a period of state repression, the lecture platform reemerged with renewed vigor in the 1820s and 30s, and may even have reached a point of over-saturation in the 1850s and 60s. In the last quarter of the century, however, it made a "handsome comeback."[88]

With the exception of Dickens, whose hugely popular public readings were documented by one of his managers, information about the agents and profitability of lecture tours in Britain is patchy. But we know something of a number of other writers who sought to augment their royalties in the late nineteenth and early twentieth centuries, including Thackeray, Anthony Trollope, G. K. Chesterton, Oscar Wilde, George du Maurier, T. P. O'Connor, Arthur Benson, H. G. Wells, and Winston Churchill. The range of remuneration was wide: fees on offer at individual venues might be as low as £10, though Winston Churchill in 1900 netted more than £273 for a lecture at Newcastle.[89]

The interest in lectures ran across the social spectrum, appealing both to those seeking merely to be entertained and those with an interest in being enlightened. For example, mechanics' institutes, typically voluntary associations of working-class people usually assisted by patronage from local worthies, provided instruction in science, literature, and the arts through lectures, classes, and a circulating library.[90] Yet, even though his grandfather, Aeneas Mackenzie, had founded the Newcastle Mechanics' Institute, these were not the kinds of venues at which Furniss performed "Humours" (see Appendix III). The nineteenth century also saw a proliferation of other institutions, and their associated structures, at which lectures were standard: clubs, political

87. *CC*II, pp. 181–82.

88. Martin Hewitt, "Aspects of Platform Culture in Nineteenth-Century Britain," *Nineteenth-Century Prose*, vol. 29, no. 1 (2002), pp. 7–12.

89. Philip Waller, *Writers, Readers, and Reputations: Literary Life in Britain, 1870–1918* (Oxford: Oxford University Press, 2006), pp. 602–9. Waller also includes Furniss in his account as "one of the most successful lecturers of the day" (p. 606).

90. Ultimately, however, lectures—considered a source of entertainment—were deemed inadequate for the objective of edifying skilled adult workers, who were more attracted to the institutes' evening classes and libraries anyway. Lecture programs offered by mechanics' institutes had far greater appeal for the middle classes. Edward Royle, "Mechanics' Institutes and the Working Classes, 1840–1860," *The Historical Journal*, vol. 14, no. 2 (1971), pp. 308, 314.

unions, cultural associations, reading societies, discussion groups, and so on. In addition to the growth of local literary and philosophical societies and other kinds of institutions established throughout the provinces as part of Britain's burgeoning municipal culture, this period also saw the widespread erection of town halls.[91] Further, all manner of special buildings created to house secular, non-theatrical performances and events were also created around this time: Manchester's Free Trade and St. James's halls, Birmingham's Bingley Hall, and London's Exeter Hall, to name a few prominent examples.[92]

Entertainment and education were hardly incompatible, though Dickens complained that lecturers had the "custom of putting the natural demand for amusement out of sight."[93] Even the so-called "comic lecture" or monologue entertainment (the genre in which "Humours" would be classified) was generally underpinned with serious intent. Thus, it can be argued that there is little sense in attempting to draw clear distinctions between education and entertainment.[94] With the advent of broadcasting, this aspect of lecturing culture was carried well into the twentieth century. Sir John Reith's vision of the BBC's purpose was to "educate, inform, entertain" and the Third Programme in particular could be seen as carrying on the nineteenth-century lecturing tradition. Like the more strictly political platform, public lectures of all kinds—by sages, popularisers, religious figures, intellectuals, and other public commentators—were a form of legitimate diversion at a time when the theater was only just starting to be viewed as respectable. According to Furniss, the lecture platform

> was both profitable and popular for many years. It flourished at a time when a goodly portion of the middle classes, particularly those of the large manufacturing cities, cherished the idea that playgoing was wicked but entertainments in public halls were harmless. The latter most certainly were instructive and elevated the minds of people in an agreeable and social fashion.[95]

The aims and effects of these lecture-entertainments were greatly enhanced by the magic lantern shows of which "Humours" is a pre-eminent example (see section IV.2). Beyond the political experiments already noted, magic lantern slides were widely used in the 1880s and 1890s for educational purposes.

91. See Colin Cunningham, *Victorian and Edwardian Town Halls* (London: Routledge & Kegan Paul, 1981).

92. Meisel, *Public Speech*, pp. 254–57.

93. Charles Dickens, "The Uncommercial Traveler," *All the Year Round*, 30 June 1860, p. 277.

94. Hewitt, "Aspects of Platform Culture," pp. 18–19.

95. *SVM*, p. 175.

The latter decade witnessed a particular growth in the use of slides for teaching associated with the ever growing adult education movement, while the "factual lantern lecture as public entertainment was closely related to this movement and was generally perceived to have an 'improving' influence."[96] A leading supplier, York's of Notting Hill, advertised in 1893 "Optical Lantern Slides and Lecture Sets for Educational Purposes, Embracing Every Branch of Science, as well as Interesting And Moral Tales."[97] The principal sections of the catalogue of one of the largest manufacturers and dealers of slides, Newton & Co., which ran to 1,200 pages (in two volumes), indicate the huge range of topics available to educators: "Sacred, Services, Temperance, Art, Literature, Sciences, Nature Study, Geography, History, Industries."[98] The 'Historical' section alone occupied 112 pages, with many of the slide series devoted to English history, along with a separate and ever changing section on politicians.[99] "Humours," illustrated with more than one hundred slides, must be seen as an important contribution to this form of public, quasi-recreational education.

"Humours" must also be seen as part of the longer tradition of political lectures. Certainly, an enormous amount of public lecturing (both pro and con) was associated with particular political campaigns from the Anti-Corn Law League of the 1840s, to Home Rule in the 1880s and 1890s, to tariff reform in the early 1900s. The political organizations that emerged toward the end of the century like the Conservative Primrose League or the socialist Fabians also sponsored lectures to promote their views.[100] But lectures on politics and current events were also widely presented on an ostensibly non-partisan basis, such as the speaker programs organized through churches.[101] A range of prominent figures in the arts and culture such as John Ruskin and the scientist John Tyndall also took to the platform to present their views on issues of the day.[102]

96. *EML*, p. 99.

97. *EML*, p. 330.

98. *EML*, p. 58.

99. *EML*, p. 137.

100. See Martin Pugh, *The Tories and the People, 1880–1935* (Oxford: Blackwell, 1985), pp. 32–35; George Bernard Shaw, "How I Became a Public Speaker," *Sixteen Self Sketches* (London: Constable, 1949), pp. 56–64. Between 1887 and 1897, before he had any reputation as a playwright or writer, Shaw delivered nearly a thousand lectures in all manner of venues and under all kinds of conditions, for which he received no payment. Michael Holroyd, *Bernard Shaw, Vol. I: 1856–1898: The Search for Love* (New York: Random House, 1988), pp. 192–93, 196.

101. Meisel, *Public Speech*, p. 148.

102. Matthew Bevis, "Ruskin, Bright, and the Politics of Eloquence," *Nineteenth-Century Prose*, vol. 27, no. 2 (2000), pp. 177–90; Jill Howard, "'Physics and Fashion': John Tyndall and His Audiences in Mid-Victorian Britain," *Studies in the History and Philosophy of Science*, vol. 35, no. 4 (2004), pp. 729–58. On scientific lecturing more generally, see Bernard Lightman, "Lecturing in the Spatial Economy of Science," in *Science in the Marketplace: Nineteenth-Century Sites and Experiences*, ed.

Politics was also a strong presence even when not the ostensible subject of the lectures. Even Dickens's readings from his novels had a strong political character. The author not only aimed to convey his views on social issues of the day and stir audiences to action, his performances also constituted a reflection on the political rhetoric of the day. His audiences experienced the readings both "as a form of instruction and as an opportunity for entertainment."[103]

Furniss's melding of amusement and education in "Humours" was much remarked upon. To take one representative example: "Every Englishman ought to know of the Parliament which makes his laws. He cannot do better than to get a working acquaintance with the subject by laughing at Mr. Furniss' merry Sketch."[104] Assured by Furniss that the show was no partisan campaign for a particular political party, audiences—which most likely came from a wide range of social classes, though probably not laborers or the poor (see section IV.5)—could become "unconsciously educated in legislative ways, receiving a good notion of the manner in which government is carried on."[105] Even *The Times* noted that "a more vivid idea of Parliamentary procedure" could not "be obtained in any other way," but it was the *Manchester Guardian,* pre-eminent among northern provincial newspapers, that hinted at the influence of "Humours" on the aspiring lower middle class who likely occupied the two-shilling seats at the "crowded" public hall, the Athenaeum (opened in the 1830s for the education and recreation of the townspeople), on the evening of Monday, 28 October 1891: "Mr. Furniss presented a very complete résumé of Parliamentary life, with which he is thoroughly familiar; and although the humour of the figures was unmistakeable, their real value lay in the thorough instruction in the ways and manners of Parliament which was so swiftly and accurately conveyed by the talented expert."[106] Six years later, an observer of "Humours," performed in an Antipodean Athenaeum, echoed these sentiments: "It is safe to say that, after spending an evening with Mr. Furniss, the average man would know more about the place and of the legislators, and have a better time withal than the casual visitor who had actually put in an afternoon there with a less gifted cicerone."[107]

Aileen Fyfe and Bernard Lightman (Chicago and London: University of Chicago Press, 2007), pp. 97–132.

103. Matthew Bevis, *The Art of Eloquence: Byron, Dickens, Tennyson, Joyce* (Oxford: Oxford University Press, 2007), p. 132. Bevis also sees in Dickens's revisions of his fiction for the purposes of performance "a reaction to, as well as a 'realization' of, contemporary Liberal rhetoric" (p. 132).

104. This notice, from the *Daily Graphic,* and nineteen like it are reproduced in *CC*II, pp. 156–57 (fig. 28).

105. *Liverpool Echo,* 29 October 1891.

106. *CC*II, p. 156; *Manchester Guardian,* 28 October 1891.

107. *Herald* (Melbourne), 24 May 1897, p. 3.

"Humours" was a classic example of instruction through entertainment as it demystified Parliament, personalized its members, and educated the audience in its procedures, so important in the new era of mass democracy. A friend of Furniss wrote of a "public intensely interested, nowadays," in Parliament,[108] and the caricaturist confirmed the general public's fascination with that institution and his intention to inform them about it. "Humours," as he wrote, was "supposed to give them an insight into the Legislative Chamber which they talk so much about, and in which they take so much interest."[109] In this respect, Furniss was an inspiration to his artistic peers, some of whom sought to capitalize on the particular content and style of his successful efforts. His *Punch* colleague George du Maurier went on tour with a lecture on the magazine's artists in 1891–92, and fellow caricaturist Francis Carruthers Gould, then working at the *Westminster Gazette*, went on the circuit in 1892 with a magic lantern lecture on "Lords and Commons from the Press Gallery."[110]

While one can never be certain as to the extent and permanency of the effect of "Humours" (and more generally of Furniss's work for *Punch* and its sister publications) upon people's views of the Parliament in which they were so interested, there is enough evidence to indicate some influence. *Black and White*'s preamble to a review of the show suggests as much: "His wonderfully facile and humorous art has done more to make the world at large familiar with the microcosm of St. Stephen's than whole columns of parliamentary descriptive articles, and the shops full of the most carefully finished photographs."[111] We will return to the question of the viewership for and impact of "Humours" below when describing the details of the performance. Before doing so, however, it is useful to touch upon some key aspects of the immediate political context for the performance, and especially Furniss's perspective on these matters.

108. *BAA*, p. 8.

109. *AH*, p. 105.

110. Waller, *Writers, Readers, and Reputations*, pp. 606, 608. A program for Gould's "Lords and Commons from the Press Galleries: Illustrated with Caricature Portraits, Shown by Oxy-Hydrogen Light," performed at Westminster Town Hall on 24 June 1892, is held in the Parliamentary Archives, PRG/5/14.

111. *B&W*, 9 May 1891, p. 439.

III

FURNISS AND THE
POLITICS OF THE 1880s AND 1890s

*L*OOKING BACK, Furniss thought of the 1880s and 1890s as a special era in the life of Parliament:

> During the eighties and nineties, certainly the most interesting period in politics of our time, there was no more entertaining place than St. Stephen's. The Fourth Party, the Grand Old Man, the Home Rule Bill, Randolph Churchill's rise and fall, Bradlaugh, Obstructionism, Parnell, Chamberlain, the Unionist Camp, excitement followed excitement. No years in the history of Parliament were so rich in political incident, and no personalities more interesting than those who filled the stage.[1]

In addition to providing a general overview of Parliament's activities—as a law court, a debating chamber, a legislating body, a social institution, and a grand stage for outsize (and sometimes undersized) political personalities—it is important to bear in mind that "Humours" was conceived and performed amid the larger political currents of the late 1880s and early 1890s. At the most general level, this was, on the one hand, a period of unprecedented power and prosperity for the nation: Britain continued to lead the other great powers in economic resources and the ability to project its forces around the world; it enjoyed the benefits of being the world's financial center (notwithstanding a long-term slump in agriculture), basked in unrivalled imperial splendor, boasted unprecedented improvement in its people's standard of living, and sustained its role as the fulcrum of international politics. On the other hand, these very indices of success, and the genuine resentments felt

1. *MBD*, p. 274.

among the other great powers, generated in Britain a wide range of fears and anxieties about the country's present vulnerability and uncertain future as the nation grappled with exacerbated tensions on a number of fronts: nationally, imperially, and internationally.

As opposed to the kind of scaremongering that was becoming increasingly prevalent at the time, "Humours" was a celebration of the strength of Britain's admittedly eccentric political institutions and traditions. Yet it was also a product of its times and in direct and indirect ways gestures toward a number (but hardly all) of these developments. Because they feature prominently in "Humours," three notable aspects of late Victorian politics in particular stand out as requiring some further historical elaboration: the figure of William Gladstone; the Irish question; and the status of women. In addition, it is important to note significant public matters on which "Humours" was silent, and consider why Furniss would have left them out.

1. The Grand Old Man

The figure of Gladstone bulks large in "Humours." This reflects not only his dominating presence on the political scene and general renown, but also his importance in Furniss's career. For Furniss, as for many others, Gladstone was "the greatest political personality of the Victorian era."[2] Certainly, he was the greatest personality in Furniss's cartoons, and Furniss was considered by contemporaries to have been more successful at capturing Gladstone than other major cartoonists such as Tenniel (whose forte was Disraeli).[3] Gladstone's death in 1898 was a major national event and the symbolic end of the political era he had come to dominate. Furniss commemorated (and profited from) the Grand Old Man's passing by mounting a traveling exhibition of two hundred of his cartoons of the late statesman.

"Humours" was first presented on the cusp of Gladstone's fourth stint as prime minister. His first ministry (1868–74) had been an energetic and embattled effort to enact a host of major reforming legislation. After the government's exhaustion and collapse, Gladstone withdrew from the Liberal leadership, although he remained an MP and, awkwardly for his successors, continued to sit on the front bench. This retirement was short-lived, but Gladstone's return to active politics and eventually to the Liberal leadership began outside the structures of party and Parliament. In 1877, he seized a

2. *SVM*, p. 222.

3. T. Wemyss Reid, "Mr. Gladstone and His Portraits," *Magazine of Art*, vol. 12 (1888), pp. 87–88.

leading part in a widespread movement to protest Ottoman atrocities against Christians in Bulgaria, and used public dismay over Disraeli's pro-Turkish foreign policy (which followed the traditional practice of supporting the Ottoman Empire as a check on perceived Russian ambitions in India) to launch a wider critique of the government. His accusations of immorality in foreign policy segued into claims of irresponsible stewardship of the nation's affairs at home and culminated in spectacular fashion with Gladstone's barnstorming Midlothian campaigns of 1879 and 1880, which brought the nexus of personality, platform, press, and popular politics to a new level and marked a watershed in Victorian political life.

What is most important in connection with "Humours" is the way that the ex-prime minister and retired party leader (with the aid of massive press coverage) generated something like a national mass following with these heroic speaking tours which commenced prior to any call for a general election. When the election took place in 1880, the Liberals were returned with a majority that was understood to be indebted to Gladstone's vigorous and sustained public assault on the previous government. Gladstone's successors in the Liberal leadership—Lord Hartington (image, p. 279) in the Commons and Earl Granville (image 48) in the Lords—bowed to the inevitability of their predecessor's return to the head of the new government. Having taken political celebrity and demagogic appeal to a new level, Gladstone dominated an increasingly fractious and fragmented political scene until his second and final retirement in 1894, three years after the launch of "Humours."

At the same time that Gladstone was a central force in national politics, he can also be seen as doing much to generate or exacerbate the political fragmentation of the era, with long-term consequences for the Liberal party and the political landscape generally. His crusading style, vehemence, and increasing radicalism—all underpinned by his belief that he was an agent of divine providence—led away from the "liberal conservatism" to which he had earlier subscribed and had proved a successful and dominant tendency across parties and coalitions throughout much of nineteenth-century British politics.[4] Official Liberal politics in these years relied on the Grand Old Man's intellect, popular appeal, mastery of parliamentary procedure, and sheer force of personality. Max Weber saw Gladstone as a classic example of the "charismatic politician" and Colin Matthew asked whether his later career could be seen as an instance of "democratic Caesarism."[5] As Furniss took delight in depicting, these traits were evident inside Parliament as well as out-of-doors.

4. See Jonathan Parry, *The Rise and Fall of Liberal Government in Victorian Britain* (New Haven: Yale University Press, 1993).

5. Matthew, *Gladstone, 1875–1898*, pp. 49–51.

Furniss's Grand Old Man is the one that Lord Randolph Churchill so bril-
liantly satirized as "an old man in a hurry," and it was the cartoonist's great
achievement to capture so effectively the dynamic public spectacle of the
ageing yet exceptionally vital politician.

2. Ireland and Home Rule

Gladstone dealt with a myriad of significant and challenging issues in his later
premierships, but it was Home Rule—i.e., political devolution—for Ireland
that dominated all others. In 1889, Furniss succinctly illustrated the central-
ity of the Irish question for Gladstone in the first of his "Puzzle Head" series,
which presented portraits of leading figures made up of numerous smaller
images depicting aspects of their public and private lives (fig. 11). Furniss made
the pupil of Gladstone's eye a shamrock and his mind full of Irish National-
ist MPs. The detailed complexity of this image was, of course, more suited to
Punch than to a magic lantern show, but in any case it was not Gladstone but
the Irish that were Furniss's target. In "Humours," the prominence of the Irish
question in British politics more generally is reflected in Furniss's satirical
and unflattering treatment of Irish MPs (especially in the member for Bal-
lyhooley) and the character of Irish politics (seen as the absurd inflation of
minor grievances). Furniss presented a public spectacle of the great debating
chamber reduced to a kind of low comedy (complete with stage brogue) by
"Oirish" members and their (in his portrayal) minstrel antics.

Furniss was born in Ireland, but his father was English and his mother
Scottish, and the family's religion was Anglican. He had little sympathy for
the people among whom he was raised, and even less for the nationalist cause.
His assessment of the Irish physiognomy is nothing short of offensive: a
"countenance in which it always strikes me that Nature had originally for-
gotten the nasal organ, and then returning to complete the work . . . make
the upper lip."[6] The supposed simian features of the Irish that had marred
Punch's pages for many years are to be seen, too, in the cartoonist's description
of a fat Irishwoman's Gaelic words sounding "very much like curses, which
chase one another out of her capacious mouth with a rapidity unequalled by
even an irritated monkey at the Zoo."[7] His writings for *Black and White* while
touring with "Humours" in Ireland are a catalogue of disparagement.

As Roy Foster has argued, however, *Punch*'s record with respect to Ireland
was more complex than it has been given credit for. Noting that a number of

6. *CC*II, p. 30.
7. *CC*II, p. 33.

MR. PUNCH'S PUZZLE-HEADED PEOPLE. No. 1.

Figure 11. "Mr. Punch's Puzzle-Headed People. No. 1" (*Punch,* 5 October 1889, p. 167)

the periodical's most influential commentators had (like Furniss) Irish back-
grounds or were otherwise "marginalized from the mainstream of English-
ness," he posits that this "may have made them define the concept all the more
emphatically; it seems that some of the transplanted Irish entered into this
process of psychological compensation with an almost unholy gusto."[8] *Punch's*
most offensive Irish material, Foster contends, was primarily a response to
the development of Irish radicalism between the 1850s and early 1890s.

Furniss certainly deprecated the character of Irish politics, noting on one
occasion that "native Irish wit" was fast disappearing "crushed out by the latter-

8. R. F. Foster, *Paddy & Mr. Punch: Connections in Irish and English History* (London: Penguin,
1995), p. 178.

day rancorous party feeling and political wrangling."[9] Irish MPs were, he thought, "by nature good speakers, but they are not always sincere,"[10] and were as well unruly troublemakers who had perfected "the art of making a scene in the House."[11] The Committee Room where they gathered he termed "The Irish Babble Shop" where "they uncrowned their king once upon a time, and brought in a potentate, named Chaos, to rule in his stead."[12] Ever the enterprising cartoonist, he half-jokingly observed that he was "strongly opposed" to Home Rule "as the disappearance of the Irish members (who are invaluable to me in my profession) from St. Stephen's would be a serious loss to me."[13] Yet, like *Punch,* Furniss's *oeuvre* was not entirely rebarbative. For instance, his depictions of poverty in Galway for the *Illustrated London News* (January–February 1880), significantly a publication that did not traffic in caricature, are graphic and touched with understanding and sympathy.

The increasingly agonized question of Ireland in late-nineteenth-century British politics is a highly complex story, the briefest outline of which must suffice here. Ireland had been formally joined to the United Kingdom by the Act of Union of 1800. Among other things, this act dissolved the Irish parliament, and added one hundred seats for Irish constituencies at Westminster. Political, religious, and economic grievances stemming from fundamental inequities within Irish society and in the structure of the union were never successfully addressed, although Gladstone had, with mixed results, attempted a number of measures to "pacify" Ireland in his first ministry. By the late 1870s, the formerly constitutionalist political movement advocating devolution took a more militant turn under the leadership of Charles Stewart Parnell (image 8). Parnell united the various anti-British factions in Ireland and organized a program of obstructing the business of the Commons in tandem with often violent protest activities in Ireland centered on the difficulties faced by tenant farmers. The parliamentary and high-political dimension of these broad-ranging developments is most relevant to "Humours," for that was the lens through which most of Furniss's audience members would have understood Irish affairs.

When Gladstone returned to the premiership following the general election of 1880, Parnell's Home Rulers had been returned for 65 seats and therefore constituted a voting bloc to be reckoned with. The 1882 attempt to

9. *FV,* pp. 15–16. The first part of this work, reproduced from Furniss's contributions to *B&W* while on tour, consists in the main of disparaging descriptions of Ireland and the Irish.

10. *CCI,* p. 183.

11. *CCI,* p. 203.

12. *PPP,* pp. 136–39.

13. *Birmingham Daily Post,* 22 March 1892, p. 4. This statement is part of a widely reported letter from Furniss stating his (generally neutral) political views.

negotiate a behind-the-scenes deal with Parnell (then imprisoned) to end the obstruction and violence in exchange for alleviating the grievances of agrarian tenants was derailed by public outrage over the assassination in Dublin of the Chief Secretary for Ireland, Lord Frederick Cavendish (Hartington's brother, connected through marriage to Gladstone) and his assistant secretary. The period 1885–86—which included the fall of Gladstone's second government, a general election, Gladstone's return following a short-lived Conservative government under Lord Salisbury, and his defeat following another general election—also saw a great deal of political turmoil over the Irish question, culminating in the introduction and (after sixteen days of debate) defeat of a Home Rule Bill. A total of 93 Liberal MPs—a combination of Whigs led by Hartington and Radicals led by Joseph Chamberlain—broke with Gladstone over the issue. After the ensuing general election, the pro-Home Rule forces (191 Liberals and 85 Irish Nationalists) were seriously outnumbered by those opposed (316 Conservatives and 78 Liberal Unionists). In the wake of the collapse of the 1886 bill, Gladstone (now 76) determined to stay on in Parliament: rescuing Home Rule was his central objective.

This was where matters stood when Furniss opened his sixteen-week tour of "Humours" on 24 August, 1891 in, of all places, Dublin. His less than flattering portrayal of Irish MPs in his show, together with his mockery of Irish life and culture in the articles he wrote for *Black and White* magazine, brought down, as he put it, "screeching criticisms of the Irish press."[14] He commented on the dirty and "disgracefully lighted" Dublin streets, the "vile decorations and furniture" of the houses; the lack of progress since he was last there twenty years previously; the scruffiness, uncouthness, and stupidity of many Irish who are "quite devoid of all artistic taste"; the pandemonium evident on Sunday mornings in Phoenix Park compared with the "comparative quiet of Hyde Park"; and so on and so forth.[15] It is not surprising that one reporter was "exceedingly and sincerely sorry that Mr. Furniss's rotund little body wasn't well kicked while he was here."[16] Despite the hostile response to "Humours" in the Irish press, large audiences attended his Dublin and Belfast shows and Furniss counted the first week of his tour to have been "a great success."[17] In keeping with his Unionist sympathies, Furniss found Belfast more to his liking. The people were "keener and more well-to-do"

14. *FV*, p. 42.

15. *FV*, pp. 13–40.

16. *FV*, p. 44.

17. HF to J. B. Pond, 1 September [1891?], quoted on catalog website of David J. Holmes Autographs [from 8vo letter inserted into a copy of *Flying Visits*], http://www.holmesautographs.com/cgi-bin/dha455.cgi/scan/mp=keywords/se=FURNISS,%20HARRY, accessed 23 March 2008.

than Dubliners, though all too ready to "worship at the shrine of one firm, Messrs. Money, Grubber and Co." at the expense of the cultivation of the arts: "they are astoundingly ignorant; I am assured they read nothing"— comments that inevitably prompted "columns of attack and abuse" in the press.[18]

Following the general election of July 1892, Gladstone (then nearly 83) returned for his final ministry and, as expected, dedicated himself almost entirely to getting a second Home Rule bill passed. The bill was introduced the following February and passed on its third reading in September after a total of 85 nights of debate during which Gladstone personally undertook the exhausting work of shepherding the measure through. A week after its passage in the Commons, the bill was defeated in the Conservative-dominated Lords by an overwhelming majority following a bare minimum of discussion. It would take another two decades for a Home Rule Bill to be enacted, which then became a dead letter on the outbreak of the First World War. By the time Furniss died in 1925, the Irish Question had been uneasily resolved by the creation of the Irish Free State as an effectively independent dominion excluding six northern counties which remained a part of the United Kingdom. At the end of his life, with the violence that had preceded the 1922 Irish settlement and the subsequent civil war in the Free State in mind, Furniss made clear his views on what he called the "Gladstonian hallucinations about Ireland": "I have just read in the morning papers pages of dastardly crime, bloodshed and rebellion in Ireland, largely due to the crass stupidity of the G. O. M. and his worshippers in the eighties."[19]

3. Women

Another important set of late-nineteenth-century developments registered in "Humours" is the changing social, legal, and political position of women. Furniss portrayed both women's keen interest in parliamentary activity—from the spectators in the cramped Ladies' Gallery, to the "crowd of petticoats" blocking the entrance to the Commons to get a peek inside the chamber, to the "exacting Lady Politician," to the woman peering through the grate under the Table—and the various ways their increasing presence served to complicate and occasionally disrupt the then all-male social institution. "Humours" literally depicted Parliament surrounded (and even infiltrated) by women, pressing

18. *FV*, pp. 48, 50, 59, 62.
19. *SVW*, pp. 143–44.

on all sides to get in, yet, apart from the Angelic Agitator (image 85), all are fashionable and attractive. Furniss's view that women were there to be admired so long as they didn't get in the way of the business of the House is even more starkly expressed in the following:

> Should the droll coterie of female dilettanti who largely compose the crowd on such occasions [visiting the Lobby] settle down like a swarm of political queen bees in the corridors and on the terrace of the House of Commons, I fear that not only members will have cause to complain, but that journalists who affect [*sic*] the Lobby will have to cry '*place aux dames*,' and, developing an acquaintance with the vocabulary of the milliners, diversify their parliamentary gossip with ornate descriptions of fashionable toilettes. Upon the other hand it must be confessed that as the end of this jaded Parliament draws near, the sight of so many fresh and fair young faces is very refreshing to the eye, and tends to relieve the sombre and monotonous background of Parliamentary existence.[20]

Be that as it may, Furniss seems to be hoisted with his own petard when he confesses that it is he who is responsible for the disruptive influx of female visitors: "During my tours with my entertainment 'The Humours of Parliament,' I have demonstrated oratorically and pictorially to the ladies, who, as a rule, know very little and care less about the doings of the occupants of our legislative Chamber, what real fun and enjoyment is to be extracted from St. Stephen's. They, in return, have informed me, more in sorrow than in anger, that it was through me that the curiosity of the feminine elite was aroused concerning the House."[21] The attempted disclaimer that precedes this passage ("at the risk of being thought egotistical") entirely fails since his desire to be known as responsible for such female curiosity about Parliament overcomes the disadvantages that curiosity causes. And later, with typical condescension, Furniss wrote of the many letters he had received from young women "thanking me for giving such a graphic idea of the proceedings of the Houses of Parliament. Girls when they went into Society could then talk of Parliament with some pre-digested knowledge and understand the conversation of men of the world at the dinner-table."[22] Beyond keeping up at social occasions, however, a wide range of late-nineteenth-century developments gave good reason for

20. *B&W*, 25 July 91, p. 132. For HF's most comprehensive view of women in Parliament see his "Ladies in Parliament," *Cassell's Magazine*, vol. 41 (December 1905), pp. 80–89.
21. "Ladies in Parliament," p. 85.
22. *SVW*, p. 130.

women to seek greater knowledge of parliamentary life, in part by attending performances of "Humours."

Women aged 30 and above gained the right to vote in parliamentary elections in 1918, and obtained the vote on the same terms as men ten years later. Although the first woman MP, Nancy Astor, took her seat in 1919, the number of women MPs remained quite small until 1997 with the influx of those derided in the press as "Blair's babes."[23] For those like Furniss who regretted many of the great changes that followed the First World War, The House of Commons was "no longer 'the best Club in London,' and one would be surprised to find as visitors, having tea on the Terrace, the celebrated women I was in the habit of meeting there in the 'good old Victorian days'—not as visitors perhaps but, as followers of Lady Astor, Members themselves."[24] Yet, even Furniss could concede that some individual women would have made great additions to the Commons. Of the suffrage movement leader Millicent Garrett Fawcett, notwithstanding the difference in their political views, Furniss would write "Mrs. Fawcett should have been there [in the House] years ago."[25] On a more personal note and consistent with the higher political profile of women following the First World War, Guy Furniss, Harry's son, married Beatrice Naysmith, friend and campaign manager for Roberta MacAdams, who was the first woman elected to the Alberta Legislature. She visited the Furniss home in Hastings in 1917.[26]

Even though women were still excluded from the parliamentary franchise at the time Furniss presented "Humours," the "good old Victorian days"— especially the latter decades of the nineteenth century—witnessed substantial improvements to their position in political, personal, economic, professional, and educational terms. The greatest immediate beneficiaries were the middle- and upper-class women who would have been in Furniss's audiences. In the political realm, unmarried women householders had been granted the municipal franchise in 1869 and the school board franchise in 1870. As candidates for, and members of, school boards and, after 1875, poor law unions, women obtained a political apprenticeship in electoral politics and in the dynamics of deliberative bodies.[27] Subsequently, women obtained the right to vote for county councillors in 1888 (though they could not stand for election until 1907), and the 1894 Local Government Act made both single and

23. See Brian Harrison, "Women in a Men's House: The Women M.P.s, 1919–1945," *The Historical Journal*, vol. 29, no. 3 (1986), pp. 623–54.

24. *SVW*, p. 43.

25. *SVW*, p. 115.

26. Debbie Marshall, *Give Your Other Vote to the Sister: A Woman's Journey into the Great War* (Calgary: University of Calgary Press, 2007), pp. 227–30.

27. See Garrard, *Democratisation in Britain*, pp. 76–79.

married women eligible to vote for, and seek election as, district and parish councillors.[28] (Furniss's lack of enthusiasm for this increasing involvement in local politics by the so-called fairer sex may be detected in the condescension informing his response to the Act: "A few years ago the ladies politically inclined had quite a thrill of excitement when the Parish Councils Woman Suffrage Bill passed by a majority of 21."[29]) These achievements in the local arena resulted in part from (and further stimulated) the efforts of politically-minded women to obtain the parliamentary franchise and duly take their place among the nation's legislators.

Organized agitation for women's suffrage began in the mid-1860s after the failure to extend the franchise to women through an amendment to the 1867 Reform Bill. (Other movements in which women took a central role, like the campaign to repeal the Contagious Diseases Acts of the 1860s, were primarily directed at influencing parliamentary action on social policy rather than gaining political rights directly, although advocates linked the issues in a variety of ways.) By the 1870s and 1880s a variety of often fractious organizations were mobilizing large-scale demonstrations of women and their male supporters throughout the country. At the same time, the movement's intellectual leaders advanced the case for suffrage in print and through ongoing social contact with male politicians of the same educated and propertied classes from which they themselves largely came.[30]

Women's partial political gains were paralleled by piecemeal, though significant, improvements in their rights and liberties. Reforming legislation made divorce easier to obtain, allowed married women to retain ownership of certain kinds of property, and gave women greater control over their children and increased protection from various forms of spousal abuse. On the economic front, barriers to certain categories of middle-class employments also began to be lowered in this period. Civil service posts, for example, were gradually opened to women: after 1873 they could serve as post office supervisors, and after 1893 as factory inspectors. An increasing number of single middle-class women sought careers as new professional opportunities began to open up. (Furniss's own beloved daughter, Dorothy, collaborated with her father on illustrations for two of G. E. Farrow's children's books and later became a professional illustrator and writer in her own right.) On one occasion, Furniss performed "Humours" to a large group of nurses (fig. 12), an occupation that

28. Patricia Hollis, *Ladies Elect: Women in English Local Government, 1865–1914* (Oxford: Clarendon Press, 1987).

29. *PPP*, p. 171.

30. See Philippa Levine, *Victorian Feminism, 1850–1900* (Gainesville: University Press of Florida, 1994), pp. 56–71.

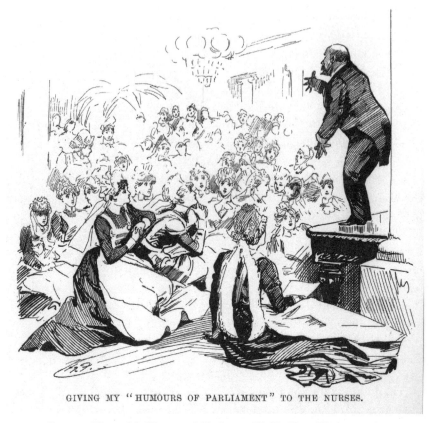

GIVING MY "HUMOURS OF PARLIAMENT" TO THE NURSES.

Figure 12. "Giving My 'Humours Of Parliament' To The Nurses" (*CC*II, p. 162)

had been recently professionalized and made respectable. Growing opportunities for girls to obtain academic schooling, and women higher education, not only enriched women intellectually, but also helped education to become a more substantial employment sector for them—as elementary school teachers, and even school administrators. Moreover, at both the school and university level, young women began to organize the kind of political debating activities that schoolboys and male undergraduates had been pursuing for decades.

In his account of touring with "Humours," Furniss regularly discusses the women he encountered on his travels—often in generalized terms as pleasing features of the local scenery. His words and his drawings show him to be a great admirer of female beauty, but also deeply entrenched in traditional ideas of women's proper role in society. As he wrote in one essay, for example: "In one particular instance women are cleverer than men, women appreciate their own good or attractive points, and lay themselves out to make the best of

them."[31] Yet, in spite of Furniss's own unadvanced views about women in politics, "Humours" clearly reflects the growing presence of women in, and their growing claims on, Victorian public life.

4. What "Humours" Left Out

A number of other highly significant late-Victorian developments do not figure in the extant text of "Humours" reproduced in this volume. It was a period in which organized labor began to emerge as an independent political force; the Empire was expanding rapidly, especially in Africa; and, in part sparked by imperial competition, relations among the European great powers were becoming frayed (prompting much parliamentary debate over military and naval expenditures). Of course, "Humours" in no way aimed to be a comprehensive record of the times, nor did it claim to represent all that was debated in Parliament. The significance of sharpening great power antagonisms, while much discussed in their time, seems far more ominous when viewed from the other side of the unimaginable cataclysm of the First World War. In 1891, Labour was not yet a major political or parliamentary force. The Empire may have been either (as some scholars have argued) not much thought about by Britons or (as others assert) so pervasive in late Victorian culture that it could almost be taken for granted. On both the Labour and imperial fronts, however, Furniss's inclusion of the working class MPs Burns and Hardie, and the Indian MP Naoroji in his 1892 tour (see section II.2)—though not reflected in the extant manuscript—would likely have occasioned some broader remarks. In print, for example, Furniss made clear his disdain for working-class MPs in general: "Working-men Politicians . . . are a very different class from the working men themselves. All must admire the horny-handed son of toil, and the typical honest British workman; but these gentlemen—I use the word advisedly—who represent their fellows in Parliament are, with very few exceptions, working the men rather than working men."[32] And, of course, Furniss ridiculed their pronunciation: "Though the House is very indulgent indeed, it is tickled at times with the *H-less* harangues of the working man's representative."[33]

Perhaps, too, Furniss did not think challenging and divisive subjects suitable for the kind of "entertainment" he had in mind for the audiences to which

31. *SVW*, p. 16.

32. *PPP*, p. 141. Lord Salisbury coined the phrase "horny-handed sons of toil" in an 1873 article for the *Quarterly Review*.

33. *PPP*, p. 144.

he played. In this light, the attention he does pay to the Irish and to women may have had less to do with reflecting political trends, and more to do with his own personal interest in both, the materials available among the body of his drawings, and the kinds of comedy (both visual and spoken) that each group afforded within the conventions of the times.

IV

THE CREATION AND PERFORMANCE OF "HUMOURS"

*I*N ADDITION TO the inherent interest and timeliness of his subject matter, Furniss developed his particular brand of lecture entertainments at a historical moment that was especially propitious for the kind of performance that he was prepared to offer. The trail had been blazed earlier on by illustrious predecessors with whom Furniss felt a special affinity, and the last decades of the nineteenth century saw a revival of public interest in lectures. Further, the availability of the magic lantern provided lecturers with a reliable and portable technology for presenting images. With his entrepreneurial spirit, fertile brain (and hand), engaging manner, vast reserves of energy and ego, and interest in exploiting the possibilities of all available media for disseminating his work (and earning money), Furniss was exceptionally well placed to take advantage of all these developments in creating and presenting "Humours."

1. Origins: From Lecture to Entertainment

When Furniss delivered his first public lecture in 1888, he joined a tradition of platform activity that had a considerable history. A great admirer of Dickens and Thackeray (whose works he would re-illustrate for major editions in the early 1910s), Furniss was keenly aware of how those novelists and others had earned money and public acclaim through lecturing in the mid-nineteenth century: "At such a time it is not to be wondered at that the lecturer, Professor Dry-as-Dust excepted, was looked down upon, or rather

up to, with some contempt; but Carlyle, Thackeray, and, to a greater extent, Dickens broke down that prejudice."[1]

In 1851, by which time his reputation as a great novelist was already secure, Thackeray gave a series of lectures on "The English Humourists of the Eighteenth Century." "An undoubted success he was invited to repeat them . . . all over the country"[2] and his stature helped raise the profile of lecturing above the taint of its then more mercenary image. Yet Thackeray was indeed tempted by the money to be made, especially in the United States (see section V.1), which he toured with "The English Humourists" (1852–53) and "The Four Georges" (1855). He calculated that he earned about £2,500 from the first tour at the rate, so he reckoned, of £1 per minute. Thackeray demonstrated that lecturing could be both respectable and profitable, but it was Dickens, with his enormously successful readings from his novels in the late 1850s through the 1860s both in England and in America, who transformed the formal lecture into a performance, widening his audience and thus increasing the profits to be made. Indeed, Dickens made as much money from his readings as from the sales of the novels themselves.[3]

Furniss learned much about the platform from his two favorite novelists and the parallels are instructive. All three traded on their well-established reputations in print before stepping onto the platform. As noted earlier, most of the advertisements for "Humours" promoted Furniss as a *Punch* man. All three, in addition, had big personalities, perhaps a prerequisite for a successful platform performer. Furniss speculated that "had Thackeray been alive to-day, and started lecturing, he would still—as a novelty—be a great draw; for what Thackeray called 'making a show of himself' is now—more than ever—the order of the day."[4] Dickens, being Dickens, was a one man show, and from him in particular Furniss recognized the importance of the performative side of being on the platform.

By the time he launched "Humours," Furniss had already acquired considerable experience with lecturing. He began his platform career, with some trepidation, in 1888 with "Art and Artists" as a result of an invitation from the Birmingham and Midlands Institute. As he wrote to the manufacturer S. W. Richards: "It is very good of you to have such confidence in a novice and I appreciate it so much. I will agree to March 17th unless I am such a failure

1. *EH*, p. xxxiv.
2. *EH*, p. viii.
3. According to Philip Collins, "Nearly half of the £93,000 Dickens left in his will" had come from the readings. Charles Dickens, *Sikes and Nancy and Other Public Readings*, ed. Philip Collins (Oxford: Oxford University Press, 1983), p. x.
4. *EH*, p. xxxvi.

that it would be better for both our sakes to drop the matter.—However, I intend to do my best and the subject of illustrations may interest some if the Lecturer does not."[5] Before going public, he rehearsed the lecture, at the Savage Club in February 1888 (fig. 13). Afterwards, he wrote: "I feel my Lecture did not go down well at the Savage but I am glad to say I have had a tremendous success in Newcastle, Birmingham, etc. I feel quite 'at home' now at the desk. What astonishes me is that the Lecture is so well followed and understood by the people (in Newcastle on Tyne audience of 3,200 persons). . . . Have been re-engaged for next year wherever I've been."[6]

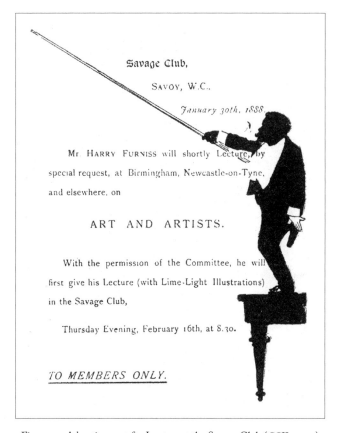

Figure 13. Advertisement for Lecture at the Savage Club (*CC*II, p. 159)

5. HF to S. W. Richards, 29 June 1887, letter in possession of Selwyn Goodacre.
6. HF to Sir James Dromgole Linton, 8 March 1888, *NPG*, 86.WW2.

In October, following upon his success with "Art and Artists," Furniss prepared a new lecture, "Portraiture: Past and Present." In both efforts he was "desperately serious" but, despite his success, "the orthodox lecture was not congenial to me." Accordingly, he decided "to appeal to the more general public, and to attempt, upon the occasion, something more ambitious than a mere discourse."[7] As his friend Milliken comments Furniss "soon fell out of love with mere lecturing, whose sphere was too limited, its character too conventional, and its results too restricted for his high aims and soaring ambition."[8] However uncongenial to his exuberant and energetic personality, these early efforts did pave the way for "Humours," which in many ways was a creative breakthrough as lecture transformed into "entertainment." "Humours" also made him a lot more money.

The idea for "Humours" came to Furniss while giving "Portraiture: Past and Present": "I had briefly narrated the manner in which I have been in the habit of making a special study of Mr. Gladstone, in the House of Commons, and the interest invariably invoked by my references to [him] . . . began to lead me to think that the subject, upon which I was most likely to engage the attention of the public, at large, was Parliament."[9] The huge audiences for his 1888 lectures also gave him the confidence to go it alone. Where the hosting organizations had "pocketed between fifty and sixty pounds,"[10] he had received only expenses plus a meager fee of ten guineas (Thackeray's was fifty). Thus, "finding that the Institutes made huge profits out of his efforts, and that his anecdotes and mimicry were the parts most relished, he abandoned the rôle of lecturer for that of entertainer with 'The Humours of Parliament.'"[11] He never regretted the change. Receiving "60 per cent. on the gross takings,"[12] he made more than £2,000 from the first tour of "Humours" and from that time on became one of the foremost platform entertainers of the 1890s, giving a series of enormously successful public performances throughout the United Kingdom, North America and Australia for nearly fourteen years.

Furniss often distinguished between the lecturer and entertainer much to the detriment of the former. He opens his chapter on "Platform Confessions" with these words: "That hateful word 'lecture'! Oh, how I detest it!"[13] Elsewhere he wrote, "some people insist on calling it ['Humours'] a lecture, a title I

7. *AH*, pp. 110, 113.
8. *BAA*, p. 8.
9. *AH*, pp. 110, 113.
10. *AH*, p. 117.
11. How, p. 309.
12. *AH*, p. 117.
13. *CCII*, p. 154.

abhor."[14] Lecturers are characterized as belonging to the "Dryasdust species"[15] the enemy he wants driven to extinction: "Some people still stick to the idea I am a lecturer; an idea I am trying to eradicate as soon as possible. I am at present [during the 'Humours' tour] engaged in mortal combat with the fiend Dryasdust"[16] (fig. 14), a battle he clearly won: "He is more of an entertainer than a lecturer," wrote one reviewer.[17] His contempt for the amateur lecturer seeking easy money and unearned fame is evident in this remark: "it is a great mistake to imagine one has only to 'write something,' and, provided with a few 'slides,' a reading-desk, and a glass of water—and a chairman, mount a platform and read."[18]

Figure 14. Fighting Dryasdust (*FV*, p. 12)

14. *AH*, p. 37.
15. *CC*II, p. 155.
16. *FV*, p. 12.
17. *AH*, p. 118.
18. *CC*II, p. 181.

2. The Magic Lantern Show

All Furniss's entertainments (as we should now call them) were illustrated
with magic lantern slides, a key dimension which the lectures and readings
of his illustrious novelistic predecessors lacked.[19] When describing how well
Thackeray would have fared with respect to the popularity of platform lec-
turing, Furniss noted that "he would now be expected to have a lantern, and
show the portraits and pictures to which he refers in the . . . lectures."[20] No
doubt he would have been pleased with the reviewer who wrote that "Mr.
Harry Furniss . . . suggested Thackeray with lantern 'slides.'"[21] Dickens,
supreme actor that he was, needed no mechanical assistance for his read-
ings, but his nursemaid Mary Weller remembers how he, as a small child,
asked her to "clear the kitchen . . . and then George Stroughill would come
in with his Magic Lantern."[22] This was during the Regency period (though
the device dates back to the seventeenth century) and by the mid-nineteenth
century it had superseded the panorama show (whereby painted pictures on
large rolls of cloth were slowly scrolled before the audience) as the pre-emi-
nent technology for reproducing images on a screen.[23]

 By the 1880s, when Furniss launched his career as a lecturer-entertainer,
the magic lantern was approaching the peak of its popularity. David Robin-
son states that "the last era of magic lantern history . . . began around 1880,"
inaugurated by "the final revolution" that saw "great improvements in illu-
mination and lens systems."[24] The illustrated public lecture was already one
of the commonest forms of cultural activity and, as we have seen earlier, it
contributed to the growing interest in self-improvement by offering a whole
range of scientific, religious, literary and political topics. But key techno-
logical developments—the replacement of hand-painted with photographic
slides; the substitution of heavy wood-framed slides for lighter, more portable
glass ones; the development of more sophisticated, convenient and reliable

 19. The Magic Lantern Society (UK) is the single most valuable source for information
about the magic lantern and this section is indebted to its publications, in particular its invaluable
Encyclopaedia of the Magic Lantern whose "Further Reading" (pp. 336–37) and "References" (pp.
338–47) direct readers to other sources. Although Furniss and "Humours" are not mentioned, use-
ful background for his Irish performances is also provided by Kevin Rockett and Emer Rockett,
Magic Lantern, Panorama and Moving Picture Shows in Ireland, 1786–1909 (Dublin: Four Courts,
2011), ch. 1.
 20. *EH*, p. xxxvi.
 21. *Melbourne Argus*, 24 May 1897, p. 6.
 22. Angus Wilson, *The World of Charles Dickens* (London: Secker & Warburg, 1970), p. 33.
 23. For a history of the development of the magic lantern, see the succinct and reliable account
in David Robinson, *Magic Images: The Art of the Hand-Painted and Photographic Lantern Slides* (Lon-
don: The Magic Lantern Society, 1990), pp. 6–8.
 24. Robinson, *Magic Images*, p. 8.

projection equipment including the triple lantern that Furniss used; and the improved safety (to operators and audiences alike) that resulted from storing the volatile oxygen-hydrogen mix used to produce limelight in metal canisters instead of canvas bags—all these widened the appeal and maintained the popularity of the illustrated lecture.

Apart from Furniss, there were dozens of other well-known lantern lecturers, as well as numerous manufacturers and dealers of the equipment. There were also manuals for operators such as *The Art of Projection and Complete Magic Lantern Manual by An Expert* (1893) and Charles Goodwin Norton's *The Lantern and How to Use It* (1895), which ran to several editions. In addition there were regular publications and trade journals, the most significant being the monthly *The Optical Magic Lantern Journal and Photographic Enlarger. A Magazine of Popular Science for the Lecture-Room and the Domestic Circle,* costing one penny and first published in June 1889.

Robinson writes "it is significant that the 'magic lantern' became the 'optical lantern' at this stage. The new seriousness of purpose was reflected in the general introduction of printed readings to accompany slides. The day of the galanty showman with his imaginative spiel was long past."[25] He goes on to make the general point that "the magic, to a large degree, had gone out of the lantern," and, indeed, "out of life in general in the 1880s and 1890s," noting the "deadly dull" portraits in the *Illustrated London News* and the dispiriting "vast catalogues of slides" available to lecturers "with their interminable lists of hymns and song services and moral tales and temperance stories, alongside dry-as-dust lectures on science, geography, history and travel."[26]

It was against this relentless cheerlessness, which increasingly characterized the world of the *fin-de-siècle* illustrated lecture, that Furniss self-consciously positioned himself. For one thing, he did not need to hire or buy printed readings to accompany his slides since he wrote his own amusing commentary. For another, as we have seen, he vehemently resented the term "lecture" applied to his entertainment "Humours" and saw the dry-as-dust lecturer as the mortal enemy. And finally his expressed intent, summed up in his title "The Humours of Parliament," was, as he says in his opening remarks, "to cut the history and the architecture and come to the men" (p. 143) with all their foibles, mannerisms, and idiosyncrasies—in short their humours. As one observer remarked, this may be "disillusionising" because "the chief political personages of the day . . . have been drawn unawares, in a degree of deshabille and in unstudied postures, when the men rather than the statesmen have been

25. Robinson, *Magic Images,* p. 8.
26. Robinson, *Magic Images,* p. 8.

in evidence."[27] On the other hand, as noted earlier, sketches provided advantages over formal portraiture for capturing Gladstone's electric and mercurial personality. And when these were projected by a lantern onto a large screen then, indeed, the Gladstone magic was on show.

Setting aside for the moment Furniss as platform performer, what were the technical requirements for an illustrated lecture-entertainment and how did Furniss meet them? There were three: the slides themselves, the magic lantern projector (and someone to operate it), and a screen of sufficient size. As already noted, most of the slides in "Humours" were based upon already published sketches, mainly those "which appear[ed] in *Punch* from week to week."[28] A few, such as the architectural drawings of the Houses of Parliament, were drawn specially for the show. It was normal for the opening slide to be prepared for the particular program, as is the case with the "No Politics" umbrella for "Humours." It is an example of a "motto slide," a term applied to "slides carrying wording, most often related to the presentation of the show."[29] Whether the images already existed or were prepared specifically beforehand all would have been produced by one of the more than twenty London-based professional slide manufacturers such as the long-established Newton & Co. of Covent Garden (not too far from the *Punch* offices in Fleet Street) which by the 1880s "had become one of the most important British lantern and slide manufacturers" and whose "reputation for quality"[30] could well have attracted Furniss.

According to Furniss the original black and white drawing was "reduced" for the lantern, "photographed on glass, and coloured by hand; the colouring is the work of the expert reproducer."[31] The photographic reproduction, and, in Furniss's case, reduction of existing engravings in books and magazines for lantern use, was common enough from the 1860s,[32] while the coloring "was often undertaken by the manufacturer" as well.[33] For example, on the original drawing for image 6a Furniss has written in pencil "a pink tint all over this slide" and for image 78 "pale orange" suggesting that these tints were "overpainted by hand in translucent colours," the artist using dyes rather than oils or watercolors, as dyes were "chiefly remarkable for the brilliance and complete

27. *The Age (Melbourne)*, 24 May 1897, p. 6.

28. *Freeman's Journal*, 25 August 1891.

29. *EML*, p. 200.

30. *EML*, p. 210.

31. *AH*, p. 142.

32. For a detailed account of this complex process, see the entry for "Photographic Processes for Slide Production" in *EML*, pp. 230–32.

33. *EML*, p. 73.

transparency of their tints."[34] The aim was "to take off the rawness"[35] of the black and white originals, but pink and pale orange are hardly parliamentary colors and the effect did not please everyone. According to one report: "Several of them are highly coloured, which, while adding considerably to the vividness of the effect, mars in some measure the merit of the sketches."[36] Even though he was a leading practitioner of, and advocate for, "black and white" art, Furniss was not wedded to any notions of purity when it came to attracting paying customers. His initial drawing of the Houses of Parliament at night (image 69) was substantially re-worked by the slide manufacturer: "the sky is his, not mine; moon and stars are scratched in by some sharp point on the glass." What Furniss called "this trivial embellishment [by] the maker of the lantern slides"[37] was once criticized by a pedantic member of an Edinburgh audience for its astronomical inaccuracies.

In order further to enhance the attractiveness of the slides, some were "masked" by mounts of opaque paper around the edges of the image[38] which produced, for example, a round or oval shaped image that softened the harsh outlines of the original square or rectangular sketch for magazine or newspaper. The masking also obscured any extraneous details such as captions that were included in the original and which might detract from the impact Furniss aimed for, namely an unadorned sketch or portrait, as is the case with Gladstone and Balfour. Figures 15 and 16 clearly show their images surrounded by a circle, as does that of W. H. Smith in *The Daily Graphic* for 2 May 1891. No doubt many other slides for "Humours" were similarly masked.

It must be clear from all of the above that many of the original images that appeared in magazines and newspapers and are reproduced in this book are approximations to those shown in "Humours" as magic lantern slides. Earlier in this introduction attention was drawn to the many processes, human and technical, that transformed Furniss's initial observations of MPs into published sketches (section I.3) and similar interventions—coloring, tinting, reworking, masking—obtain for turning those sketches into slides. Thus, what the audience actually saw on the screen at a performance of "Humours" is some distance from those first rudimentary scribbles on the little cards

34. *EML*, pp. 232, 284. The original drawings of images 6a and 78, with annotations to indicate the tinting for slides, are in the Parliamentary Archives HC/LB/1/112/397 and 248. Furniss specifically mentions that his drawings were "coloured by hand" so it is unlikely he used "tinters" (color filters fitted over the lens), even though they were what most professional lanternists used. The word "tints" in the *EML* quote seems to be describing, somewhat misleadingly, the colors themselves. We are grateful to David Francis for clarifying this point.

35. *Preston Guardian*, 19 December 1891.

36. *Freeman's Journal*, 25 August 1891.

37. *AH*, p. 142.

38. *EML*, p. 189.

MR. HARRY FURNISS LECTURING ON "THE HUMOURS OF PARLIAMENT"
THE LECTURER AND THE G.O.M. BECOME A LITTLE MIXED ON THE SCREEN

Figure 15. "Mr. Harry Furniss Lecturing On 'The Humours of
Parliament.' The Lecturer and the G. O. M. Become A Little
Mixed on the Screen" (*The Graphic*, 9 May 1891, p. 515)

secreted in Furniss's pocket. We, in turn, are even further away from experiencing the magic lantern slides. In attempting to recreate a rough facsimile of "Humours" we must acknowledge this distance even as we recognize that such interventions are an inevitable part of artistic production.[39]

39. As they are for authors whose manuscripts must pass by the eyes of editors and, during the nineteenth century, through the hands of compositors. As a contributor of sketches to *Punch*, which steadfastly refused to embrace process engraving using mechanical blocks until the turn of the century, Furniss would have been familiar with such interventions by hand engravers and thus alert to potential alterations to his originals.

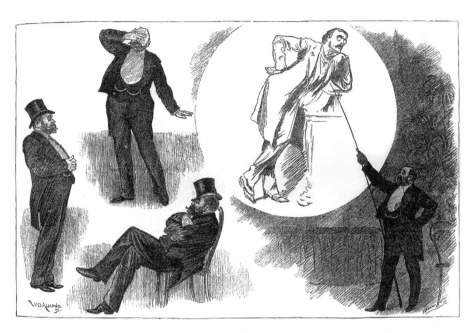

Figure 16. "Lecture By Mr. Harry Furniss On 'The Humours of Parliament'" (*ILN,* 9 May 1891, p. 599)

While the extant manuscript gives cues for 104 slides, 160 was the figure noted in two accounts from 1891.[40] The higher number is confirmed in a report quoted by Furniss in his own book: "In most illustrated lectures and entertainments, the number of slides used varies from fifty and sixty, seventy being an exceptionally large number. Mr. Furniss has one hundred and sixty. He also has a duplicate set, in case of any accidents happening to the one he is using."[41] Transporting such a large number was made possible by the replacement in the 1870s of relatively heavy wooden-framed slides with lighter, less bulky, glass slides, the kind Furniss used. Because they were made of glass the slides had to be protected as Furniss moved from one venue to the next and so they were transported in elaborate wooden or metal "transit boxes" padded with felt or rubber. They were manufactured to accommodate eighty or one hundred slides, each three-and-a-quarter inches by three-and-a-quarter inches (the standard dimension at the time), so Furniss probably had four boxes to house the original and duplicate sets. During the two-hour entertainment, a slide was shown on average every forty-five seconds and on display for less than

40. *Birmingham Post,* 26 October 1891; *Manchester Guardian,* 28 October 1891. "150 sketches" were reported for the Australian tour (*The Age [Melbourne],* 24 May 1897, p. 6).

41. *AH,* pp. 151–52.

that, passing before the audience's eyes "in some thirty seconds (and owing to the number to be shown some will not even be before them as long as that)."[42]

The second essential element of an illustrated lecture was, of course, the lantern itself. In the 1890s magic lanterns were powered by what was known popularly as limelight, "an intense white light produced by heating a piece of lime, or calcium oxide, generally with a flame of combined oxygen and hydrogen gases" which were contained in a cylinder.[43] The dangers of operating such equipment were very real as shown by an illustration in the *Graphic* that "represents an unfortunate lime-light man, who lost an eye through a gas explosion in the theatre while manipulating the apparatus. He was laid up for eight months, after which he was able to resume his ordinary functions."[44] Such accidents were usually caused by the incorrect mixing of gasses, and the occasionally fatal risks associated with the lantern were recorded in gruesome, not to say sensational, newspaper accounts ("Extraordinary Explosion in Bradford. A Boy's Head Blown Off"[45]).

As Furniss noted, however, the risks associated with the volatile mixture had been considerably reduced by the time he performed "Humours." He compared the relatively safe nature of "the elaborate apparatus and strong gas cylinders in use nowadays" (they were introduced in the mid-1880s) with the more accident-prone "old-fashioned lanterns and gas bags"[46] which were liable to "blowback" whereby "the flame would travel back up the tubes into the bag."[47] Sometimes the gas "suddenly failed"[48] and the audience would be plunged into darkness until the fault had been repaired, or the unforeseen might lead to unexpected amusement as when a fly, caught between the lenses, "was magnified a hundred fold on to the screen" while a slide of Gladstone was being displayed, so it appeared as if "a gigantic fly [was] promenading on the nasal organ of the Grand Old Man"[49] (fig. 17). At one city, when the accidental hissing of the lime in the lantern accompanied Gladstone's image, "the audience rose in indignation" and the following day's reviewer wrote that it "'was a disgrace to the people of Leicester.'"[50]

Such accidents were infrequent during the "Humours" tour partly because Furniss by 1891 had learned not to rely upon incompetent local lanternists

42. *Daily Graphic*, 23 April 1891, p. 12.
43. *EML*, p. 174.
44. *Graphic*, 6 April 1889, p. 351.
45. *EML*, p. 110.
46. *FV*, p. 141.
47. *EML*, p. 110.
48. *AH*, p. 150.
49. *CC*II, p. 169.
50. *How*, p. 310.

Figure 17. "The Fly In The Camera" (*CC*II, p. 169)

such as those he hired for his 1888 "Portraiture: Past and Present" lecture. He complained of slides that were out of focus, only partly on the screen, put in sideways or upside-down, or quite simply were the wrong ones for his lecture commentary. On one occasion the operator accidentally rubbed off from the slide the number of minutes for the interval (which raised unscheduled laughter) and on another he disappeared half way through the show after the gas failed. So "after such experiences . . . I determined I would devise my own arrangements for showing my own pictures, engaging my own operators exclusively for the purpose."[51]

For "Humours" the same lanternist accompanied Furniss for the whole tour, the infallible "Professor C—, *facile princeps* in the art of manipulating the lantern," (fig. 18) whom Furniss rather tiresomely characterizes as a melan-

51. *AH*, p. 150.

Figure 18. Furniss's Lanternist (*FV*, p. 11)

choly man with an unhealthy obsession for corpses and graveyards.[52] His lugu-
briousness notwithstanding, the "great skill and dexterity" needed to operate
sophisticated (and potentially dangerous) equipment was duly noted: "One
word ought to be said of the views, which were shown by the aid of a powerful
oxy-hydrogen light. The greatest credit is due to the manipulator, who per-
formed his part most creditably, and without a single hitch."[53]

No doubt because of the growing popularity of lantern shows, eventu-
ally local lanternists became more reliable and so for his later entertainments
the Professor was released to pursue his morbid interests: "after several sea-
sons, however, I found that the lanternists in the provinces had improved and
become trustworthy and excellent operators."[54] For his Australian tour of 1897
Furniss must have found an expert lanternist who was, from the very first show
in Melbourne, quickly in tune with his employer's script: "In no instance was
Mr. Furniss and his lantern slide operator more in sympathy than in dealing
with the studies of Mr. Gladstone. As the entertainer described vividly, with all

52. *FV*, p. 11. The lanternist's last name was Catlin. *Leeds Mercury*, 29 August 1896, p. 1.
53. *EML*, p. 309; *Dart: The Birmingham Pictorial*, 11 November 1892.
54. *AH*, p. 151.

the fervour of a true artist, the attitudes and characteristics of the Grand Old Man, the illustrations appeared to the instant on the screen, and the applause thereat was demonstrative."[55]

Artist though he was, Furniss liked to use the latest technology: he experimented with an early type of dictaphone and for "wash work" he "tried the Aërograph: a machine brush in which the air is pumped through a many-pointed, fine-tubed pen, and throws a spray of ink over the paper, with very soft and wonderful effects."[56] For his "Humours" tour he wanted his black and white slides to be as aesthetically pleasing as possible so, in addition to hiring an expert to color them, after "a long and tedious search" he ordered "an entirely new triple lantern, of the most modern type."[57] Known also as a triunial lantern it had three separate lenses though all three were not needed for "Humours" ("dissolving views" were not part of the show and a biunial lantern would have sufficed).

As a contemporary lantern lecturer T. C. Hepworth remarked the triple lantern was "commonly used by those exhibitors who may be described rather as entertainers than lecturers" and as we have seen Furniss confessed to belonging to the first category. Ever the showman, his aim was, in part, no doubt to "simply impress the audience and dazzle them with technology"—much to his own inconvenience, one might add. The finest triple lanterns "were majestic instruments in brass and mahogany"[58] and as a popular journal noted "the oxyhydrogen lantern, with which Mr. Harry Furniss illustrates his 'Humours of Parliament,' is one of the finest, if not absolutely the best of its kind in the world. It cost nearly 150 guineas."[59] Figure 19 shows an upmarket triunial of the kind Furniss used.

One of the leading suppliers of the time, Walter Tyler of Waterloo Road, London, claimed to have "the largest and best stock of lanterns and slides in the world" with "Bi-unials and Triple Lanterns" for sale "from £3 to £200."[60] Furniss had nightmares (fig. 20) about this "new and complicated apparatus" when it was delivered to his house in St John's Wood[61] and also about how to move it from venue to venue. "Of colossal weight . . . massive and difficult to transport,"[62] especially on a four months tour of 7,000 miles, this "triple reflex combination self-acting double-riveted 400 horse-power lantern" traveled

55. *Herald* (Melbourne), 24 May 1897, p. 3.

56. *HTD*, pp. 38–39.

57. *AH*, pp. 150–51.

58. *EML*, p. 309.

59. *AH*, p. 151.

60. Cover to the *Optical Magic Lantern Journal*, September 1896.

61. *AH*, p. 151.

62. *EML*, p. 309.

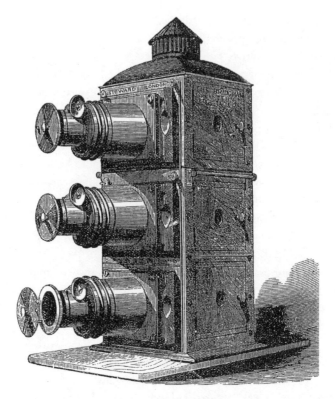

Figure 19. A Triple Lantern
(*The Optical Magic Lantern Journal*, 1 December 1894, cover)

with Furniss in enormous packing cases together with his other "elaborate
paraphernalia" necessary for the tour (fig. 21), including the traveling studio
described earlier (section I.3) and "a new elastic-sided electro-plated writing-
case, jewelled in four places."[63]

The final requirement for an illustrated lecture was a screen onto which
the slides could be projected. According to Furniss the screen was "any size
from twelve to forty square feet"[64] depending on the venue. At the Masonic
Hall, Birmingham, it was twenty-one square feet,[65] at the Music Hall, Edin-
burgh, it was forty square feet.[66] This range of screen sizes was pretty much
the average for the 1890s for one of the "greatest authorities in lanterns and

63. *FV*, p. 10.
64. *AH*, p. 142.
65. *Birmingham Daily Post*, 26 October 1891.
66. *AH*, p. 142.

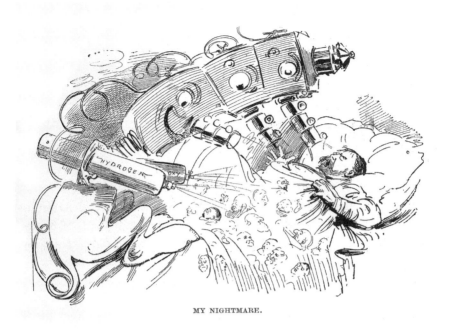

MY NIGHTMARE.

Figure 20. "My Nightmare" (*The Daily Graphic,* 23 April 1891, p. 12)

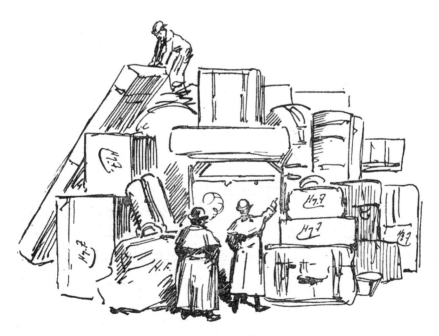

Figure 21. Luggage for the Tour (*FV,* p. 10)

their manipulation," a Professor Koenig, projected "pictures from 10 to 50 feet in diameter,"[67] although one of the largest slide projections ever was at the Royal Albert Hall "with a throw of 167 feet and a screen image of 35 feet in diameter, to illustrate a lecture by Dr. Nansen" in 1897.[68] Judging from contemporary sketches of the five-feet two-inch tall Furniss standing alongside the screen at Prince's Hall, Piccadilly (figs. 15 and 16), the projected images at that venue were the smaller ones, approximately twelve feet in diameter. Sydney Prior Hall, the artist of figure 15 in which "The Lecturer and the G. O. M. Become A Little Mixed on the Screen," depicts the egotistical Furniss accidentally competing with Gladstone for the audience's attention much, it appears, to the latter's chagrin.

Clearly in those early performances Furniss had not yet perfected his stagecraft. One reviewer criticized the slides of "crowded groups of figures" as unsuited to magic lantern projection "on a white sheet before a large audience." No doubt he had in mind scenes such as those in images 58 or 70. The oxyhydrogen light "was somewhat glaring, and prevented a very clear impression of these complex scenes . . . the simpler the pictures were, the better they were comprehended. Mere outlines were exceedingly effective" such as the series of Furniss and the Monitor of the Press Gallery (images 11–18) and the Gladstone series (images 21–29).[69]

The magic lantern became a necessary component of all Furniss's shows and central to their success, but its vogue was short lived and eventually, in his own words, "the entertainer and the lecturer [were] killed by the cinema."[70] It is tempting to locate "Humours" as a technological precursor to cinema especially as Furniss himself, after sitting at the feet of Edison in New York, returned to England in 1914 and set up his own (ultimately unsuccessful) film studio in Hastings. While there is little doubt that the magic lantern significantly influenced film, and the two did in fact exist side by side for some time,[71] it should not be pigeonholed as a pre-cinematic form locked into a teleological film history. Film historians increasingly reject the notion of "pre-cinema" because it assumes a linear progression from one form to another and distorts the historical study of independent forms like the magic lantern.[72] In Tom Gunning's influential formulation, however, an important function of cinema in its earliest days was to present audiences with a series of exotic,

67. *EML*, p. 155.
68. *EML*, p. 177.
69. *Saturday Review*, 9 May 1891, p. 556.
70. *SVM*, p. 175.
71. *EML*, p. 69.
72. Simon Popple and Joe Kember, *Early Cinema: From Factory Gate to Dream Factory* (London: Wallflower Press, 2004), p. 129.

spectacular, or magical views, rather than to tell a story, which became the dominant mode from the mid-1910s. This "cinema of attractions" exhibited strong continuities with magic lantern shows and other forms of nineteenth-century visual entertainment.[73]

Furniss's later involvement in film notwithstanding, the question of cinematic antecedents is far less significant for a study of "Humours" than other dimensions of nineteenth-century culture: graphic arts, political culture and public life, and the presenting technology of the magic lantern.[74] At the same time, "Humours" must also be understood as an individual's performance at a particular time and at specific locations, and thus much more than simply a series of magic lantern slides projected by a triune onto a large screen by an expert lanternist.

3. Furniss as Platform Performer

While it is difficult to recover completely from the extant evidence what, exactly, a performance of "Humours" was like, we can get a reasonable idea based upon Furniss's own accounts, and from reviews, illustrations, and contemporary interviews. A short, stocky figure who, as the years advanced, became increasingly "globular," Furniss had "a bald head, green eyes, and a pointedly 'auburn,' short-cropped beard, with a moustache to match."[75] The Antipodean reviewers could, perhaps, afford to be less tactful than their northern hemisphere counterparts as we see in this description in the *Melbourne Punch*: "Personally he is a short gentleman with an aggressive *embonpoint*, but tapering suddenly both ways, to the toes and to the head, which gives him the pert appearance of a sparrow that has dined well and is at peace with the world" (fig. 22).[76] The Sydney *Bulletin* characterized him as "a podgy little gentleman very like the Prince of Wales in appearance, and has nothing at all of the Bohemian about his aspect. He is sleek and well groomed and wears the largest and stiffest expanse of pallid shirt-front that a man of his size ever appeared in."[77] Furniss himself had no illusions about his physique,

73. Tom Gunning, "The Cinema of Attractions: Early Film, Its Spectator, and the Avant-Garde," in *Early Cinema: Space, Frame, Narrative,* ed. Thomas Elsaesser and Adam Barker (London: British Film Institute, 1990), pp. 56–62.

74. Cf. *EML*, p. 336.

75. *Argus* (Melbourne), 21 May 1897, p. 6.

76. *Melbourne Punch,* 27 May 1897, p. 417.

77. *Bulletin* (Sydney), 19 June 1897, p. 8. Furniss was also regularly likened to the Prince of Wales in Canada, albeit with more reserve; see, e.g., *Globe* (Toronto) 11 January 1897, p. 2. Physical resemblances aside, such a comparison is to be seen in the context of men's fashions of the 1890s, whose undoubted leader was the future king: "The Prince's less radical fashion initiatives were usually taken

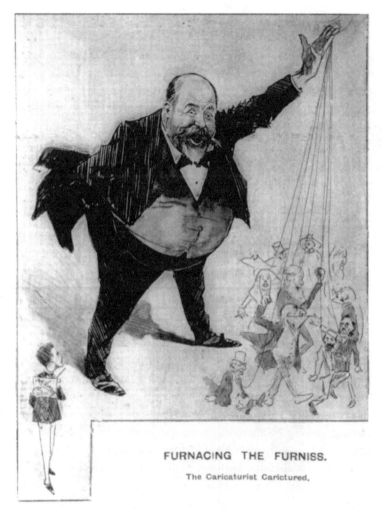

FURNACING THE FURNISS.

The Caricaturist Carictured.

Figure 22. "Furnacing The Furniss"
(*Melbourne Punch*, 27 May 1897, p. 410)

describing it three years later, when he was forty six, as "*podgy*, of a full face, but with a head somewhat depleted of its capillary adornments."[78]

up by the gentlemen around him, and even those not of his circle could at least partake of his aura by emulating his taste to the extent of their means, even if only by leaving the bottom button of their waistcoats undone as a tribute to his *embonpoint*," Christopher Kent, "Gentlemen's Fashions in the *Tailor and Cutter, 1866–1900*," in *The Lure of Illustration in the Nineteenth Century*, ed. Laurel Brake and Marysa Demoor (Houndmills: Palgrave Macmillan, 2009), p. 194. "The Original Drawing" of a menu designed by HF for a dinner at the Savage Club attended by the Prince of Wales "was by request presented to His Royal Highness" (*CC*I, p. 47).

 78. *CC*II, p. 273. HF's italics.

He wore the usual garb of the professional stage entertainer, for "the dress suit and the regulation white tie are essential to those who appear in public upon the platform."[79] "Portrait Of The Lecturer" (fig. 23), from 1888, shows him in typical pose standing rather stiffly and formally alongside the lectern. For his "entertainment," however, he needed the whole stage in order to act out his imitations of MPs. So the lectern, on which he placed his notes, like those reproduced in this volume, was set to one side, almost hidden from view for his Prince's Hall performance by potted ferns. With a long pointer in hand, he would stand, as was the custom, "next to the screen at the front, facing his audience, whilst the lanternist operated the slides from the back of the hall"[80] (figs. 15 and 16).

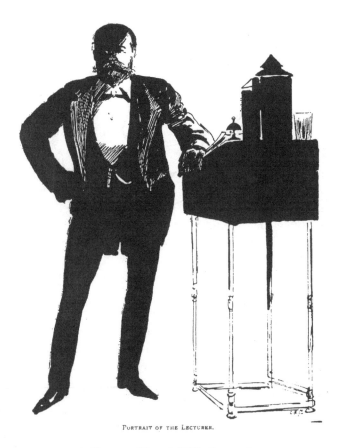

PORTRAIT OF THE LECTURER.

Figure 23. "Portrait Of The Lecturer"
(*Pall Mall Budget*, 11 October 1888, p. 12)

79. *CC*II, p. 165.
80. *EML,* p. 165.

While "supplying a sort of chorus or accompaniment to the ludicrous scenes and personalities his pencil has sketched,"[81] Furniss usually remained

> in the dark during most of my entertainment, the gas in the hall being low-ered, as far as it will go without being extinguished altogether; so I need not look at my audience, but can keep my eyes shut and hammer away. The people, of course, have their eyes fixed on my quickly changing pictures, and the strong light on the screen, in the centre of the platform, makes the dark-ness, at either side, seem more intense. But, on the other hand, it lights up my audience for my own benefit. If my audience is an interesting one, I like to watch it closely, but if it is not, I simply shut my eyes, and thus save both their feelings and my own.[82]

Except when, in the early days, he and the G. O. M. became a little mixed on the screen (fig. 15).

In order to communicate with the lanternist there existed various "inge-nious gadgets—red flashes from the special lecturer's lamp, pings from a bell, or the 'clack' of a steel clicker held in the hand."[83] The bell and the lamp are clearly shown in figure 23 but it is not known which device Furniss used for "Humours" to indicate "next slide please," though given his enthusiasm for the latest gadgets he probably used an electric signal, which became more necessary due to the increasing size of venues for magic lantern shows as the nineteenth century wore on.[84] But over the course of the sixteen-week tour such cues were doubtless needed less and less, so familiar must the dismal but infallible Professor have become with Furniss's delivery, while the entertainer himself, according to one reviewer, "dispense[d] with the notes, the wand, and the desk and glass of water, inseparable from the lecturer."[85] Unencumbered by such props, Furniss could then strut and fret his hour upon the stage, delight-ing his audiences with anything but Shakespearean seriousness.

But Furniss was no poor player. His success as an entertainer was due in no small part to his personality and natural acting ability. Before attempting his first public lecture Furniss was advised to take elocution lessons, but he reports that these ended in complete failure. By his own account, the soundest advice he received came from the actress Mary Anderson: "Say what you have to say in your own way. Speak slowly and distinctly, and let everyone hear right at the

81. *Australasian*, 29 May 1897, p. 1086.
82. *AH*, pp. 144–45.
83. *EML*, p. 165.
84. *EML*, p. 165.
85. *AH*, p. 118.

end of the room."[86] This he put into practice and also learned to vary the tone of his voice, imparting what the *Melbourne Punch* rather curiously described as "a nutty flavour,"[87] thus avoiding "the 'preachy' style of delivery."[88] According to one account:

> A born actor, he has that personal magnetism that gets over the footlights. He is endowed with a strong carrying voice and an easy, conversational manner. . . . But it was especially the personality of Harry Furniss himself that made these lecture entertainments so attractive that although such entertainments are fast going out of fashion, Harry Furniss still continued to 'draw' audiences as well as pictures after others have found it almost as difficult to do the one as the other."[89]

His "personal magnetism" overcame his small stature, for he appeared "bigger on the stage"[90] than his actual five feet two inches: "in fact," he wrote, "bets have been made that I am over six feet high."[91]

His imitations of the Member for Ballyhooley (images 66 and 68) indicate the extent to which he acted out his text: "Had he not been a caricaturist he must have been a comedian. His powers of imitation are unlimited."[92] It was this last talent that many reviewers remarked upon as he mimicked the "voices, manners and mannerisms, attitudes and various other peculiarities attaching to hon. Members."[93] His overseas reviewers also emphasized this aspect of the show. According to a report of his performance in New York: "Mr. Furniss is a mimic, as well as a caricaturist, and hit off admirably the peculiarities in manner and utterance of half a dozen of the most prominent Englishmen."[94]

Furniss, it was observed, "enjoys an extensive acquaintance with dialect,"[95] and some parts of the text clearly indicate his use of accents. In Aberdeen, his portrayal of the Irish MPs' shenanigans over the "Assassinated Scarecrow" (image 68) "brought down the house,"[96] although the mimicry was also controversial and led to Swift MacNeill's "technical assault" on Furniss in the

86. *CC* II, p. 159.
87. *Melbourne Punch,* 27 May 1897, p. 417.
88. *CC* II, p. 159.
89. "Carnival," pp. 15–17.
90. *FV*, p. 54.
91. *CC* II, p. 188.
92. How, p. 310.
93. *Daily News,* 1 May 1891, p. 3.
94. *NYT,* 24 November 1896.
95. *TT,* 2 November 1900.
96. *Aberdeen Weekly Journal,* 1 December 1891.

Commons Lobby.[97] Also noteworthy were Furniss's voice characterizations for "the Member for Boredom, the Member for Mashertown, [and] the reply of the War Secretary to that inquiring member as to the number of horses lamed at a recent volunteer review,"[98] though this last the *Saturday Review* saw as an example of his "egregious pomposity."[99]

In addition to acting out the parts through accent and voice, Furniss also drew attention for his imitations of the "chief peculiarities of walk and gesture"[100] of numerous politicians, some, but not all, of whom were also shown on the magic lantern screen. In the earliest performances of "Humours," while Furniss was honing the show, some of these impressions drew criticism. In May 1891, one reviewer urged Furniss to "see the propriety of removing from his own show one or two representations which ridicule the consequences of physical infirmity."[101] Another wrote, "It is worth while to ask Mr. Furniss's friends to tell him of the mistake he unconsciously made in mimicking a member whose peculiar walk is due not to habit but to paralysis."[102]

More generally, however, Furniss's imitations of gesture and walk entertained, and reviews mentioned several as especially successful, including Arthur Balfour, Henry Labouchere, Thomas "Windbag" Sexton, and Sir Richard Temple. A few others attracted particular attention. His impersonation of Lord Derby was thought "especially amusing."[103] Furniss himself described how "by means of a few steps across the stage, [I] show the peculiar walk of the noble lord."[104] Another notable impersonation was of John Morley, whose style of bowing to the Chair Furniss described as "a low sweeping step, as if he were about to skate, this step varying a trifle from his usual step in the bow."[105] He also imitated Morley's walk: according to one review, the statesman "marches, according to Mr. Furniss, as if he were measuring a carpet

97. Upset by Furniss's imitations of the Irish members in "Humours" and by his caricature of the MP for South Donegal in *Punch* (see p. 9), MacNeill confronted Furniss in the Members' Lobby and, as described by Furniss, "merely touched the sleeve of my coat with the tip of his finger, and asked me if I would accept that as a 'technical assault'" (*CCI*, pp. 262–63). The incident took place on the evening of 25 August 1893, and was widely reported in the press. Distance encourages exaggeration so that by the time the news reached New Zealand MacNeill had "caned and pulled the ears of the distinguished caricaturist" (*Taranaki Herald*, 28 August 1893). Inevitably, Furniss exploited the publicity. See, for example, his lengthy account (with illustrations) in *CCI*, pp. 260–67 and his letters to newspapers, such as the *Scotsman* (28 August 1893), largely exonerating himself.

98. *Stage*, 7 May 1891, p. 14.

99. *Saturday Review*, 9 May 1891, p. 556.

100. *Aberdeen Weekly Journal*, 1 December 1891.

101. *Saturday Review*, 9 May 1891, p. 556.

102. *Pall Mall Gazette*, 1 May 1891, p. 3.

103. *Liverpool Echo*, 24 October 1891.

104. *Black and White*, 29 August 1891, p. 313.

105. *PPP*, p. 21.

which he intended to buy by the length."[106] In another review, his mimicry of
Morley's walk and the phenomenal strides of Lord Derby were thought to be
in the spirit of true farce.[107] Later, in his international tours, he added the Irish
historian W. E. H. Lecky, elected to Parliament in 1895. "Professor Lecky's
walk, a curious crippled motion" that, "if half as awkward, diffident, and gro-
tesque as the caricaturist represented him, must be one of the most amusing
spectacles of Europe."[108]

Furniss, then, possessed "the two great qualifications by which success
would be ensured. He is numbered among our greatest caricaturists, and he
is an actor of far more than average merit."[109] Thus, "Humours" was not just a
reworking of and elaboration on many of his already published caricatures,
but a performance piece in its own right. "Humours," to summarize, was com-
posed of various interacting elements: the visual images themselves, rang-
ing from realistic architecture to human caricatures projected onto a large
screen; action in the form of his own mimicry and stage antics; and voice.
This last encompassed spoken lecture, jokes, anecdotes, voice imitations of
MPs, and dialect. His deep familiarity with Parliament garnered from years in
the Press Gallery provided him with a fund of reminiscences that enlivened
his show: "Mr. Harry Furniss has a good many stories to tell, and tells them
splendidly."[110] The platform, then, was the forum where Furniss could display
his undoubted talents as a caricaturist, speaker, actor, and raconteur.

4. London and the Provinces, 1891–92

Furniss's success with his early lectures, his talent as a platform performer,
his fame as *Punch's* pre-eminent political caricaturist, and of course the
hope of making considerable sums of money, all persuaded him to develop
"Humours," which he launched on 30 April 1891. He chose his title with care.
For one thing it clearly indicated that the show was to be amusing: "The
humours of Parliament are scarce indeed, and if men were endowed with
more humour, they would see the ridiculous side of things, and probably
never put up for Parliament."[111] But the title also alludes to the old medical
theory of the four main liquids of the human body (blood, phlegm, yellow

106. *Irish Times*, 25 August 1891.
107. *Lloyd's Weekly Newspaper*, 17 May 1891, p. 2.
108. *The Age* (Melbourne), 24 May 1897, p. 6; *NYT*, 24 November 1896.
109. *Daily Graphic* 1 May 1891, p. 3,
110. *Daily Chronicle*, 1 May 1891.
111. *PPP*, p. 60.

bile, black bile) known as the cardinal humours, whose mixture determined, it was believed, a person's temperament. If any one of them predominated, then that person's character would be sanguine, phlegmatic, choleric or melancholic. A key text for the English theatrical tradition was Ben Jonson's play *Every Man in His Humour* (1598), for it exemplified the theory by identifying a character's ruling passion with his or her name, such as "Dame Purecraft" or "Wellbred." Jonson inaugurated the "Comedy of Humours" genre so popular in Elizabethan times which in turn influenced the Restoration and late-eighteenth-century Comedy of Manners and the tradition was revived in modified form by Furniss's contemporary Oscar Wilde. *The Importance of Being Earnest* (1895), with its punning title on the main character's disposition to be E(a)rnest (or not), was performed a year before Furniss set off overseas with "Humours."

Its title thus invokes a whole theatrical tradition and many of the magic lantern slides that exaggerated individual politicians' particular features with which they became identified may be seen as the visual equivalent of the comedy of humours.[112] While they were being shown on the screen Furniss would be acting out the peculiarities of his "victims" on a stage that was a simulacrum of the theater at Westminster. The Wellbreds, Purecrafts, and Earnests are replaced by Mr. Nincompoop, The Official Windbag, The MP for Ballyhooley, The MP for Boredom, The Member for Mashertown, and A Tory General. These generic types were complemented by the characteristic traits or humours of individual MPs: the effeminacy of Balfour, the belligerency of Harcourt, the aggressive vulgarity of MacNeill. Hence the humours genre lies unmistakably behind the title and Furniss's entertainment as a whole, which may be seen as a unique contribution to the late-nineteenth-century flowering of the form. The frontispiece of this book, which may be a trial advertisement or indeed originally intended as a cover for the book Furniss never produced (see section VI.1), draws attention to the humours tradition in its deliberate (?) misspelling of the word[113] and in the sketch of Gladstone. The visual and textual pun—Furniss's first sketch for *Punch* of the Grand Old Man was titled "Getting Gladstone's Collar Up" (fig. 9)—is a clear reference to one of the four cardinal humours.

112. While he would have resented the suggestion, William Hogarth is often seen as the father of English caricature, and it was he who made the connection between theatrical performance and the visual arts: "My picture is my stage, and men and women my players." *The Oxford Companion to Art,* ed. Harold Osborne (Oxford: Oxford University Press, 1970), p. 539.

113. "Humor" is, of course, the American spelling so Furniss may already have had the transatlantic market in mind.

The creation of "Humours" took some time and involved a great deal of hard work and preparation. As early as 1888, Furniss had applied for and been granted permission "to take sketches in the Palace of Westminster" which were necessary "for the elaborate interiors and exteriors" used in the show (see section I.3).[114] He relinquished "all lecture engagements, with few exceptions, for a year," and "was likewise compelled to decline nearly all invitations of a social and festive character," causing him to "fly from town and bury myself in the country" at Hastings.[115] There, by his own fanciful account, he found inspiration for various aspects of the show: a tree reminded him of Harcourt's face, the sails of fishing boats Gladstone's collars, the Lover's Seat the Ladies' Gallery, and the train whistle the Parliamentary Bore. Rejecting an invitation to speak at the Cardiff Institute of Journalists on 17 January because of pressure of work, he wrote: "Parliament opens a few days afterwards . . . and I really have not a moment. I am coming out with something quite new and very elaborate early this year."[116] In another letter of 12 February, he declined a dinner invitation: "I cannot possibly leave this new venture of mine for a moment—and I have a month's work to do on it in the next fortnight—working early and late. I expect there will be nothing left of me when I have to appear."[117]

In these letters Furniss seems unwilling to reveal the exact nature of "this new venture" but this reticence is not in keeping with his egotistical personality. As this "new and very elaborate" "something" neared completion he must have leaked its general contents to the press. In early February, nearly seven weeks before "Humours" opened, the *Daily News* reported that "Mr. Furniss aims not merely at giving a complete and comprehensive view of the ordinary proceedings of the two Houses, but also at depicting as graphically and minutely as possible the more entertaining and social aspects of life at St. Stephen's. . . . He will endeavour to reproduce for the amusement of his audiences the tones of voice, the gestures, the walk, and various other characteristics of the leading politicians and statesmen."[118]

Apart from preparing the actual substance of "Humours," the show had to be promoted and Furniss turned to one of the best London agents, N. Vert (born Narciso Vertigliano), known as the "Napoleon of Managers."[119] Not

114. *CCI*, p. 246.

115. *AH*, p. 113.

116. HF to Mr. Cornish, 17 January 1891, Getty Archive.

117. HF to Mrs. Capper, 12 February 1891, Getty Archive. The accompanying sketch is of HF next to one of Gladstone's winged collars, so the new venture is undoubtedly "Humours."

118. *Daily News,* 7 February 1891.

119. Later, Vert helped to establish the leading concert agency of Ibbs and Tillett, with clients

coincidentally, Vert had come up in the business under George Dolby, who had overseen the management of Dickens's reading tours beginning in 1866. Vert took over Dolby's Concert and Music Agency when the elder man retired in 1880. The connection to Dickens would have resonated with Furniss, but Vert was a major name in his own right. That he was prepared to promote Furniss suggests his confidence in the success of "Humours," and Furniss was, for his part, quick to include Vert's name on his posters and programs (fig. 24). They were fellow travelers on the voyage to New York in April 1892 and Furniss found Vert a "genial and energetic impresario," though Vert disliked the term.[120]

As he had done with his earlier "lectures" Furniss rehearsed "Humours" at the Savage Club, but in addition he gave it a trial run in "the neighbourhood of Liverpool, where he was engaged to give the first public rehearsal . . . Mr. Furniss has taken the Prince's Hall, Piccadilly, for a series of evenings in May and June, and will give his first impersonation on Thursday, 30th inst."[121] It duly opened at 8:30 p.m. on that day and at that venue before a packed audience that included William Agnew the proprietor of *Punch* and most of its staff as well as the editor Francis Burnand and his assistant Arthur A'Beckett, Furniss's fellow illustrators Linley Sambourne and Bernard Partridge, and of course Henry Lucy. No doubt they had all received a personal invitation to attend the first performance (fig. 25). Also present were several MPs including William Woodall, Sir E. J. Reed (Liberals and former holders of minor office) and Sir George Elliot (Tory self-made coal industrialist), as well as the writers Edmund Yates and Percy Fitzgerald. Despite his vast experience on the platform, Furniss, like all good actors on the opening night of a show before an illustrious audience, "once or twice . . . seemed a little nervous,"[122] an accusation he roundly rejected: "I am never nervous on the platform. I could sit down and eat my dinner there and ask the audience to wait until I had finished."[123] Whatever the case "Humours" was "a gratifying success, from the first" and Furniss "was well repaid" for his enterprise.[124]

Furniss was quick to take up the suggestion by the *Pall Mall Gazette* to give "not one or two as he proposes, but a series of repetitions,"[125] so he extended

that included the singers Edward Lloyd and Nellie Melba, as well as Edward Elgar, whose "Enigma Variations" saw the light of day in June 1899 through Vert's efforts. See Christopher Field, *Ibbs and Tillett: The Rise and Fall of a Musical Empire* (Aldershot: Ashgate, 2005), ch. 1.

120. *CCII*, p. 37.
121. *Daily News*, 10 April 1891.
122. *Birmingham Daily Post*, 2 May 1891.
123. *Reynold's Newspaper*, 3 May 1891.
124. *AH*, p. 117.
125. *Pall Mall Gazette*, 1 May 1891, p. 3.

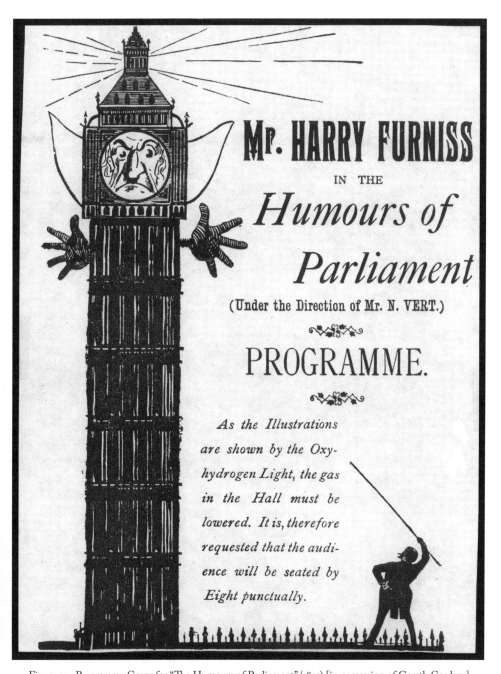

Figure 24. Programme Cover for "The Humours of Parliament" (1891) [in possession of Gareth Cordery]

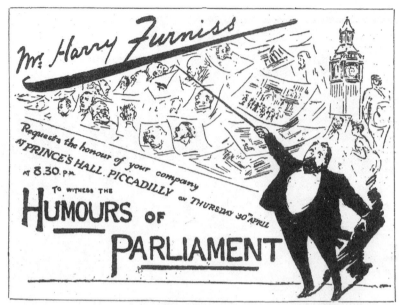

"THE HUMOURS OF PARLIAMENT": THE INVITATION CARD. (Drawn by Harry Furniss.)

Figure 25. "The Humours of Parliament: The Invitation Card"
(*Daily Graphic,* 23 April 1891, p. 12)

it "for the season," filling Prince's Hall "for many days and evenings"[126] during
May and June. In mid-May, *The Times* noted that "Mr. Furniss will appear for
the last time in The Humours of Parliament at Prince's Hall,"[127] but clearly
the demand was such that Furniss and his promoters, keen to cash in on its
undoubted success, engaged Prince's Hall for the five evenings it was available
during June until his final performance there on 1 July. Even then he continued
to perform (often "by special request") at other London venues such as Mer-
chant Taylor's Hall, Crystal Palace, and St. James's Hall during those summer
months.

Capitalizing on the success of the London performances, Furniss decided
to tour the provinces once Parliament was prorogued for the summer. Sev-
eral reviewers complained of the show's length (it initially ran for over two
hours) and its overly satiric tone. From May to August, Furniss worked at a
frantic pace, continuing to contribute to several magazines while pruning and
refining his entertainment. A letter to Lucy of 9 May states "I am worked to

126. *AH,* pp. 114, 138.
127. *TT,* 21 May 1891, p. 1.

a shadow"[128] and the accompanying sketch shows him as a shadow laboring simultaneously on *Black and White, Punch,* and "Humours."

Before the provincial tour could get underway venues and accommodation had to be booked, dates and times (matinees or evening performances) arranged, and the whole show "boomed": advertisements placed in newspapers, handbills printed, and posters pasted up in and around the venues. Local managers, like Charles Harvey in Sheffield and D. B. Jones in Derby, were hired to deal with all this, and part of their job was to try to avoid clashes with major attractions such as Buffalo Bill's Wild West Show which was touring at the same time.[129] Furniss obviously revisited those places like Birmingham and Newcastle where he had made his reputation with his earlier lectures, but there was a clear touring circuit that partly determined his itinerary, especially the holiday spots, recreational resorts, and spas such as Llandudno, Southport, and Scarborough which during the summer were full of visitors ready to be entertained.

Clashes with other shows at times were unavoidable for competition for the discretionary shillings of the holidaymakers and excursionists was fierce. At Southport, for example, Furniss performed at the same time as a promenade concert, a circus, and "The Dancing Girl," a play starring the noted former dancer and comic actress Kate Vaughan. While it was "an expensive matter to advertise," it was a necessary expense.[130] Local newspapers were the main form of advertisement, but on occasion the agent hired donkeys to pull hoardings on carts (as at Llandudno), or sandwich board men to parade the streets of Edinburgh, or wander the sands of Brighton.[131] Furniss, perhaps ready to cash in on the success of his first tour by planning a second, later exploited *Punch* to keep his show at the forefront of his readers' minds as shown in figure 26, a neat combination of satire and self-promotion. Furniss designed his own program cover (fig. 24) and poster (fig. 27), using a standard template of himself standing, with pointer in hand, before Big Ben whose clock face consisted of Gladstone's. Details such as ticket prices, venue, date and time of the performance could then be added as in figure 27.[132]

Shortly after Parliament recessed for the summer, Furniss boarded the Irish Mail at Euston station bound for Holyhead and opened the provincial tour of "Humours" in Dublin on 24 August (see pp. 57–58). Seven thousand miles later he gave his final performance at Darwen near Manchester on 17

128. HF to Henry Lucy, 9 May 1891, Getty Archive.
129. *FV*, p. 251.
130. *AH*, p. 99.
131. *FV*, p. 74, *AH*, pp. 140–41, *Punch*, 28 November 1891.
132. A similar design was used for the cover to *Pen and Pencil in Parliament* (1897).

MR. JOSEPH CHAMBERLAIN ON THE HUMOURS OF PARLIAMENT."

Figure 26. "Mr. Joseph Chamberlain On The Humours of Parliament"
(*Punch*, 2 April 1892, p. 166)

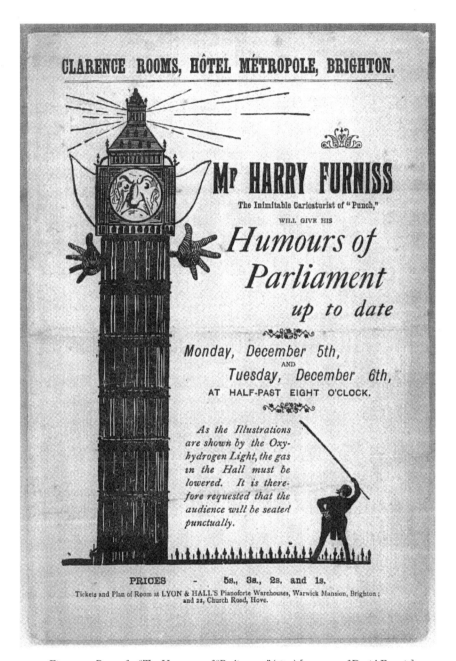

Figure 27. Poster for "The Humours of "Parliament" (1892) [courtesy of David Francis]

December. Even though he was "quite delighted" with his tour and had "probably done better than anyone else," he was also "tired out"[133] after sixteen weeks of unbroken engagements, and was ordered to rest and go on a diet by his physician, Dr. Roose. Roose's prescription, as Furniss described it, was "No Work!" but for a workaholic like Furniss this was anathema: to him work was "my mad disease, the worst mania of all" and so "much against my doctor's and nurse's wish, [I] worked all the time."[134] But "Humours" was exceptionally exhausting and this time he did, reluctantly, obey doctor's orders with immediate results, as the letter to his son indicates. It was, typically, accompanied by a sketch, this time of himself looking very thin.

> Dear Frank,
> I am much better. You will not know me. I am getting quite thin and my clothes will not fit. I am only allowed to eat half an eggshell for breakfast, no egg and a spoonful of sawdust, and I can smell tea but can drink nothing. Then I must run 6 miles and walk 17. Home to lunch. For that I can suck a fishbone, smell a piece of toast, and [illegible] some watercress in my hair and taste the sealing wax on a whiskey bottle.[135]

Three weeks later he wrote to Frank from Hastings, his favorite resort for rest and recreation, describing himself as "a mere spider."[136] He completed his recuperation by going at the end of March to America for a month's so-called holiday. The headline to the paragraph in the *New York Times* reporting his arrival neatly captured the tension between his doctor's orders and his mania for work: "Caricaturist Here To Recover Health And Write A Book."[137] That book was never written but the trip supplied him with material for his future entertainment "America in a Hurry" and like Dickens, whose profitable yet exhausting readings contributed to his early death, Furniss soon ignored medical advice: "I arrived after a week's thorough rest with my sketchbook full! I could not help breaking my pledge; it was my first trip across the Atlantic, and everything was therefore new and interesting. In fact, so was all I saw in the States, and my pencil was always busy."[138] Having cleared £2,500 from the first UK tour of "Humours," Furniss was back on the British circuit the following year. What follows is a selective account of the provincial tour and its reception.

133. HF to M. H. Spielmann, 28 and 31 December 1891, JRL, English Manuscript 1302, items 215, 217.

134. *CCII*, p. 27 and p. 188.

135. HF to Frank F, 24 January 1892, letter in possession of Mrs. Rosemary Wood.

136. HF to Frank F, 14 February 1892, letter in possession of Mrs. Rosemary Wood.

137. *NYT*, 7 April 1891.

138. *CCII*, p. 46.

He was accompanied for the sixteen weeks by his secretary and his lanternist, "the infallible Professor,"[139] but not by his family, whom he visited each time he passed through London and to whom he wrote affectionate, illustrated letters as he crisscrossed the country by train from one venue to the next. But these were brief interludes in an otherwise punishing schedule which is best described in his own words and worth quoting in full.

Travelling every day, giving 'The Humours of Parliament,' with my imitations of ranting M. P.'s—nearly a two hours' tearing recitation—to large audiences every night, was perhaps sufficient for one man. The excitement of the success I made, the 'booming,' interviewing, and unavoidable entertainment at every town, the late hours, the early start, the business worries, fresh to each place, day after day, week after week, can only be understood by those who have gone through it. But this was only part of my work. Each week as I travelled I had to keep up my contributions to *Punch*—a whole page and several small drawings. I also wrote an article, fully illustrated, on every town I went to week by week for *Black and White* (subsequently reprinted in book form, 'On Tour'), to say nothing of drawing in the train.[140]

Let me briefly give a fair average of one day's work at a time:

Morning: Start 9.30 train, eight hours' journey,—means up at seven, breakfast at eight. In train dictate letters to secretary, who takes down in shorthand . . . 3.30 arrive at destination; go to hotel and order dinner. Then to my 'travelling studio'—a large case fitted up with everything necessary for drawing in black and white. Straight to private sitting-room, order dinner to be ready in half-an-hour, at work at once—before the others and the luggage arrive. After light dinner, to hall or theatre to see if arrangements are complete. Then visit from local manager or secretary—friends—strangers, a walk around the town to get 'copy,' tea, a good hour's drawing (no matter how tired I can work on tea), dress, off to evening's work on stage; autographs to be written and people to meet; back to change, supper at some club, speeches; back 3 a.m., bed, sleep—no, only occasionally.[141]

It is clear from all this that Furniss was astonishingly productive and this was due in no small part to meticulous planning and sticking to a tight timetable. To keep up with his "current Press work" he was not averse to "double dipping," for the series "Mr. Punch On Tour" (12 September 1891 through 23

139. *CC*II, p. 169.

140. The book was actually titled *Flying Visits* (1892), which collected Furniss's "impressions" of the places visited on the 1891 tour from the original *Black and White* pieces, accompanied by "extracts from letters to a friend at home" (*FV*, p. iii), namely his wife, Marian.

141. *CC*II, pp. 184–87.

January 1892) contained several of the same places (and even images) to be found in the *Black and White* articles (12 September 1891 through 20 February 1892).[142] Even in his early lecturing days he had checked out his venues to make sure that all was as it should be—"It strikes me I must get down to Bournemouth *Friday* night, as I will have to rehearse the lecture with the lantern or the operator will not know what to do"[143]—though with agents and his own lanternist this was less necessary for the "Humours" tour. Amid boring and persistent hosts, visits to local industries, unwanted banquets, introductions to local dignitaries, signing autographs, and giving interviews he cherished the little free time he had to himself (he had "only one afternoon to spare"[144] during his week in Dublin, for example).

He was quite prepared to refuse dinner invitations from even prominent artists like Henry Rensburg, chairman of the Liverpool Arts Society and the Liverpool Philharmonic Orchestra: "Your kind letter has just reached me today. . . . I am very much obliged to you indeed for the kind offer of your hospitality, but even while I am rushing about all over the country I have a lot of current Press work to do, consequently you can see that I never have a minute to spare, and am reluctantly obliged to refuse all kind invitations, however I trust to have the pleasure of seeing Mrs Rensburg and yourself at St George's Hall."[145] The deference and regret evident in this unusually carefully penned letter, written in, for Furniss, an elegant hand, are testimony to the priorities of a truly professional performer.

Still, Furniss could not avoid all social engagements, especially with art institutes and the like: "the popular caricaturist was the guest of the Aberdeen Pen and Pencil Club on Tuesday night after business, the Marquis of Huntly presiding."[146] Most of all, perhaps, he dreaded being buttonholed by a local nonentity and paraded before his dinner guests when "your anecdotes and jokes are wrung out of you like water out of a dishcloth. . . . Oh, what would you not give to be left alone, to have a cup of tea and a cigarette, and to lie

142. For example, the account of his disembarkation from the "Royal Mail steamer *Ulster*" at the port of Kingstown en route to Dublin (*B&W*, 12 September 1891) and the sketch "Mr Punch . . . Arrives at Kingstown by the Irish Mail" (*Punch*, 12 September 1891) both include images of a roguish-looking con man named "Davy." Furniss's complaints about the extra charges levied at the Ryde Pier, Isle of Wight (*B&W*, 14 November 1891), are precisely mirrored by the signs "Toll 2d Luggage One Shilling An Ounce" displayed in the *Punch* sketch "A Reminiscence of the Ryde Season" (7 November 1891).

143. HF to S. W. Richards, 7 January 1888, letter in possession of Selwyn Goodacre.

144. *FV*, p. 50.

145. HF to H. E. Rensburg, 27 October 1891, BL MS Mus. 309, ff. 227–28.

146. *Era*, 5 December 1891.

down on the sofa, for half an hour's respite, before going through the ordeal of amusing the public!"[147]

Amused the public certainly was, and the popularity of "Humours" is undoubted. Its London opening in April was such a success that, as we have seen, Furniss at once made plans to take it to the provinces where he performed in small towns and large cities from the north of Scotland to the south of England for two successive years before taking it to North America and Australia. Furniss even bragged that "it was all but arranged for me to give my 'Humours of Parliament' before her late Majesty at Balmoral. I got as far as Aberdeen, but a death in the Royal Family put a stop to all entertainments."[148] The claim is not so far-fetched as it seems, since a newspaper headline proclaimed "Mr. Harry Furniss To Visit Balmoral."[149]

"Humours" was reviewed in all the major newspapers, both metropolitan and provincial, popular (*The Penny Illustrated Paper*) and establishment (*The Times*), as well as in important magazines like the *Illustrated London News*. The reviews in the provincial press were largely if not invariably positive, noting, as had the metropolitan newspapers, his excellence as an actor, his droll stories, his amusing imitations, and "a very complete resume of Parliamentary life, with which he is thoroughly familiar" that provided a "thorough instruction in the ways and manners of Parliament."[150] Not surprisingly, Furniss attached the most enthusiastic and complimentary reviews to his program (fig. 28), but inevitably he received some stick from the Irish press.

5. Audiences

In general, although the nature of audiences for lectures and platform events is a hugely important subject, it is also very difficult to reconstruct on account of the scarcity and unevenness of documentation.[151] For the most part, it is necessary to rely on general characterizations left in writing by the speakers themselves, informed observers, or the press. In press accounts, for example, audiences for late-nineteenth-century political platform events were generally described as "respectable," although the working classes were often present

147. *AH*, p. 131.
148. *CC* II, pp. 164–65.
149. *Aberdeen Weekly Journal,* 22 August 1891.
150. *Manchester Guardian,* 28 October 1891.
151. On the problems associated with producing "a broader kind of reading history, which could be called a history of audiences," see Rose, *Intellectual Life,* pp. 1–11.

The Era.—" Mr. Furniss has an easy air and a knowledge of dramatic effect. Loud laughter attended the lecturer as in his own person he proceeded to illustrate the style of locomotion adopted by certain well-known representatives of the great British Public "

The Times.—" A more vivid idea of our Parliamentary procedure than could be obtained in any other way "
Saturday Review—" The audience was enchanted "

The Graphic—" By means of his own sketches, aided by an amusing running commentary, he supplies a complete picture of Parliamentary life "

The Stage.—" Perhaps Mr Furniss astonished even his intimate friends, and certainly all not intimately acquainted with him, by the excellence, pungency, and satire of his mimicry "

Harry Furniss is a wag,
Ha! ha! the humour o't!
All the tricks are in his bag.
He! he! the humour o't!
He can mimic, he can mime,
Draw, and act, and—what is prime—
Keep you laughing all the time,
Humph! humph! the humour o't!
Punch.

The Daily Graphic—" Every Englishman ought to know something of the Parliament which makes his laws. He cannot do better than get a working acquaintance with the subject by laughing at Mr Furniss' merry Sketch "

The Standard—" Upon his crystallized impressions of the manners of the members of the 'best Club in the World ' he proceeded to expatiate in a most amusing strain. Altogether the Humours of Parliament is a happy idea "

The Star.—" Has not a dull moment, and is followed throughout with an absorbed attention. That the caricaturist should be able to extract so much fun from so solemn a topic is nothing short of miraculous."

Illustrated London News—" The hearty laughter which greeted Mr. Furniss' exposition of the Parliamentary Humours had no echo of malice . Excellent sense as well as delightful fooling "

North British Mail—" This entertainment cannot be compared to any other. It is absolutely unique. and is more amusing than anything else we have seen for many a day."

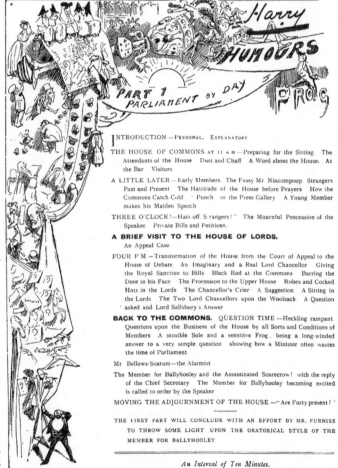

INTRODUCTION —Personal. Explanatory

THE HOUSE OF COMMONS at 11 a m —Preparing for the Sitting. The Attendants of the House Dust and Chaff A Word about the House. At the Bar Visitors

A LITTLE LATER —Early Members. The Fussy Mr Nincompoop Strangers Past and Present The Hattitude of the House before Prayers How the Commons Catch Cold " Punch in the Press Gallery A Young Member makes his Maiden Speech

THREE O'CLOCK!—Hats off. S rangers! " The Mournful Procession of the Speaker Private Bills and Petitions.

A BRIEF VISIT TO THE HOUSE OF LORDS.
An Appeal Case

FOUR P M —Transformation of the House from the Court of Appeal to the House of Debate An Imaginary and a Real Lord Chancellor Giving the Royal Sanction to Bills Black Rod at the Commons Barring the Door in his Face The Procession to the Upper House Robes and Cocked Hats in the Lords The Chancellor's Crier A Suggestion A Sitting in the Lords The Two Lord Chancellors upon the Woolsack. A Question asked and Lord Salisbury s Answer

BACK TO THE COMMONS. QUESTION TIME —Heckling rampant. Questions upon the Business of the House by all Sorts and Conditions of Members A sensible Sole and a sensitive Frog , being a long-winded answer to a very simple question showing how a Minister often wastes the time of Parliament

Mr Bellows-Scarum—the Alarmist

The Member for Ballyhooley and the Assassinated Scarecrow! with the reply of the Chief Secretary The Member for Ballyhooley becoming excited is called to order by the Speaker

MOVING THE ADJOURNMENT OF THE HOUSE —" Are Forty present ? "

THE FIRST PART WILL CONCLUDE WITH AN EFFORT BY MR. FURNISS TO THROW SOME LIGHT UPON THE ORATORICAL STYLE OF THE MEMBER FOR BALLYHOOLEY

An Interval of Ten Minutes.

Figure 28. The Program for "The Humours of Parliament" (*CC*II, pp. 156–57)

Pall Mall Gazette — "Without doubt, the success of the entertainment is more than sufficient to justify its author in giving, not one or two as he proposes, but a series of repetitions"

Daily Telegraph. — "A novel and instructive exhibition."

Daily News. — "A House of Commons *pour rire.* A liberal education in itself"

Daily Chronicle — "Parliament, as we know it at Westminster, may be dull enough sometimes, but Parliament in Mr FURNISS' way is never dull "

Newcastle Weekly Chronicle. " His pictorial and verbal descriptions of ministers and members on both sides of the House were irresistibly funny ; but still more amusing were his imitations of some of them "

Derby Mercury. — " An entertainment which reminds you of George Grossmith, without the piano, and in point of real genuine hearty fun, without a tinge of malice in it, an equally mirth-provoking hour and three-quarter's amusement."

Notts Post. — " Wit sparkles from every picture * * * the humorous explanations of Mr. FURNISS afford the greatest diversion."

Vanity Fair. — " Amusing, instructive, never unkind His powers of mimicry are scarcely less powerful vocally than pictorially "

Irish Times. — " The best entertainment of the kind that has ever been submitted to the public."

Belfast News Letter — " His genial manner and fascinating style are irresistible."

" Nothing more amusing, or in fact instructive, has been seen on a platform, either in Belfast or elsewhere."

Yorkshire Post. — "Certain it is that the walls of the Albert Hall never more resounded with genuine roars of laughter than last night "

VIEW OF THE HOUSE AND ILLUMINATED CLOCK TOWER BY NIGHT FROM WESTMINSTER BRIDGE

A too-impressionable stranger is personally conducted into the House His great expectations and consequent disenchantment

ST. STEPHEN'S HALL,

THE INNER LOBBY

IN THE LEGISLATIVE CHAMBER

THE HOUSE AT DINNER TIME — The Member for Boredom addresses empty benches. A Count-Out "Come like shadows, so depart" The Member for Masherton is interrupted by an indignant Irish Member, which leads to

A SCENE IN THE HOUSE!

A Tory General pours oil upon the flames. The effect

IN THE PRESS GALLEY, and

IN THE LADIES' GALLERY. What the Ladies see behind the Gridiron. A warning to Members. A Sketch from the Press Gallery. A warning to the Public

IN THE TEA ROOM.

IN THE DINING ROOM.

IN THE SMOKING ROOM.

THE TERRACE BY MOONLIGHT!

Or, VENICE IN LONDON.

IN THE LOBBY.

The Green Room of Parliament and Mr. Furniss's happy hunting ground.

Some Parliamentary Impersonations from Life.

THE WHIPS. THE PAIRING SEASON. "BREAKING HIS PLEDGE "

BACK TO THE HOUSE.

MR. GLADSTONE.—A REMINISCENCE.

Showing the Right Hon. Gentleman at various moments from the time when he entered the House in the afternoon until he sat down at the close of a Great Speech !

MR. BALFOUR.

SIR WILLIAM HARCOURT

MR CHAMBERLAIN

AND OTHER LEADING POLITICIANS.

The Parliamentary Proceedings will conclude with

THE ILLUSTRATION & DESCRIPTION OF A DEBATE,

With the subsequent Division in the Early Hours of the Morning

where free or cheap admission could be obtained and became a greater presence in the 1880s.[152]

The audiences for "Humours" ranged from the "small but select"[153] for a matinee in Llandudno to an estimated 1,000 to 3,000 in the main cities. Its reception at the local level may be gauged from this report in the *Brighton Gazette:* "A vast audience assembled in the Clarence Rooms. . . . Applause and laughter at several points compelled the speaker to stop until the excitement had somewhat subsided."[154] Such reactions were not uncommon: the performance sent the audiences variously into "fits of laughter," "roars of laughter," or "incessant outbursts of merriment."[155] On stage Furniss was clearly a very funny man. Still, "Humours" was not universally popular across the United Kingdom. North of the border, "Humours" proved to be rather less of a draw for the Scots, who were sometimes "less numerous than the merits of the entertainment should have warranted,"[156] as in Glasgow where "there was not a large attendance."[157]

One can only guess at the total number of people who actually saw Furniss perform "Humours." In his writings, Furniss himself makes no claim as to the total number of people that came to his entertainment. This is most likely because no such figure was available for him to parade. In general, press reviews employed descriptive terms like "small," "large," or "vast" to describe audiences, and only very seldom gave numerical estimates. Furniss does give a figure of 1,100 for his performance before nurses in London, which he may have obtained from a newspaper report.[158] Significantly, however, this number is only slightly more than half the two thousand attendees that had been predicted.[159]

In the absence of reports of audience numbers, we must turn to the seating afforded by the venues at which Furniss performed. The types and sizes of the performance spaces covered a considerable range: holiday pavilions (Scarborough), resort theaters (Llandudno), large provincial town halls (Newcastle, Oxford), hotel banqueting rooms (Brighton), music halls and concert rooms (Edinburgh, Dublin), temperance halls (Derby), gentlemen's institutions (Manchester), literary societies (Manchester Athenaeum), and public school auditoriums. On the last, he is said to have performed "Humours" in "most of

152. Meisel, *Public Speech*, pp. 258–59.
153. *FV*, p. 76.
154. *Brighton Gazette*, 15 October 1891.
155. *Country Gentleman; CC*II, p. 157; *Scotsman*, 20 November 1891.
156. *Dundee Advertiser*, 26 November 1891.
157. *Glasgow Herald*, 24 November 1891.
158. *CC*II, p. 163; *Pall Mall Gazette*, 24 July 1891.
159. *Birmingham Daily Post*, 18 July 1891.

the principal schools—Rossal [Fleetwood, Lancashire], Harrow, the Charter-house, and Cheltenham."[160]

While Furniss left a good record of where he performed, information on seating capacity is available in only a subset of cases. Appendix III gives Furniss's 1891 itinerary, and indicates seating capacity where it is known. The figures for seating range from 300 to 3,000. As the case of the nurses suggests, however, not every venue filled to capacity. A review of his performance at the Newcastle Town Hall observed that "Humours" was given "before an audience, the numerical strength of which disappointed and surprised everyone. On the two previous occasions when Mr. Furniss visited the town, where his grandfather, Mr. Aeneas Mackenzie, was a well-known publisher, it was to lecture and he had the pleasure of addressing audiences numbering about three thousand."[161]

Yet, dwelling on disappointing turnouts does not do justice to the overall impact of "Humours." Some audiences were, after all, characterized variously as "large" or "vast" and the venues were frequently "crowded." For the opening night in London there was "a large and distinguished audience" at the "crowded" Prince's Hall, and during the subsequent metropolitan summer season "notwithstanding the hot weather, the audiences have not fallen off, that of last Saturday night having been as large as any." A "vast audience assembled in the Clarence Rooms" of the Hotel Metropole in Brighton, and a "large" one at Charterhouse public school. "A crowded and fashionable audience" attended Aberdeen's Albert Hall, while St. George's Hall, Belfast, "was filled to its utmost capacity."[162] All this suggests that, despite the occasional disappointment, "Humours" was generally very well attended.

Additionally, it is important to consider the geographical reach and frequency of the performances. As already noted, Furniss gave "Humours" throughout England, Wales, Scotland, and Ireland. On tour, he performed six days a week, so over the sixteen weeks of his 1891 tour he gave around 100 performances and the same number again in 1892. Using a conservative estimate of 500 as the average audience size, this means Furniss would have performed to 100,000 people on his two tours. Given the number of large-capacity halls at which he appeared, the total may well have been rather higher than that. Further, this conservative estimate does not include the "large" audi-

160. *Chums,* 6 December 1892, p. 239.

161. *Newcastle Weekly Courant,* 21 November 1891. Furniss gives the figure of 3,200 for an 1888 lecture. Elsewhere, he describes addressing audiences of 3,500 and 3,700 on different occasions in the same building in the "far north." HF to Sir James Dromgole Linton, 8 March 1888, NPG, 86.WW2; *AH,* p. 117.

162. *Era,* 2 May 1891, p. 15; *TT,* 30 June 1891, p. 10; *Brighton Gazette,* 15 October 1891; *AH,* p. 148; *Era,* 5 December 1891; *Belfast News-Letter,* 1 September 1891.

ences for the initial 1891 London season, which ran on and off for two months at Prince's Hall. (The overseas audiences for "Humours" are taken up in Section V.) While this may not have satisfied Furniss in terms of attendance or revenue, it is nevertheless a considerable achievement for an illustrated lecture.

Just as important for considering influence was the composition of Furniss's audiences. The appeal of "Humours" to various kinds of socially elite groups can be seen in a number of ways: the trial run at the exclusive Savage Club; the presence of various notables at the Prince's Hall (London) performances already mentioned; the "large audience" at Charterhouse pubic school;[163] the "fashionable audiences" at Aberdeen's Albert Hall that included "the Marquis of Huntly, Sir John Clark, Bart., Sir Arthur and Lady Grant of Monymusk;"[164] Lord and Lady Aberdeen's attendance at the Ottawa performance in 1897 (see section V.2); and the aborted showing before the Queen herself. Ticket pricing schemes provide the basis for making broader inferences about audience composition. Indeed, a significant point of interest for examining "Humours" is the availability of information on admission prices for a number of the shows.

A variety of ticketing and seating practices obtained across the broad and diverse lecturing world. Lectures aimed at the religious or social edification of the less well-off had lower financial barriers to admission than events aimed at enriching the speaker or venue. Perhaps the least expensive version of such activities was the "penny reading," in which working-class people were encouraged to take the platform themselves. Because of the importance of the author and the sensation of his work on the platform, Dickens's lectures may be the best studied cases in this diverse genre. They involved reserved seating with lowest prices often around a shilling, which (as discussed below) tracks with the available data about "Humours" and seems to suggest a kind of standard for literary or artistic speakers with a national public reputation. Yet, given his general sympathies, it is not surprising that Dickens appears to have made greater efforts to open his readings to people who could not afford such prices. Less expensive seats were set aside for the lower classes at some events, and he also organized nights for "working people only" when the price of admission would be 6d.[165]

The available information on ticket prices for "Humours" suggests that, in addition to more elite categories already noted, the audience reached across

163. *AH*, p. 148.

164. *Aberdeen Weekly Journal*, 1 December 1891.

165. Bevis, *Art of Eloquence*, p. 131; Graham Storey, Kathleen Tillotson, and Angus Easson, eds., *The Letters of Charles Dickens: The Pilgrim Edition: Vol. 7, 1853–1855* (New York: Oxford University Press, 1993), pp. 133, 233n, 234.

the spectrum of the middle classes. For Furniss's opening London show, the "prices were West End theatre prices: 10s. 6d. stalls, 5s. 6d. second seats, and a 2s. 6d. gallery."[166] In the provinces, seats were somewhat cheaper, ranging from five shillings to one shilling. Children could get in at half-price. The following table assembles such information on ticket pricing as is available, primarily from posters and advertisements and mentions in Furniss's writings.

Table 1. Ticket Prices for "The Humours of Parliament" at Selected Locations *(in shillings/pence)*

VENUE	PRICES	NOTES
London (Prince's Hall)	10/6, 5/6, 2/6	"West End theatre prices"
London (St. James's Hall)	7/6, 5, 3, 1	
Ayr	5, 4, 3, 2, 1	
Edinburgh	5, 4, 3, 2, 1	same prices for 1892 tour
London (Crystal Palace)	5, 3/6, 2/6, 1/6, 1	
Glasgow	5, 3/6, 2/6, 1/6	same prices for 1892 tour
Brighton	5, 3, 2, 1	
Liverpool	5, 3, 2	
Dublin	5, 2/6, 1	
Doncaster	5	front row (*AH*, p. 145)
Scarborough	4, 3, 2, 1	
Dundee	4, 2/6, 2, 1	
Birmingham	4, 2, 1	4, 3, 1 for 1892 tour
Belfast	4, 2, 1	
Sheffield	4, 2, 1	
Manchester	4, 2	
Llandudno	3, 2, 1	matinee
Preston	3, 2, 1	
Sale	2	for the most expensive seats

In the context of the era's generally rising living standards, burgeoning leisure culture that catered to all classes with some disposable income, and socially condoned cultures of respectability and self-improvement,[167] the range of ticket prices that these data indicate were available suggests that at least some portion of Furniss's audiences would have come from the lower middle

166. *AH*, p. 138.

167. See Hugh Cunningham, *Leisure in the Industrial Revolution, c. 1780–c. 1880* (London: Croom Helm, 1980), esp. ch. 5.

and artisanal classes, the most recently enfranchised segments of the elector-
ate (1867 in the boroughs and 1884 in the counties). In major provincial towns,
both pricing and location could ensure a broad-based audience, although even
the least expensive seats may have been beyond the reach of the average com-
mon laborer—those for whom Dickens had arranged 6d admission.[168] In some
cases, the combination of location and pricing suggests a geographical seg-
mentation of audiences. For example, where the better classes could pay the
four shillings to see Furniss in the more select surroundings of the Manches-
ter Gentleman's Concert Hall, the residents of nearby Sale were able to see
the same show for a top price of two shillings. By and large, however, the high
and the low would be present even at smaller non-urban venues. At Lewes on
the South coast, "in a hall that looked as if it had just been used for a Sunday-
school tea, decorated all over, and hung with Chinese lanterns, &c.," Furniss's
expectation that he would "address a comparatively unsophisticated audi-
ence" was confounded when he discovered Lord Hampden (formerly Speaker
Brand) sitting in the front row.[169]

168. According to the 1886 Wage Census, average weekly wages for ordinary unskilled laborers
was around 20 shillings, almost all of which would have been required to cover basic necessities. See
A. L. Bowley, *Wages and Income in the United Kingdom since 1860* (Cambridge: Cambridge University
Press, 1937), pp. 41–43.
169. *AH*, p. 148.

V

"HUMOURS" ABROAD

*J*UST AS *PUNCH* was an international as well as a national institution,[1] the influence of "Humours" also carried beyond England's shores even before Furniss left them for his overseas tours in 1896. Indeed, when at the request of the British Nurses Association Furniss performed at Merchant Taylor's Hall before "the greatest gathering of nurses which has ever been held" (fig. 12), Sir Henry Burdett wrote to him afterwards to tell him that "the fame of your handiwork will be carried all over the United Kingdom and to the Colonies, for there were over 1,100 nurses present, and some from the Colonies."[2] How Furniss himself took "Humours" overseas is a significant part of the story, not least for the way it exemplifies the understudied flows of cultural activity and popular knowledge between Britain and America, and between Britain and its major imperial outposts in this period.

1. The American Lecture Circuit

Furniss first traveled to America in April 1892.[3] Although his stated objective at the time was to recover from the previous year's exertions with "Humours," it cannot be doubted that the industrious cartoonist had an eye on the lucrative American lecture market. Further, pencil always at the ready, he also used his visit to gather material for what would become a new entertain-

1. Helen Walasek, "*Punch* and the Lantern Slide Industry," in *Visual Delights-Two: Exhibition and Reception,* ed. Vanessa Toulmin and Simon Popple (Eastleigh: John Libby, 2005), p. 145.
2. *CC*II, p. 163.
3. See *CC*II, ch. 9 ("Confessions of a Columbus") for Furniss's own digressive impressions of America, largely from his 1892 trip.

ment: "America in a Hurry." As Philip Collins has shown, however great the British taste for lectures seems to have been, the American appetite was far greater.[4] There was, indeed, a transatlantic "traffic in brains," though a rather lopsided traffic since a far greater number of Britons crossed the ocean to partake in the considerably more rewarding lecture market in the United States than did their American counterparts traveling in the other direction. As the example of Furniss indicates, British lecturers benefited not only from their US income, but also from the material they acquired on tour which could generate additional revenue on their return as lectures or books for their compatriots.

The "lecture habit," as Collins terms it, was institutionalized through the establishment of thousands of Lyceums throughout America beginning in the early nineteenth century, and facilitated by the growth of the US railroad system. Although Britons had appeared on American platforms with increasing frequency from the 1830s, the transatlantic lecture trade was flourishing by the 1870s, thanks in large measure to the expansion and improvement of steamship services from the middle of the century and the creation of big lecture agencies in the late 1860s. The primary (though not the only) motivation for British lecturers to undertake this notoriously grueling work appears to have been money—the "filthy greenbacks" in the words of the Anglican clergyman and author Charles Kingsley, who was nearly done in by the rigors of his US tour.

The actual profitability of most American tours is difficult to judge, but even if not all lecturers achieved their financial dreams, the remuneration on offer in the United States was far greater than what could be gained from similar exertions back home. It is not surprising, therefore, that, even while he was launching his first British tour of "Humours" in 1891, Furniss was already attempting to drum up American interest. From Belfast, he wrote to promote himself to the leading American lecture agent of the day, J. B. Pond (who was possibly in Britain lining up speakers for the US circuit): "I shall be glad to hear from you when convenient. All my letters are forwarded from 'Punch' office. My first week on Tour has been a great success. I send by this post a local paper—they are all the same—giving me splendid notices."[5]

4. Philip Collins, "'Agglomerating Dollars with Prodigious Rapidity': British Pioneers on the American Lecture Circuit," in *Victorian Literature and Society*, ed. James R. Kincaid and Albert J. Kuhn (Columbus: Ohio State University Press, 1984), pp. 3–29. The rest of this paragraph and the following one draw on Collins, supplemented with information from Waller, *Writers, Readers, and Reputations*, ch. 16.

5. HF to J. B. Pond, 1 September [1891?], quoted on catalog website of David J. Holmes Autographs [from 8vo letter inserted into a copy of *Flying Visits*], http://www.holmesautographs.com/cgi-bin/dha455.cgi/scan/mp=keywords/se=FURNISS,%20HARRY, accessed 23 March 2008. Item

Possibly, Furniss's exhaustion at the end of the tour forced any incipient plans to be postponed. Evidently, however, the connection had been made even though Furniss took pains to dismiss any commercial implications of his 1892 American vacation: "I was . . . extremely annoyed on my arrival to find the irrepressible lecture agent, Major Pond, had coolly announced that I was going over to him, and he had actually taken rooms for me at the Everett House! Of course I informed the interviewers that I was not going to tour with Pond or to make money in any way. I was merely a bird of passage, a *rara avis,* a visitor without an eye on the almighty dollar."[6] Furniss was happy to admit that he spent time in Pond's company, but also noted that he did not appear in the impresario's "entertaining book" *Eccentricities of Genius,* and was "never on his business books either."[7] Yet, notwithstanding the avowedly non-commercial nature of his trip to America, Furniss's own irrepressible qualities and business acumen led him to talk up "Humours" in interviews he gave to the press, which were reproduced in a number of regional papers throughout the country.[8] In this way, the widely disseminated news of the famous cartoonist's visit was routinely accompanied by information about his principal lecturing wares, no doubt with an eye to drumming up future business.

In all events, Furniss proved to be a popular figure during his visit and made a lasting impression on the Americans. In Milwaukee, he was described as "one of the greatest living caricaturists."[9] In Washington, he was invited to attend a dinner at the Gridiron Club, which prompted him to quip: "I have heard of putting a gridiron on a furnace, but never a Furniss on a gridiron."[10] The *New York Herald,* commenting upon the interviews reported with Furniss on his return to England, wrote: "Harry Furniss, the famous caricaturist, has returned home, and, unlike many other Englishmen who visit America, has been saying some pleasant things about us . . . he is such a refreshing exception to some of his literary and artistic countrymen who have accepted our hospitality and then abused us."[11] All this suggests that Furniss intended his 1892 visit to America, at least in part, to lay the groundwork for a future tour.

no longer available on website. Transcription in possession of Gareth Cordery.

6. *CC*II, p. 58. A sketch of Pond is reproduced on p. 59.

7. *CC*II, p. 59; J. B. Pond, *Eccentricities of Genius: Memories of Famous Men and Women of the Platform and the Stage* (London: Chatto & Windus, 1901).

8. See, e.g. *Daily Inter Ocean* (Chicago), 17 April 1892, p. 26, and *St. Paul Daily News,* 21 April 1892, p. 3, both of which reprint an interview given to the New York *Sun.* See also his interview in *Daily Inter Ocean* (Chicago), 24 April 1892, p. 19.

9. *Yenowine's Illustrated News* (Milwaukee), 16 April 1892.

10. Reprinted from the *New York World* in the *Atchison* [Kansas] *Daily Globe,* 30 April 1892.

11. *BAA,* p. 9.

2. The North American Tour, 1896–97

Furniss returned to America in October 1896. Following his split with *Punch* in March 1894 he had invested considerable time and money in two magazine enterprises, *Lika Joko* (October 1894–April 1895), named after his *Punch* sobriquet, and the *New Budget* (April-October 1895), successor to Astor's *Pall Mall Budget*. Both were short lived and financially disastrous. In 1896, he took to the platform again, this time with "America in a Hurry," based upon his visit to the US four years earlier. The show was "a tremendous success."[12] Consequently, and to further recoup the losses from his publishing failures, he revived the idea of a North American tour with an updated version of "Humours" paired, audaciously, with "America in a Hurry."

For an Englishman to take such a show to the country that was the subject of his humorous entertainment might seem risky, yet his first (private) visit had created a favorable impression and a stock of good will that he could now draw upon. The year 1896 stood at the beginning of what would later be called the "Great Rapprochement" in Anglo-American relations, following conflicts which had flared up periodically throughout the nineteenth century.[13] Tensions, including talk of war, had returned for a brief period in 1895 when the US asserted its rights under the Monroe Doctrine to arbitrate a dispute with Venezuela over the borders of British Guiana. With its vast array of imperial commitments (including trouble brewing in South Africa) and growing friction among the European great powers, Britain considered war with the US unthinkable. In the following decade, Britain would effectively cede authority in the Western Hemisphere to the US, which itself became an overseas imperial power following its war with Spain. In the context of the racial and social Darwinistic ideas of the time, it became popular in various quarters to conceive of a shared destiny for the two "Anglo-Saxon" nations.

By presenting both "Humours" and "America in a Hurry" at this particular juncture, Furniss built upon the cultural links between the two countries that had been intensifying (in part, through the transatlantic lecture business) by showing Americans something of Britain's most central institution while also providing them with an ultimately appreciative view of themselves from the outside. He was no doubt encouraged to try "America in a Hurry" in the land of its inspiration by press reports of his London performances. As the *New York Tribune* reporter who saw the show at the Queen's Hall commented, "it

12. *BAA*, p. 9.

13. For a summary of how scholars have understood this process, see Ritchie Ovendale, *Anglo-American Relations in the Twentieth Century* (Houndmills: Macmillan, 1998), pp. 4–9.

was good-humoured fun, without satire or ridicule, and could be enjoyed as keenly by American as by English auditors."¹⁴ Similarly the London press noted that the show was hardly anti-American: "The limits of good taste were not passed, and the underlying basis of that good feeling which exists between the 'Cousins,' in spite of family feuds and petty national jealousies, was never lost sight of, but tempered the criticisms from beginning to end."¹⁵ Thus, in spite of the tensions that had arisen over the Guiana border issue, Furniss was an unwitting harbinger of the Great Rapprochement in seeing the value of including "America in a Hurry" along with "Humours" (and two other entertainments performed less frequently, "Harry Furniss At Home" and "Stories and Sketches") in his North American tour.

Furniss arrived at New York aboard the White Star Line's steamship RMS *Germanic* on 22 October.¹⁶ (Appendix IV provides the known details of Furniss's 1896–97 North American tour.) That numerous papers across the country included notices of his arrival gives some indication of the impression he made during his 1892 visit and his general celebrity standing. He remained in New York (at the Holland House hotel) for an extended sojourn through December. During the early part of his stay, he observed the final weeks of the dramatic presidential election contest between Republican William McKinley and the populist Democrat William Jennings Bryan.¹⁷ With his expertise in political caricature and the benefit of his previous introduction to the US, it made a great deal of sense that Furniss would want "to contribute sketches, in his own inimitable way, of the eccentricities of American politics."¹⁸ He had already been steeped in the great contest between "sound money" (gold standard) and "Free Silver" while crossing on the *Germanic*. As he wrote to his son Frank: "I am heartily sick of the elections before I get to America as the Yankees talk of nothing else on board noon and night."¹⁹ Furniss liked to recount how, on the night of the election, he dined in company with eleven Republican bankers and merchants, and an equal number of Democratic counterparts, "who met at the same board for the first time in their lives, and waited with white faces for the result of the election."²⁰

14. *BAA*, p. 9.

15. *BAA*, p. 9.

16. *Daily Inter Ocean* (Chicago), 23 October 1896; numerous other US papers took note of his arrival. In his published account, Furniss identifies the vessel as the *Teutonic* to allow for a pun on the "tonic" the trip would provide for his health. *CC*II, pp. 27–28.

17. For Furniss's reflections on the contest, see *CC*II, pp. 114–21.

18. *Gazette* (Montreal), 6 January 1897, p. 3.

19. *CC*II, pp. 114–15; HF to Frank F, undated letter [October 1896], in possession of Rosemary Wood.

20. "Harry Furniss: 'A Chat with an Entertainer,'" *Argus* (Melbourne), 21 May 1897, p. 6.

Following McKinley's victory, Furniss performed at least two shows—
"Humours" and "America in a Hurry"—in late November at Chickering
Hall, a 1,300-seat concert hall in the theater district near Union Square
where, among other notable lecturers who had appeared there, Oscar Wilde
had made his American debut in 1892.[21] Earlier, it had been anticipated that
Furniss would also perform "Life on the Ocean Wave" (about his experiences
on steamships) and "Stories and Sketches," but there is no evidence that he
ultimately gave these shows.[22]

Furniss's letters home from New York provide characteristically amus-
ing observations on the wonders of the great metropolis: "The railway is not
underground like in London—but it is in the air and twists round the houses
close up to the windows all over the city and the horses and carts are under it
in the Roadway. No one walks here. They all go in tramways or these high up
railways so I have to do the same and I am getting horribly fat!"[23] The Amer-
icans, he wrote, "boast of their Republic, their President, the Astors and
their Vanderbilts,"[24] and he described New Yorkers as "very much dressed, all
hats and sleeves and frills and yes teeth and money."[25]

These were, of course, the people Furniss met as he made the social rounds
and was the featured guest at a variety of events. He shows up in newspa-
per accounts of events ranging from the New York Horse Show to the third
irregular dinner of the Society of Pointed Beards.[26] He wrote to his daughter
about being the guest of the Twelfth Night Club: "The only man among all
the charming ladies. What an ordeal! And then I had to get up and address
them."[27] But part of the wonder of New York was also its ethnic mix, though
Furniss seems to have encountered this directly only by way of service. In
terms characteristic of the day, he remarked on "the black waiters and the
Chinese washer men and the little niggers selling papers."[28] Apparently, he did
not have any direct dealings with the New York Irish community, otherwise
he would surely have added yet another chapter to his annals of Hibernian
antipathy.

21. Information on Chickering Hall from T. Allston Brown, *A History of the New York Stage,
from the First Performance in 1732 to 1901*, 3 vols. (New York: Dodd Mead, 1903), vol. 2, pp. 591–92.

22. According to *NYT*, 23 October 1896, p. 16, Furniss planned to give three or four shows in
New York, with these four titles given. Yet the paper only recorded two performances: "Humours"
on 23 November (*NYT*, 24 November 1896, p. 5), and "America" on 25 November (*NYT*, 26 Novem-
ber 1896, p. 3).

23. HF to Guy F, 8? November 1896, letter in possession of Gareth Cordery.

24. HF to Dorothy F, 1 December 1896, letter in possession of Gareth Cordery.

25. HF to Dorothy F, 15 December 1896, Getty Archive.

26. *Daily Inter Ocean* (Chicago), 15 November 1896, p. 24; *NYT*, 11 December 1896, p. 3.

27. HF to Dorothy F, 1 December 1896, letter in possession of Gareth Cordery.

28. HF to Guy F, 15 December 1896, letter in possession of Gareth Cordery.

Following his extended stay in New York, Furniss got down to the serious business of touring in the New Year. He traveled to Montreal on 5 January, arriving at the Windsor Hotel a day later than expected after "urgent and unexpected business" of an unknown character led him to postpone his departure.[29] From his work for *Punch* and other publications, Furniss was well known in Britain's premier dominion and, especially following his successful turns in New York, the "desire to see and hear him is unprecedented."[30] Indeed, he was regarded as "the very strongest attraction in the lyceum field this season."[31] In Montreal, Furniss gave three performances at the 1,300-seat Windsor Hall (adjoining the hotel): "Humours" on 6 January and on 9 January as a matinee followed by "America in a Hurry" in the evening.[32] As predicted, he played to crowded houses and "Hundreds of people were turned away" from Windsor Hall.[33] The day after the first performance, the "excellence of his entertainment was a general subject of conversation about the city," and demand for seats to the last two Montreal shows was reported to be "already very large."[34] The great audience that attended his last show was said to be "composed of many of the best people of the city."[35]

In between the two Montreal dates, Furniss made a quick trip to Ottawa, where he "attracted much attention" with "Humours," delivered to "a crowded audience at the Opera House" on 7 January.[36] The performance, filling the 1,400-seat venue to capacity, was given under the auspices of the Governor General and his wife, Lord and Lady Aberdeen, who occupied the Royal box.[37] Aberdeen was Gladstone's friend and political ally, but there is no record of his specific reactions to Furniss's portrayal of the Grand Old Man. It was reported, however, that both Their Excellencies had been "appreciative auditors" and "expressed to Mr. Furniss their delight at his effort."[38] Later, Furniss would recount that, after giving compliments on "Humours," Aberdeen questioned the propriety of holding up Parliament to ridicule. "I

29. *Gazette* (Montreal), 5 January 1897, p. 3.

30. *Gazette* (Montreal), 5 January 1897, p. 3.

31. *Gazette* (Montreal), 1 January 1897, p. 3.

32. Seating capacity of Windsor Hall from Gilles Potvin, "Windsor Hall/Salle Windsor," *The Encyclopedia of Music in Canada*, http://www.thecanadianencyclopedia.com/index.cfm?PgNm=TCE&Params=U1ARTU0003715, accessed 10 November 2013.

33. *Daily Citizen* (Ottawa), 7 January 1897, p. 8.

34. *Gazette* (Montreal), 8 January 1897, p. 2.

35. *Gazette* (Montreal), 11 January 1897, p. 2.

36. *Daily News*, 3 March 1897.

37. *Daily Mail and Empire* (Toronto), 8 January 1897, p. 5; *Daily Citizen* (Ottawa), 7 January 1897, p. 8. Seating capacity of the Opera House from Felicia Hardison Londré and Daniel J. Watermeier, *The History of North American Theater: The United States, Canada, and Mexico: From Pre-Columbian Times to the Present* (New York: Continuum, 2000), p. 246.

38. *Daily Citizen* (Ottawa), 8 January 1897, p. 8.

respectfully replied that His Excellency's mission was to impress the pub-
lic with the *seriousness* of Parliament, mine to amuse the public with the
Humours of Parliament. His Excellency and I were unfortunately in the same
boat, we were both creatures of circumstance—for we had both to act up to
our titles!"[39]

The following morning, Furniss returned to Montreal for his double bill
the next day and also to get material for sketches.[40] Then, after a "tedious
twelve hours' railroad journey," Furniss arrived in Toronto, where he per-
formed "Humours" twice followed by "America in a Hurry," at the recently
constructed 4,000-seat Massey Music Hall.[41] After the first performance, the
press "regretted that the audience at Massey hall last night was not as large as
the excellent character of the entertainment provided by Mr. Harry Furniss
deserved." The report noted, however, that "the audience, although small,
was rather select, and one of the most interested spectators was Mr. Speaker
Edgar."[42]

While Edgar might claim a special connection to the substance of
"Humours," British parliamentary forms and personalities were, of course,
generally better known to Canadian audiences than to their US counterparts.
As one press account noted, Furniss "has convulsed the people of Gotham
with his strange sketches and manners, which to a Canadian are more famil-
iar, reflected as they are on our own parliament."[43] But Furniss, hardly above
a little clap-trap, also took an opportunity to include in his performances
material of special relevance to Canadians. In particular, he added to his cata-
logue of notable MPs some remarks about and an image of Edward Blake, the
highly regarded and influential former leader of Canada's Liberal party, who
shortly after moving to Britain was unexpectedly invited to stand as an Irish
Nationalist in the 1892 general election for the South Longford constituency,
which he represented, without establishing himself as a major parliamen-
tary presence, until his resignation in 1907.[44] According to one account: "The
sketch of Mr. Edward Blake was a capital one, and the caricaturist's reference
to the distinguished Canadian, and his admission that Mr. Blake's reserve

39. "Cartoon," p. 3 (emphasis in original).

40. *Gazette* (Montreal), 8 January 1897, p. 2.

41. *Globe* (Toronto), 11 January 1897, p. 2. Information on Massey Music Hall from Patricia
Wardrop, Timothy Maloney, and Andrew McIntosh, "Massey Hall," *The Encyclopedia of Music in
Canada*, http://www.thecanadianencyclopedia.com/articles/massey-hall, accessed 10 November 2013.

42. *Daily Mail and Empire* (Toronto), 12 January 1897, p. 7. James David Edgar (1841–1899) was
Speaker of the Canadian House of Commons from 1896 to 1899.

43. *Daily Citizen* (Ottawa), 8 January 1897, p. 8.

44. Ben Forster and Jonathan Swainger, "Blake, Edward," in *Dictionary of Canadian Biogra-
phy*, vol. 14 (Toronto and Quebec: University of Toronto/Université Laval, 2003–), http://www.
biographi.ca/en/bio/blake_edward_14E., accessed 10 November 2013.

force would bring him yet still more prominently to the fore, was greeted with loud applause."[45]

There is an unresolved question regarding Furniss's Canadian tour. As he would describe in the British press and recount later, Lord Aberdeen "invited—I should say commanded me to dinner at Government House the following evening so by 'Royal Command' the Opera House was closed that night, which my manager said was always a grand advertisement for the tour."[46] There is, however, no report of these events in the Canadian press. Instead, the newspapers describe Furniss returning to Montreal the morning after his turn at the Opera House. He did return to Ottawa on 13 January, in between his Toronto performances on the 12th and 14th, but is reported only to have spent the afternoon sketching at the Canadian Parliament.[47] The Aberdeens are reported, without further elaboration, to have been unable to attend a charity event on the 13th, but there is nothing to suggest that they chose to dine with Furniss instead.[48] The extant record, therefore, does not support Furniss's account. Yet, while he could be relied upon to squeeze the maximum value out of a story, there are no other obvious instances of his wholly inventing a tale of this kind involving prominent public figures.[49] Thus, his account of dinner with the Aberdeens remains a mystery.

After his last date in Toronto on 14 January, Furniss returned to the US and made a loop of the major cities in upstate New York and the northeast corridor: Buffalo, Rochester, Albany, Washington, Baltimore, Philadelphia, and Boston, where he closed the tour. Along the way, he was routinely fêted by groups of local worthies, most splendidly perhaps in Washington where a luncheon was held in his honor at the Metropolitan Club with a guest list that included the Secretary of State, the Postmaster General, the Secretaries of War and the Navy, and the Solicitor General among other national and local notables.[50]

45. *Daily Mail and Empire* (Toronto), 12 January 1897, p. 7. Another account took the more skeptical, and ultimately accurate, view that "while Mr. Blake is the intellectual peer of the best men in the imperial parliament, his career there has been somewhat of a failure. You cannot transplant a public man at sixty with success." *Daily Citizen* (Ottawa), 7 January 1897, p. 2.

46. "Cartoon," p. 3. *Daily News,* 3 March 1897.

47. *Globe* (Toronto), 13 January 1897, p. 12.

48. *Daily Citizen* (Ottawa), 14 January 1897, p. 8.

49. In his account of his relationship with Lewis Carroll, whose *Sylvie and Bruno* and *Sylvie and Bruno Concluded* he illustrated, Furniss has been accused of "outrageous falsehoods." Morton Cohen and Edward Wakefield, *Lewis Carroll and His Illustrators* (Ithaca. NY: Cornell University Press, 2003), p. 104. We find little evidence to substantiate this claim. See Gareth Cordery, "The Book Illustrations of Harry Furniss," *Imaginative Book Illustration Society Journal,* vol. 3 (2009), pp. 70–71.

50. *Washington Post,* 28 January 1897, p. 7. Since presidential inaugurations then took place in March (before they were moved in 1932 to January), these would have been members of outgoing president Grover Cleveland's administration.

Press accounts indicate that, overall, the reception of "Humours" in both Canada and the US was quite positive. In New York, Furniss was "warmly applauded" and his images and characterizations "were greeted with laughter and cheers."[51] In Montreal, he "thoroughly delighted the large audience that had gathered to listen to him."[52] In Philadelphia, "Wave after wave of laughter swept over Association Hall. . . . The whole was exceedingly interesting, to say nothing of its humor."[53] In Boston, "He was interrupted continually by appreciative applause," although the audience "was not as large as it ought to have been."[54]

Accounts were not unalloyed. A generally positive review of "Humours" at the Ottawa Opera House noted that occasionally "Mr. Furniss' British wit fell somewhat flat."[55] A reviewer in Montreal observed that "Mr. Furniss' pencil is superior to his discourse" and "his wit is somewhat forced," although the "occasional striving after effect" did not mar "what was on the whole an entertainment of merit and one that was a two hours' delight."[56] In Philadelphia, a reporter opined that, at his second date in the city, Furniss "chose an interesting subject, and as a result was more successful than upon his previous attempt last Wednesday. At that time he took the English Parliament as a fit matter for his sketches and humor, but last night the subject which he considered was on a topic nearer home, entitled 'America in a Hurry.'"[57]

Beyond the generally positive reviews of the entertainments, there was a great deal of praise for Furniss himself. "Mr. Furniss has given to the English-speaking people such clever sketches of its most prominent figures and incidents in public life, that he received the title of the first caricaturist of the day."[58] "We have not a draughtsman in the country, funny as many of them are, and good workmen, who can compare to him."[59] "As a platform entertainer he has merits of a high character and is able to raise the enthusiasm of his audiences."[60] Many papers, too, made special note of his abilities as a mimic of voices and styles of speech, and imitations of the walks of particular individuals. In the US, Furniss's English accent and delivery also contributed to the interest of the performance:

51. *NYT*, 24 November 1896, p. 5.
52. *Gazette* (Montreal), 8 January 1897, p. 5.
53. *Philadelphia Inquirer*, 4 February 1897, p. 2.
54. *Boston Daily Advertiser*, 11 February, 1897; *Boston Daily Globe*, 11 February 1897, p. 8.
55. *Daily Citizen* (Ottawa), 8 January 1897, p. 8.
56. *Gazette* (Montreal), 11 January 1897, p. 2.
57. *North American* (Philadelphia), 6 February 1897, p. 2.
58. *Gazette* (Montreal), 6 January 1897, p. 3.
59. *Philadelphia Inquirer*, 7 February 1897, p. 24.
60. *Boston Daily Globe*, 17 January 1897, p. 9.

Mr. Furniss is an Englishman before he is a humorist, and unconsciously in his own utterances often illustrated the very essence of the ridiculous that he was caricaturing in British orators in Parliament. He talks in the up and down sliding tones, regardless of the meaning or importance of words, that make English oratory, and even everyday English speech, seem so irresistibly droll when reproduced on the stage.[61]

In ways that surely pleased Furniss, several accounts also noted the novel qualities of his entertainment. "He is even more than the conventional lecturer, being a caricaturist, comedian, and speaker at once."[62] Indeed, Furniss blamed the low turnout for "Humours" in Boston on the fact that it was billed as a "lecture" when, according to the local reporter, it was "so widely different from the stereotyped stereopticon exhibition that the two scarcely seem to be related at all."[63] Similar causes may lie behind the depressed turnout in Toronto.

As this indicates, there were some organizational problems with the tour, which was hardly uncommon on the American circuit.[64] As Furniss recalled:

I did very bad business in Washington, largely due to bad management. Five o'clock teas had become the rage of Washington Society, and my appearances in the [Columbia] theatre were between 4.15 and 6 o'clock in the afternoon. Alluding to this a critic wrote in the *Morning Times:* "It may help Mr. Furniss to forgive the small audiences here in Washington if he is informed that during this season none of his English friends have made a very glittering success; nearly all of them have lost money or made very little. We seem to be somewhat down on Englishmen this year."[65]

Although Thackeray, Dickens, and other lecturers had demonstrated the financial rewards that could be obtained by US tours, Furniss here gives some indication that he failed to turn much of a profit from his 1896–97 effort. In addition to the smaller than hoped for turnouts at some dates already noted, Furniss's tour, with appearances in only eight US and three Canadian cities (all well-connected by rail), was also more limited than those of other Britons who traversed far more of the country—a less debilitating but also less lucrative itinerary.

61. *NYT*, 24 November 1896, p. 5.
62. *Washington Post*, 26 January 1987, p. 7.
63. *Boston Daily Globe*, 11 February 1897, p. 8.
64. See Collins, "Agglomerating Dollars,'" p. 21; Waller, *Writers, Readers, and Reputations*, p. 602.
65. *CC*II, p. 71.

Another reason for reduced profits may have been that at least some of these limited number of appearances were associated with charitable bodies (e.g., the Philadelphia County Medical Society, established for the relief of widows and orphans of medical men; and, in Boston, the Industrial School for Crippled and Deformed Children), to which a portion of the revenue would have gone. In these cases, the American tour reproduced the situation Furniss had resolved to avoid in Britain following his first lecturing efforts in the late 1880s in which the hosting institutions, not the performer, received the bulk of the profit. This, too, might be an indication of poor management.

Furniss returned to England at the end of February 1897, where he wasted no time in exploiting his recent American experiences by offering to the editor of the *Boston Herald* a group of "sketches he made while in Boston . . . for $200.00"[66] and by updating his "America in a Hurry" with images of the recent November election. Whatever disappointments he may have experienced in North America, his touring days were hardly over. As one newspaper reported: "Mr. Harry Furniss has just returned to London after a successful lecturing tour with his 'Humours of Parliament' in the United States and Canada. He is now making arrangements for a five months' visit to the Australian colonies."[67]

3. The Southern Hemisphere Lecture Circuit

Furniss's plans for a visit to the Antipodes had been in the offing for some time. Indeed, some North American press accounts indicated (no doubt based on what he told them) that he planned to head directly to Australia from the US.[68] When Furniss was sojourning in New York, the Wellington (New Zealand) *Evening Post* reported he was "coming out in May [1897] on a lecture tour, under the guiding hand of Mr. R. S. Smythe,"[69] although the New Zealand visit did not eventuate. Robert Sparrow Smythe[70] "was widely regarded

66. HF to Editor of the *Boston Herald*, 1 March 1897, from online catalog description at Kennedy's West Books, http://www.kennedyswest.net/ap_furniss_harry.html, accessed 24 November 2008. Website no longer active. Transcription in possession of Gareth Cordery.

67. *Belfast News-Letter*, 25 March 1897.

68. See, e.g., *Gazette* (Montreal), 6 January 1897, p. 3.

69. *Evening Post* (Wellington), 14 November 1896, p. 2.

70. There exists no biography of Smythe and the discussion of his Antipodean managerial activities draws largely upon newspaper reports and the following scholarly sources: M. Shillingsburg, "Smythe, Robert Sparrow (1833–1917)," *Australian Dictionary of Biography*, online ed., http://adb. anu.edu.au/biography/smythe-robert-sparrow-8568, accessed 10 November 2013; Robert Dingley's introduction to George Augustus Sala's *The Land of the Golden Fleece* (Canberra: Mulini Press, 1995), pp. vii–xxvi; Judy McKenzie, "G. A. S. in Australia: Hot Air Down-Under?" *Australian Literary*

as one of the best" Australian agents and promoters[71] and was a key figure in
arranging for northern hemisphere (including American) celebrities to tour
south of the equator, just as Major Pond was equally crucial for the transat-
lantic traffic in, as the title of his book put it, famous men and women of the
platform and stage.

Just as there was a well-established North American itinerary for such
personalities so there was a colonial circuit made possible by the faster and
more frequent steamships that carried these entertainers, along with increas-
ing numbers of immigrants and the all-important cargoes and mail, to the
far reaches of the British Empire. Among Smythe's clients were "English
astronomer R. A. Proctor, war correspondent Archibald Forbes, journalist G.
Augustus Sala, authors Annie Besant and Professor M. D. Conway, preacher
Dr Talmadge, and explorer Henry Stanley."[72] It was the last who recom-
mended Smythe as "the lecture agent for Australia and New Zealand . . . *par
excellence*" to Mark Twain,[73] whose world tour, just seventeen months before
Furniss's, took in Ceylon, India, South Africa and Mauritius as well as the
Antipodes.

The tours by Sala (1885–86) and by Twain (1895–96) offer an instruc-
tive context for Furniss's own effort. "The greatest living journalist," as Sala
was dubbed by the Australian press,[74] and the greatest living humorist both
embarked on overseas lecture tours quite simply because, like Furniss, there
was money to be made and they badly needed it. The bankrupt Twain's trip
of thirteen months was so financially successful that he discharged his debts
in two and a half years rather than the four originally projected and still
there was $18,500 left over.[75] The profligate Sala's profit, after ten months in
Australasia and tours of the US and India, was considerably less but he still
"returned to England with some £3,000 or more in his pocket."[76]

Furniss, as we have seen, was endeavoring to recoup the losses follow-
ing the collapse of his magazines *Lika Joko* and the *New Budget* and the
returns for his US tour were relatively disappointing, but it is unlikely that
he matched the figures for Twain and Sala. He spent barely a month tour-

Studies, vol. 15, no. 4 (1992), pp. 313–22; Miriam Jones Shillingsburg, *At Home Abroad: Mark Twain
in Australasia* (Jackson and London: University Press of Mississippi, 1988); Ralph Straus, *Sala: The
Portrait of an Eminent Victorian* (London: Constable, 1942).

 71. Shillingsburg, *At Home Abroad*, p. 61.
 72. Shillingsburg, "Smythe, Robert Sparrow (1833–1917)."
 73. Mark Twain, *How to Tell a Story and Other Essays*, ed. Shelley Fisher Fishkin (New York and
Oxford: Oxford University Press, 1996), p. 171.
 74. McKenzie, "G. A. S. in Australia," p. 4.
 75. Shillingsburg, *At Home Abroad*, p. 230.
 76. Straus, *Sala*, p. 243.

ing Australia plus a couple of shows in Colombo (Ceylon) on the way back
to England. This raises the question as to why Furniss went so far for such a
brief tour. One can only speculate but his shows were confined to Melbourne,
Sydney, and Adelaide whereas Sala and Twain journeyed through the Austra-
lian countryside for weeks on end giving performances at smaller towns like
Horsham, where Smythe "required a guarantee of £35 before he would accept"
the engagement for Twain.[77] Furniss's more limited foray into Australia mir-
rors that of his comparatively circumscribed tour of North America. Perhaps
outside the three main cities no guarantees like those Twain could command
were forthcoming for "Humours." Then again, unlike Sala and Twain, Furniss
did not take his family with him: he had four children and a sickly wife and
by all accounts was a devoted father and husband. He had already spent
some four months in North America, missing Christmas with his family, and
within six weeks of his return he was off to the Antipodes. He had originally
planned a "five months visit to the Australian colonies" that was to "include
New Zealand,"[78] and there is also some evidence that he intended to travel to
South Africa,[79] so news from home (whatever that was) probably persuaded
him to curtail the tour.

Whatever the reasons for Furniss's quick return, the southern hemisphere
celebrity circuit was, like the transatlantic one, clearly lucrative for both agents
and performers alike. It is reasonable to surmise that "although the terms of
[Twain's] contract with Smythe are not known, it seems probable that he took
twenty percent, the same fee paid J. B. Pond, the North American agent."[80]
There is little reason to assume that the arrangements with Furniss were sub-
stantially different. But the agent's cut was confined to the performances he
arranged and promoted and a significant income for the tours of Sala, Twain,
and Furniss came from contracts with various publishers for accounts of their
exotic travels. Furniss's impressions appeared initially in the *Australasian* (the
weekend supplement to the Melbourne *Argus*), later in the prestigious *Wind-
sor Magazine*, and finally in book form as *Australian Sketches Made on Tour*
(1899) and in *The Confessions of a Caricaturist* (1902). His experiences of the
voyages out and back are recorded as "a series of sketches, drawn on the spot,
and illustrating any subject which appealed to him at the moment" in *P & O
Sketches in Pen and Ink* (1898).[81] He also planned a magic lantern show called

77. Shillingsburg, *At Home Abroad*, p. 92.
78. *Belfast News-Letter*, 25 March 1897; *Evening Post* (Wellington), 14 November 1896, p. 2.
79. *NYT*, 23 October 1896, p. 16.
80. Shillingsburg, *At Home Abroad*, p. 53.
81. HF, "Introduction" to *P & O Sketches in Pen and Ink* (London: Studio of Design & Illustra-
tion, 1898). A lavishly illustrated, cloth-bound book with gilt edges, it was advertised as "Descriptive

"The World in a Hurry," modeled on his successful "America in a Hurry," but this never saw the light of day.

And so, as with his UK and North American tours, Furniss was again following in the footsteps of famous predecessors, this time on a well-trodden path around the southern hemisphere. When Smythe saw him "on the platform in London" he "entered into negotiations with Mr. Furniss for the present Australian tour."[82] We do not know the substance of these negotiations, but given their personalities and interests they must have hit it off: a photo in the Sydney *Bulletin* of the two of them is titled "A Happy Pair."[83] Smythe's background was remarkably similar to Furniss's: he had worked "as a music and drama critic for newspapers in New South Wales . . . [and] as a parliamentary reporter on the *Register* in Adelaide. He soon founded and edited the *Illustrated Post*, the first illustrated newspaper in Australia, and he had journalistic practice with the *Age* in Melbourne" before becoming a theater manager and making tour management his full-time occupation in 1895.[84] Their physical likeness was noted by the interviewer of the *Argus* when Furniss first arrived in Melbourne: "He is short as well as globular—almost as short and globular as his manager."[85] Smythe's "varied experience, genial disposition, and excellence as a raconteur" made him a sought after companion[86] and it was his practice to accompany and play host to his clients on their tours. At the same time he was also "notorious for driving hard bargains"[87] and as the *Australasian* noted "a lecturer who puts himself in the hands of Mr. Smythe cannot serve two masters. Mr. Smythe is suave and gentle, with most delicate touch, but inexorable, and the rule is 'business first and pleasure afterwards.'"[88] It was a rule that suited Furniss and one he had followed all his life: he was proud to own that he had never missed a performance or a newspaper deadline.

Such personal harmonies aside, what might have persuaded Smythe that Furniss would go down well down-under? He was already well known in the Antipodes so his reputation preceded him: "famous as a caricaturist in *Punch*" he had "contributed some of his brightest pictures to that journal" which was still "the comic paper of the world."[89] Secondly, with the relative

of a Voyage in one of the P. & O. Liners. Full of Humour and Amusement. An Art Gift Book" and cost ten shillings and sixpence (*Fair Game*, April 1899, p. 35).

82. *Sydney Morning Herald*, 11 June 1897, p. 6.
83. *Bulletin* (Sydney), 12 June 1897, p. 8.
84. Shillingsburg, *At Home Abroad*, p. 60.
85. "'Harry Furniss.' A Chat with an Entertainer," *Argus*, 21 May 1897, p. 6.
86. Shillingsburg, *At Home Abroad*, p. 61.
87. Dingley, introduction to Sala, *Land of the Golden Fleece*, p. xxi.
88. *Australasian*, 28 December 1895, qtd. in Shillingsburg, *At Home Abroad*, p. 191.
89. *Sydney Morning Herald*, 11 June 1897, p. 6; 12 June, p. 10.

failure of Sala's tour and the recent great success of Twain's in mind, Smythe must have recognized the sheer stage presence and entertainment value of an experienced and already successful platform performer who offered what his famous predecessors had not: magic lantern slides.[90] Sala did not even offer a decent lecture for he was, according to Smythe himself, unprepared and "frequently inaudible," the very opposite of Furniss. So, when Smythe saw him perform, most likely "America in a Hurry" in London,[91] he signed him up directly. Perhaps, too, Smythe detected in Furniss some similarities with his prize lecturer, Twain. Both, unlike Sala, were seasoned orators (Twain had begun his platform career in 1866) and both used tried and tested material on Australian audiences. Indeed, Furniss may be seen to be hanging onto the coat tails of the American author by including in his program a piece called "Harry Furniss At Home,"[92] for Smythe had marketed Clemens's tour under the general title "Mark Twain At Home." Finally, by including "America in a Hurry," with its latest take on the recent presidential election, in the program Furniss would be exploiting the Australians' penchant for things American so evident during Twain's recent tour, as well as their traditional fascination for things English.

The colonial cringe, an attitude of deference that saw the mother country as somehow superior in virtually all areas, was alive and well at the end of the nineteenth century. As an emigrant himself, Smythe was fully attuned to the complexities of the Anglo-Australian relationship and he didn't want a repeat of the reactions prompted by what some saw as Sala's smug, English middle class superiority. The *Sydney Morning Herald,* for example, "openly accused him of adopting a condescending attitude towards his audience by offering them inferior material because they were colonials," and the *Bulletin* sent him up "as a passé product of a class-ridden society whose message had nothing to offer a maturing Australia. To them he was not only a monarchist, but an agent of the middle classes, something that their aggressive egalitarianism could not stomach."[93] On the other hand the Australians (who were, and still are, not alone in this) envied and admired, if only for their quaintness and ancient heritage, English traditions and institutions. It was a paradox that "has continued to puzzle ever since: the predilection of the Australian democ-

90. Some lesser-known figures such as the Reverend Haskett Smith (another of Smythe's clients) who "toured throughout Australasia almost simultaneously with Twain . . . had lantern pictures . . . to accompany his lectures on the Holy Land." Shillingsburg, *At Home Abroad,* p. 175. Smythe, then, already knew which venues had the facilities for showing magic lantern slides.

91. The show opened at the Queen's Hall on 2 February, and was attracting audiences in Oxford in May and in Bournemouth in the autumn. *Era,* 26 September 1896.

92. This was performed only once but a book by that title appeared in 1904.

93. McKenzie, "G. A. S. in Australia," pp. 317–18.

racy, one of the most classless societies on earth, for things English, particularly the monarchy and all its hierarchical trappings."[94]

Westminster, too, had its trappings (and who better to make fun of them than Harry Furniss?), but either directly or indirectly the British legislature (as the "mother of parliaments") served as a model for emerging democracies around the world,[95] not least in settler colonies like Australia in which the development of responsible self-government had been advancing for some decades. Indeed, the timing of Furniss's arrival in Australia was especially fortunate in light of the heightened constitutional interest generated by the start only two months earlier of its second Federal Convention, which would ultimately establish the bases for the union of the colonies in 1901. Further, late-nineteenth-century Britain was in many ways the world's leading nation; its colorful and brilliant statesmen were well-known from afar and were the envy of many a colony:

> That there should be anything novel, diverting, or interesting in a Parliament are propositions that most Australians would doubt, until they begin to look abroad. The average colonial may regard the Legislature of his particular province as a necessary infliction. Nevertheless he takes quite a keen interest in the Imperial Parliament, and the prominent figures in it are at all times vividly before his mind. . . . Mr. Reid [the premier of New South Wales] can go down any street in Sydney without exciting wonder, but Mr. Chamberlain would be mobbed. . . . As for Mr. Gladstone, of course, we should all like to see that great and venerable figure in the flesh—lives there a man so base that to himself has said he would not like to see Mr. Gladstone? But the wish is in too many cases impossible of fulfilment—unless you go to Mr. Furniss.[96]

Thus Smythe anticipated that the *Punch* caricaturist would, as he had in England, feed the Australian public's appetite for knowledge about Westminster and its inhabitants. The doings of the Imperial Parliament were regularly reported in the Australian papers. British parliamentarians were already "familiarly known by name in this part of the world" and also by looks via the pages of the *"London Charivari*," but what Furniss's performance provided in addition were "the bearing, manners, and rhetorical styles of Ministers and prominent party politicians" as travestied by the naturally gifted mimic.[97] Thus, "Humours" played upon two conflicting attitudes that existed side

94. McKenzie, "G. A. S. in Australia," p. 321.
95. See, e.g., Alan Burns, ed., *Parliament as an Export* (London: George Allen & Unwin, 1966).
96. *Sydney Morning Herald*, 12 June 1897, p. 10.
97. *Sydney Morning Herald*, 11 June 1897, p. 6.

by side: a recognition of "the great dominating forces of Imperial politics"[98] accompanied by a colonial deference that glorified politicians like Gladstone, and a growing sense of Australian nationhood that welcomed the humanizing, and in some cases the deflation, of famous Imperial figures by the art of the caricaturist.

On top of all this, Smythe also planned Furniss's tour to coincide with, and take advantage of, Queen Victoria's Diamond Jubilee, celebrated throughout her far-flung dominions with all the ceremony and respect due to England's longest reigning and most revered monarch. But all that pomp and circumstance needed to be leavened by a good dose of humor and Furniss had that in abundance. The Queen herself was off limits, but those who served under her and whose decisions affected her colonial subjects were not. It must have seemed to Smythe that "Humours" was exactly the show to tour Australia in 1897.

4. The Australian Tour, 1897

Furniss set sail from London aboard the P & O steamship RMS *Victoria* on 9 April, a "long and tedious journey"[99] of some five weeks that took Furniss via Malta, Brindisi, Port Said, through the Suez Canal to Aden, and on to Colombo (Ceylon) before the uninterrupted ten-day leg to Western Australia where the ship docked at the port of Albany on 13 May. Until 1900, when Fremantle's harbor was opened up, Albany was the first port of call for mail from England but as a result of quarantine restrictions, imposed because of smallpox at Aden, Furniss and his "fellow-passengers [were] forbidden to land" there,[100] though he visited that city on his return journey.

He set foot on Australian soil on 19 May at Port Melbourne and made the Menzies Hotel (a favorite with overseas celebrities, including Mark Twain) his base for his two weeks in the Victorian capital. While there he gave five performances of "Humours," four of "America in a Hurry" and one each of "Stories and Sketches" and "Harry Furniss At Home." Then it was on to Sydney by train to give four performances of "Humours," and two of "America." He traveled from Sydney to Port Adelaide by ship and to Adelaide itself by train where he gave his final two performances of "Humours" and "America" before leaving Australia via Albany on 3 July. (Appendix V provides a detailed itinerary of the Australian tour.) In between shows, Furniss gathered mate-

98. *Argus* (Melbourne), 24 May 1897, p. 6.
99. *CC* II, p. 133.
100. *CC* II, p. 133.

rial on the country's life, habits, and institutions, with his caricaturist's eye ever peeled for eccentric characters. As he had done in the US and Canada, Furniss also made legislative observations, in this case with permission granted by The Speaker of the New South Wales Legislative Assembly, Sir Joseph Abbott, to enter the chamber.

The Australian "Humours" was a slightly updated version of the British program of five years earlier. There were roughly the same number of slides (150) and the first was still "No Politics," a gambit that prompted one reviewer to remark that "Mr. Furniss carefully deodorised himself of the contact from any suspicion of party feeling."[101] Not that this prevented audiences from taking sides, for when individual politicians appeared on the screen there was "loud cheering" and "the leaders of both the great parties were greeted with equal applause."[102]

Furniss retained all those features that had made "Humours" so successful in the past: generic types such as the "masher" member making his maiden speech, the member for boredom, the irascible Anglo-Indian colonel, the ideal and the real MP (a "contrast between the god-like gentleman who might have uttered certain highfalutin' sentiments and the small, smug, pug-nosed, wheezing M. P. who did utter them"[103]), and, of course, the ever popular member for Ballyhooley, "the item that caused the most laughter"[104]; the "pen and ink" drawings of the interior of the House of Commons "tinted with a light wash of colour afterwards, [which] were really beautiful examples of architectural draughtsmanship, and contained an immense quality of work . . . so uniform and so perfectly finished"[105]; the proceedings in the Lords such as "the judicial committee, waggishly represented in such a way that all the grandeur of their lordships' attire seemed entirely ill assorted with their extremely commonplace peculiarities of face and figure," and the appeals scene, a "sketch of almost Hogarthian quaintness and realism"[106]; and the varied (and little known) activities in the Commons, including "sketches of the appearance of the House at all important stages of business, extravagantly comical scenes in the lobbies and in the dining and smoking rooms, created by the rushes to be present on bells ringing for 'counts' and 'divisions,' the Speaker's Procession and certain aspects of the Ladies' and Press Galleries," and "the terrace overlooking the river and Westminster by moonlight."[107]

101. *Argus* (Melbourne), 24 May 1897, p. 6.
102. *Daily Telegraph* (Sydney), 14 June, p. 6.
103. *Melbourne Punch*, 27 May 1897, p. 417.
104. *Herald* (Melbourne), 24 May 1897, p. 3. Cf. *Montreal Daily Star*, 7 January 1897, p. 6.
105. *Argus* (Melbourne), 24 May 1897, p. 6.
106. *The Age* (Melbourne), 24 May 1897, p. 6.
107. *The Age* (Melbourne), 24 May 1897, p. 6; *Argus*, 24 May 1897, p. 6.

All this well-rehearsed material was evidently as popular with the Australians as it was with the British, Canadians, and Americans, but it was the individual politicians, rarely seen in the flesh, that audiences most wanted to see on the screen and acted out by Furniss on the stage. All of the following caricatures, which were shown during the UK tours are named in the Australian press: Balfour, Burns, Chamberlain, Gladstone, Goschen, Halsbury the Lord Chancellor, Sir William Harcourt ("multiple-chinned and grandiose of aspect"[108]), Keir Hardie, Labouchere, Sir Wilfred Lawson, Justin McCarthy, Swift MacNeill, John Morley, Parnell, Redmond, and Salisbury. "Mr Chamberlain and Mr. Balfour received a good share of attention," and there is one new name, Gerald Balfour (brother of the "aesthetically sprawling" Arthur).[109] "Joe" Chamberlain, Colonial Secretary since 1895, received more attention down-under than he had up-top: he was shown "in many phases, including a heroic picture of him slaying all his political selves, and aiming at a peerage and the Premiership" (image 34a).[110]

Furniss retained the mimicking of some MPs that had featured in previous performances and added William Lecky, a new Irish MP who opposed Gladstone's Home Rule effort: "Professor Lecky's walk, a curious crippled motion, and the perambulatory styles affected by Messrs. Morley, Labouchere and others were personally imitated by Mr. Furniss."[111] Australian reviewers, perhaps less constrained by the deferential proprieties of English culture, expressed no reservations about the imitations involving physical infirmities that had earlier drawn criticism from their London counterparts. As, indeed, was Furniss who probably felt that, twelve thousand miles away, he could more freely indulge his penchant for mimicry, as is evident in this account of his "lightning impersonations" during an interview shortly after his arrival in Melbourne:

> Even without the assistance of grease-paints and a property-coat, he can give one very fair portraits—with just the spice of caricature necessary to secure an effective likeness—of all the leaders of contemporary, political, social, and literary activity. For a few seconds he is Mr. Gladstone, thundering on the second reading of the Home Rule Bill, then a new slide is slipped into the human machine, and we see Mr. Chamberlain, logical, clear, cold, but unanswerable, with an eye-glass in his eye, producing proofs of the insincerity of

108. *Australasian*, 29 May 1897, p. 1086.
109. *Herald* (Melbourne), 24 May 1897, p. 3.
110. *The Age* (Melbourne), 24 May 1897, p. 6.
111. *The Age* (Melbourne), 24 May 1897, p. 6; cf. the description of Furniss's imitations of MPs' walks in the *Gazette* (Montreal), 7 January 1897, p. 5.

[Afrikaner leader Paul] Kruger. In a flash we hear the accents of Mr. Redmond passionately demanding the amnesty of Fenian prisoners, and then Arthur Balfour rises to say that if oratory of the highest order could sway the mind of His Majesty's Government the Fenians should go free. This was all impromptu, conversational, unstudied.[112]

Admittedly this was during an interview and not on the public stage but the report was published in a leading Melbourne newspaper and is clearly admiring of the human slide machine. In the balmier and less repressive climate of Australia he seems to have given freer rein to his natural comic inclinations. A *Sydney Morning Herald* reviewer recognized that "America in a Hurry," at least, was "very much after the plan of those music-hall artists whose chief attraction is the 'gag.'"[113]

Under such conditions even the Grand Old Man himself was not immune to a dose of Furnissian mimicry. The highlight of "Humours," inevitably, was Gladstone who, as always, audiences most wanted to see. His political career was at an end and he had almost exactly one year to live when Furniss stepped ashore at Port Melbourne on 17 May (Gladstone died on 19 May 1898), but his reputation and fame were undiminished. Thus, in anticipation of Mark Twain's visit, the *Sydney Morning Herald* noted there was "probably no other man living, except, perhaps, Gladstone, so universally known."[114] Furniss had made his reputation with his caricatures of Gladstone in *Punch* (he never lost an opportunity to remind anyone who cared to listen that he had invented the G. O. M.'s collars) and had too much respect for the veteran politician to mimic, as he was to do with Lecky, Morley and Labouchere, his walk, whose peculiarities he had in fact noted with the characteristic eye of the artist: an "energetic stride—'fair toe and heel,' as professional pedestrians would say" while few men "have the elasticity of walking, all in one motion, which Mr. Gladstone had."[115] Furniss resisted the temptation to contrast his walk with, say, that of Professor Lecky and confined himself to attempting to capture the serious moods of the age's leading statesman, successfully if the following account is to be believed:

Sometimes Mr. Furniss is satirical, sometimes merely animated; always interestingly descriptive. One of his happiest touches in the graver manner is the professed reproduction of Mr Gladstone's Parliamentary efforts—the slow,

112. "Harry Furniss: 'A Chat with an Entertainer,'" *Argus*, 21 May 1897, p. 6.
113. *Sydney Morning Herald*, 17 June 1897, p. 3.
114. Quoted in Shillingsburg, *At Home Abroad*, p. 22.
115. *Fair Game*, July 1898, p. 13.

deliberate rising of the orator, the laboured, gruff, almost inaudible opening sentences, and the sudden, electrifying change which face, figure, and voice undergo when the veteran warms to his subject, stepping a pace back, with kindling glance, raised tones, and impressive gesture. This, for its dramatic merit, and the Hibernian fury of the honourable member for Ballyhooly, as a purely comic effort, are Mr. Furniss's chief triumphs.[116]

Such actings out complemented the "12 or 13 sketches of Mr. Gladstone representing him in all his best remembered positions"[117] that had been, and still were, the centerpiece of the show. Together they created a figure whom the Australians could get to know better than in any other way, short of seeing Gladstone in the flesh.

Perhaps the most interesting series of pictures were those which represented a great figure now gone from the active political stage. Mr. Furniss has made a study of Mr. Gladstone and his series of drawings showing us that statesman in his varied moods of invective, denunciation, and passionate outbursts, as he delivered a great speech, were remarkable examples of bold and successful characterisation, and such as no mere photographs could possible supply. The audience were hurried from phase to phase of the orator's temperament with impetuous rapidity, while the admirable figures thrown upon the screen were accompanied by appropriate comment, and one felt when the series was concluded that the art of the draughtsman had said its last word in reproducing a famous personality.[118]

Like the English press, Australian reviewers appreciated the educational value of "Humours." It gave "really valuable glimpses of odd corners of the House little known to outsiders." "In looking at the pictures which Mr. Furniss gave us one has the additional satisfaction of feeling that one is learning something of the conditions under which contemporary history is made." "After spending an evening with Mr Furniss the average man would know more about the place and the legislators . . . than the casual visitor." Even the one hostile reviewer conceded that "he knows his subject thoroughly . . . he is well worth hearing, more because of the things he knows than by reason of the very solemn frame of mind he knows them in."[119]

116. *Australasian*, 29 May 1897, p. 1086.
117. *The Age* (Melbourne), 24 May 1897, p. 6.
118. *Argus*, 24 May 1897, p. 6.
119. *Australasian*, 29 May 1897, p. 1086; *Argus* (Melbourne), 24 May 1897, p. 6; *Herald* (Melbourne), 24 May 1897, p. 3; *Bulletin* (Sydney), 19 June 1897, p. 8.

The same reviewer saw Furniss as no more than "a steady-going speaker with no startling powers of elocution" who is "a painfully ordinary orator." This and the same paper's earlier assessment that Furniss delivered his comic address like "a pet parson at a chapel bun fight" was very much an exception, for the majority praised his "clear and distinct" voice. The following may be seen as a more representative response: he has "a considerable share of eloquence, and an infinite variety of mimic tones . . . Mr. Furniss is himself a speaker of considerable oratorical gifts . . . [who] has both elocutionary power and real intensity."[120]

As with English audiences the Australians were entertained as well as educated by "Humours" and they liked what they saw. The Melbourne performances were hailed as "immensely successful" so much so that *The Age*'s reviewer lamented that the "diverting entertainment closed all too soon at 9.30" (it had begun at 8 pm).[121] There were the usual reports of applause, great laughter and loud cheering and the venues were variously described as "crowded" or "packed" and the audiences "splendid" or "large."[122] As with the UK tours it is difficult to pin down precise attendances but a rough idea may be obtained from Twain's shows in the Antipodes since these figures are available: 2,000 in Sydney, 1,000 in Prahran (near Melbourne), 1,100 in Auckland, and 1,000 in New Plymouth (NZ).[123] "Humours" may well have matched these figures given the briefness of the tour and the population of the three main cities where Furniss performed: 495,000, 380,000 and 320,000 for Melbourne, Sydney, and Adelaide respectively. On at least one occasion an extra performance was scheduled "in compliance with numerous requests." Reasonable ticket prices, too, probably encouraged good attendances. Throughout the tour they were uniformly three shillings for reserved seats, two for unreserved, and one for a place called, at the Melbourne Athenaeum, the "Area" (presumably standing room).[124]

Twain had charged more: five, three and two shillings, respectively, but Smythe must have learned his lesson from Twain's tour when there were complaints from some country venues that such prices were "rather steep" and calls for more "popular prices to suit the times."[125] Smythe advertised

120. *Bulletin* (Sydney), 29 May 1897, p. 8; *Herald* (Melbourne), 24 May 1897, p. 3; *Sydney Morning Herald*, 12 June 1897, p. 10.

121. *Evening Post* (Wellington), 19 June 1897, p. 3; *The Age* (Melbourne), 24 May 1897, p. 6.

122. *Argus* (Melbourne), 24 May 1897, p. 6; *Melbourne Punch*, 27 May 1897, p. 417; *The Age* (Melbourne), 24 May 1897, p. 6.

123. Shillingsburg, *At Home Abroad*, pp. 52, 104, 160, 172. The population figures that follow are provided by Shillingsburg for Twain's 1895 tour.

124. Advertisement in *The Age* (Melbourne), 29 May 1897, p. 12.

125. Shillingsburg, *At Home Abroad*, p. 182.

"Humours" and "America in a Hurry" at "popular prices" in the *Sydney Morning Herald* of 11 June so it is reasonable to conclude that Furniss's audiences would not have been exclusively middle class and above. The Melbourne *Herald* observed that "The Athenaeum was on Saturday night crowded with an audience representative of all classes."[126]

Still, the content of "Humours" would have attracted Australian legislators keen to hear about and see their British counterparts and it was also the norm for celebrity performances to be graced with the presence of the colony's Governor as had been the case in Ottawa. The Governor of Victoria and Lady Brassey attended "America in a Hurry" while the Governor of South Australia and Lady Victoria Buxton saw "Humours" at the Adelaide Town Hall, hailed as the largest municipal building south of the equator on its opening in 1866. The Melbourne Athenaeum, which hosted the opening night of "Humours," was an especially prestigious venue. Founded in 1839, it was regarded as Victoria's oldest and leading cultural institution and was particularly suited to a magic lantern show, for only seven months earlier it had screened the first film ever shown in Australia.

After a month in Australia Furniss, accompanied by Smythe, boarded in Sydney the RMS *China* bound for London via Adelaide where he gave his final performance of "Humours." The ship briefly called at Albany in Western Australia before departing for Colombo on 3 July, arriving some ten days later (fig. 29). There he gave two evening "shows" (surely "Humours" and "America") in between which he traveled inland by train to Kandy, Ceylon's capital. Here is Furniss's unpublished account of his experience of performing his entertainments in the tropical heat of Colombo:

> My death nearly occurred by giving shows in the Theatre many hours after the sun had gone down. I did not begin till ten o'clock, and yet the heat all but settled me! It was on my return from my Australian tour; I had put in two nights at the Theatre in Colombo. A pretty little theatre by a lake, opening onto a balcony all round, so as to get as much air as possible; palms and other tropical plants, with the moon peeping from behind them, and the reflection of the lights in the lake, the noiseless rickshaws drawn up under the trees, with groups of their attendants in their white turbans, the audience so cool looking, ladies in evening dress, men in white, and mostly composed of the military, combined to make an ideal scene of coolness, peace, and comfort. But—the poor performer! The stage unfortunately was like an oven, and I felt as if I were being roasted for the cooks in front of me to feast upon.

126. *Herald* (Melbourne), 24 May 1897, p. 3.

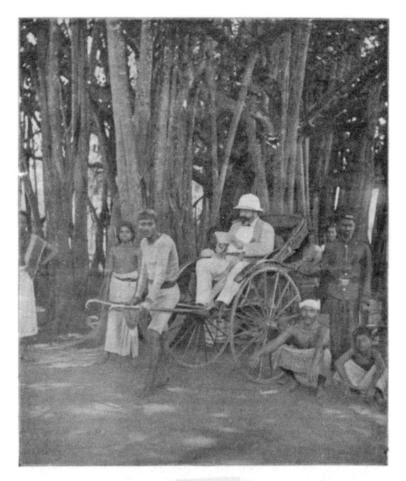

MR. FURNISS STUDYING THE NATIVES IN COLOMBO.

Figure 29. "Mr. Furniss Studying the Natives in Colombo"
(untraced newspaper cutting)

A friend of mine, resident in Colombo, kindly lent me his native servant. This intelligent man, knowing what I would have to suffer in giving my entertainment, had placed three bottles of "Tonic Water" (Soda water with a little quinine in it) in a pail of ice. He also packed up an extra evening shirt and preceded me to the Theatre. The stage was an old fashioned one, with flaring gas footlights and "floats." The heat from these was most trying, and after I had got through my first half of the evening my dress shirt hung on me limp, and to my disgust the ice had melted and my tonic water was lukewarm. The aggravating part was that the audience looked so cool, while I

was being boiled alive. At night I could not sleep in consequence of the heat, and, defying mosquitoes and other vicious playmates, I sat on a chair on my balcony and melted till morning. The next time I visit Colombo I shall give a *matinee*—five a.m.[127]

There never was a next time. For Furniss the trip was tiring and stressful and his relief on finally getting back to England may be gauged in this letter, from his retreat at the Garrick Club, to his close friend and *Punch* colleague Francis Cowley Burnand: "I have had a most interesting if a too long trip around the world. . . . Now after a rest I am settled down in better health and spirits than I have enjoyed for a long time. If any of our mutual friends think of doing the same round trip give them Mr. Punch's advice to those about to marry. I went through it in my forty first year—a man ten years older would have collapsed." But never one to rest for long he was soon at work again preparing for publication the drawings of his recent voyages: "Some day perhaps I may be able to tell you of my interesting experiences. I am at present seeing through a volume of sketches for the P & O which I will send you when complete."[128]

Furniss never went overseas again with any of his entertainments, which after 1897 were confined to the UK. The American and Australian circuits had proved grueling and, more importantly, not very profitable. Unlike Dickens who had "cleared a profit of £19,000 for seventy-six readings" from his 1867–68 visit to America,[129] or Sala and Twain who made enough and more to discharge their debts, Furniss, clearly disillusioned, complained that "in consequence of the long distances and expenses lecturing does not pay, and the stories one reads about men returning with thousands of pounds in their pockets are absolutely false. Do not believe them. They are manufactured statements for booming purposes."[130] Instead he revisited New York in 1912 to learn from Edison the art of film making, but the half dozen films that were produced from his Hastings studio failed, like his international tours, to make his fortune.

127. "A Caricaturist in Colombo: Written and Illustrated by Harry Furniss," unpublished typescript in possession of Gareth Cordery, pp. 5–6. This fifteen-page typescript may have been intended for a magazine or a chapter in *The Confessions of a Caricaturist*. A few sentences appear in *P & O Sketches*, which contains thirteen sketches of his impressions of Ceylon, its inhabitants, and their encounter with the ship's passengers.

128. HF to F. C. Burnand, 3 January 1898, Getty Archive.

129. Schlicke, *Oxford Reader's Companion to Dickens*, p. 17.

130. *CC*II, p. 183.

VI

EDITORIAL PRINCIPLES

*T*HE "HUMOURS" MANUSCRIPT is from a richly documented recent period of history, and not a newly discovered text from a more remote era for which evidence is comparatively scarce. Our editorial approach, therefore, has been to give greater weight to the "spirit" of what is most significant for political and cultural historians of the late nineteenth century, than to the "letter" of strict fealty to an idealized text and set of images which are, in any event, as explained below, inaccessible. Here we describe how we have approached a number of complex issues in order to bring "Humours" to light.

1. The Text

The manuscript that forms the basis of this book is a composite document. It is not, strictly speaking, the text of "The Humours of Parliament" as delivered in 1891, 1892, or 1896–97. But this is the only text that survives. The document reproduced in the following pages appears to be composed largely of "The Humours of Parliament," but it is mixed with elements of Furniss's entertainment "Peace with Humour," which opened 1 November 1900 at the Steinway Hall in London (fig. 30). The phrase "Peace with Humour" appears twice (pp. 200, 242) and there are numerous other allusions in the text. According to a review of the opening in *The Times,* we deduce that the first part has, roughly, to do with "Peace," and "in the second part of his lecture Mr. Furniss chiefly concerns himself with the subject which he has studied so long and to such good purpose—the humours and eccentricities of

HARRY FURNISS AS A PICTORIAL ENTERTAINER.

Figure 30. "Harry Furniss As A Pictorial Entertainer" (*CC*II, p. 182)

Parliament."[1] The review specifically mentions Mrs. Keeley's remark on the ladies' gallery as a "Harem" (p. 236).

As already described, "Humours" was constantly adapted, first to respond to critiques as it moved from the metropolis to the provinces in 1891, then to take into account new political circumstances and personalities in the wake of the 1892 general election, and lastly to appeal specifically to American and colonial audiences. The extant manuscript bears the marks of the kind of constant revision and editing that occurs in the course of a repeated performance. For example, the numbers in the margins that indicate the images shown (discussed in the next section) are of two kinds: those in red pencil are crossed out and replaced by numbers in blue pencil or, rarely, in black ink. Some sections of the typescript have been crossed out, while there are numerous handwritten notes (e.g., "dilate") for extemporizing. Since these are still legible, it seemed sensible from an editorial perspective to reproduce as much of this text as possible, either in the body of the transcript (italicized) or in footnotes.

Even with the knowledge that the manuscript represents a later elaboration of "Humours," dating the text is far from simple. On the one hand, there is internal evidence to support 1900. Furniss refers to July 1881 as "nineteen years ago" (p. 238). During the original tour of "Humours" in 1891, two significant figures discussed in the entertainment, Parnell and W. H. Smith, died (on the same day, 6 October). As a result, "Mr. Furniss had to reconstruct a considerable portion of his entertainment whilst on tour."[2] References to Parnell, who commanded considerable posthumous interest, remain in the text (p. 152), but there is no longer any mention of W. H. Smith. On the other hand, parts of the extant text suggest that it is a post-1900 version. There is a reference to His Majesty the King (p. 202), who acceded to the throne in 1901, and Furniss mentions the "late Sir William Harcourt" (p. 164), who died in 1904.

The constantly changing nature of "Humours" over many years meant that Furniss never turned it into a book. The entrepreneurial cartoonist routinely developed his journalism and entertainments into publications, but "Humours"—one of his signal successes in the area where he achieved his greatest renown—remained unpublished. Various passages draw upon already existing material or eventually made their way into other published writings, but they are scattered, piecemeal, and integrated into different projects.[3]

1. *TT*, 2 November 1900.

2. *AH*, p. 152.

3. For example, the account of the admission of strangers (pp. 147–49) draws upon that in *The Graphic*, 9 March 1889, pp. 247–49; of Harcourt (p. 175–78) that in *B&W*, 28 March 1891, p. 254; of the

Since "Humours" never appeared in print, readers now have the opportunity to appreciate this material from multiple perspectives and examine it as a living, evolving production.

2. The Images

Although there are extensive holdings of original Furniss drawings in the Parliamentary Archives, the National Portrait Gallery, and elsewhere, the whereabouts of the magic lantern slides that were projected as an integral part of "Humours"—if they still exist—are unknown. As already discussed, a few images were drawn specially for "Humours"—the "No Politics" umbrella (recreated for the purposes of this volume), and the architectural drawings of Parliament that were subsequently published on their own. But the vast majority of the images used in "Humours" were already published in the newspapers or magazines for which Furniss had worked. As one reviewer caustically noted: "his repertory, at present, consists chiefly of these" sketches for *Punch* and *Black and White* magazine.[4] When made into slides, the original sketches were altered by the removal of extraneous matter such as captions and signatures (see section IV.2), but in the interests of clarity we have provided the original captions.

The extant manuscript gives cues for 104 slides but some cues have the same number (there are three 98s for example), while others are distinguished by the addition of letters (e.g., 33 and 33A). The manuscript also includes additional, unnumbered images, indicated by blank circles, while some numbers are crossed out. Furthermore, there are no cues indicated in places—for example the passage on Joseph Chamberlain—where press accounts clearly describe the images that were shown. Indeed, as discussed above, reports of performances consistently indicate that "Humours" involved some 150 to 160 slides. In other words, the number of cues (104) in the extant manuscript does not correspond to the number of images actually shown. Accordingly, editorial additions and interventions have been necessary. These are indicated in the List of Illustrations. Where reports of performances mention images that

Black Rod (pp. 192–93) that in *Good Words*, 1888, p. 107; of Salisbury's impressiveness (p. 199) that in *B&W*, 11 July 1891, p. 44; of crowds of ladies in Parliament (pp. 233–35) that in *Daily Graphic*, 17 July 1890, p. 8; of the Ladies' Gallery and flirtations in the House (pp. 228–30) that in *Graphic*, 16 March 1889, p. 278; of the search for an MP to make up a "pair" (p. 254) that in *B&W*, 4 July 1891, p. 4. The dialogue with the Usher (pp. 155–61) reappears in *CCI*, pp. 234–37; the misreporting of Swift MacNeill (pp. 161–62) in *MBD*, p. 282; the Parliamentary hat (pp. 203–7) in *Cassell's Magazine*, December 1903, p. 10; the Table of the Commons as a ventilator (p. 242) in *MBD*, pp. 268–69.

4. *Saturday Review*, 9 May 1891.

are clearly identifiable in Furniss's *oeuvre,* but are not indicated or cued in the extant text, we have reproduced the relevant cartoons in Appendix II.

We have not been able to identify conclusively all images for which the extant text provides cues. In addition, there is some ambiguity in the connection between text and cues. In places, it is not clear whether the image cues refer to the text that precedes or follows them; in any case, in a magic lantern show, images would have been displayed on the screen some seconds before the actual descriptions of them. (The location of the cues in the margins of the extant manuscript presumably indicates at what point a particular image was shown on the screen.) As this is a book, and in the interests of clarity, we have adjusted the location of the numbers to correlate more closely with what the text says at a given point, deducing from the context and from the known store of Furniss cartoons, which image was on display. For the most part, we have sought to include only those images where there are grounds for positive identification. Where we have hazarded a guess for the purposes of reconstruction, we have attempted to make this clear.

Thus, some editorial license has inevitably been exercised and the absolute integrity of the manuscript sacrificed in the interests of larger historical, cultural, and critical issues. Our aim has been, not to reproduce Furniss's entertainment as it was performed on any given occasion (an impossibility given the composite nature of the document), but to give readers, to the extent possible, an understanding of "Humours" as it was likely to have been performed on the basis of the manuscript itself, of Furniss's own comments in other works and letters, of reviews, and of published comments by contemporaries in periodicals and books. In doing so, we hope to give as accurate a picture as possible of, on the one hand, Furniss's particular "take" on Parliament, its denizens, and its milieu; and on the other, the ways in which his presentation was received throughout the UK and in significant locations abroad.

"THE HUMOURS OF PARLIAMENT"

The Extant Text

I APPEAR BEFORE YOU this evening not as a reader, or as a lecturer, but as an artist pure and simple. Pure, inasmuch as I take no side in politics: simple, perhaps, in imagining that I can interest you this evening in going over familiar pages in my Parliamentary sketch-books and briefly describing them to you.

At the outset I must ask you a favour; and in doing so I am reminded of a story told of that eminent comedian the late Charles Matthews.[1] He was impersonating a conjurer in a new piece, and at the rising of the curtain came forward to the footlights with an umbrella which he opened and tied to a string depending from the proscenium. He then

1. Among other things, Matthews was known for performing in a series of solo entertainments followed by a stage "'monopolylogue,' in which, by means of quick changes of costume, ventriloquism, and sharp differentiation of character, he played all the roles." Paul Schlicke, ed., *Oxford Reader's Companion to Dickens* (Oxford and New York: Oxford University Press, 1999), p. 379. These greatly influenced Dickens' readings from his novels, and "Humours" may be seen as a late-nineteenth-century variation of this tradition.

requested the audience to keep their eyes fixed steadfastly upon the ging-
ham, which they did during the whole of the play, evidently expecting that
it contained some surprise. The piece ended, down came the curtain, out-
side which still dangled the mysterious umbrella. Nothing having happened,
and the audience becoming impatient, Matthews appeared and bowed. Again
they called him before the curtain, and as he was retiring, they shouted "The
umbrella! the umbrella!" "Ah yes," said Mr. Matthews looking up, "I quite for-
got it. The fact is I have lost three umbrellas since I came to this theatre, and
I was determined not to lose another. Now, I knew you were all my friends in
front, and would kindly look after it for me. You have done so. Thank you very
much." The only thing, Ladies and Gentlemen, which I fear the loss of to-
night is that good humour, which upon a purely artistic and unpolitical occa-
sion like this, should always prevail. Now, I know that you are all my friends,
and feel sure that you will kindly keep an eye upon my umbrella. [1][2] Have I
your promise to do so? Thank you very much.

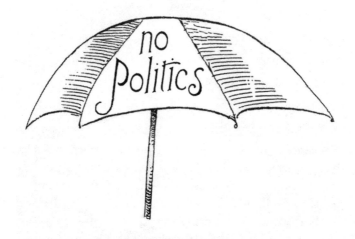

1. The "No Politics" Umbrella
Source: Image untraced. Recreated by Douglas Horrell

To my mind there is no bore like the elderly lady or gentleman who insists
upon personally conducting you through public edifices, whether you are one

2. This "motto slide" was probably specially prepared for the show (see Introduction, p. 72) and
has been recreated from drawings of umbrellas by HF. "Relating a funny but familiar anecdote re-
specting the late Charles Matthews, he [HF] cried 'There's my umbrella,' and forthwith on the screen
appeared the picture of a huge gingham umbrella bearing the words 'No Politics.'" *The Era*, 2 May
1891, p. 15.

of a gang of tourists "doing" a cathedral or a palace, or are the victim of a too good-natured friend who insists upon showing you every nook and corner of the new town hall, the new baths and wash-houses, or the recent improvements in the main sewer, although he knows well that you can get all he tells you in a sixpenny guide-book. Were I to attempt to dwell this evening upon the history of Parliament, or upon the architectural merits or defects of the buildings at St. Stephen's, you would doubtless soon give me as suggestive a hint as the famous Astley once gave to his leading tragedian, viz: "Cut the cackle, and come to the 'osses.'"[3] In my case I suppose it would be, "Cut the history and the architecture, and come to the men." So, I at once usher you into the House of Commons at eleven o'clock in the morning.[4]

The House, when not sitting, like a theatre in the day-time is but the shell of itself. [2]

The busy attendants like sportive shrimps in the house of the hermit crab when the host is from home, are making light of the solemn traditions of the place.

The men dressed like French cooks, I need scarcely say, are not hiding choice kickshaws[5] under the seats—to surprise the members when they arrive, but are merely dusting the empty benches. Chaff flies between the servants in the gallery and those below. The attendant in the Press Gallery as he pours into the numerous inkstands the portentous fluid which will shortly be record-

3. HF refers to the equestrian performer and circus proprietor John Conway Philip Astley (1768–1821), who inherited the management of the performing amphitheater created by his father, Philip Astley (1742–1814), and also wrote and acted in popular dramas. Elsewhere, however, the quotation is attributed to Andrew Ducrow (1793–1842), who managed Astley's amphitheater after his death. See Albert Barrère and Charles G. Leleand, *A Dictionary of Slang, Jargon & Cant*, 2 vols. (London and Edinburgh: Ballantyne Press, 1889–90), vol. 1, p. 216. HF, himself a keen horseman, would have been aware that Astley's amphitheater, which had a stage in addition to a ring, was located in "Westminster Bridge Road, across the Thames from the Houses of Parliament" (Schlicke, *Oxford Reader's Companion to Dickens*, p. 106). Thus from the very beginning of "Humours" HF portrays the House, as he says three lines later, "like a theatre," a circus ring of performers turning their tricks for the amusement of his (HF's) audience. Astley's closed permanently in 1893 and only a few years later HF's own "entertainments" fell before the unstoppable rise of the cinema.

4. Although HF cuts the history and the architecture in order to get to the men, the Parliament buildings he drew and are the setting for "Humours" were the New Palace of Westminster, which was designed, constructed, and fitted out over the two decades following the great fire that destroyed the old Houses of Parliament in 1834. On the architecture, building, and decoration of the New Palace, see M. H. Port, ed. *The Houses of Parliament* (New Haven: Yale University Press, 1976). Important interpretations of the functional significance and symbolic meanings of the Houses of Parliament include Roland Quinault, "Westminster and the Victorian Constitution," *Transactions of the Royal Historical Society*, 6th series, vol. 2 (1992), pp. 79–104; and David Cannadine, "The Palace of Westminster as the Palace of Varieties," in idem, *In Churchill's Shadow: Confronting the Past in Modern Britain* (London: Penguin, 2002), pp. 3–25. See note 14 for the seating arrangements in the Commons chamber.

5. Fancy dishes in cookery.

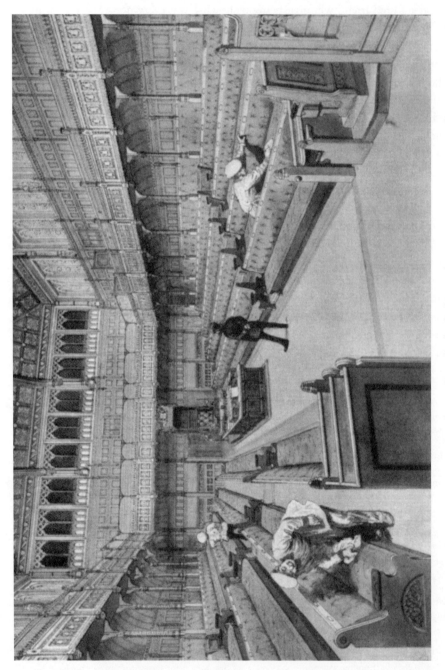

2. Preparing for the Sitting

Source: "In the House of Commons. 10am" (*PPP*, p. 3)

ing matters of the mightiest moment,—edicts which perchance may rule the destiny of nations, thoughtlessly hums a comic song, and actually so far forgets the place he is in as to enquire of another domestic how his old woman is, or whether the chickens are laying, and what is good for rheumatics.[6]

In the centre is the Speaker's chair, which in times of obstruction[7] might be called the chair of torture, for here he must pass many weary hours, listening to the rasping voice of the irrepressible bore, the windbag orator, or some murderer of the Queen's English. Upon his right, sit the members of the Government, and upon his left the members of the Opposition, the ministers and ex-ministers sitting on the front benches.

The three clerks sit in front of him.

This is the Gangway, below which the fiercer spirits sit.

No member when addressing the House is allowed to overstep these red lines marked on the floor. Should his foot protrude in front of them, howls from the members and loud calls of "Order" are immediately heard.

It may interest you to know that this line is a relic of the past when sharp swords were sometimes the parliamentary weapons in vogue, instead of sharp words as now. The object was to prevent bloodshed, but this survival of past times is of little practical use now as even umbrellas are not allowed in the chamber itself.

The only sword in the House is worn by the Sergeant-at-arms sitting here, but I have never seen it unsheathed.

This is the bar of the House. When anyone is brought to it a double pole is pulled out like a telescope from either side, but except on these rare occa-

6. Until 1803, when the House of Commons passed a resolution giving official sanction for members of the press to attend debates, reporting had been greatly inhibited by a variety of laws and practices that forbade publicizing the business of the House. In the old Commons chamber, the press colonized one of the galleries, leading Macaulay to declare famously in 1828 that "The gallery in which the reporters sit has become a fourth estate of the realm" (quoted in Meisel, *Public Speech*, p. 27). In the New Palace of Westminster, which opened in 1852, the press was provided with its own purpose-built gallery. Until 1881, when the gallery was extended (though insufficiently according to HF—see note 540), seats were made available only to members of the London press, although their provincial colleagues found various ways to gain admission. In 1895, after he had left *Punch* and started his own magazine, *Lika Joko*, Furniss applied for and, notwithstanding his long parliamentary association and professional status, was repeatedly denied permission to sit in the Reporter's Gallery. See HF correspondence with Sergeant-at-Arms Erskine, 2–18 January 1895, Parliamentary Archives, HC/SA/SJ/5/18.

7. A strategy used by Irish MPs in the mid-1870s through the mid-1880s that sought to force Parliament to deal with the Irish question by using procedural gimmicks to bring other business to a standstill. Under the leadership of Charles Stewart Parnell obstruction became official policy for the Home Rulers, but the introduction of new procedures allowing for closure of debate in 1882 began to blunt its effectiveness as a political weapon. While obstruction did not achieve Home Rule, it and the frustration it generated became a fact of political life.

sions it is as invisible as Sir Wilfred Lawson would have certain other bars in the kingdom if he had his way.[8]

Presently a member enters to show the House to a party of friends. [3, no image]

The ladies are delighted beyond measure.

One is soon seated where she is told the charming Mr. Balfour lolls.

Another prefers where dear Mr. Gladstone used to sit; while the youngest opens the despatch boxes upon the table, thinking she may discover left behind one of Mr. Gladstone's collars,[9] or a bottle of his eggflip.[10]

A little later a buzz of life begins in the Inner Lobby. Early members are popping in and out of the Post Office for letters, and of the Vote Office for Bills.

Some members, indeed, seem to think that their whole duty to their Queen and country insists in rushing about with the largest possible quantity of documents. The fussy Mr. Nincompoop, the member for Muddlebrain, makes a vast parade of appearing to be busy. [4][11] He has no sooner left the Office with a big bundle, than some member carrying a larger one still catches his envious eye and straightway he rushes back like a parliamentary Oliver Twist for more.

In this office in fact are kept all bills, orders of the day, estimates, blue books, and printed matter which with other parliamentary papers so swell the annual vote for stationery. [5, no image] You can get everything in this office but an order for the Strangers' Gallery.

8. Lawson was a leader in the temperance movement (see Appendix VI). Furniss later vehemently opposed teetotalers in a series of pamphlets caricaturing them as killjoys and promoting instead, as a good clubman would, a John Bullish beer-is-good-for-you campaign.

9. On HF and Gladstone's collars, see note 42.

10. During major oratorical efforts, Gladstone sustained himself with a concoction of egg and sherry which he kept in a small pomatum pot. As Furniss demonstrates, the pomatum pot was the object of some amusement among parliamentary observers. Henry Lucy, writing in 1878, gives an excellent account: "This mysterious vessel, which exercises a modest but important influence upon our principal Parliamentary debates, is brought into the House only on great occasions. It is of glass, oval in shape, and two and a half inches high, and closed with a cork with a wooden top. These details appear minute. But I dwell upon them for the sufficient reason that I cannot further describe the contents than to say they resemble a preparation for the hair as it might look in sultry weather. Members who aspire to oratorical success have wasted much valuable time in the endeavour to ascertain the precise qualities of the substance with which Gladstone lubricates his vocal organs during the delivery of his orations. . . . Whatever the bottle contains, it is carefully brought into the House and cautiously deposited on a corner of the table where it is likely to be free from the sweep of the orator's arm. There at convenient intervals it is produced, and Imperial Parliament looks on in wonder as Gladstone, putting the stout neck of the ungainly bottle to his lips, draws in the nourishment, and starts again like a giant refreshed; but not before he has corked up the bottle and replaced it in a situation of security on the desk." Henry Lucy, *A Diary of Two Parliaments: The Disraeli Parliament, 1874–1880*, 2nd ed. (London: Cassell, 1885), pp. 450–51. See also image 24.

11. "We see a well-known member in the exaggerated jacket with which Mr. Furniss has fitted him, struggling under the weight of his letters." *Daily Chronicle*, 1 January 1891.

4. The Fussy Mr. Nincompoop
Source: "Hon. C. R. Spencer. 'A Serious Politician'"
(*Punch*, 26 May 1888, p. 252; rpt. in *MPS*, p. 52)

Twenty years ago there was a free and easy haphazard admission of strang-ers. Every member could give one order a day. That is, 670 orders for the only 60 seats available. An M. P. wrote your pass on any piece of paper which was handy, on an old envelope, your shirt cuff, or on the lining of your hat. You did not trouble to rush down to the House to secure your seat yourself, hours in advance, but sent a substitute, an unfortunate creature who kept your seat warm from early morn to dewy eve when the fun began.

Now-a-days a little red-tapeism in addition is required, and you then get a proper admission ticket printed and dated.

Arrived at the turn-stile which leads to the Gallery, you hear that your favourite orator is on his legs, and are therefore all excitement to get into the House. But first you have to sign your name, and it is aggravating to find that

Mr. Giles is stopping the way. [6a][12] Already he has written his name three times in the wrong column, and Mr. Shillelagh,[13] from the 'Ould counthry' who has come to hear his darlin' member 'spachify,' is indignant as he reads the notice on the wall that all demonstrations by strangers in the Gallery are out of order, and must be treated accordingly, [6b] which he soon discovers is no idle threat as he witnesses the ejectment of this highly respectable stranger, [6c] who I may mention has either been eating buns, or cracking nuts, or reading papers, or winking at the Ladies' Gallery, or making faces at the Speaker to incur the risk of such a terrible humiliation.

6a. Admission of Strangers
Source: "This Way to the Strangers' Gallery" (*The Graphic*, 9 March 1889, p. 249)

12. The editors have expanded the original single image 6 to three (6a, 6b, 6c) since HF's description matches all three images and the typescript has numbers 9 and 10 crossed out suggesting that at one time three images of the scene were shown. HF has written on the draft sketch of 6a "a pink tint all over this slide." PA HC/LB/1/112/397.

13. A shillelagh is a thick stick of blackthorn or oak used in Ireland especially as a weapon. Shillelagh is a town in County Wicklow. This is the first of many disparaging references to the Irish.

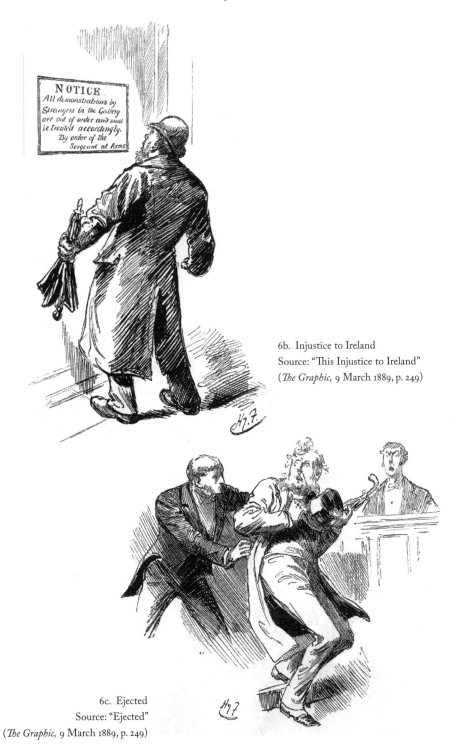

NOTICE
All demonstrations by
Strangers in the Gallery
are out of order and must
be treated accordingly.
By order of the
Sergeant at Arms.

6b. Injustice to Ireland
Source: "This Injustice to Ireland"
(*The Graphic*, 9 March 1889, p. 249)

6c. Ejected
Source: "Ejected"
(*The Graphic*, 9 March 1889, p. 249)

The first impression of the stranger on entering the House of Commons is undoubtedly one of disappointment. The building looks small and insignificant, and in point of fact was not originally designed with a view to the accommodation of such crowded assemblies as recent times have witnessed.[14]

The space is limited, but M.P's are not rejected like pictures at an Art Gallery on account of their size, and positively there are not seats enough to accommodate the members, so that a candidate who has fiercely contested a vacant seat when he is elected and rushes off to St. Stephen's may find when he gets there that he is either skied in the gallery[15] or has to sit upon the floor. A propos of this I may remark that the phrase 'taking a seat for such or such a place' originally meant that the newly elected member had to take with him to the House his own camp-stool or library chair.

The stranger will next feel amused at the curious and unique sight of rows of hats on the seats, which Mr. Punch has called 'The hattitude of the House before prayers.' [7][16]

You would imagine from the appearance of the benches that hon. members were for some reason hiding under them.[17] In reality this is the only way they can reserve their seats. Old ladies could not be more fidgety about their favourite corner in their pew in Church than M. P.'s are about their seats in Parliament. Their devotion is shewn by their placing their hats upon the benches whilst they walk about the lobbies and corridors bareheaded at the risk of catching violent colds. I may mention an incident which occurred when Mr. Gladstone introduced his great Home Rule scheme on the memorable 8th April 1886. The excitement was intense. Irish members did not

14. Before the fire that consumed the Houses of Parliament in 1834, the Commons met in St. Stephen's Chapel, which had a seating capacity far less than the full membership of 658 after the union with Ireland (and had been too small to seat all 558 members before 1801). The extremely crowded debates over the Reform bills in 1830–32 prompted the creation of a select committee to examine how to make St. Stephen's more commodious. The specifications for the new Houses of Parliament drawn up after the 1834 fire included seating for 420 to 460 MPs on the benches and accommodation for the remainder in the galleries. As it turned out, however, the realized design of Charles Barry, into which the Commons moved beginning in 1850, provided seating for only around 300 on the floor and 120 in the galleries. See Port, ed. *Houses of Parliament.*

15. To sky means to hang a picture high up on the wall.

16. "The 'hattitude of the House before prayers' showed the seats in the Commons occupied by a motley array of hats." *Aberdeen Weekly Journal,* 1 December 1891. See also "Reserving Seats Before Prayers." *PPP,* p. 11.

17. Writing in 1856, the door-keeper of the House of Commons noted: "Most of the members sit covered, as well as Government officials. It is convenient for them to do so. The hat is a kind of pent-house under which they can retire from the gaze of the members and of strangers; for as the light comes all from the ceiling the brim of the hat throws the upper part of the face into shadow; and whether they wince under an attack or are excited to smile, nobody can see their movements." William White, *The Inner Life of the House of Commons,* 2 vols. (London: T. Fisher Unwin, 1897), vol. 1, pp. 5–6. HF has more to say about hats later in the show (see pp. 203–7).

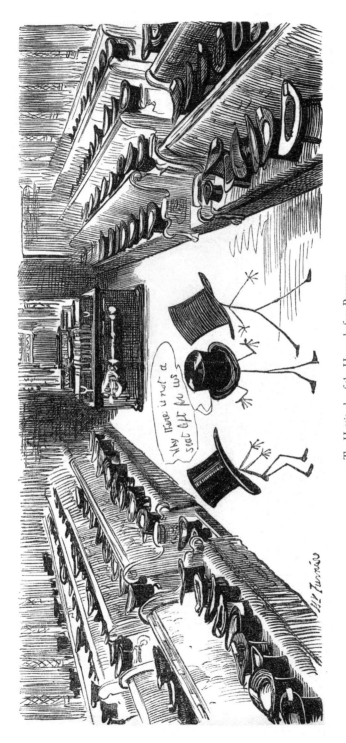

7. The Hattitude of the House before Prayers

Source: "Hat Étude of the House (Before Prayers)" (*Punch*, 7 April 1883, p. 165)

8. Parnell
Source: Image untraced. Editorial substitution:
"The Irish Leader" (*Diary SP*, p. 299)

trust to their hats to retain their seats, but at break of day made their way into the House and lay down upon the benches, where wrapped up in railway rugs they went to sleep.

I recollect arriving before ten o'clock. These members were then just awaking from their slumbers, but I have never for a moment given credit to the story I heard that a certain wag had aroused them by calling out,

"Tickets please. All change here for College Green."[18] Or that a certain member, slumbering on a back bench, was carried by his imagination into mid-channel and was heard to faintly murmur "Steward."

When Mr. Parnell fell out with his party he insisted upon retaining his usual seat on the Irish Benches, but, to prevent any breach of the peace, the

18. A square in the center of Dublin. In 1885 Dublin was divided into four constituencies, one of which was named College Green and this became an Irish Nationalist stronghold. College Green was also an especially evocative location for nationalists because it was the site of the pre-1800 Irish parliament building.

Irish members selected the largest member of the Liberal side, placed him between Mr. Parnell and Mr. Justin McCarthy to act as a sort of Political Buffer for the time. [8][19]

A few years ago an hon. member brought to light the terrible fact that a certain member had actually two parliamentary hats, and thus bitterly complained. [9][20]

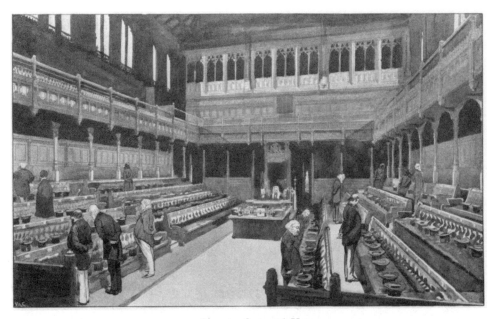

9. Reserving Seats with Hats
Source: Image untraced. Editorial substitution: "Cause and Effect in the Commons.
The Speaker has modified the unwritten rule concerning the retention of seats by members.
Owing to the prevalence of Influenza, so easily caught by the bare-headed" (*PPP*, p. 23)

"Bister Sbeaker,—I bust caud the adtedshud of the House of Cobbods to a circubstadzt that has cub udder by obzervashud. It is the custob id this House for bembers to retaid their seats by placid their hats upod the bedch,

19. HF found difficulty in capturing the essence of Parnell, which may account for the ordinariness of this sketch: "No portrait ever drawn by pen or pencil can hand down to future generations the mysterious subtlety in the personality of the all-powerful leader" (*CCI*, p. 179). When the image was shown the *Scarborough Evening News* remarked that "it was noteworthy that Parnell's was the only sketch that met with hisses" (16 September 1891). On the typescript, a marginal note "Police" is inserted after this paragraph. Possibly, this had something to do with Parnell's arrest and imprisonment in October 1881 for his violent speeches in opposition to Gladstone's Land Act, perhaps in connection with the more recent (November 1890) verdict in the O'Shea divorce case in which the Irish leader was named as corespondent.

20. Clearly related to image 7.

but I fide that certaid bembers provided thebselves with two hats, leaving one od the bedch ad wearing the udder, thus evadid the ruds of the House, whereas bembers like myself strictly ashered to a didshud if dolselsical custob rud the risk of getting a colt id the head."

A propos of reserving seats, I may tell of my awkward position when I first claimed mine as Mr. Punch's representative.

The Press Gallery is, as you all know, directly over the Speaker. The front row is divided into little boxes where the representatives of the leading papers sit. The others are seated above them against the wall.[21] [10]

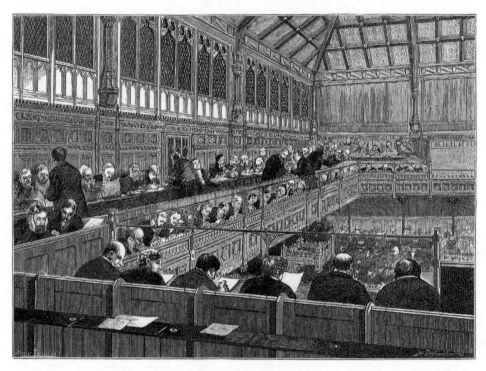

10. The Press Gallery
Source: "The Press Gallery, House of Commons" (*B&W*, 30 May 1891, p. 560)

21. HF criticized the cramped quarters of the Press Gallery: It "is not large enough to accommodate all those who have a right to sit there. There is a row of boxes in front allotted to the representatives of the principal newspapers, and a couple of funny-looking pews at either corner, also reserved for special papers or news agencies; but the mass of gentlemen of the Press have to sit at the back, at a narrow piece of wood as a desk. . . . The fighting to get into the Reporters' Gallery by those authorized to be there is a disgrace to all responsible for the accommodation of the House." HF, "The Press in Parliament," *Cassell's Magazine*, vol. 40 (June 1905), p. 143.

These members of the press look like a row of aged school-boys very much troubled to write anything about Parliament to-day.

Their monitors sit by the seats near the doors.

I shall never forget my first experience of a press gallery official.[22] He was big and fat, in evening dress, and wore a real gold chain, with a badge in front like a Mayor or sheriff. He awed me—recollect I am now speaking of the day I entered as a new boy, and I trembled in his presence.

There was no vacant seat except the one next to him.

He sleeps! [11][23] Nervously I slip into the seat!

11. The Sleeping Usher
Source: "He Sleeps" (*CCI*, p. 235)

22. The following account is reprinted and expanded in *CCI*, pp. 234–41.

23. Although the typescript gives eight image cues for this sequence, only the five that are reproduced here appear in *CCI*, pp. 234–41. There are no images in the published group that are a clear match for cues 14, 15, and 17. It may be that some of these repeat other images in the sequence. We have decided to leave the cues as they are in the typescript in order to preserve the sense of the flow of images in the performance.

He wakes! and looks down at me.

"H'm! What are you?" is his sleepy remark. [12]

12. The Usher Questions Furniss
Source: "Here, I Say, What Are You?" (*CCI*, p. 236)

"Punch," I reply.

"Ticket?"

"Left it at home."

"Bring it next time."

"Certainly," say I relieved.

He slumbers again. I strain over to see who is speaking. This wakes the gentleman with the real gold chain again. He gazes down upon me. I feel smaller. [13]

"What are you?"

"Punch."

"Eh! Where's ticket?"

"Left at home."

"Bring it next time. Saves bother, young fellow."

"Certainly," I reply, and encouraged by his familiarity I venture to ask,

"Who is that speaking?"

I just got the question out in time, for he was dozing off again. [14]

13. The Usher Gazes Down on Furniss
Source: "'Punch,' I replied" (*CC*I, p. 236)

14. The Usher Dozes off Again
Source: Image untraced. Editorial substitution: repeat of
image 11 "He Sleeps" (*CC*I, p. 235)

"New Member," he replied, and half dozing he goes on more to himself than to me.

"One more fool! find his level here! all fools here! Stuff you've been givin' them at your College Union. Rubbish! Yer perambulator's waitin' outside. Oh, follow yer dad to the Upper House, an' look sharp about it."

He mumbles.

I well recollect the youthful member, so criticised, labouring through his maiden speech.

The eldest son of a peer, with a rather effeminate face, Saxon fairness of complexion and with an apology for a moustache.[24]

It struck me that if petrified he would do very well as a dummy outside a tailor's establishment.

Yet this youthful scion of a noble line has a good record. He carried off innumerable prizes at Eton, was a double first at Oxford, President of the Union, and a fellow of his college, one of the University Eight, and of the eleven.[25] Distinguished at tennis, racquets, and football. Hero of three balloon ascents. Great at amateur theatricals. A writer upon every possible subject, including theology, for the leading magazines. Member of sixteen London clubs. Married a titled heiress, and is only thirty years of age.

Some of his college friends sit in the Strangers Gallery to hear their late President make his first great effort in the real Parliament.

The effort disappoints them. Their champion is "funky." When the Oxford Eight was behind at Barnes Bridge, it was Dolly's muscle and nerve that pulled the crew together, and won the race. When at Lord's the match was over and the Light Blues had won all but the shouting, Dolly went in last man and rattled up fifty in half an hour, and won the match.[26]

When at the Oxford Union he spoke on the very question now before the

24. Possibly William St. John Brodrick (1856–1942), later Earl Midleton. A peer's son, Brodrick had attended Eton and was president of the Oxford Union in Hilary Term 1878, although HF may have exaggerated his other distinctions. He made his maiden speech on 29 June 1880 during the debate over the second reading of the Compensation for Disturbance (Ireland) Bill.

25. Double first was to achieve the highest class of examination results in both the *Literae Humaniores* and Mathematics honors schools (Gladstone was one of the earliest among those with this remarkable achievement). The presidency of the Oxford Union Society, the prestigious debating forum dubbed the "nursery of statesman," was considered to mark one out for greatness, not least on account of the precedent set by Gladstone, who had been elected president in 1830. Far more than distinction in academics and at the Union, the highest undergraduate status was usually obtained in sports, especially as part of the eight-member rowing crew or the eleven-member cricket team. See next note.

26. The traditional rivalry between Oxford University (the "Dark Blues") and Cambridge University (the "Light Blues") was marked annually by the Boat Race on the River Thames, the crews at one point passing under Barnes Bridge, and the match at Lord's, home of English cricket. Furniss sketched both events for the *Illustrated London News*.

House, namely, whether a tax should be imposed upon periwinkles, his oratory alone turned the scale and gave his party the victory.

Yet now, his speech upon the Periwinkle problem has certainly not impressed the House. Men listened for a time and then adjourned to dinner, and his splendid peroration—recognised by his friends as the same which he had delivered at the Oxford Union, failed to elicit a single cheer.

Curiosity, however, induced his supporters to remain and hear the reply.

The next speaker was a contrast to their hero, and a titter went round among Dolly's friends in the Gallery.[27] He was a type of the preaching member. No doubt a very worthy soul, but hardly an adonis to look at nor a Cicero to listen to. Still, he is sincere, and with his own class effective; and sincerity, after all, is the most valuable and I may add the most rare quality in the composition of an ordinary member of Parliament.

My neighbour, the Usher, at this point opens his left eye, which takes in at a glance the Opposition side of the House and breaks out in this style. [15, no image]

"All right, little; 'un! Keep wot yer sayin' till Sunday. Yer sermon's sending me to sleep. Forcing taxation on the winks[28] of the 'ungry Englishman will raise the country to revolt. Tommy rot! Here endeth the first lesson, thank goodness!"

The soliloquizing official rolls off his seat chuckling at his self-enjoyed witticism, and as he rolls along the Gallery envelopes are handed to him by the reporters. He rolls back to the door, opens it, gives the copy to the messengers waiting for it, and rolls back once more into his seat. In doing so he spies me.

I feel smaller. [16]

"Here, I say, what are you?"

"Punch."

"Where's ticket?"

"Left at home."

"H'm! don't forget it again."

"Certainly not."

I say nothing more as I am too much interested in his running commentary upon the proceedings.

With a grunt he shakes himself down in his place and proceeds. [17, no image]

27. Broderick was followed by Captain William O'Shea (best known for being the husband of Parnell's mistress), but HF's description is a better fit for the next speaker, W. H. Smith, the newsagent turned politician who was known for being sincere, effective, and representative of his class.

28. Periwinkles.

16. Furniss Feels Smaller
Source: "I Feel Smaller" (*CCI*, p. 238)

18. The Usher Looks Down at Furniss
Source: "I Feel Smaller!" (*CCI*, p. 241)

"Blow periwinkles, say I. Words! Words! No 'ead nor tail. Oh! 'ere's the old un up. We're getting' 'usky, old un. Both 'ad too much of this job. We're very much alike, Gladdy and me. Both great eaters and great sleepers. But spare us 'Arcourt!"

"Sir William has just come in," I venture to remark.

"Eh, what!" he ejaculates, looking down at me. [18]

I feel I am getting smaller than ever.

"What are you?" he thunders.

"Punch."

"Ticket?"

"Left at home."

"Bring it next time. Hullo! what's that?"

"This?" I said, "This is a sketch."

"Got 'im, chins and all! 'Arcourt to the life! Shake 'ands."[29]

And the good-natured soliloquizing official and I were the best of friends ever afterwards.

PRESS REPORTERS DIFFICULTY *Dilate on Press*
IRISH ACCENT[30]

M.P's get mis-reported. [19][31]

When in the course of a speech, Mr. Swift MacNeill quoted the judicial declaration of the late Baron Dowse[32] that "The resident magistrates could no more state a case than write a Greek ode" it was deliciously given by a reporter as "The resident magistrates could no more state a case than they could ride a Greek goat!"

Mr. Swift MacNeill figured in another amusing case of mishearing in the Reporters' Gallery. [20] He once complained of being roughly treated by the constabulary while attending some evictions in his constituency in Donegal.[33] "But," said the honourable member, "I took measures to put a stop to this

29. Sir William Harcourt with several chins was HF's signature for *Punch*. See images 30 and 31.

30. These are clearly notes to himself. HF repeats the anecdotes that follow in *MBD*, pp. 281–83.

31. An "enlarged reproduction" of a *Punch* cartoon of MacNeill "caught in the act of laughing is one of Mr. Furniss's most popular effects in his lecture on the 'Humours of Parliament.'" *Freeman's Journal & Daily Commercial Advertiser,* 24 June 1891.

32. Richard Dowse, MP for Londonderry and erstwhile Attorney-General for Ireland, had died in 1890.

33. Exacerbated by the onset of a prolonged agricultural depression, the Irish tenant farming system became highly politicized at the close of the 1870s. The Land League, formed in 1879 with Parnell as president, organized a campaign of violence and intimidation against landlords who evicted tenants as well as against Irish farmers who tried to move onto land where evictions had occurred. Gladstone's land legislation in the early 1870s and early 1880s failed to ameliorate conditions.

LI RA
JORO

19. The Mis-reporting of MPs
Source: Image untraced. Editorial substitution: "Swift MacNeill refuses to be named"
(*Punch*, 26 August 1893, p. 96)

conduct. Whenever I was hustled or knocked about by a policeman I simply chalked him, and by that means was able to identify him afterwards." This was rendered, "Whenever I was hustled or knocked about by a policeman I simply choked him!"

Let me pass on to greater men. To those who have stood at the Table of the House.[34]

What tales the despatch boxes of the House could tell, of human emotion and of political ambition, if only they could speak! Examine them closely, my

34. Following this handwritten insertion is "G. O. M." (for Grand Old Man, Gladstone's nick-name from around 1880). On the bottom of the next typescript page, HF has written "Dilate—then old G. O. M."

20. Swift MacNeill
Source: Image untraced. Editorial Substitution: "Mr. McNeill [*sic*] Is Irrepressible"
(*The Daily Graphic*, 19 June 1890, p. 9)

reader,[35] when you are next in the Commons, and note the peculiar kind of wear and tear from which they have suffered. Their edges have become positively polished by the statesmen who have stood beside them, and whilst delivering their speeches have laid their hands upon them; some with a light caressing touch while indulging in a vein of satirical humour, others with the hard grip significant of passionate enthusiasm, racial hatred, or personal ambition. They are dented all over by the sharp stones of many a signet ring, conjuring up

35. An indication of the hybrid nature of the typescript and a hint that HF intended publishing "Humours" in some form, though only small parts appeared sporadically elsewhere. See Introduction, p. 137 and note 3.

visions of those Ruperts of debate[36] past and present, who, with arm uplifted
and kindling eye, have suited the action to the word, and given emphasis to
an argument, or clinched a doubtful point, with a resounding blow upon the
unoffending box, which it has recorded in the scars thus inflicted upon its
shining surfaces. How many illustrious politicians have used those boxes, and
how differently has each, in turn, handled them! Among the many traits pecu-
liar to different statesmen and members of Parliament, of which I have had
occasion to take note in the course of my lengthened experience of the House
of Commons, few have been more interesting to observe than those by which
these boxes have been effected. Naturally, the orators of the present day, who
care little for dramatic effect, get less out of the table and the boxes than did
most of the distinguished men mentioned in my former article.[37] It is chiefly
the orators of the past who have helped to give the significance indicated by
those valuable "properties." Mr. Disraeli, however, simply treated them with
contempt, as he showed when in his neat but careless phrase, he stigmatised
the table of the House as "a substantial piece of furniture." Mr. Disraeli never
seemed to be on very good terms with the boxes, for when he stood at the
table in the attitude which was so familiar to the habitues of the House, that
is, with one hand under his coat tails, he was wont with the other to place
merely the tips of his fingers upon the lid of the box, just as if he thought it
wanted dusting.

But other ministers have reason to be thankful that when Cromwell
pointed to the Mace, and cried "Remove that bauble!"[38] he did not also order
a clean sweep of the table and all that was upon it—provided, of course, the
boxes were there in his day—for they have been, since then, undoubtedly a
considerable assistance to the oratorical efforts of many a would-be Cicero.
The late Sir William Harcourt, for instance, pitched into the box in a fierce
pugilistic fashion, that in more senses than one formed a striking contrast to

36. Prince Rupert, a Royalist commander during the English Civil War, gained fame both for
his tactical genius and for the critical defeats he suffered. In April 1844, Disraeli famously invoked
the Prince in order to mock the Secretary of State for War and the Colonies, Lord Stanley: "The
noble lord in this case, as in so many others, first destroys his opponent, and then destroys his own
position. The noble lord is the Prince Rupert of Parliamentary discussion; his charge is resistless; but
when he returns from the pursuit he always finds his camp in the possession of the enemy (cheers
and laughter)" (quoted in M&B, vol. 2, p. 237). The phrase "Rupert of debate" was coined two years
later by Disraeli's friend Edward Bulwer Lytton, who, in his *New Timon* (1846), described Stanley
as "Frank, haughty, rash—the Rupert of debate" in reference to his fearless but reckless attacks on
the Irish political leader Daniel O'Connell in 1833.

37. Another indication of the mixed nature of the extant text.

38. On 20 April 1653, Oliver Cromwell forcibly dissolved the House of Commons. Following the
removal of the Speaker, Cromwell looked at the Mace of Parliament—the symbol of royal author-
ity and, therefore, the authority of Parliament—and asked, "What shall we do with this bauble?" to
which he then answered, "Here, take it away!" *EP*, pp. 182–83.

the attitude adopted by the late Tory Chief. Mr. W. H. Smith used to handle it in a business like, mercantile manner, as though he were offering you a remarkably cheap bargain. G. O. M. Every member, in fact, has his pet way of displaying his fancy for the box. But there has only been one man in the House of Commons, within my recollection, who really understood how to court the mysterious receptacle, and that was Mr. Gladstone. I can see him, in imagination, as I speak, approach the table at the beginning of a speech, and, as it were, shake hands with the box. [21][39] Lovingly, he places his hands around it, and bends over it with an air of tenderness that is positively touching. When he coaxes the House, he also coaxes the box. He rubs it sideways gently, as you stroke a favourite cat. When he leans over it, it is as if a friend had whispered in his ear, "Hold on to the box, and it will pull you through." When, to gain effect, he stands away from it for a moment, and with that wonderful command of by-play and appropriate gesture which contributed so much to the effective exposition of his views, draws all eyes towards him, the box almost seems sensible of the desertion, and almost inconsolable until he returns to it again, and pats it softly with one hand as much as to say, "Keep quiet! Don't be alarmed! I'll bring the sentence round all right." And as he does so he almost embraces it once more. No one, in fact, ever made so much byplay with the box as Mr. Gladstone; and I firmly believe that if anyone had removed it just before he began to speak, he would have been as much discomforted as was Charles Lamb when a mischievous wag cut off the button of his coat,[40] or as was Lord Chief Justice Russell when incontinently deprived of his inevitable snuff box.[41]

39. Drawing a contrast with Frank Holl's portrait of 1888, HF claimed his sketch of Gladstone, who "was more at ease at the table in the House of Commons than in any other position," captures his "true and characteristic pose" since it shows his habit of resting his hands on the box when "in the act of delivering a speech" (*CCI*, pp. 170, 169). The sketch clearly shows Gladstone's left hand with only three fingers. Gladstone accidentally shot off his left forefinger in 1842. HF claimed to be the first to notice this deformity: "It was I who . . . drew public attention for the first time to the fact that, although Mr. Gladstone used the expression 'an old Parliamentary hand' figuratively, in reality the left hand he held up while he spoke those words, had but three fingers . . . and yet Members who had sat in the House with him for twenty years had never noticed it! So much for observation" (*PPP*, pp. 70–73).

40. HF here muddles an apocryphal story about the writer Charles Lamb (1775–1834) encountering his friend Samuel Taylor Coleridge (1772–1834) who, to describe the ideas filling his head, took Lamb by the button of his coat into a nearby garden and commenced a lengthy discourse with his eyes closed in thought. After listening for some time, Lamb is said to have cut the button off his coat with his penknife and continued about his business. The story ends with Lamb passing the same spot hours later and finding Coleridge still talking with his eyes shut and Lamb's button in hand. For a full account, see E. V. Lucas, *The Life of Charles Lamb*, 3rd ed., 2 vols. (London: Methuen, 1906), vol. 2, pp. 267–68.

41. Russell's snuff-box is described by his biographer as "ever-present." R. Barry O'Brien, *The Life of Lord Russell of Killowen*, 2nd ed. (London: Smith, Elder & Co, 1902), p. 103.

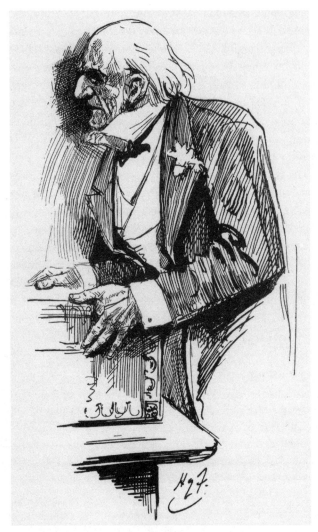

21. Despatch Box
Source: "Mr Gladstone Leaning Over Box On Table" (*SVM*, p. 234)

Taking a typical day, when the House was pretty crowded and there was an interesting debate on, Mr. Gladstone generally put in an appearance just before the Questions were over.

With an apologetic air he walked to his seat, retained of late years between Sir William Harcourt and Mr. John Morley, and a cheer from his own side when any excitement is in the air, signalled his arrival. If he was a little late, he asked his neighbours what had happened, and if there had been nothing

of very great importance he leant forward to the table which Lord Beacons-field once called "a substantial piece of furniture," and placing an ink-bottle in front of him, and a blotting pad on his knee, scribbled away.

His thoughts flew with his pen, but his ears were open, and should any-thing occur, however trivial, which personally concerned or interested him, he was quickly all attention, and leaning forward he placed his hand to his ear, so as to catch every syllable.

I am popularly supposed to have invented Mr. Gladstone's collars. I believe I discovered them. Many members wear collars quite as large as Mr. Glad-stone did—even larger, but they are not so evident, for the reason that when Mr. Gladstone sat down it was his habit to place himself forward upon the bench, with body bent, arms folded, and his head so buried in his coat that his collar was bound to rise, and I have frequently seen it looking quite as con-spicuous as any that I show in my caricatures.[42]

Upon great occasions Mr. Gladstone's dress was worthy of notice. His free and easy grey clothes were discarded, and he came to the House looking quite spruce. In an ordinary way, although no doubt he could have written vol-umes on "How to Dress" from the days of Trojan homespun to those of Irish frieze,[43] he was not regarded as a model for the cut of his clothes.

But a black coat, light trousers, and a flower in his button hole were indica-tive of a great speech, and when the historical pomatum pot—which con-tained I believe a mixture of egg-flip and honey—was produced from his coat pocket and placed by the despatch box, reporters sharpened their pencils, sent for more 'flimsy,'[44] and prepared for a long speech.

Of course, the Speaker of the House is well aware before hand of the order in which the more important speakers will follow each other, and after whom Mr. Gladstone wished to speak. Yet, before rising to address the House, the ex-Premier invariably appeared very anxious, holding his carefully prepared notes in his right hand, and sitting forward with both hands upon his knees,

42. Gladstone's turned-up collars were in fact no larger than was consistent with his gener-ally conservative and (for the 1880s) somewhat old-fashioned style of dress. HF claimed to have invented Gladstone's exaggerated collar purely for "grotesque effect." The device first appeared in the sequential cartoon "Getting Gladstone's Collar Up" in *Punch,* 8 April 1882, p. 160 (see Introduc-tion, fig. 9) in order to convey the statesman's famous vehemence in debate. The collar grows over five panels as Gladstone becomes increasingly exercised—that is (in a Furnissian pun), as he gets his *choler* up—the term for the bilious humor indicating anger, heat of temper, wrath, and irascibil-ity (see Introduction, pp. 89–90). To underscore the success of this iconographic innovation, HF claimed that when the editors of *Punch* ordered him to discontinue the collar device, they quickly changed their minds (*CCI,* pp. 163, 175). It was indeed rare for Furniss not to mention collars in the same breath as Gladstone.

43. A coarse, woolen cloth. Another hit at the Irish.

44. Very thin paper.

his firm, pallid face and hawk-like eye fixed upon the Speaker waiting for the signal to spring upon his foe.

Once up, he seems composed enough, played with his notes in front of him, and leaning forward with his hands upon the box, and latterly with a husky voice, slowly began.

The graceful introduction over, a tug at his wristbands an easing of his collar with one finger, a step or two back, a flash from those wonderful eyes, and then

Let others describe what followed.

As an artist, using his eyes perhaps more than his ears, I noticed that when confident he stood with his arms tight to his sides of his strong and quivering frame, that when the mighty orator paused to consider a difficult point he was apt to scratch the top of his head with the thumb of his right hand, when gracefully persuasive that he used this action, when excited and indignant this. [22][45] When emphatic he drove his arguments home to his listeners with tremendous power, bringing down his hand upon the box with amazing energy. [23]

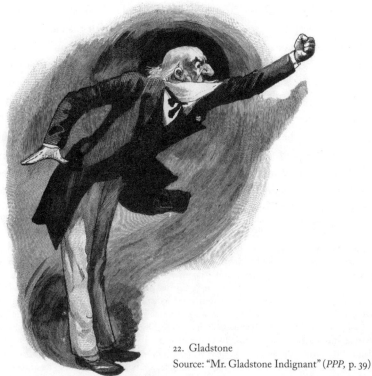

22. Gladstone
Source: "Mr. Gladstone Indignant" (*PPP*, p. 39)

45. This sketch is the first of a sequence reproduced in *PPP*, pp. 29–45.

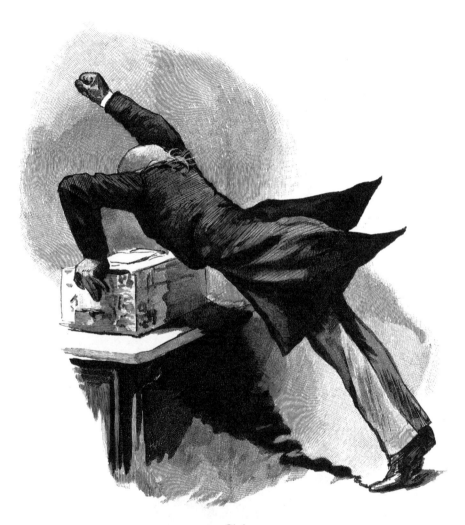

23. Gladstone
Source: "Mr. Gladstone Excited" (*PPP*, p. 37)

And then, and then, he took some egg-flip. [24]

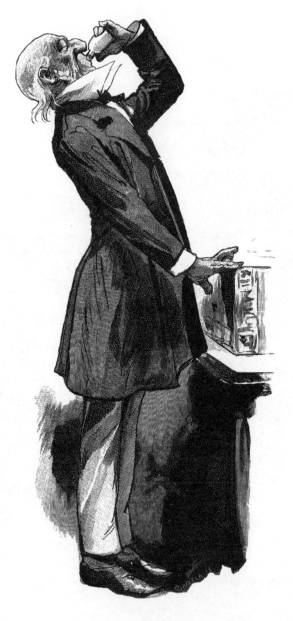

24. Gladstone
Source: "Egg-Flip" (*PPP*, p. 41)

That is his picture upon one side of the table, ladies and gentlemen. Now let us see him as he appeared on the other—that is, when he is in opposition.

Some member or other had caused the collar of the Grand Old Man to rise. Leaning forward, without any preparation, he rubs his legs from the knees downwards with nervous irritability. Then with collar fixed, eyes starting, and livid face, he awaits the moment to jump upon the members opposed to him. [25]

25. Gladstone
Source: "Mr. Gladstone Waiting To Spring" (*PPP*, p. 33)

Once up, he seemed all over the place. [26] There is a further rising of that wonderful collar, a sweeping away of the papers in front of him, a bang upon that unfortunate box, and then—

26. Gladstone
Source: "Mr. Gladstone Attacking The Front Bench" (*PPP,* p. 35)

Let me describe what follows.

As a caricaturist, flirting with fancy perhaps more than with fact, I note that when on the rampage, as I may call it, the Grand Old Man seemed as if in another moment, he would jump over the table, that when contradicted he took this action, and often of late he turned round to certain members upon the benches behind him, and oratorically, belaboured them up and down, showering his vehement outbursts upon their heads. [27] Then the mighty orator's

chest heaved with indignation, and the old Parliamentary hands rose and fell with dazzling rapidity, until at last, overcome by his power and eloquence, [28]⁴⁶ he threw himself down on the bench. [29]⁴⁷

27. Gladstone
Source: "A Peroration" (*PPP*, p. 45)

46. There is no number for this image in the typescript but is part of the sequence in *PPP* and according to the *Dundee Advertiser* of 26 November 1891 was shown, so it is included here.

47. This paragraph is followed, on separate lines, by the following handwritten notes: "Harcourt." "My Desk," with an image cue. And "Read what follows," underscored.

28. Gladstone
Source: "Mr. Gladstone Eloquent" (*PPP*, p. 43)

29. Gladstone
Source: "The G.O.M.'s Last Session" (*PPP*, p. 29)

It matters [little] what subject may be engrossing the attention of Parliament, casual visitors to the House will always take more interest in the men than in measures, and during the times I deal with this evening, next to Chamberlain, and, perhaps I should add Mr. Balfour, it was the massive figure of Sir William Harcourt that inevitably arrested their chief attention.[48] Nor would the stranger, as a rule, have to rest content with merely catching sight of that great statesman, for he was almost sure to rise, and, in the attitude in which I have here sketched him [30]—standing at the table with one hand upon the box, whilst with the other he points his arguments or adorns a tale perhaps—proceed to raise some point of Parliamentary procedure, of which, by the way, he was a past master; or else descant upon some question of tact or etiquette, which, perhaps, was not quite so much in his line.

48. For HF's extensive comments on Harcourt, see *PPP*, pp. 98–117.

30. Harcourt
Source: "The Late Sir William Harcourt" (PA HC/LB/1/112/145)

Even his best friend must admit that Sir William Harcourt's humour—however excellent—was not exactly that of a light comedian. When demolishing the arguments of his opponents, he did not divide the meal into three courses, after the manner of his great leader, Gladstone, but disposed of them in one mouthful. The very table quivered as he drove his arguments home with clenched fist [31]; and he positively hypnotised those in front of him by energetically wagging his fore-finger before their eyes.

31. Harcourt
Source: "A Stormy Day In The Commons: Sir William, Of Course"
(*The Daily Graphic*, 14 June 1890, p. 8)

Sir William Harcourt could prepare and deliver a witty speech on occasion, but it must be so labelled, otherwise he was serious and his hearers are not. Members sitting behind him, being his own supporters, often enjoyed the joke of his laboured efforts, and I have noticed them frequently "guy" him; in fact, some of them have confessed to me that their applause was purposely planned. He took it all seriously, and frequently turned right around and grandiloquently thanked his followers for their appreciation, which after all is their

joke,—as all the House, but Sir William, saw and enjoyed. They "drew" him far better than an artist could.

The only doubt is,—would not Mr. Balfour have made a better bishop than a statesman. His rapid rise is due almost solely to his charming manner. For a long time he was looked upon as a "philosophical dilettante, who was playing at politics for want of some better amusement."[49] He affected the airs of a sybarite—lackadaisical in manner, effeminate in address, apparently lazy in office, and indifferent to criticism. [32][50] It is in a great measure to this latter peculiarity that he owes his success. When he became Chief Secretary for Ireland, he changed his political character; worked hard, spoke with spirit, was fearless and strong. He boasted that he never read a newspaper, so that the Irish could orate to their heart's content, abuse him up hill and down dale; so long as their tirades were not considered worthy of police notice, Mr. Balfour saw them not. In the House he lay in the most aesthetic attitude, apparently [sic] indifferent to virulent outpourings of eloquence and abuse from the Irish benches. [33] When he did rise he won their admiration by hitting back at them without mercy. His reputation was made; he became the acknowledged leader of the Conservative Party.[51] Since then, politically, he has stopped growing. The description Bismark gave of Mr. Balfour's uncle, the late Lord Salisbury, when he was his age, might be well applied to Mr. Balfour: "a lath painted to look like iron."[52]

There is no desire on my part, to touch in any way on politics. I merely introduce these sketches as studies of manners, not of men. The manner of Mr. Balfour is that of a dilettante, "a parliamentary dilletante, an aesthetic dawdler," as someone has written of him[53]; but of perfect temper and exquisite

49. Although we have been unable to identify the source of this quotation, much that was written about Balfour, both during his early days in the House and later, retrospectively, after he had gained a reputation for being an effective statesman, used the same set of terms ("dilettante," etc.) to describe his inauspicious parliamentary beginnings.

50. The image is not exactly the same as Almond's sketch in the *ILN* of HF pointing to Balfour (fig. 16 of the Introduction) so HF probably reworked the *Daily Graphic* sketch for the magic lantern. "Mr. Furniss's caricatures of individuals in the Commons included . . . Mr. A. J. Balfour, on his feet and aesthetically sprawling [image 33]." *The Age* (Melbourne), 24 May 1897, p. 6.

51. A marginal note here reads "Explain slide."

52. Bismarck's assessment of Salisbury (in contrast to Disraeli, of whom he said, "But that old Jew means business") was related by the German ambassador, Count Münster, to George W. E. Russell after the 1878 Congress of Berlin and was afterwards often quoted. G. W. E. Russell, *Collections and Recollections* (New York and London: Harper & Brothers, 1898), p. 218. The reference to the "late" Lord Salisbury dates this portion of the typescript to after 1903. A faint marginal note in pencil alongside this quotation reads "Asquith" (underscored). It is unclear how this might relate to Bismarck's quip.

53. Source unidentified. See note 49. The term "dawdler" appears in connection with Balfour's name in a satiric poem in *Punch* (11 June 1887, p. 278) that accompanied Furniss's drawing "Parliamentary Views, No. 11: 'Ringing Them In'" depicting the reassembling of Parliament: "Come, lounging Balfour, do not lag,/Dawdlers ere now have greatly dared."

32. Balfour
Source: "Mr. Balfour Under Fire" (*The Daily Graphic,* 19 June 1890, p. 8)

33. Balfour
Source: "Work, Work, Work!" (*B&W*, 23 May 1891, p. 504)

taste. Two remarks made to me about Mr. Balfour are, I think, worth repeat-
ing: one by my son, fresh from school, paying his first visit to the strangers'
gallery in the Commons, I asked him what struck him about the Premier. "A
frightfully languid man with long legs, but he looked more of a gentleman
than anyone in the House." The other remark was that of a lady, who said to
me: "Mr. Balfour will never be great until he is married."

It was said of Mr. Chamberlain, [34a][54] when he left Mr. Gladstone and
caused such a sensation by opposing him in the House, that "the best way of
describing Mr. Chamberlain's terse, nervous, logical, and convincing style of
oratory is to note the fact that what he puts into a column of a 'Times' report
nowadays seems to cause Mr. Gladstone to fill two in attempting to answer

54. There is no indication in the typescript that images of Chamberlain were shown (images 34a
and 34b are, then, editorial insertions), but it is inconceivable that such a prominent politician, who
here has a substantial paragraph devoted to him, and who was frequently sketched by HF, would
be omitted from "Humours." In fact the Melbourne *Age* (24 May 1897, p. 6) reports that he was
depicted "in many phases, including a heroic picture of him slaying all his former political selves,
and aiming at a peerage and the Premiership." "The Seven Cham-Berlains of Brummagen" (that is,
Birmingham, the industrial city so closely associated with Chamberlain), alludes to Richard John-
son's 1596 chivalric romance *The Famous History of the Seven Champions of Christendom*, who are the
patron saints of England, Scotland, Ireland, Wales, France, Italy, and Spain. HF could safely assume
his audience would recognize the allusion since the stories were often reprinted or adapted for the
stage during the nineteenth century.

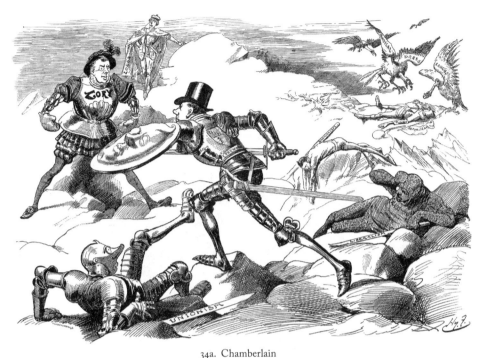

34a. Chamberlain
Source: "The Seven Cham-Berlains of Brummagen" (*Lika Joko,* 27 October 1894, pp. 24–25)

it."[55] That, in a sentence, sums up Mr. Chamberlain at the table of the House. [34b][56] He never rose to speak unless it was necessary; he never said a word that was unnecessary, and he never said a word that was not distinctly heard. He was no orator in the strict sense of the term. In the days of Pitt—a man by the way he strongly resembles in face and figure,—in the days of Burke, Canning, Peel, or Palmerston, the Rt. Hon. Joseph Chamberlain would have been reckoned a poor speaker. For those were the days in which flights of oratory, enriched by classic quotations, by studied perorations, and general theatrical effect were common; such flights of oratory, now would be laughed at.[57] It is

55. Source unidentified. Cf. Meisel, *Public Speech,* pp. 270–71. Chamberlain broke with Gladstone in 1886 over Home Rule. See Introduction, section III.2.

56. This is a nice contrast to Balfour in similar pose (image 32).

57. Some years later HF elaborated on these observations: "The day of florid speeches, studied rhetoric, and classic quotations are gone. Perhaps Sir William Harcourt was the last of the old school that indulged in all three. John Redmond indulges still in two, but he does not quote Greek; in fact, any member doing so now would be laughed at. Yet it was, at one time, thought that a speech worthy of being called a speech was not complete without classic quotations. Flippancy has, in a

34b. Chamberlain
Source: "Birmingham in the House—Mr. Joseph Chamberlain"
(*B&W*, 25 April 1891, p. 360)

only Sir William Harcourt who dares to quote a Latin phrase. We live in a matter of fact age, with a matter of fact House of Commons, and Mr. Chamberlain was the most matter of fact member in it. He cannot, therefore, be placed with the orators who have stood at the table; but no man, at any time in the history of our country, has risen in the House, whose individuality is so

measure, taken the place of studied oratory. The wit, with an epigram, makes a hit now and then, but the scholar is not listened to." HF, "To Succeed in Parliament," *Cassell's Magazine*, vol. 42 (June 1906), pp. 86–87. On the eighteenth-century "golden age of oratory" and the practices of classical quotation in Parliament, see Meisel, *Public Speech*, pp. 52–60.

strong as his, and whose words are listened to with greater interest than those of Mr. Chamberlain, the least oratorical of all the members I mention.[58]

It is now three o'clock, and the approach of the Speaker is heralded by the chief inspector of police who exclaims in peremptory tones,

"Hats off, strangers." [35]

35. The Speaker's Procession
Source: "The Speaker's Procession: 'Hats Off For The Speaker!'" (*B&W*, 14 February 1891, p. 42)

I remember the first time I heard this command in the Lobby that it sounded like "Heads off," and that the Speaker and his retinue as they passed by reminded me strongly of a state prisoner of former days on his way from the Tower to the block. The only executioner, however, that appeared upon this occasion was the special artist of "Punch," and he was subsequently assured, although he certainly did not deserve the compliment, that he took off the Speaker's head to perfection.[59]

58. This is followed by an underscored note, "Explain Slide," under which HF has written and crossed out "Asquith." Below this, and repeated on the next page, are further handwritten notes to "Present Rulers" with an image cue.

59. A typical comment by Furniss, at once witty (in its *Punch*-like play on words) and self-serving.

First in the procession comes an attendant, looking excessively foolish, with his hands encased in conspicuous white gloves. The Sergeant-at-arms follows, struggling manfully under the weight of the mace. Then comes the Speaker in his wig and gown, moving with stately stride and having a train bearer in tow. On his left he is supported by his chaplain, on the right by his secretary, who as I was pained to notice deserted his master at the threshold rather than, as it seemed, witness the last terrible scene.[60]

The Speaker and the Chaplain bow to each other as if they had met for the first time. Upon arriving at the table, they bow again, just as if it were another accidental meeting, and when the ceremony is over, they bow once more; this time, I suppose, just to show there is no ill feeling.

Then the Chaplain walks out of the House backwards, keeping an eye upon the Speaker and the other upon his pockets, but bowing all the time, so as to imply in dumb show that he does not suspect him of any evil design.

During the ceremony, the few members present turn their faces to the wall, presumably not to see the deed, but as soon as the Chaplain begins to back out, in rush the other members to claim their hats.[61]

They tread upon the poor clergyman's heels, hustling and knocking him about sadly. Nevertheless, the ever popular Chaplain, well up in his part, like Sir Pertinax,[62] continues to 'boo.'

And now, the Speaker, for all the world like the leader of an orchestra, takes his place, and his wigged clerks three tune up.[63] [36]

The Overture is rather a dull tune. The first item in the programme, the reading of private bills,[64] is interesting to none but the directors of Ruskin railways,[65] Coalville canals, Traction tramways, Soft Soap subways, and Tadpole waterworks.

60. Since the office was established in the mid-seventeenth century, the Speaker's Chaplain says a prayer at the beginning of each day's business (*EP*, p. 568). Clerks remain outside the chamber until prayers are finished. The Chaplain at the time "Humours" was first performed was the Rev. F. E. C. Byng (1835–1918) whom HF describes as a "jolly Bohemian, outside Westminster" who hosted "little Bohemian suppers at his club. . . . Byng was afterwards the Earl of Stafford, and Canon Wilberforce, the ardent teetotaller, became Chaplain in his stead" (*MBD*, pp. 267–68).

61. The whole ceremony is also described in an article illustrated by HF: William Woodall, "A Night in the House of Commons," *Good Words*, vol. 29 (1888), pp. 104–13. See also image 7, the full title of which is "The Hattitude of the House Before Prayers."

62. In Charles Macklin's comedy *The Man of the World* (1781), the obsequious Sir Pertinax "bowed, and bowed, and bowed," and cringed, and fawned, to obtain the object of his ambition.

63. The Speaker is Arthur Wellesley Peel. For HF's discussion of the Chair, see *PPP*, pp. 13–26.

64. Private Bills are introduced following a petition from local authorities, private corporations, and other statutory bodies seeking certain kinds of authorization. These should not be confused with Private Members' Bills, which are public bills introduced by MPs who do not hold government offices. See *EP*, pp. 585–89.

65. Perhaps an allusion to John Ruskin's lifelong hatred of railways.

36. The Speaker and His Clerks
Source: "The Speaker Ascends 'to the Chair'" (*Good Words*, 1888, p. 105)

Then follows the farce of presenting petitions. Bags hang by the table, into which the blind petitions, like kittens, are thrust, soon to be cast into the stream of superfluity, which deposits them in the ocean of waste paper.

Perhaps, however, you have not got further than the Outer Lobby by this time, and straying to the right, find yourself in the House of Lords, where an appeal case is on.

I suppose most of us in our youth, when playing indoors on a wet day, have turned a room topsy-turvy, to make belief [*sic*] it was a law-court or something of the kind. Well, that is exactly the process which the House of Lords seems to have undergone when it is turned into the Highest Court of Appeal.[66]

The cross benches are bundled together in the centre of the House, just as on a cleaning day, and temporary tables are placed near the bar of the House. The Lord Chancellor takes up his position at a table in the centre. Four smaller tables, two on each side, are placed near the benches, for the other Lords of Appeal, who look when seated like professional chess-players at Simpson's,[67] waiting for someone to turn up. [37]

37. Appeal Case in the House of Lords
Source: "An Appeal Case. House of Lords" (*Punch*, 14 February 1891, p. 82)

66. The House of Lords includes a group of "Law Lords" (properly "Lords of Appeal"), consisting of the current Lord Chancellor, former Lord Chancellors, peers who are current or former members of the Privy Council's Judicial Committee or judges of the superior courts, and the Lords of Appeal in Ordinary appointed by the Crown. Their function is to clarify the law and render considered opinions regarding appeals. When the Lords sits as a court of appeal, only the active judicial peers normally take part in the proceedings, although other peers may attend if they wish to do so. *EP*, p. 447.

67. Simpson's-in-the-Strand, a noted London restaurant, was the center of British chess playing.

A platform is placed at the bar, on which are more tables and chairs, and here all the Counsel and Solicitors and their clerks are packed together like sardines in a box, and perhaps you may think quite as oily.

The Counsel addressing the House stands in the centre at a reading desk, like a preacher delivering a sermon, and a very dull sermon it generally is.

The case, as you know, has been fought out from one Court to another, higher and higher from the regions of short wigs and long fees until at last it has come to the big wigs with still bigger fees in the highest tribunal in the land, after which the unfortunate litigant is left too often without a feather to fly with, and may reflect upon the folly of going to law.

As you are turning all this over in your mind, you find that you yourself are being turned out.

It is four o'clock, and the House has to be got ready for the more important affairs of the State. And the way in which the Court of Appeal is transformed into the House of Debate is a quick change worthy of the stage arrangements we are so familiar with in modern realistic dramas. Half a dozen men in their white caps and overalls rush in the moment the majestic form of the Lord Chancellor is lost to view. The platform disappears down a trap in the floor. The tables are removed, the desks subside upon their hinges and fall into panels. The seats are rolled round into their places, and in a few minutes the familiar set-scene is ready in which the stock company of political actors will presently make its appearance. Unless you have a peer's order you cannot re-enter the sanctum.

Some friendly member of the Commons must go into the House of Lords and ask leave for you to enter.

It is a question of first catch your member. To do this, of course the usual business of sending in your card and of waiting until the member is found, and comes out, has to be gone through. Then he disappears again, to make application to Black Rod,[68] and comes back generally just in time to shew you the Lords walking out; [38][69] for, on an ordinary day, frequently the Lords sit at about a quarter past four o'clock, and rise at twenty minutes to five.[70]

68. The Gentleman Usher of the Black Rod is an office associated with the Order of the Garter dating back to 1361. Under Henry VIII, the office was designated as chief of all the ushers of the kingdom, with care for all the doors of Parliament. Black Rod is sent to desire the attendance of the Commons in the House of Lords at the opening and proroguing of Parliament. The practice of barring the door of the Commons in Black Rod's face until he has rapped three times with his ebony wand is intended to demonstrate the Commons' right to close their doors and proceedings to anyone (*EP*, pp. 283–85). From 1883 to 1895, Black Rod was Admiral Sir J. R. Drummond (1812–1895).

69. The sketch appears in HF, *Parliamentary Views "From Punch"* (London: Bradbury & Co., 1885) where the 26 Lords are identified by a key.

70. HF exaggerates the brevity of the Lords' sittings, for the business of the upper house was certainly more leisurely than that of the Commons. Published debates for the Lords occupied a fraction

PARLIAMENTARY VIEWS: No. 22. THE HOUSE OF LORDS "UP" 5.15. P.M.

38. The Lords Walking Out

Source: "Parliamentary Views: No. 22. The House of Lords 'Up' 5:15pm" (*Punch*, 2 August 1884, p. 59)

You have, perhaps, seen this sketch of the Peer's Chamber by a Japanese artist, and you are anxious to see if it is the same when viewed through English Glasses.[71]

Napoleon is reported to have said that every private soldier carried a Field-Marshal's baton in his knapsack, and it may be said with equal truth that every politician carries a peerage in his pocket.

It may be truly said that every lawyer's clerk carries a woolsack in his pocket. I fear it would rather impede his progress, however, in his day-dreams, and surely lawyers' clerks have plenty of opportunity for day-dreaming. He sees himself sitting upon the Woolsack, although most people now-a-days are not content with the idea of sitting upon the woolsack, but want to sit in the House of Lords itself.

Your imagination must not run away with you and leave you to picture the Lord Chancellor of England like this imaginary one before you. [39] Lord Chancellors are chosen for their brains and not for their appearance merely. Now, here is the most genial and popular of the Keepers of the Queen's Conscience that I have seen. [40][72]

An ordinary sitting of the House of Lords is not attractive. The attendance is mostly very meagre, and the proceedings which seem to be for the sole benefit of the clerks and servants of the House, dull and insipid.

Reversing the proverb "Much cry and little wool," there is much woolsack and very little cry about the House of Lords.[73]

of the space taken up by Commons debates, though in part this is the result of the non-legislative functions of the House that HF described for his audiences. It is also the case that the Lords met on fewer days than the Commons. Taking 1890 as a sample year (one in which the Prime Minister, Salisbury, sat in the upper house), the Lords met on 72 days, and the Commons on 175 days. In general, according to the official report for that year, Lords' sittings commenced between 10:00 and 11:00 a.m. and tended to conclude sometime between 4:30 and 6:30 p.m. There were a small number of late sittings, and a few sittings of very brief duration such as HF satirizes.

71. This paragraph, and an associated image cue (HF produced numerous cartoons in mock-Japanese style which he sometimes signed "Lika Joko"), have been crossed out in the typescript.

72. "Lord Halsbury looked like an ugly midget with a hydrocephalous forehead, perched upon a chair many sizes too large for him" (*The Age* [Melbourne], 24 May 1897, p. 6). "An odd-looking figure, with a phenominally [*sic*] large forehead and wig" which was "thrown upon the white background, amid great laughter" (*Aberdeen Weekly Journal*, 1 December 1891). In another lecture, HF used images 39 and 40 to illustrate his point about contrast in cartooning: "Another hint I would give the student is 'keep your eye on contrasts,' for contrast is the essence of humorous effect. To show the Lord Chancellor like this idealised and then as he was—yes, you see—gets the laugh" ("Cartoon," p. 56).

73. Derived from an ancient mystery play, the proverb "Great cry and little wool" expresses contempt for people who make promises but fail to fulfill them. See *Brewer's Dictionary of Phrase & Fable*, 17th ed. (London: Weidenfeld & Nicolson, 2005), p. 610.

39. The Imaginary Lord Chancellor
Source: "The Ideal Lord Chancellor' (*Fair Game,* May 1899, p. 7)

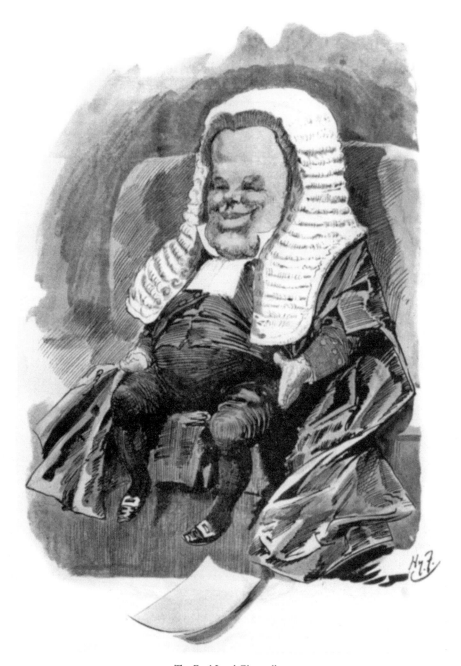

40. The Real Lord Chancellor
Source: "Swelled Head No.12. The Right Hon. Viscount Halsbury" (*Fair Game*, May 1899, p. 9)

One very amusing scene takes place when bills come back to the House of Lords to officially receive the Royal sanction, [41][74] and I have been rather surprised to notice that repetition does not rob this ceremony of its amusing aspect towards the Peers themselves, who, I have observed, always seem to regard the performance with scarcely repressed glee.

The Usher of the Black Rod receives his orders from the Lords Commissioners to go and summons the Commons to hear the Commission read. This official marches off through the lobbies to the House of Commons. As he approaches the entrance to the Lower House, the Sergeant-at-arms, apparently suspecting the gentleman of some felonious intent, "gets up and bars the door,"—literally slams the door and bolts it in his face.

Then Black Rod upraises his wand of office and strikes three majestic blows of authority upon the door. Hereon the keepers at once open the portal and try to look as if they were surprised and delighted to see him.

The old gentleman who tries his best to look the part, dressed in Court dress, marches with rather goutyish dignity up the centre of the floor, bowing as he goes, at certain points three times. [42]

41. Giving the Royal Sanction to Bills
Source: "The Commons In The Lords—Royal Consent to Bills" (*B&W*, 4 April 1891, p. 264)

74. "The picture . . . represents a crowd of members rushing into the House of Lords to hear the Royal Assent." *B&W*, p. 264.

42. Black Rod at the Commons
Source: "The Black Rod" (*B&W*, 20 June 1891, p. 632)

When he has whistled to the standing Speaker and beckoned him as Hamlet's father invited his sable-clad son, to follow, he retraces his steps, still bowing, until he gets to the wings—I mean the bar. His majestic movements have brought the Speaker, the Sergeant and Mace, and certain members fond of pedestrianism after him.

As soon as the informal procession reaches the House of Lords, the bowing commences, and the fun is fast and furious. [43][75]

The Lords Commissioners have put on robes and cocked hats for the occasion, and the Lord Chancellor balances a three-cornered hat on the top of his full bottomed wig, a "jeu d'esprit" which always upsets the gravity of the House. [44][76]

These uncanny "tiles" they remove in salute to Her Majesty's faithful Commoners, who return the compliment. These Lords are seated upon a bench behind the woolsack, the Speaker and his followers meantime standing at the bar. As soon as the Commission has been read, the two barristers standing on

75. This is followed by a handwritten note, "1. Ideal [underscored] Chancellor 2. Then Halsbury with others [underscored] in appeal."

76. "A sketch of almost Hogarthian quaintness and realism" (*The Age* [Melbourne], 24 May 1897, p. 6). The reviewer may have had in mind William Hogarth's "The Bench" (1758).

43. The Procession to the Upper House
Source: "Following The Black Rod" (*B&W*, 27 June 1891, p. 664)

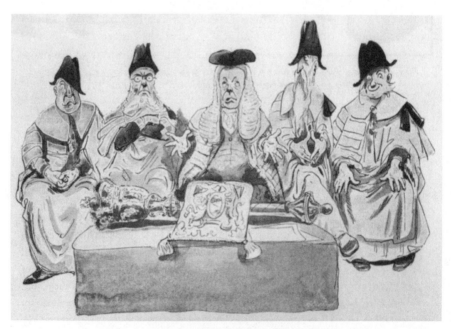

44. Robes and Cocked Hats in the Lords
Source: "These noble Lords will be easily recognised by those who have seen the 'Humours of Parliament'" (*PPP*, p. 2)

either side of the table "take the floor." If this entertainment were to be given by Messrs. Moore and Burgess,[77] perhaps we should vote it rather absurd.

To see it in the House of Lords is simply screamingly funny.

The Clerk to the Crown bows to his colleague in wig and gown across the table, who also bows at the same instant, as though worked by the same machinery. [45]

45. The Clerk of the Crown Bows to His Colleague
Source: "The Speaker In The House of Lords" (*PPP*, p. 27)

For instance, the Clerk at the table calls out to the other Clerk, "The Biddleton Bog Extension Bill."

Then they bow to each other like clock-work figures upon a street organ.

Then they turn round, and bow again to the House. The clerks to the Parliament shrieking,

"La Rayne—le Vault"[78]

And so on through all the list.

77. In 1865, George Washington "Pony" Moore (1815–1909) and Frederick Burgess (1827?–1893) established a long-running minstrel show catering to respectable audiences at St. James's Hall, Piccadilly.

78. "La Reyne le veult" is Norman French for "The Queen wishes it," pronounced by Lords Commissioners appointed by the Sovereign to signify the Royal assent to bills that have passed both houses of Parliament (*EP*, p. 654).

This entertainment over, the Speaker, the Sergeant-at-arms, the Mace, and all, retrace their steps to the Lower House, and resume work.

I do not stand here to propose reforms, or I might suggest that in place of the farce of "Black Rod" which sadly interferes with the parliamentary drama, the Chancellor's crier should appear at the bar of the House and cry, "Oh yez! Oh yez! Oh yez! Take notice. The following bills have received Royal assent"—read them, and retire. [46]

46. The Chancellor's Crier
Source: "A Suggestion" (*PPP*, p. 26)

When the Commons retire from the Upper House, the noble Lords throw off their disguises and resume their small and early.[79]

Contrary to the customs in the Commons where members must address the Chair, the noble Lords turn their backs upon the figure-head upon the woolsack, and address the Reporters' Gallery.

The Lord Chancellor doesn't mind.

There is plenty of room upon the Sack for some friend. The silver-haired Lord Chancellor of Ireland, for instance, who is regaling him with the latest stories of Irish humour. [47]

47. The Two Lord Chancellors on the Woolsack
Source: "Two Lord Chancellors—Lord Chancellor Of England And Lord Chancellor Of Ireland"
(*English Illustrated Magazine*, December 1885, p. 204)

79. "Small and early" was the term used for an evening party not intended to last very long. The first *OED* reference is from Dickens' *Our Mutual Friend* (1865), ch. 11 (where the hostess, Mrs. Podsnap, wants to get rid of her boring dinner guests as quickly as possible), followed by one from Disraeli's *Endymion* (1880), ch. 77. These sources indicate that small and earlies were not held in very high regard.

In order to give you some idea of what ordinarily passes in the House of Lords, in a nutshell, I may say that after the clerks read over something which nobody listens to, and then, after a pause, Lord Granville, say, may rise and proceed as follows:—[48]

48. Lord Granville Asks a Question
Source: "Earl Granville" (*English Illustrated Magazine,* December 1885, p. 197)

"I beg to ask the noble Lord opposite, if he has any information which he can give to the House respecting the rumoured incapacity of the Sultan of Gingeralybar to decipher the contents of a despatch recently addressed to His Highness by Her Majesty's Government, and that such incapacity is due to the existence of a wholly unmanageable sty in His Highness' left eye."

In reply to this momentous enquiry, Lord Salisbury rolls out in deep impressive tones the following reply, though I fear I can but feebly imitate his sonorous voice.[80] [49]

49. Lord Salisbury
Source: "Lord Salisbury" (*B&W*, 7 March 1891, p. 140)

80. HF wrote that "the Conservative chief is pre-eminently a practical man, and this characteristic of his mind is displayed unmistakably when speaking, the attitude in which I have here represented him" (*B&W*, 7 March 1891, p. 140), and that when he rises to speak "the ideal statesman stands forth" (*PPP*, p. 132).

—"The noble Lord opposite asks me if I can give any information to the House respecting the sensational rumour as to the incapacity of His Highness the Sultan of Gingeralybar, to decipher the contents of a dispatch recently addressed to His Highness by Her Majesty's Government, owing to the existence of a sty in His Highness' left eye.

"I can only say that we know of no such sty in His Majesty's eye. But should any such obstacle unhappily exist to the vision of His Highness, we cannot pretend to say that we see how it concerns Her Majesty's Government, or any other of the subjects of Her Majesty."

This brings our visit to the House of Lords to a close, for should the brilliant but fertile shower of eloquence continue long, some peer of practical common sense will rise and say,

"As it is now long past the dinner hour, I beg to move the adjournment of the House," which proposition is readily assented to. [50][81] *Rosebery* [51][82]

Conclusion[83]

The Parliamentary Enthusiast has now but one chance of Peace with Humour.[84] He must become a member of the House of Lords. £80,000 to his party will buy a Peerage,[85] but it is cheaper to be a failure in his Government— then the title will be thrust upon him—once in the Gilded Chamber he finds Peace on Scarlet Sofas, and discovers Humour in the Red Tape of Procedure.

81. "A portrait of Lord Spencer and of another noble lord who moves the adjournment of the house on the ground that it is long past the dinner-hour." *Belfast News Letter*, 1 September 1891.

82. For HF's comments on Rosebery, see *PPP*, pp. 77–95. HF did several sketches of Rosebery, and we have therefore preserved the image cue associated with HF's annotation and selected an image for inclusion.

83. These later (?) additions, the reference to "His Majesty the King" in the following paragraph, and the continuing discussion of the Lords after having stated, "this brings our visit to the House of Lords to a close," all indicate a shift in direction of the text inconsistent with what has gone before.

84. This paragraph is preceded by a handwritten marginal note to "Read" (double underscored). The phrase "Peace with Humour" plays on Disraeli's statement that he had obtained "peace with honour" at the 1877–78 Berlin conference on the Eastern Question. This resulted in a convention with the Ottoman Empire under which Britain occupied Cyprus in exchange for guaranteeing the integrity of Turkey in Asia. As noted in the Introduction, the appearance of this phrase is one of numerous indications that the extant text of "Humours" is a conflation, since Furniss toured with a magic lantern show bearing this title in 1900. See Introduction, fig. 30. In the margin next to this sentence is an image cue with "House itself" written next to it.

85. The sale of honors dates back at least to James I and played a notable role in the union with Ireland. Its revival in the late nineteenth century arose from the financial pressures placed on the new central party organizations by the need to reach a mass electorate after traditional forms of electoral corruption had been curtailed (see Introduction, section II.1). Gladstone agreed to the sale of at least two peerages, which were eventually seen through by his successor, Lord Rosebery in 1895. Practiced by both parties, though strongly disapproved of by the public, the sale of honors was a recurrent political issue through the 1922 downfall of David Lloyd George, who was especially notorious in this respect. See H. J. Hanham, ed., *The Nineteenth-Century Constitution 1815–1914: Documents and Commentary* (Cambridge: Cambridge University Press, 1969), p. 170.

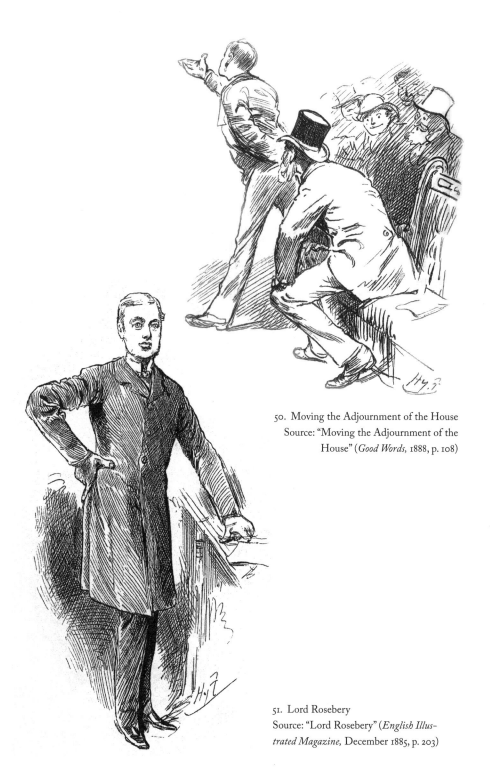

50. Moving the Adjournment of the House
Source: "Moving the Adjournment of the
House" (*Good Words*, 1888, p. 108)

51. Lord Rosebery
Source: "Lord Rosebery" (*English Illus-
trated Magazine*, December 1885, p. 203)

The only occasion when his Peace is disturbed is when Parliament is opened by His Majesty the King.[86]

Now, one of the unwritten laws in connection with the Procedure of that august assembly is, that when the Sovereign opens Parliament no Member of the House of Lords must lean back in his seat. To obviate the unwitting or perchance defiant committal of such a dire offence against the Majesty of the Throne, the seats of the Upper House are furnished with movable backs, which are let down in the presence of the Sovereign, so that the aristocratic Politicians must of necessity preserve a posture upright and respectful.[87] [52] Were the Sovereign to put in an appearance at the Gilded Chamber unexpectedly, the noble Lord drowsing on the benches and dreaming of a good run with the hounds across the slopes of Leicestershire,[88] or a good day's sport on the Highland Moors, would find himself suddenly executing a back somersault more benefiting an acrobat on the stage of the Variety Theatre, than a blue-blooded Politician in the sacred Chamber of debate.

52. A Respectful Posture in the House of Lords
Source: "Lord Cross" (*Pearson's Magazine*, July–December 1896, p. 28)

86. An indication that the extant text incorporates material from after Queen Victoria's death in 1901.

87. This and the previous sentence are similar to passages in *PPP*, p. 10, and HF, "The Best Club in England," *Pearson's Magazine*, vol. 2, no. 7 (1896), pp. 27–28.

88. A county known for its fox hunting.

Still, such interruptions in the Upper House are very rare, and generally the Peer can slumber in Peace during the usual ten or fifteen minutes sitting of the House of Lords, and I have no doubt his sweetest dream is when he pictures himself back in the Commons. [53]

53. A Peer Asleep
Source: Image untraced. Editorial substitution: "The Week In The Commons: Question Time. The Baron Takes Forty Winks" (*The Daily Graphic*, 10 July 1890, p. 5)

Where Miss Parliamentina waves her wand and transforms the dull, dreary babbly shop into a fair of the fairest.[89]

I ask you to notice how this fairy scene is spoilt by that badge of respectability, the ugliest head-gear ever invented—the tall hat. [54][90] In every Parliament of the world, with the exception of our own, a legislator leaves his hat, his umbrella and his conscience in the cloak room to be picked up again on leaving the building; nothing strikes the foreigner as more ludicrous than the sight of the members in both our Houses wearing their hats, as if they were at a Quakers' meeting, or orthodox Jews, in the synagogue.

It is strange how antiquated procedure claims the hat, and how very important a role is assigned to that article of attire in the etiquette of Parliament. All members—with the exception of the Whips, members of the

89. On Miss Parliamentina, see Introduction, p. 42 note 73.

90. There is no number in the margin of the typescript for this image yet the text indicates that an image was shown. This is, then, an editorial insertion of the headpiece to HF's article "The Parliamentary Hat" in *Cassell's Magazine*, vol. 37 (December 1903), pp. 10–16, the text of which is a reworking of this discussion of hats. Elsewhere he writes that "there is nothing more difficult to draw than a tall hat" (*AH*, p. 264).

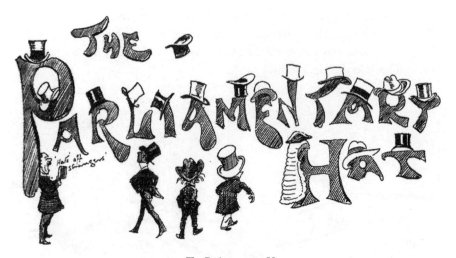

54. The Parliamentary Hat
Source: "The Parliamentary Hat" (*Cassell's Magazine*, December 1903, p. 10)

Government accommodated with official rooms, and Officials—are bound, by the rules of Parliamentary etiquette, to wear their hats, when sitting. In other words, to be hatless in the House is to be an official. Members must, however, uncover when entering or leaving the House, and when making a speech. But on the other hand, it is—for some unknown reason—obligatory for any member (even an official) who wishes to address the Speaker after the bell has rung for division, to do so with his hat on. An interruption of the kind, has usually for its purpose the raising of some important point or the making of some serious objection. Therefore, when a member of the Government wishes to speak, at such a time, the curiosity of the House is excited and all eyes are turned on him. Unfortunately every member does not take a hat into the House. [55] Mr. Gladstone, for instance, never wore his hat in the House, and never took one with him.[91] Consequently whenever he wished to ask a question, after the Question had been put, or to address the Speaker on some important point after the ringing of the Division bell, one of his colleagues used to rush up and down among the benches, to borrow a hat from some member having a head as large as that of the Premier, or failing to find one among his own supporters, Mr. Gladstone had to put on the first hat

91. Perhaps he forgot it. When HF, by hook or by crook, found himself in the hall of 10 Downing Street, he noticed three hats belonging to the prime minister which, according to the official, "Mr Gladstone always had by him,—three hats symbolic of his oratorical peculiarity of using the well-known phrase, 'There are three courses open to us'" (*CCI*, p. 82).

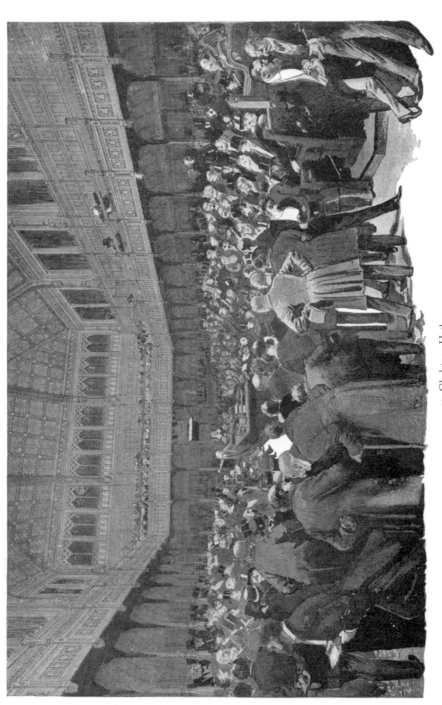

55. Gladstone Hatless

Source: Image untraced. Editorial substitution: "A Full House: Mr. Gladstone Up" (*PPP*, p. 49)

handed to him. I recollect that on more than one occasion when the result was rather funny. Here is a picture of the Premier of England asking a question of national importance. [56]

56. Gladstone Wearing a Borrowed Hat
Source: Image untraced. Editorial substitution:
"The Hat That Did Not Fit" (*Cassell's Magazine*,
December 1903, p. 11)

Mr. Gladstone at the time of the Home Rule Bill, when he had fallen out with Mr. John Bright and some of his other supporters, happened to call at his hatters, when that purveyor of felt and base flattery, assured Mr. Gladstone

that, according to measurements, his head was growing larger. "Yes," said Mr. Gladstone, energetically, "I know it is, and do you know, Sir, that Mr. Bright's head is growing smaller?" [57]

57. Gladstone Puts on John Bright's Hat
Source: "Mr. Gladstone Puts On John Bright's Hat"
(*Cassell's Magazine,* December 1903, p. 11)

Leaving the House of Lords you return to the Strangers' Gallery just as the private bills are read and the Blind petitions, which I alluded to a few minutes ago, are buried.

And now question time has arrived and the House is crowded to see the fun. [58]

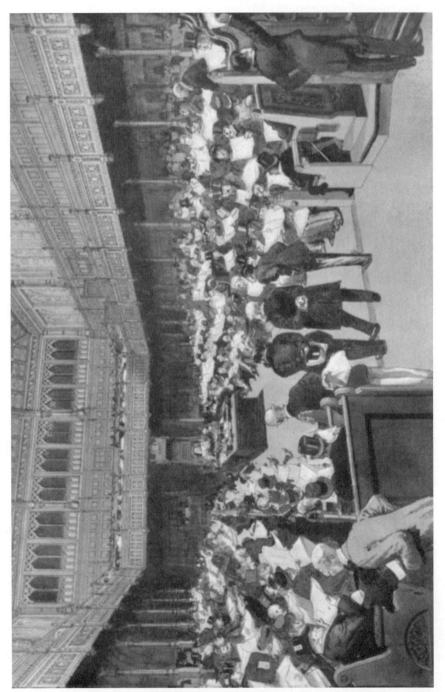

58. Question Time

Source: "Scenes In The House Of Commons: III—Question Time" (*PPP*, p. 65)

The poor members of the Government sit like so many Aunt Sallies to be shied at.[92]

In the old days it was the custom for members to ask their questions in full, and they were heard something like this,—Portarlington.[93]

I wonder how the poor ministers could answer a question in that fashion.

But now questions are printed upon paper and taken as read, and when a member is called upon, he simply rises and says,—"I beg to ask the Honourable Lord, or the Right Honourable Gentleman opposite a question—so and so—"

This is well, for questioners are not often Speakers and frequently not even Parliamentary workers, and merely ask questions to advertise their Parliamentary existence. Sometimes a question of trivial importance is placed upon the table.

Then the Official Windbag[94] sees his chance for a display of verbiage, and coming forward with his reply carefully prepared during the morning by his clerks and Secretaries, reads his elaborate reply. [59]

59. The Official Windbag
Source: "Mr. Sexton" (*PPP*, p. 48)

92. Aunt Sallies: dummies. From the game Aunt Sally in which players throw objects at a wooden dummy.

93. A rotten borough constituency in Ireland, which became the smallest constituency in the United Kingdom. Finally abolished in 1885.

94. This is Thomas Sexton (see *PPP*, p. 48). There are also several references in *Punch* (6 April 1889, 13 April 1889, and 11 June 1892) to Sexton as a "windbag."

"No Sir one horse only which I am pleased to inform the honourable gentlemen opposite is 50 per cent lower than are usually lamed on such occasions.

The case is now being thoroughly investigated by the highest paid officials of the War office, and I promise the House that all the valuable time possible will be devoted to the matter.

The facts of the case are as follows:—The horse went lame through the vascular secreating surface of the sensitive frog coming in continual contact with a too energetically forged nail, which our trusted experts believe was sent beyond prescribed limits and evidently touched the case of the coffin bone— or to be more correct. The sensitive frog attached to the coffin bone above, and the horney sole below. For the animal I may inform the House is an aged one.

The horney sole being composed of oil, cellular membrane, and cartolage, the honourable member must see that the injury though slight, necessarily causes the recovery to be tedious—particularly as the tendon of the Flexor Perforans is inserted at the exact point where it comes into contact with the horney sole.[95]

The sensitive or insensitive frog may, or may not be quite well by this time, but I have telegraphed for further particulars and when I receive any further details I shall be delighted to lay them before the House."

This is sufficient to show you that a reform is needed—the replies of Ministers ought to be printed on the paper as well as the questions they are asked. But even now some member will rise and bring a question like this upon the Minister. [60][96]

"I beg to ask the Right Hon. Gentleman opposite whether it is true that the Troopship "Leaker" ran into Her Majesty's Ship "Egg-shell" and both have gone to the bottom?

Whether it is true that all the bayonets tested for South Africa were found useless?

Whether Portugal are receiving thousands of Piano Cases, directed to secret Societies in Africa, every day?

Whether Russia and Germany have already agreed to an Alliance against England?

Whether Gibraltar has been shaken by an Earthquake and is totally unfit for defence?

95. HF, a keen horseman, here shows his knowledge of equine anatomy. The frog is an elastic, horny substance on the sole of a horse's foot.

96. Lucy in his "Essence of Parliament" column (*Punch*, 18 June 1892, p. 300) identifies the questioner as Stuart Wortley.

60. Asking a Question of a Minister
Source: "Question! Question!" (*Punch*, 18 June 1892, p. 300)

Whether a European War is imminent and England in every way unfit to defend itself against the world?"

To which the Minister replies emphatically—"No Sir!" to every question.

[61] *Churchill*[97]
[62] *Redmond*
[63] *Keir Hardie*
[64] *Ballahooly* [*sic*]

97. Crossed out by HF. This, and images 62 and 63, are written in pencil on the typescript, although there is no mention of any of the three politicians in the text. The sketch of Churchill highlights his beard. HF reports that an audience member once interjected, "Little Randy, eh? Grown his beard, has he? Better grow his wisdom teeth!" (*AH*, p. 147).

61. Lord Randolph Churchill
Source: "The Bearded Pard" (*Diary SP*, p. 342)

62. John Redmond
Source: "Mr. John Redmond"
(*PPP*, p. 188)

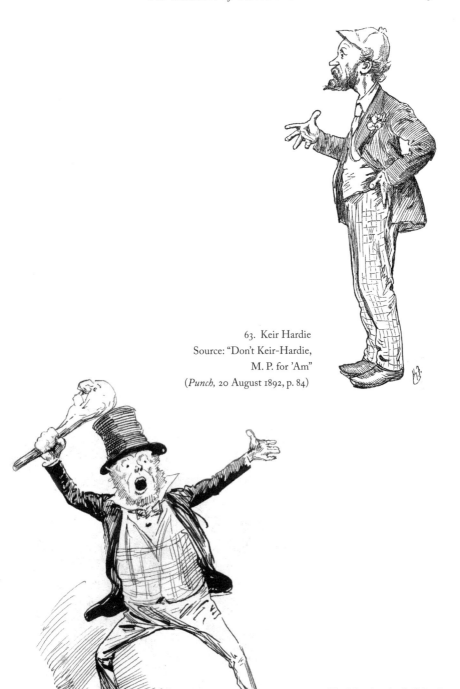

63. Keir Hardie
Source: "Don't Keir-Hardie,
M. P. for 'Am"
(*Punch*, 20 August 1892, p. 84)

64. The Member for Ballyhooley
Source: "The Member For
Ballyhooley" (*The Weekly
Scotsman*, 9 September 1893)

But seventy-five per cent of the questions are in the name of the Irish Members—this one, in the name of the Member for Ballyhooley, is a fair specimen.[98]

It is to ask the Chief Secretary for Ireland whether it is true that the Royal Irish Constabulary, stationed at Ballyhooley, deliberately shot down the scarecrow which was innocently standing in the field of one Myles Mulligan? And whether in consequence of this wanton act the crows have been playing havoc with the grain, and whether Her Majesty's Government will explain the manner of the outrage and compensate Myles Mulligan for the same?

The Chief Secretary for Ireland comes forward to the table and replies in the following words,—[65]

65. The Reply of the Chief Secretary for Ireland
Source: "Mr. Balfour" (*Diary SP*, frontispiece)

98. The shillelagh is made up of Gladstone's head. Ballyhooley is a small village in County Cork.

"The Hon. Gentlemen's question is a double-barrelled one, but both barrels have missed fire. It is true that the Irish Constabulary had some target practice near Ballyhooley on the date mentioned and that there is a field, or, more correctly speaking, a disused stone quarry situated about thirty yards behind the rifle butts—one of the firing party may have sighted high, and a spent bullet may have reached the stone quarry and upset the scarecrow, but there is no evidence of this and the whole story is believed to be a pure fabrication."

Up jumps the Member for Ballyhooley[99] [66]—"Have you the mane spirit of a man to stand on your two pins there and give such a half-hearted—"

66. The Member for Ballyhooley Gets Excited
Source: Image untraced. Editorial substitution: "Ballyhooly, M.P., Gets Excited" (How, p. 306)

99. HF's impersonation was singled out by many reviewers as having "brought down the house" (*Aberdeen Weekly Journal*, 1 December 1891), and was even reproduced on stage. HF relates how he was at a theater "when who should rush on to the stage and commence to shout a patriotic song about Home Rule than the 'Member for Ballyhooley,' capitally played by Mr. John L. Shine" (*The Weekly Scotsman*, 9 September 1893). Images 66 and 68 are part of a series of photographs, included in How (pp. 306–10) of HF mimicking the Ballyhooley MP.

Up jumps the Speaker—"Order—Order!"

"Have yer the mane spirit—"

"Order! Order!"

"Have yer-"

"Order! Order!! Order!!! The Hon. Gentleman must not enter into debate."
[67][100]

67. The Speaker Calls a Member to Order
Source: "The Speaker Calling A Peccant Member To Order" (*B&W*, 14 March 1891, p. 170)

And the Speaker calls upon the next inquisitive gentleman.

But the Member for Ballyhooley is not to be so silenced. The question over
he is up again to move the adjournment of the House in order to call attention

100. "In presenting his [Peel's] portrait I have selected the pose and expression with which he
generally calls some peccant member to order" (*B&W*, p. 170). See note 63.

to a matter of public importance, namely, the unsatisfactory reply of the Chief Secretary to his question about the scarecrow.

As you know any member can stop the business of the House in this way if he is supported by forty other members.

So the Speaker rises and asks the House if it is their wish the Member for Ballyhooley shall be heard, not forty, but sixty or a hundred sympathetic members rise like a whole regiment of scarecrows, to frighten the Irish Secretary.

The Speaker then calls upon the Member for Ballyhooley.

In giving you an oratorical imitation of the Member for Ballyhooley, I wish you to understand Ladies and Gentlemen, that I do not wish to cause ridicule upon the Irish, among whom I have many friends, but there is no denying the fact that the Irish are a very excitable race and are often carried away by their oratory—so that the Member for Ballyhooley who has had the ear of the House for the last forty minutes, winds up by pouring this into it by way of peroration. [68]

68. The Member for Ballyhooley as the Assassinated Scarecrow
Source: Image untraced. Editorial substitution: "'The Assassinated Scarecrow, Sor!'" (How, p. 309)

"But there are rumours of a dark side to this question—I ask the Right Hon. Gentleman opposite if the red coated ruffians did not believe in their heart of hearts that the poor innocent scarecrow they butchered was in reality a son of the soil and if they did then to all intents and purposes they are blood-stained assassins and should be made surrender to justice.

You deny that it happened! You deny that it happened! Why, not trusting my eyes to mere hearsay I visited the ghastly spot next mornin'—a sight too horrible to describe. The poor figure lying helplessly upon its straw-bound face, showing that it was shot from behind—the well worn coat, a whole pedigree of patches of the Mulligan family, was completely riddled with bullets, the sleeves of the coat torn in shreds laid bare the grand old shillelagh that answered for its arms, and the brimless hat lay six paces away half buried in the earth, leaving the spinal pole—an old broomstick—exposed to the dews of early morn.

I have no doubt that the Hon. Gentleman opposite can procure experts to swear anything, to swear that the moths, not the bullets, riddled that coat, but I am not afeared to say that I will knock the siven sinses out of anyone as complately as the siven sinses were knocked out of that poor scarecrow, that dares to contradict me in this matter."

[Intermission—*eds.*]

A stranger standing upon Westminster Bridge and gazing in rapture at the imposing palace of the British Legislature, conjures up in his mind the stirring scene within.[101] [69]

The light flashing in grandeur from the tower top is symbolic of the fire of debate in the House beneath.[102]

Its radiance shines o'er millions of people and o'er the temples of commerce, science, art and gaiety.

It is there to let the world know that mighty brains are at work for its good, and as the illumined clock chimes the hour, another page in the magnificent history of our country has been written in the oratory of our chosen ones.

Scores of pens record the words as they fall upon a breathless assembly, and could you but tap the hundred wires overhead, you would find that they are

101. HF used this image as the basis for advertisements that promoted "Humours." See Introduction, p. 95.

102. Beginning in 1885, a light in the Clock Tower indicated that the House of Commons was sitting (*EP,* p. 43).

69. A View of the House by Night from Westminster Bridge
Source: *AH*, p. 140

full charged with the substance of oratorical outpourings which they are flashing to the myriads of monster printing presses panting to receive and record them.

Yet so few without running the gauntlet of red-tapeism are privileged to witness the scene within.

The world at large must wait until to-morrow and be satisfied with what the reporters, type, paper, ink and machinery can give it.

But come with me, I shall take you into the Council Chamber, and show you the Legislative machinery of this great country at work.

Through Palace Yard we enter Westminster Hall the scene of state trials and much else which is historical and grand.

Up the steps we find ourselves in St. Stephen's Hall, around which marble statues of Pitt and Fox, Hampden and Canning stand in stately array.[103] [70]

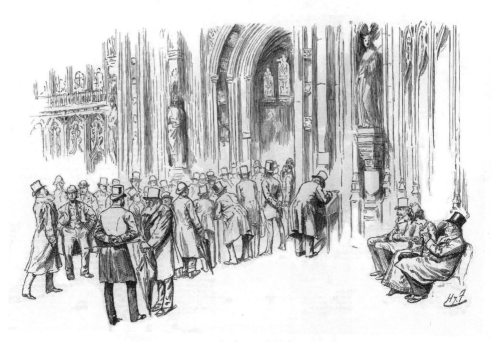

70. St. Stephen's Hall
Source: "A Sketch in the Outer Lobby" (*The Graphic*, 9 March 1889, p. 248)

Passing through this door we enter the great Octagon Central Hall where a crowd of persons is besieging the entrance to the Inner Lobby anxiously waiting a chance to get an envied peep into the House itself.

We pass through the frescoed passage where Ward's masterpieces decorate the walls.[104]

The last sleep of Argyle, The Sorrows of Charles, and The Fate of James give your artistic imagination a taste of the authority wielded within, and already we seem to hear the throbbing of the great heart of Parliament.

103. St. Stephen's Hall, on the site of the chapel in which the Commons used to meet before the 1834 fire (see notes 4 and 14), is decorated by statues of great figures from the old chamber.

104. Edward Matthew Ward was commissioned in 1851 to paint eight murals, completed in the 1860s, for the "passage" leading into the House of Commons depicting scenes from British history, including the three mentioned here. HF is probably referring to the more correctly titled "The Last Sleep of Argyle," "Antechamber at Whitehall During the Dying Moments of Charles II," and "James II Receiving News of the Landing of William of Orange" (*ODNB*, s.v., "Ward, Edward Matthew (1816–1879").

At length we reach the Inner Lobby, and I daresay you are very much surprised at the common-place appearance of this 'Sanctum sanctorum.' [71][105]

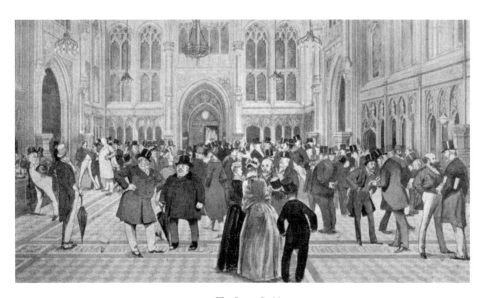

71. The Inner Lobby
Source: Image untraced. Editorial substitution: "The Inner Lobby Of The House Of Commons"
(*CCI*, p. 156)

The tessellated floor you see is strewn with multitudinous pieces of torn paper. Four weary policemen yawn against the pillars.

A row of messengers you observe are lolling in the corner.

A couple of whips at the left entrance are cracking jokes together, while you will not fail to notice that the only other member present is Sir William Harcourt who is standing at the refreshment counter, and eating a bath bun.[106]

Let us now go through to the Legislative Chamber itself.

Dear me! What a small place, you say, and the scene!

A large chair with a sounding-board tacked on faces you. It is empty, as the House is in Committee, and the Chairman resigned to the inevitable, with his arms crossed, and staring at the ceiling, sits at the table.

The legislator upon his legs represents the five thousand electors of the Borough of Boredom, and for the last hour has been addressing the empty benches before him.[107] [72]

105. HF provides a key to the 41 individuals in *CCI*, p. 157.
106. A round, spiced, sugar-coated currant bun originating from Bath.
107. This is Sir George Campbell whose long, dull speeches were notorious. According to the

72. The Member for Boredom
Source: "Essence of Parliament" (*Punch*, 16 August 1890, p. 83)

"I have to thank the Members of Her Majesty's House of Commons for their patient hearing of my oration—I repeat the word oration—on this prodigious question before us, namely whether black sticking-plaister should be used in the Government Hospitals. I have traversed this gigantic question from the earliest use of this adhesive substance commonly called sticking-plaister to-"

The verbose orator is interrupted by a vigilant Irish Member who dearly loves a count-out.

ILN (9 May 1891), the sketch "bears no sort of resemblance to the loquacious member for the Kircaldy Burghs. This fierce-looking ranter with the prominent nose is not the genial, pensive, paternal Scot whose voice is the signal for a hasty exodus." HF's account of preparing "Humours" suggests that he probably mimicked Campbell's voice: "the shrill whistle of the railway engine . . . enabled me the more vividly to recall the dulcet accents of Sir George Campbell" (Appendix I, p. 271).

"Mr. Chairman! I beg to call attention to the fact that there ain't forty mimbers prisint!"

This is followed by the ringing of the electric bells throughout the building.[108] [73] Whilst the Chairman slowly counts those present other members quickly rush in—"Thirty seven!

"Thirty-eight!!

"Thirty-nine!!!

"Forty!!!!"

There is a House: but this formality over, as the Member for Boredom again rises, the members quickly run out again.

"Come like shadows, so depart."[109] [74]

"Yes, Sir, I repeat, I have traversed this gigantic question from the earliest use of this adhesive substance. When sticking-plaister was not a question to jeopardise a ministry, nor a surgical appliance the lever with which to overthrow a Government—and I venture to prophecy that when that prospective New Zealander whom the historian has imagined shall be treading the ruins of this House,[110] that the rancorous wound—I repeat, rancorous wound now caused by party spite through this momentous question—will be healed—healed by black sticking-plaister, and not by white sticking-plaister, and that thus the awful warnings I have fore-shadowed during the last two hours will prove the means of having saved from destruction this great and glorious country!"[111]

108. HF has written "Bell" (underscored) next to this sentence. He probably used an electric bell to communicate with his lanternist (see Introduction, p. 86) but it is not known whether he rang a bell at this point in "Humours."

109. The quotation is from *Macbeth*, IV.i.

110. Thomas Babington Macaulay, in an 1840 *Edinburgh Review* notice on a translation of Leopold von Ranke's *Ecclesiastical and Political History of the Popes*, conjured an image of a New Zealander of the future standing on a broken arch of London Bridge to sketch the ruins of St. Paul's Cathedral. In 1865, *Punch* placed "Macaulay's New Zealander" at the top of the list of hackneyed literary conceits that should be banned. See David Skilton, "Contemplating the Ruins of London: Macaulay's New Zealander and Others," *Literary London: Interdisciplinary Studies in the Representation of London*, vol. 2, no. 1 [2004], http://homepages.gold.ac.uk/london-journal/march2004/skilton.html. Gustave Doré famously illustrated this image as part of his collaboration with Blanchard Jerrold, *London: A Pilgrimage* (London: Grant & Co., 1872).

111. HF notes the effect of this particular speech on a gathering of nurses (see Introduction, fig. 12): "In the second part of my entertainment I made a speech in the character of the 'Member for Boredom,' anent the use of black sticking-plaster in public hospitals. This is intended by me to be more of a satire than a humorous incident, and I am supposed to bore my audience as the honourable gentleman is supposed to bore the House; but on this occasion the nurses, who understood very little about politics, simply roared with laughter at the mention of a subject with which they were so familiar" (*CC*II, p. 163). Elsewhere, HF uses the same device to illustrate the minutiae taken up in debate: "Mr Gladstone was telling the House all about black plaster, and gave three points why it should not be used in public hospitals" (*CC*I, p. 238).

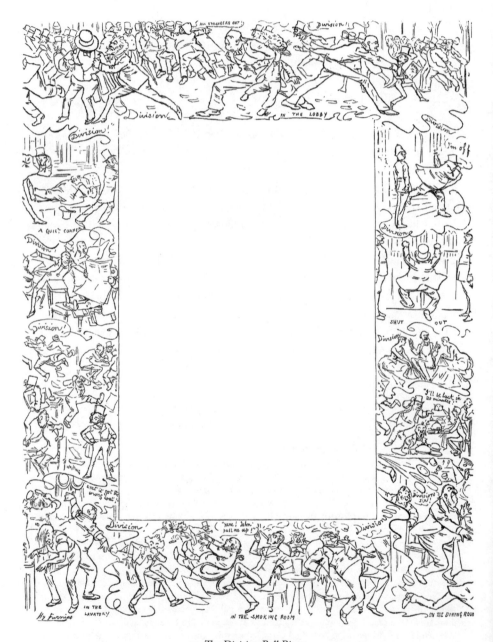

73. The Division Bell Rings
Source: "The 'Division' Bell. Electric Shock Round The House" (*Punch,* 12 March 1887, p. 131)

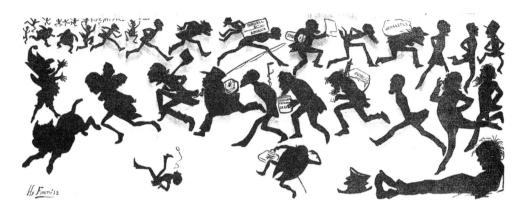

74. MPs Depart

Source: "End Of Session—'Come Like Shadows, So Depart!' (Exeunt Omnes.)" (*Punch*, 3 September 1881, p. 108)

The member for Boredom is followed by the member for Mashertown in this haw-haw fashion.[112] [75]

75. The Member for Mashertown

Source: Image untraced. Editorial substitution: "Hon. C. Spencer, M.P. (Masher of Parliament)" (*Punch*, 17 March 1883, p. 125)

112. In this context a masher is "a fop of affected manners" rather than its other meaning of "lady killer" (*OED*).

"Hum—aw—weally—ah, this ah—subject—is—ah—vewy important. The interwest is ah—evident—by—all—the appearwance of—the—ah—House—ah–"

"Hear! Hear!! Hear!!!" ironically cheers a member from Oirland.

"I shall—ah—not be subdued—ah—by—ah, vulgar interwuptions—ah! No doubt—ah—the painful experwience—ah of the hon. gentleman opposite—ah—of plaister—of late—ah—"

"Mister Chairman—Sor—I rise to order." [76][113]

76. An Irish Member Rises
Source: Image untraced. Editorial substitution: "It's no place for Irishmen!"
(*Punch*, 2 October 1886, p. 168)

"The mimber opposite throws in me face the plaister I had to apply to moi poor broken head, after his murthurous red-coated ruffians cut me and me counthrymen to paces in a dastardly and cowardly way—"[114]

113. The image is of Dr. C. K. D. Tanner, MP for mid-Cork.

114. Henry Lucy reports that Dr. Tanner, "made a succession of speeches on the subject. . . . Twice

This brings up all the oratorical field artillery of a worthy Tory General. He speaks as if his words were shot from a gun. The effect, which I fear I cannot imitate, somewhat resembles volley-firing.

"Mr. Chairman, Sir! I—ah—rise to order. [77][115] The enemy opposite charges my friend in our camp, with, ah, cowardice. I am an old soldier, and proud to serve my country and my Queen,[116] and I say in this House what I shall say outside it, that the Hon. Gentleman opposite is a liar, and I mean it offensively!"

77. A Tory General Rises
Source: "In rising to respond" (*Punch*, 21 February 1891, p. 96)

called to order by the Speaker" (*Punch*, 2 October 1886, p. 168). HF retells the incident in *CCI*, pp. 239–40.

 115. The image is of Lieutenant-General Sir Charles Crauford Fraser, MP for Lambeth North.

 116. Cf. earlier references to the King. More evidence that the text is assembled from pieces written at different times. In the context of an Edwardian performance, however, the old soldier's reference to the Queen might be taken to indicate either that he lives in the past, or his years in service occurred during the Victorian era.

The gallant member explodes, and sets off minor squibs, after whose fizz-ing there is a general apology for what is said in the heat of debate.[117]

The report has brought in some members, but the House subsides into langour as Mr. Nobody takes the floor.

An incident like this is what reporters call good copy, and the scene has caused quite a flutter in the Ladies' Gallery, [78][118] where the criticisms passed on Parliamentary processings are frequently much more severe that those ema-nating from the Press Gallery.[119]

One trembles to think what another Star Chamber this snuggery may become[120], should the tidal wave of feminine influence which we now see sweeping over the ocean of politics bear down the opposition which at present confronts it, overpowering and destroying the feeble walls with which man has marked the crooked coast-line of his narrow kingdom, until we wake up one fine morning to find that the 'political geography' of to-day is no more.

For the present, they content themselves, these fair and fervid politicians, with determining that when they have to form a Parliament, the dull and colourless proceedings which they have just witnessed will be a thing of the

117. The use of terms like "cowardice" and "liar" with respect to other members was prohib-ited by rules of parliamentary debate. In his 1844 codification of parliamentary procedure (which became *de facto* the official handbook), Thomas Erskine May wrote that the "imputation of bad motives, or motives different from those acknowledged; misrepresenting the language of another, or accusing him, in his turn of misrepresentation; charging him with falsehood or deceit; or con-temptuous or insulting language of any kind—all these are unparliamentary and call for prompt interference." Thomas Erskine May, *A Treatise on the Law, Privileges, Proceedings, and Usage of Parliament* (London: Charles Knight, 1844), p. 204. In practice, however, the Speaker's rulings from the later decades of the nineteenth century indicate "that he is very solicitous to prevent any at-tacks on personal honour, but that ample latitude is allowed in the use of severe words, of forcible expressions of conviction, and that there is no undue restraint upon the personal attacks which are, to a certain extent, unavoidable in parliamentary warfare." Josef Redlich, *The Procedure of the House of Commons: A Study of its History and Present Form*, 3 vols. (London: Constable, 1908), vol. 3, p. 62n.

118. HF has written on the draft sketch "pale orange," indicating the tint for the slide. PA HC/LB/1/112/248.

119. As discussed in the Introduction (section III.3), although HF was a great admirer of women, he held rather limited conventional views of women's capabilities. In one essay, he described his re-joinder to the popular author Marie Corelli's complaints about the "cage" that divided the ladies in the Gallery from the House: "They [women] don't want it removed," I argued, "for the simple reason that its removal would necessitate their 'dressing' for the House. As it is at present they can go 'as they are.' But you would never find ladies agree to sit in walking attire when others looked more attractive in evening dress. That is the crux of the whole question. I am inclined to think," I added, "that even apart from this point the 'gridiron' is essential. The ladies would be shocked, were they near enough, to hear all that goes on during a 'scene'; the Members for their part would hardly be edified to see the conduct of some of their lady friends in the gallery behind the 'gridiron.' It is not so very long since that one lady 'bonneted' another, and a 'lady' visitor astonished others by coolly taking from her pocket a flask and rapidly consuming its contents" (*SVW*, p. 41).

120. HF has written in the margin "Ladies gallery."

78. In the Ladies' Gallery
Source: "Corner In Ladies' Gallery" (*The Graphic*, 16 March 1889, p. 281)

past, the day of action will have arrived, and volumes of frivolous and fruitless talk will no longer consume the precious time of the country.

The nearest approach which the Ladies now make to the House is a little nook—really an official seat—inside the passage of the House by the entrance, where they get a privileged peep.

But for the present members ought not to forget that ears are behind the gridiron, and that the opera glasses in the Ladies' Gallery are fixed searchingly upon them.

The orchids in the button-holes of certain M.P's are admired and minutely discussed. A change of ties or breast-pins is noted. Whiskers freshly-dyed are detected, even letters written in the Reporters' Gallery are read. At least a lady

has informed me that a journalist she watched, when he was supposed to be reporting, was in reality accepting an invitation to dinner, whilst another was proposing an engagement of a more lasting nature.

But it is interesting to note that this is all ladies can see of the House from their Gallery. Their Gallery is immediately over the Press Gallery, where I made this sketch in pen and ink one day when Mr. Gladstone was addressing it. [79]

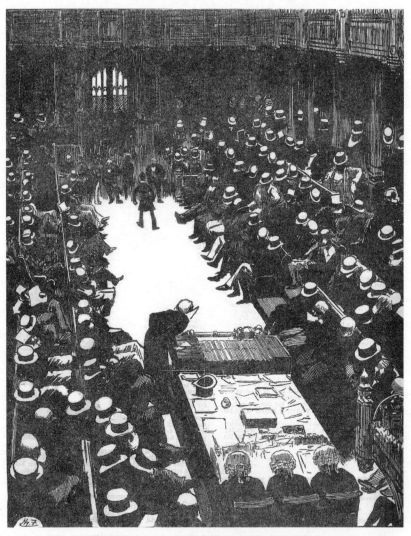

79. The View from the Press Gallery over the Ladies' Gallery
Source: "The House Of Commons From Toby's Private Box"
(*Punch*, 29 March 1890, p. 154; rpt. in *CCI*, p. 208)

You will notice that ladies get, at least, a very good idea of the tall hats in Parliament.

Mentioning the Press Gallery reminds me that you ought to be very careful indeed of the impressions you form of members through reading the debates in the House. When you read a report of a speech, naturally, you conjure up in your own mind the man who had delivered it reading a passage such as this—This is the member you would imagine would speak the following words—[80]

Figure 80. The Ideal MP
Source: "The M.P. Real and Ideal" (*CCI*, p. 150)

"Standing on this classic floor I do not scruple to defy the power both of this House and of the Upper House. Your threats I scorn, your sneers delight me, your jeers amuse me, and though in my heart of hearts you know that I detest you all your looks of envy only flatter and encourage me."

But, Ladies and Gentlemen, I happened to be in the House when these words were spoken and I made a sketch of the member.

This is the member, and this is how he delivered these words—[81]

81. The Real MP
Source: "The M.P. Real and Ideal" (*CCI*, p. 150)

"Standing on this classic floor I do not scruple to defy the power both of this House and of the Upper[121] House. Your threats I scorn, your sneers delight me, your jeers amuse me and though in my heart of hearts you know that I detest you all your looks of envy only flatter and encourage me."[122]

Ladies[123]
Election Clerk asks a voter [82, no image]
"Who do you vote for?"
"I vote for the lady."

121. In the typescript, HF has inserted here the sections that follow on ladies and Hibernian oratory, interrupting the conclusion of this passage. At the bottom of the page, HF has written "Your threats I scorn &c." The remaining text of this paragraph (crossed out) occurs several pages later, right before HF starts discussing the dining habits of archetypical members. For the sake of clarity, we have rejoined the broken text.

122. The *Melbourne Punch* (27 May 1897, p. 417) reported that HF's "fancy runs riot, as in the case of the contrast between the god-like gentleman who might have uttered certain highfalutin' sentiments and the small, smug, pug-nosed, wheezing M. P. who did utter them."

123. At this point in the typescript the text does not follow from what preceded it and moves on without any transition to the Election Clerk and then to ladies in Parliament. HF has written "Read" at the beginning of this section.

"But there isn't one standing for the place!"

"Well, Poll Early's name comes on my voting paper, before the names of two men, and I thought I'd vote for her."

Ladies, however, are more useful as canvassers than as candidates, particularly if endowed with personal attractions. In the old days the beautiful Duchess of Devonshire immortalised by Gainsborough[124]—was very active in canvassing votes for Fox, and dazzled the Electors with her beauty—in fact she dazzled an Irish elector so much that he declared "he could loit his poipe at her oies."

The difficulty nowadays is, to light the pipe of Peace, in the Eyes of Parliament.

There may be an occasional, a very occasional, touch of Humour in Parliament, but let me warn any aspiring legislator there is absolutely no Peace for the M. P. In the old days a jaded politician found in the House a relief from the society struggles of the West End and the worries of work in the city. The House to him then was the place in which to spend a happy day and a Peaceful evening.

When a legislator had listened long enough to the speech of the Member for Boredom he left the Debating Chamber for the Peace and quietude of the Lobbies and Corridors, a book and forty winks in the Library, a few letters to write in Peace in the smoking-room, or, perchance, a Peaceful game of chess, a chop and a chat with some congenial member in the Dining-room, or a stroll in Peaceful solitude on the Terrace to collect his thoughts for his coming speech.

But, alas! that relief is no longer to be had—Nowadays, when the fatigued M. P. bows to the Speaker and departs through the swinging doors he stumbles across a crowd of ladies actually within the precincts of the House, [83] stopping up the only entrance, so anxious are they to get a peep from the floor of the House.[125] Ladies have but one chance to survey the Commons in this way. By the inner door there is a seat for an attendant, and in spite of the strict regulations the fair visitor stands up on this seat whilst a gallant member points out to her the Speaker's Chair, the Table, the Mace, and other mysteries of the House, which cannot be seen from the Ladies' Gallery, and as the door by her side swings backwards and forwards she has a closer view of those in

124. Thomas Gainsborough (1727–1788) painted in 1787 his famous portrait of the Duchess wearing a large black hat.

125. A popular topic with HF (see Introduction, pp. 58–59) the text here and later draws upon, among others, "Strangers In The House. No. 2," (*The Graphic*, 16 March 1889, pp. 273–83); "The Week In The Commons: Petticoats in Parliament," (*The Daily Graphic*, 17 July, 1890, p. 8); "The Week In Parliament," (*Black and White*, 16 May 1891, p. 478). He repeated it all later in "Ladies in Parliament," *Cassell's Magazine*, vol. 41 (December 1905), p. 87.

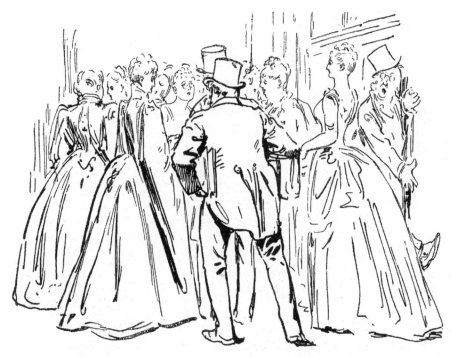

83. A Crowd of Ladies
Source: "The Week In The Commons: A Block In The Corridor"
(*The Daily Graphic*, 17 July 1890, p. 8)

whom the destinies of her country are confided. Gazing, as I here show her, like the Peri at the Gate of Paradise,[126] upon the solemn scene where she may not intrude [84][127]—and as the lady steps down another and another take her place for they are there not singly but in battalions!

The M. P. pushes his way through the crowd of petticoats in the Lobby into the Members' Corridor, there to find the passage blocked by more of them. He tries the roundabout way to the smoking-rooms, but in the Corridor, leading to the Outer Lobby, sit ladies waiting, for some Members to take them into the House. "Oh! Mr. Blank, so glad to see you. You know our Member Captain Whitelace has made some dreadful mistake. He invited us here to-

126. A reference to Thomas Moore's poem "Paradise and the Peri" from *Lalla Rookh: An Oriental Romance* (1817). The Peri, a fallen angel driven out of Paradise with Lucifer, languishes at the heavenly gates. Pitied by the guardian angel, she is told she will be forgiven if she brings the gift most dear to Heaven. After several spectacular but unsuccessful efforts, she gains entry to Paradise with the repentant tear of a sinner redeemed.

127. There is no number in the typescript for this image but the text indicates that it was shown, so this is an editorial insertion. Similar images appear in the publications mentioned in note 125.

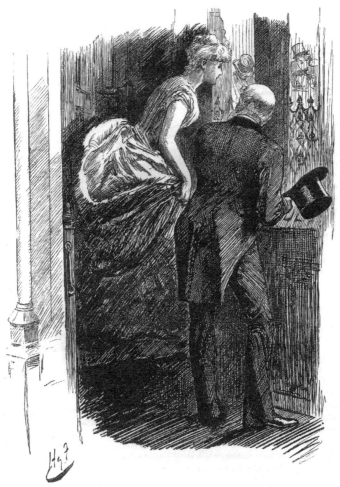

84. Gazing at the Commons
Source: "A Privileged Peep" (*The Graphic*, 16 March 1889, p. 280)

day, and we were to stop to dinner and see the Terrace by moonlight, and hear Mr. Campbell Bannerman and Mr. Balfour, and all that, but the servants tell us he is not to be found. Now, will you, as an old friend, get us into the House, and show these young ladies the House of Lords, and the Gallery, and the Terrace, and, and—?" Poor Mr. Blank! Perhaps he runs the gauntlet and escapes the petticoats in waiting, and falls into the Outer Lobby, there to find—Oh, Horror of Horrors!—some angelic agitator ready to pounce upon him! [85] In fact, go where he may about the House, he is certain nowadays to find the fair strangers, or, worse still, the exacting Lady Politician.

85. An Angelic Agitator
Source: "The Week In The Commons: An Angelic Agitator"
(*The Daily Graphic*, 17 July 1890, p. 8)

Up to a session or two ago it was quite a relief to see a lovely woman flit across the Lobby; now the difficulty is to find your way through the crowd of them.

The Members themselves are to blame. The Gallery provided for the Ladies is simply a big cage, and bad for air, sound and sight. [86] The Members of "The Best Club in England" invite their fair visitors, and then cage them as if they were wild animals—the wild animals, however, are on the other side of the grating.[128]

That venerable actress, the late Mrs. Keeley, when introduced to the Gallery, exclaimed to her lady friend—"Oh! my dear, I feel just as if I were in a Harem."[129] To an everyday mind neither given to exercising the wings of

128. HF reported on the unsuccessful attempts to have the grille replaced with a lighter screen in "Ladies in Parliament," pp. 80–81.

129. Elsewhere, HF attributes the remark to Mary Anne (Fanny) Stirling (1815–1895): "When dear

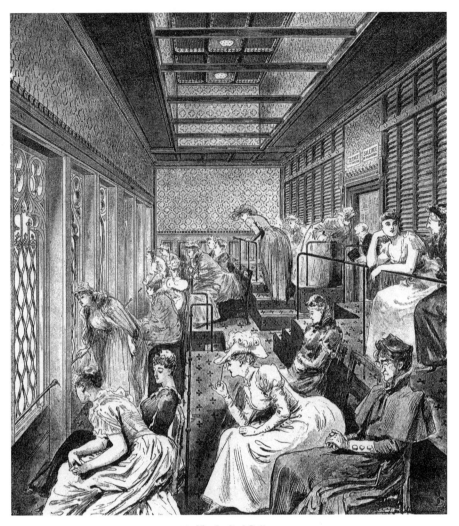

86. The Ladies' Gallery
Source: "The Ladies' Gallery In The House of Commons" (*B&W*, 18 July 1891, p. 92)

fancy nor indulging in the oriental luxury of suggestive metaphor, the Ladies' Gallery—known as the Gridiron—is a small loft, containing thirty-four chairs, in three rows. These rise in steps towards the back; and there is an iron bar or handrail in front of each row to prevent the fair occupants from tumbling over one another.

Mrs. Stirling, the veteran actress, paid her first visit to the Ladies' Gallery in the House of Commons, she remarked to her neighbour: 'This is the first time in my life, my dear, I have ever been in a harem'" (*MAHTD*, p. 13).

In times past there was some consolation in being caged for a Member, as shown here, used often to run up and chat with a friend in the Gallery, and the back row behind the Gridiron became the recognised flirting place of the House. But, strange to say, there appear to have been some unhappy persons for whom their country's Political progress had more attractions than Britain's fairest daughters, and who preferred hearing the words of some of England's first orators to having their ears assailed with a continuous fire of choice melodious gibberish. Consequently, we have to sing—with Byron, mourning the "dying glory" of Venice—"And music meets not always now the ear,

Those days are gone, but Beauty still is here."[130]

Plainly, Members may now only come to the door of the Gallery, and send in for the lady they may wish to speak to.

Small wonder then that ladies escape from this cage and flutter all over the House to their own amusement, although the older Members resent this intrusion in their Peace in Parliament.

And here I must make a confession—I am the person guilty of making this change in Parliament, for nineteen years ago I made this drawing now before you, and it was published in the "Illustrated London News" of July '81.[131]

Many Members, and most of the wives, left in the country imagined this to be a mid-summer dream on my part, but when afterwards I appeared in the "Humours of Parliament" and described in detail this pleasant scene on the Terrace, I am informed by the officials of the House, that, since then, they know no Peace.

No! Ladies and Gentlemen, the Houses of Parliament is no longer a Parliament of Peace—It is a Parliament of Petticoats.

To ensure Peace in Parliament and to supply some Humour as a curtain raiser on the session, a search is regularly made in the cellars of the House for any descendant of Guy Fawkes—on the principle no doubt that it's the early Beefeater who catches the Bomb. [87]

Just picture to yourself what would happen if he were to be found in underground Parliament! [88][132]

130. Lines from Byron's "Childe Harold's Pilgrimage" (1818), canto IV, stanza III.

131. The drawing referred to is "A Midsummer Night On The Terrace Of The House Of Commons" (image 98) and, together with "when afterwards I appeared in the 'Humours of Parliament'" in the next paragraph, dates this section of the typescript as 1900, the year HF performed "Peace With Humour." The numerous references to "peace" in this portion of the text confirm this. See also note 604. Hence the editors have retained the position of image 98 where it was shown on the 1891–92 tours.

132. Here HF inserts a note to "Read" what follows.

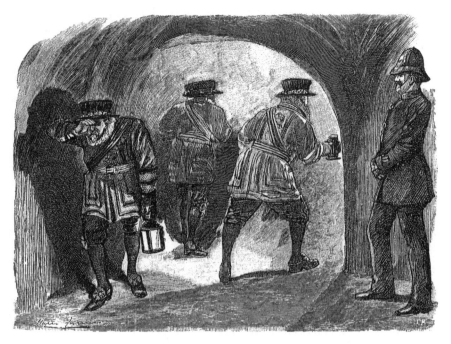

87. Searching for Guy Fawkes
Source: "The Yeomen Of The Guard In Underground Parliament" (*B&W*, 11 April 1891, p. 296)

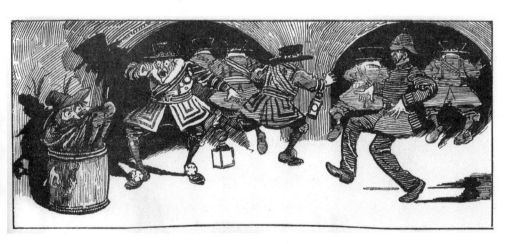

88. If Guy Fawkes Were to Be Found
Source: "What would happen if he were to be found? Anything like this?" (*PPP*, p. 1)

Well, I may safely say that a few years ago the sight of a lady in underground Parliament would have caused quite as much astonishment—yet nowadays ladies are found, not only in the Lobbies and on the Terraces, but over the whole building, from the Clock Tower to the Deepest Dungeon below the House. And the poor Member who rushes away from the galaxy of beauty flooding his House of Peace escapes, as he thinks, when he gains the Cellars.

But alas! there is the lady also—caged again, you will say—not a bit of it! she is here being shown the mysterious passages underneath the floor of the Commons, [89][133] and the woman-hunted M. P. at last comes to the conclusion that Peace in Parliament is a sham—but does he realise this Temple of Peace—The House of Commons—is really a House of Shams?

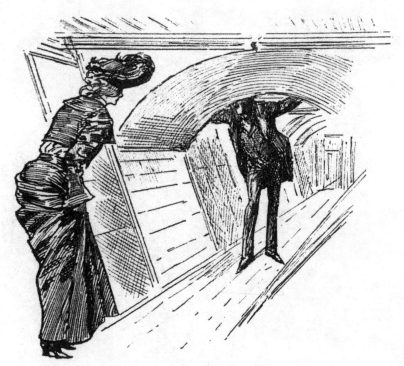

89. Underneath the Commons
Source: "The Fog Filter" (*Cassell's Magazine,* December 1905, p. 86)

133. There is no number in the typescript for this image but the text indicates that it or something similar was shown, so this is an editorial insertion. The *Cassell's Magazine* article, "Ladies in Parliament," has one lady, concerned for her "nice new dress," remark that "Underground Parliament is not only one of the most interesting, but also one of the cleanest and best kept places I ever visited" (p. 89).

The majority of M.P's returned to Parliament to look after their con-
stituents' interests, look after their own—the man of War outside the House,
voting kharki [*sic*][134] is, once inside, a vacillating coward with a white flag.
The man of Peace outside Parliament is the noisy braggart when within—
the working man's representative is more often the idle M. P. You send a Saint
to Parliament—see, he may leave it a Don Juan.

The "Table" of the House itself is a sham. [90]

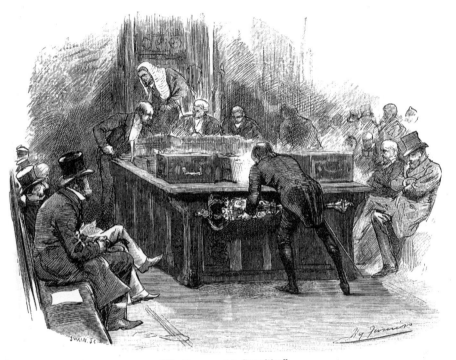

"The House goes into Committee."

90. The "Table" of the House
Source: "'The House Goes into Committee.'" (*Good Words,* 1888, p. 109)

134. Khaki (Hindi for dust-colored) refers to the fabric of this hue adopted by the British Army
in the late 1890s. The new uniforms came to be closely identified in the popular mind with the South
African War of 1899–1902. The war was the dominant issue of the general election of September/
October 1900, which was dubbed the "khaki election" and returned Salisbury's Unionist government
with its majority intact. HF's reference to the patriotic politics of "voting khaki" is another indication
that this part of the typescript dates from 1900.

After an awe inspiring procession, with great pomp the Mace is daily placed upon the "Table"—to remain there during the sitting of the House as the bauble of the Sovereign, but when the "first gentleman in England" otherwise known as "Mister Spaker Sor" vacates his chair, and the common or committee Chairman presides—with much ceremony, as I show in this sketch—the "Table" is formally uncrowned.

Members approach the "Table" as something sacred—in reality it is a sham. Disraeli's historic reference to it—"He felt thankful for the solid piece of furniture which separated him from his antagonist"[135]—was a sham.

Matters of Imperial importance are officially placed on the "Table." The "Table" is constantly referred to in speeches as something symbolic of the stolidity of our Empire. It looks as safe and sound as the Bank of England—in reality, it is as hollow as the promises politicians make over it—as empty as the minds of some seated around it—a sham of shams—it is not a "Table" at all, but a ventilator!

Taking a section of the House you will easily see how it is a ventilator, at the same time allow me, my dear Member, to point out to you that the irrepressible lady, is seated within that so called "Table" looking straight into your face and listening to the whispers of those on the front benches[136]—a word from her, a sneeze or a cough, would mean a rebellion in the House, so she sits like—Patience on a Monument—as silent and as quiet as a graven image.[137] [91] Of all the pictures I will show you to-night of "Peace with Humour" I do not think I can select a better or a more unique illustration than a lady in such a position trying to hold her tongue! Or what is nearly as trying to suppress a laugh when listening to some of the speeches, for instance—the following specimen from the Irish benches is no invention of mine as any one reading the Parliamentary debates will admit.

This Hiberian Oration can only be objected to on the same score as the old lady objected to the play of Hamlet—"that it is too full of quotations."[138]

"Mister Spaker Sor, the Right Hon. gintilman opposite—the Chafe Secretary for Oireland,—who has just sat down remains the standing joke of his

135. On 26 March 1867, closing the debate on the second reading of the Second Reform Bill, Disraeli took note of Gladstone's violence in attacking the Bill: "The right hon. Gentleman gets up and addresses me in a tone which, I must say, is very unusual in this House. Not that I at all care for the heat he displays, although really his manner is sometimes so very excited and so alarming that one might almost feel thankful that the gentlemen in this House who sit on opposite sides of this table, are divided by a good broad piece of furniture." Quoted in M&B, vol. 4, p. 524.
136. In "Ladies in Parliament," the lady visitor remarks: "There was I staring right into the eyes of the Premier. Positively, I could have run my parasol through the grating, and knocked one of the member's hats off" (p. 89).
137. Viola "sat like patience on a monument/Smiling at grief." Twelfth Night, act II, scene iv.
138. Furniss's handwritten note reads "This is the Irish Bull fighter."

91. Sitting like Patience on a Monument
Source: "Under the Mace" (*Cassell's Magazine,* December 1905, p. 89)

party, it's grand talk entirely to spake iv thrampling out Oirishddiscontint with a firm hand, but loike his praydeessors in office he only puts his foot into it by shoving the mailed fist in the face ov Oirish Patriots! Is'nt the toime roipe for the Chafe Secretary of Oirland to pluck an olive branch off the English Oak and offer Pace to those Hon. gintilman sitting around me—who I am sorry to say are not in their places!

"The roight Hon. gintilman shakes his head—I am sorry to hearit, I have heard the same reply toime after toime, year after year, from benches. Contamination, let me remoind the Hon. Giltilman is the thafe of toime[139]; and when Oi close moi oies I same to see his brothers voice and hear the scoffing laugh-

139. A malapropism for the traditional saying "procrastination is the thief of time."

ter of those long silent, who have filled the ignoble office. Marl moi words the day is not far distant; if it has not already arrived whin the Oirish Soldier will cease to fight yer battles. It's all roight for ye' to sind Oirishmen to the front to be kilt in your wars and thin to come back to spend the remainder of thir loives in an Oirish Workhouse!"

"I am now going to repate what I was prevnted saying—and more that this amindmint be now considered this day three months—" "Order, order!" interrupted the Speaker. "Well O'ill not conclude what I was about to say, but spaking for myself I must confess I cannot sleep for draming in that day—" "Order, order!" cries the Speaker, "The Hon. gentleman has no right to speak for himself or anyone else at present there being no amendment before the House."

Here the House nearly choked with laughter and the lady rushed up to the gridiron there to be nearly roasted alive.

Tea.[140]

But leaving these matters to the ladies to discuss over their tea, [92][141] we go in search of the members.[142]

In passing the dining saloons[143] [93] you may notice the burly country member polishing off his House of Commons steak, as he would the affairs of the nation if he had his way, to the disgust of the dyspeptic Anglo-Indian General whose palate is destroyed by Indian curries and his health by the Indian climate.

The member from Ireland is engaged upon an Irish Stew.

The burly Englishman has just cut the juicy steak.

The Anglo-Indian has at last managed, after many failures, to get an Indian curry properly made. The worn-out minister is about to raise the soothing soup of turtle to his lips. The canny Scot is gleesome over the first real haggis which the House steward has provided.

Taffy has just had the delicious Welsh rarebit placed before him, when! horrible to relate, the division-bell!!!

140. Here the typescript includes a flap of paper on which HF has written "Time? [triple underscored] Close Book or Read Division," referring to the description of the division with which he ends.

141. HF has written on the draft sketch "pink," a conventional color for females, indicating the tint for the slide. PA HC/LB/1/112/288.

142. Furniss's handwritten notes read "Tea" and "supply matter."

143. As HF writes they are "complete and well-appointed, [and] qualified nowadays to cater for and pander to the tastes of an epicure" (*PPP*, p. 10). The reprint of the sketch in *Parliamentary Views* supplies a key for the 25 MPs shown.

92. The Ladies' Tea Room
Source: "The Ladies' Tea Room" (*The Graphic*, 16 March 1889, p. 280)

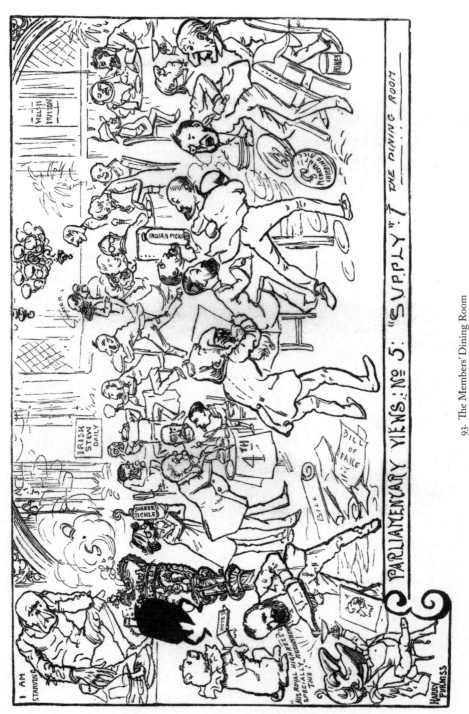

93. The Members' Dining Room

Source: Image untraced. Editorial substitution: "Parliamentary Views: No. 5: 'Supply.' The Dining Room" (*Punch*, 22 March 1884, p. 143)

The Sancho-Panzian feast[144] is deserted, and as all rush off to duty, dinners and tempers are destroyed wholesale. [94][145]

94. The Division Bell Rings
Source: Image untraced. Editorial substitution: "The Week In Parliament: Sir Richard Too Late"
(*The Daily Graphic,* 26 June 1890, p. 8)

A little later we look in at the members' smoking room. [95][146]

144. Sancho Panza, the fat-bellied squire of Don Quixote, was allowed to eat nothing at a feast because the presiding doctor "caused every dish set upon the board to be removed without being tasted." *Brewer's Dictionary of Phrase and Fable,* p. 104.

145. This is Sir Richard Temple, renowned for rarely missing a Division. "I am sure a picture of Sir Richard Temple running at full speed across the Palace Yard would be received with cheers when thrown by the lanternist on to the sheet, for all sides appreciate the extraordinary loyalty shown by Sir Richard to his Parliamentary and other duties" (*The Daily Graphic,* 26 June 1890, p. 8).

146. The reprint of the sketch in *Parliamentary Views* supplies a key for the 16 MPs shown.

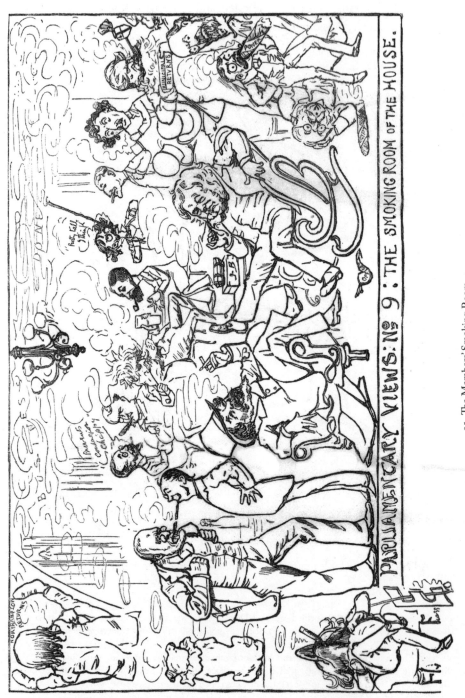

95. The Members' Smoking Room

Source: "Parliamentary Views: No. 9: The Smoking Room of the House" (*Punch*, 19 April 1884. p. 191)

Anyone seeing the apartment for the first time might imagine that here was a competitive exhibition of easy chairs, for the furniture is of marvellously varied design.[147]

There are high chairs, low chairs, soft chairs, hard chairs, big chairs, little chairs, round chairs, square chairs, wide chairs, narrow chairs, spring chairs, cane chairs, rocking chairs, and chairs on wheels, saddle-bag chairs, and last but most curious, straddle-chairs—chairs that equestrian members can mount when they have lost their morning canter in the Row and fancy themselves in a pig's skin.[148]

We may hope in time to see these members provided with rocking-horses, with "real hair."

Mr. Labouchere has just come to the point of his best story. Mr. John Aird has just lit one of his beautiful Havannahs, Lord Randolph Churchill is just giving the straight tip about the Derby winner to a friend, Mr. Storey has just finished a leading article for one of his papers, when that division-bell again!! The point of the story is lost, the cigar destroyed, the Derby tip missed, the article confused, as all clear out of the room. [96]

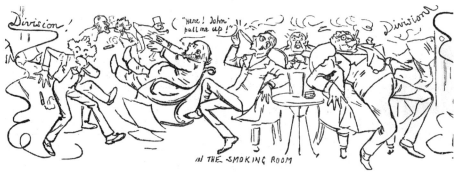

96. The Smoking Room Cleared
Source: Image untraced. Editorial substitution:
"The Division Bell. Electric Shock Round The House" (*Punch*, 12 March 1887, p. 131).
[The lower part of image 73 ("In The Smoking Room") makes up this image.]

Some find metal more attractive upon the Terrace, which skirts the Houses of Parliament upon the river side. [97]

147. "The chairs, indeed, are made to fit all sorts and conditions of M. P.s" (*PPP*, p. 7).

148. Rotten Row in Hyde Park was a broad riding avenue popular with high society horsemen and women. A pig's skin is a saddle.

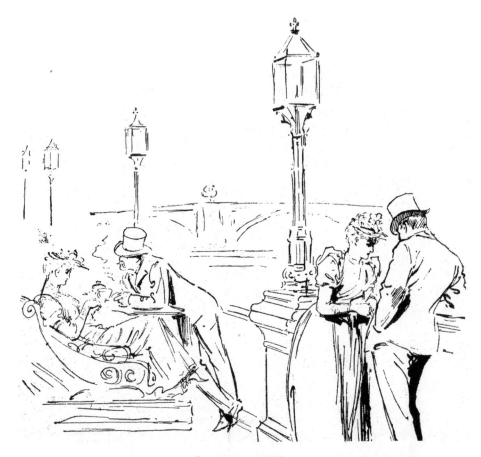

97. Attractions on the Terrace
Source: "The Week In The Commons: On The Terrace" (*The Daily Graphic*, 7 August 1890, p. 5)

On a midsummer evening the scene here is quite continental. [98][149]

Numbers of members sit out in the open, or promenade, accompanied by their own, oftener by other people's sisters, cousins, or aunts—or sometimes by their wives.

With a great stretch of the imagination you can almost fancy you are in Venice.

The graceful gondola, which ceaselessly with silent oars glides slowly and mysteriously to and fro, may turn out to be a common, or Thames police boat.

149. According to HF the drawing, when published in the *ILN*, "caused an unpleasant sensation" (*Daily Graphic*, 7 August 1890, p. 5).

98. The Terrace by Moonlight, or Venice in London

Source: "A Midsummer Night On The Terrace Of The House of Commons" (*ILN*, 79, 30 July 1881, p. 101)

The silhouetted hansom cab or rumbling 'bus may spoil your romantic picturing that Westminster Bridge is the Bridge of Sighs,[150] but flirtations are the same all the world over, and Italians frequently speak with an Irish accent.[151]

The members and their friends sip their coffee, smoke cigarettes, drink sherry cobbler, or coquette with an ice.

Indeed I have reason to believe 'the question' has more than once been 'put' on the Terrace.

The lady is about to respond, when—yes, that confounded division-bell or 'count-out' clears the Terrace as effectually as a mad dog. [99]

99. MPs Abandon the Terrace
Source: "The Week In The Commons: On The Terrace—'Division!'"
(*The Daily Graphic*, 7 August 1890, p. 5)

This spot, the Lobby, is, as it were, the Green-room of the Parliamentary Theatre.[152] [100]

150. Another allusion to Byron's "Childe Harold's Pilgrimage," here the opening of canto IV: "I stood in Venice on the Bridge of Sighs." See note 130.

151. HF recalls one response to these comments: "One night, I was giving my entertainment in a large manufacturing centre, in the north, to a crowded house. . . . I was just expatiating, in a romantic vein, upon the charms of the Terrace of the House of Commons by moonlight . . . and in drawing attention to a young couple in the picture, who were leaning on the parapet, very close together, I remarked that 'Flirtations were the same all over the world,' when some male member of the audience . . . called out 'Hear, hear!' [which] . . . fairly brought down the house" (*AH*, p. 147).

152. "Green-room" is the traditional name given to the offstage waiting room for actors. The Lobbies were favorite haunts of HF and his sketches appear in other publications such as *The English*

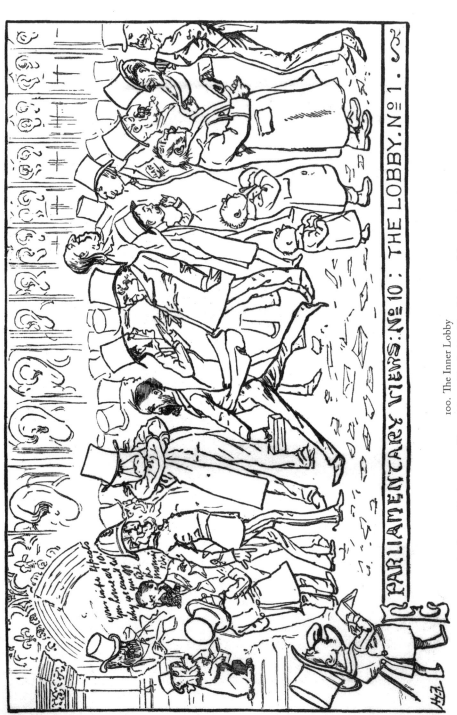

100. The Inner Lobby

Source: "Parliamentary Views: No. 10: The Lobby. No. 1" (*Punch*, 3 May 1884, p. 215)

The House itself is the stage, and whatever is said and done in it, is political acting for public effect.

But it is in the Green-room, the Inner Lobby, which I may also call the pulse of Parliament, where the member throws off his stage manner, and tells you what he really thinks of the Parliamentary play, the players, and the prospects of the new piece.

The whips are conspicuous in the Lobby by not wearing their hats.

They act in the same capacity as the whip in the hunting field. Hence the name. For they control the Movements of the Parliamentary pack, whipping them up for a division, and not allowing them to break away while the fox is likely to beat them.

A member to "pair" I need hardly explain has to get a member of the opposite side to agree to keep out of the House for a certain time. [101] For a few hours this is often not difficult, but when, later in the session, members want to "pair off" for the remainder of the time, the matter is much more difficult to arrange; for if you happen to be an able-bodied M. P. you must not pair with a member on the other side who is obliged to leave on account of ill-health, as this is clearly a vote lost to your party, since your pair would have left in any case.[153]

This difficulty must sometimes cause your conscientious M. P. some misgivings, but although I have often observed the members during pairing season, I have never noticed them examine each other's tongues, or feel each other's pulses. Still, I have no doubt the wary Gladstonian will artfully lure his Tory friend near enough to Dr. Farquharson or Sir Josiah Forster[154] for one of those worthy medicos to report as to the soundness of the investment.

If a hungry member cannot get a "pair," you may see him at the door, using all his blandishments on one of the whips and making every excuse to get off, like a school-boy wheedling for a half-holiday.

Illustrated Magazine (December 1885, p. 195), *The Graphic* (20 July 1889, p. 79, p. 82), and HF, "Press in Parliament," p. 145. The reprint of the sketch in *Parliamentary Views* supplies a key for the 13 MPs shown.

153. HF has here inserted a note "Without Boots" and an image cue but since there is nothing in the text that is relevant and no suitable image could be traced it is not included. However, HF describes elsewhere how the MP Peter Rylands (1820–87), "on one occasion—an 'all-night sitting'—rolled himself up on a long couch to rest in the outer corridor directly under Ward's fresco painting of 'The last sleep of Argyle,' and some young members of Bohemian inclinations took off the sleeper's boots, and hid them away. And I remember how the enraged Peter, when the division bell aroused him, ran through the cold stone lobbies and sat in the House in white-stockinged feet for the rest of that celebrated night" (*MBD*, p. 248).

154. It is unclear to whom HF intends to refer here. There was no MP named Josiah Forster. An abolitionist of that name (1782–1870) did not enter Parliament, was never knighted, and died two decades before "Humours." Sir Charles Forster (1815–1891) was in Parliament at the time HF would have been composing "Humours," but he was a lawyer not a "medico."

101. The Pairing Session
Source: "Pairing" (*B&W*, 4 July 1891, p. 5)

It is a very funny sight sometimes when a member has paired say from eight o'clock until eleven, and saunters into the House at ten o'clock or half-past.

The division-bell rings. The mystic sound enchants him. Members crowd in, the doors are about to be closed, when the forgetful one recollects that he has broken his pair, the penalties for which are diresome.

Terrified, he struggles to get out, knocking over in his frantic haste the last few members who are rushing in, assaulting the door-keeper, who is in the act of closing the doors, and flinging himself breathless into the Lobby, never pausing until he finds himself in some safe retreat, in the smoking-room or Inner Lobby. [102]

Time? *End* *Read This*

But, ladies and gentlemen, were I to continue my Parliamentary portrait gallery in this way, we would have an all night sitting, and you would doubt-

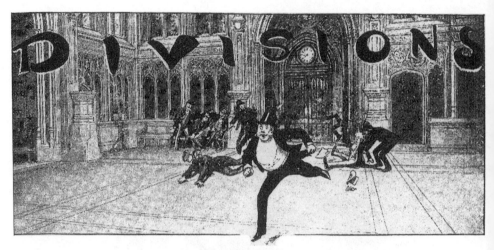

102. Fleeing the Chamber
Source: Headpiece "Divisions" (*Cassell's Magazine,* June 1901, p. 285)

less move the Closure upon me very soon, I will therefore reserve my Portraits of politicians and my remarks upon them for another evening and will close the Parliamentary proceedings to-night by giving you, as briefly as possible, a description of a Division, and I will ask you to be kind enough not to leave your seats until I have finished, and the gas is turned up.

A big debate ends like a big battle. [103]

When the skirmishing is over the rival forces are mustered for a final engagement between the Generals.

An old Irish sergeant in the service of Mr. Punch more than once described his Crimean engagements to me.

"You see, Sir, we was drawn up 'ere, and the inimy we was told was over there, and all of a sudden there was a dale of bangin', and no end of smoke, and when it cleared away the inimy had gone and we was where we was, and that's all I knows about it."

It is much the same in a Parliamentary battle.

Early in the afternoon the sharpshooters commence hostilities. Later on heavy cannonading begins, and continues up to the dinner hour, when by mutual consent the rival combatants leave the battle field and retire to their dining tents.

In the meantime mere desultory firing is kept up by the rawest material. Mere matter of form firing at imaginary targets, or a skeleton enemy. But the Government forces have retired to a man, and the reporters although apparently hard at work are in reality paying no attention whatever to the stray

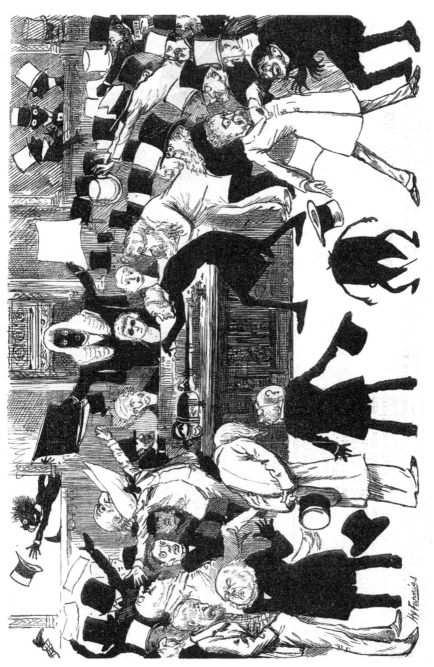

103. A Debate

Source: exact image untraced. Editorial substitution: "A Discord In Black And White" (*Punch*, 18 August 1883, p. 73)

firing, but are re-writing their accounts of the afternoon's battle, and preparing to record the expected engagement in the evening.

The Government face the Opposition.

There is a deal of noise and talk, which generally ends in smoke.

Ninety-nine times out of a hundred the Opposition disappears, and the Government remains where it was.

But the hundredth time must come, and with it the excitement of impending disaster.

It is not always a leader of the Opposition who discovers the weak point in the tactics of the Government, but generally a sharp lieutenant, whose chance has come, and if he is successful his Parliamentary reputation is made.

All possible and impossible members are brought up for the final charge. [104][155]

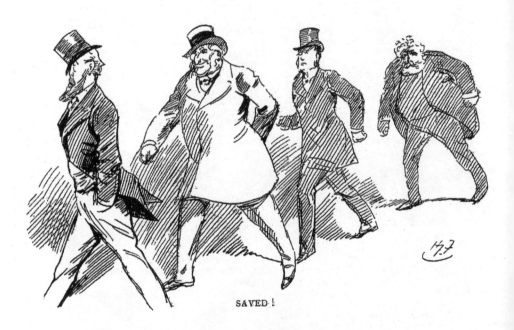

SAVED !

104. The Final Charge
Source: image untraced. Editorial substitution: "Saved!" (*Cassell's Magazine*, June 1901, p. 287)

155. HF identifies the "four members" who come "rushing in as the doors were being closed" as "Lord Hartington, Mr. Chaplin, Mr. Hornby, and 'John William' Maclure." HF, "Divisions," *Cassell's Magazine*, vol. 32 (June 1901), p. 288.

Both sides are in earnest, and curious old Parliamentary hands appear, that are never seen at any other time.

A sort of reserve force of Parliamentary Rip Van Winkles, and the maimed, the halt, and the blind are literally carried through the division.

The sharpshooters are silent.

The big oratorical guns have exhausted their powder.

The Generals commanding have charged and re-charged, with eloquence flashing like steel, and with cheers and counter-cheers, both sides claim a victory amid a blaze of excitement strongly resembling the set piece in a fire-work display, after which all is darkness.

Suddenly, some insignificant member jumps up to speak—the forgotten damp squib that spurts off after a shower of rockets.

But cries from both sides of "Vide! Vide!! Vide!!!" are heard, and the pow-der, metaphorically, is knocked out of that miserable squib.

The Speaker rises to put the Question.

The Government want the Bill now.

The Opposition say—"No, leave out the word 'Now,' and read the bill six months hence." The Question therefore is that the word "Now" remain part of the Bill.

The Speaker says—"As many as are of that opinion say 'Aye,' the con-trary 'No.' I think the 'Ayes' have it!"—"The 'Noes' have it," rudely roars the Opposition.

"I think the 'Ayes' have it."

"The 'Noes' have it–" This means business. So the Speaker orders strangers to withdraw, and the bells are set ringing all over the building.

The attendants fling open the doors, calling out "Division! Division!! Division!!!"

The strangers, although only under the Gallery are in the meantime rushed out.

The stream of members pours in from all parts of the building; from the library, the smoking-room, the Terrace, everywhere.

The Whips flit about like gulls before a storm.

The time-glass upon the table is reversed, and as the last grain of sand descends the two minutes are up, and the doors are closed.

The Speaker again puts the Question.

The 'Ayes' and 'Noes' still disagree about the "Now." So the Speaker calls out "'Ayes' to the right; 'Noes' to the left. [105] Tellers for the 'Ayes' Mr. Fourliner and Mr. Pairem. Tellers for the 'Noes' Colonel Whipper and Mr. Siezem."

105. Ayes to the Right, Noes to the Left
Source: "Ayes To The Right, Noes To The Left" (*Punch,* 5 March 1881, p. 100)

The doors are opened and the House slowly empties.

One stream of opinion passing out by the central door, the other by the door at the other end of the House, behind the Speaker's chair. [106]

A few members remain behind to watch the doubtful voters and cheer, should an 'Aye' follow the 'Noes,' or vice versa. In strong contrast to the crowd and excitement of a moment ago is the perfect stillness of the House now. No noise, save the clicking of the locks as the attendants secure the doors, not only of the House itself, but of the Lobby, which is also empty. But this temporary imprisonment is soon over.

The members having traversed the lobbies, pass the clerks who credit them with their appearance by placing a mark opposite their names. [107]

They then pass the tellers. An 'Aye' teller, and a 'No' teller, who count them as they pass into the House. [108]

Having thus made a semi-circuit of the House, they re-enter by the doors opposite to those by which they left. Like a swarm of bees they crowd the benches, filling up even the doorways and gangways.

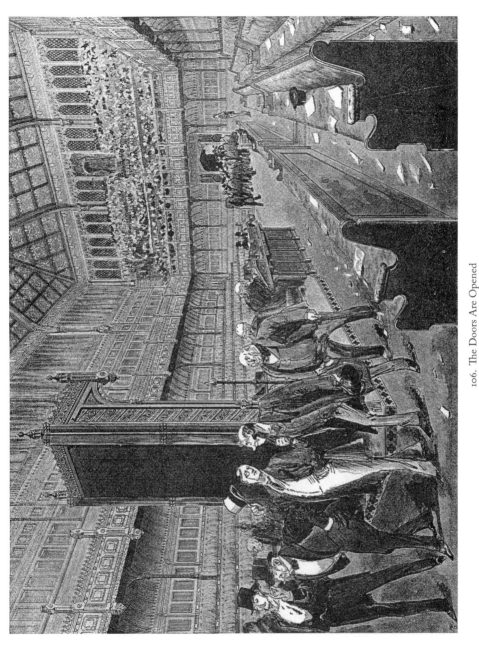

106. The Doors Are Opened

Source: "A Division" (*B&W*, 13 June 1891, p. 600)

107. Passing the Clerks
Source: "Members pass before the clerks who tick off their names" (*Good Words,* 1888, p. 110)

The excitement is intense as the end approaches.

Every eye is fixed upon the door.

The Question is, how will the tellers enter.

If the Government teller does not stand upon the right, the Government is defeated.

Presently there is a murmur, "They come! They come!!"

They fight their way through the crowd.

108. Passing the Tellers
Source: "They are counted, as they pass out, by the tellers" (*Good Words*, 1888, p. 111)

Like a scrimmage at a foot-ball match, all is confusion. Presently one of the tellers has extricated himself.

"Yes! No! Yes! No! Yes!"

He represents the Opposition, and with a winning smile he takes up his position on the right.

The other three take their places. A wild cheer rends the air as they approach the table bowing, and cheer follows cheer as the numbers are announced.

The members on the wrong side jump up and wave their handkerchiefs.

Some rush frantically out to telegraph the good news to the country.

The Government sit in gloomy silence.

Already their leader is writing his dispatch, which is the death-warrant of his Government, to the Queen. [109][156]

109. The Government Leader Writing to the Queen
Source: "Mr. Gladstone. Writing to the Queen. A Study From Life In The House Of Commons"
(*Fair Game,* July 1898, p. 13)

156. The occasion may have been the Third Reading of the second Home Rule Bill on 1 September 1893. But Gladstone didn't resign until after the Lords negatived the bill in March 1894, and the Liberals remained in government under Rosebery. This would, then, be a case of repurposing an image for the entertainment, rather than presenting it in its original context. HF used the sketch as the frontispiece to the catalogue of his 1898 exhibition of 150 drawings of Gladstone. A similar, but earlier sketch, appeared in *The Weekly Scotsman* (9 September, 1893).

The play is over.

The cheers are re-echoing in the Lobbies as the actors slowly depart, some never to return, passing for the last time the familiar figure of the trusty door-keeper, who is calling out the cry—that relic of centuries—the words with which I close my address to you to-night—"Who Goes Home?"[157] [110]

110. "Who Goes Home?"
Source: "'Who Goes Home?' Members of Parliament Dispersing After The Rising Of The House"
(*B&W*, 16 May 1891, p. 479)

THE END.

157. HF explains the origin of this phrase: "The words were called out in times of old as an invitation to members to accompany the Speaker home to his house" because of the dangers from "footpads and thieves on the road." "The words 'Who goes home?' therefore, were a real invitation to share in a material benefit, and meant that whoever was so pleased might have the advantage of safe conduct in the train of the Speaker." (*B&W*, 16 May 91, p. 478). It was, as HF notes, a relic of the past: "Seeing that most Members disappear from St. Stephen's after their work in hansoms and four-wheelers, the cry of 'Who goes home?' merely means 'All out'" (*PPP*, p. 2).

APPENDICES

APPENDICES

Appendix I

Harry Furniss, "Preparing to Lecture"

(*The Daily Graphic*, 23 April 1891)

NOTE: Never one to miss an opportunity for free advertising and self-promotion Furniss must have persuaded the editor of the Daily Graphic *(to which he contributed frequently) to publish this article just one week before the opening of "Humours." The text was accompanied by three self portraits, including figures 20 and 25 of the Introduction—the latter was an "Invitation Card" that gave the date and venue for the opening night. It is, nevertheless, an important account of his lecturing preparations.*

To the Editor of the *Daily Graphic.*

Sir,—As many of my Parliamentary sketches have appeared from time to time in your columns, it has occurred to me that a few of your readers may be interested to know how the idea of my new venture, "The Humours of Parliament," originated. It is now a few years ago since, with a soul burning with zeal for the advancement of Art in my native country, I succumbed to the flattering proposals of the Birmingham and Midland Institute, which is the chief centre of the lecturing business in England, and was bold enough to mount the platform and address the British public upon art in general and upon art in connection with the Royal Academy in particular. The favourable and kindly reception which was everywhere accorded to my efforts led to my being invited by the numerous literary and scientific institutions scattered throughout the country to pay them a return visit, and I did so, choosing "Portraiture" for my theme. To the surprise of the majority of my audiences, who knew me only as a *Punch* artist, and expected me to treat of lighter subjects and in a more humorous vein, I was desperately serious in both of these early lectures.

The Requirements of an Illustrated Lecture

But my listeners forgot that a lecture, like a City dinner, is not complete without a *pièce de résistance,* and that it is the office of the lecturer to instruct as well as to amuse. Moreover, in an illustrated lecture it should be remembered that the pictures must fit in with the text, and that the audiences at literary and scientific institutions who are accustomed to be fed upon the driest of subjects cannot digest anything too fanciful and frivolous. In short, my experience taught me that "what is one man's food is the poison of another" is as true in the lecturing business as in any other, and the fact, to which I have referred, that wherever I appeared I had to pay a return visit, and always to equally large audiences, encouraged me at length to appeal, as I am now about to do, to the more general public, and to attempt upon the occasion something more ambitious than a mere discourse. In the course of my lecture on "Portraiture," I had briefly narrated the manner in which I have been in the habit of making a special study of Mr. Gladstone in the House of Commons, and the interest invariably evoked by my references to the right honourable gentleman—for I could hardly think that interest centred in myself—began to lead me to think that the subject upon which I was most likely to engage the attention of the public at large was Parliament, and now I am about to put the correctness of my surmise to a practical test.

How I Coached Myself Up

The preparations necessary for the effective achievement of my enterprise have necessitated my relinquishing all lecture engagements, with a few exceptions, for the past year, and I have likewise been compelled also to decline nearly all invitations of a social and festive character. In a word, the "Humours of Parliament" have proved sufficiently engrossing to cause me to shun delights and live laborious days, to fly from town and bury myself in the country in order to do anything like justice to my subject. In truth, I was not altogether sorry this winter to have an excuse for quitting the fogs of the Metropolis, and for enjoying the bright sunshine of a southern watering-place, the better to prepare my forthcoming entertainment. In the beautiful Fairlight Glen, near Hastings, I found many an opportunity of developing my Parliamentary portraits, and refreshing my memory of life at St. Stephen's for many a long year past.

Inspirations from Nature

Not only did the breezes of the South Downs help to brace me for the hard work before me, but Nature herself lent a helping hand. As I passed some massive oak or beech, some twist or turn in its branches gave an invaluable turn to many a thought, and supplied hints which I have turned to account in my sketches of Sir William Harcourt, while the sails of the Hastings fishing-boats, as they quitted the harbour in the glow of the evening, somehow persisted in reminding me of the collars of the Grand Old Man. When I wanted inspiration for the Ladies' Gallery I sought the seclusion of the lower seat; and even the shrill whistle of the railway engine, as it wafted me back to bricks and mortar, was not without its use, for it enabled me the more vividly to recall the dulcet accents of Sir George Campbell.

Studies from Life

For often I had to return to the House of Commons to study my subjects from life, although when groping my way about in the fog among the lobbies and corridors, nay, even in the Chamber itself, notwithstanding the wonderful fog filter's assistance, I have often found it impossible to distinguish between the chair of the House and the massive form of Chief Inspector Horsley, as I sat down upon the benches of the House, and have had to fly once more to the sunny south after a fruitless journey, almost determined to relinquish Parliament in despair, and lecture instead upon the Smoke and Fog Abatement question and the terrors of the English climate.

Preparing a Sketch for Publication

Little did I know when I commenced this self-imposed task of the work which it would entail. The readers of your interesting paper, sir, have little idea of the tremendous amount of labour, or of the complex and elaborate processes requisite before one of the sketches which so please them in your columns can be placed before their eyes. They know that the original sketch has first to be made, but they are probably unaware that it then has to be redrawn, then photographed, afterwards transformed into a relief block, then to be mounted, subsequently electrotyped upon a forme for the press, from which a papier-mâché impression has to be taken again, which in its turn has to be re-electrotyped before ink or paper must touch it. So it is in the reproduction

of such work as that with which I am about to illustrate "The Humours of Parliament" at Prince's Hall, Piccadilly. My drawings, after being designed, have had to be all carefully drawn out and subjected to elaborate processes before it was possible for them to be reproduced on glass for the powerful limelight instrument by means of which they will be presented to the notice of the public; and little will the audience on the 30th inst. and subsequent evenings realise that a picture which passes before their eyes in some thirty seconds (and owing to the number to be shown some will not even be before them as long as that) has perhaps taken many weeks to produce in the form in which they will behold it. The cobbler should stick to his last; and it was not until I had to tackle technicalities apart from those of my own art that I fully discovered the trouble that was in store for me.

The Advantage of Self-Dependence

Owing to my long experience in lecturing with the use of the magic lantern, I resolved never more to trust myself to the tender mercies of the strange operator and his generally stranger instrument. You may judge of what my feelings must have been on such occasions, when the picture has a trick of coming on the screen upside down, when the gas, too, often suddenly fails, and when, what is worse still, the operator, having to catch his train, disappears in the middle of the entertainment. Such experiences have unhappily been mine, and I therefore determined that in my new venture I would depend upon no one but myself, and that I would devise my own arrangements for showing my own pictures, engaging my own operators exclusively for the purpose.

Wanted—A Magic Lantern

The search for a lantern was long and tedious, and no sooner was it announced that I was about to use such an instrument in my entertainment than I was inundated with letters from all parts of the country, not only from the trade, but from amateurs in possession of magic lanterns, who invited me to rush down to Gloucestershire or Cornwall, as the case might be, to view venerable instruments inherited from ancestors who must have lived in the time of Guy Fawkes, with a view to purchase. At last I had to procure an entirely new triple lantern of the most modern type, which will be used not only at the Prince's Hall, Piccadilly, but wherever I give my entertainment throughout the country, and this sketch of my dream [Introduction fig. 20] on the night upon

which this elaborate instrument, with all its new and complicated apparatus for holding the gases, was delivered at my residence, may serve to indicate what I have gone through on this score better than any words which I can use. In conclusion, I will only remark that it is not necessary for me to remind your readers of the extraordinary fatality which has pursued Members of Parliament for the last few weeks. Suffice it to say that when I open my *Times* in the morning now it is with fear and trembling that I glance at the obituary column, lest the lamentable gaps in the ranks of our legislators, which have already played sad havoc with my programme, should have received a fresh addition.—

Yours obediently,

Harry Furniss

Appendix II

Images Reported As Shown In "Humours" But Not Referenced In The Extant Text

Because of the constantly evolving nature of 'Humours' over several years, the extant text does not reflect the changes Furniss made to his show. This Appendix lists people who are not named in the manuscript, but for whom there is a record—newspaper reports, advertisements, or the Brighton Programme for 'Humours' of 5–6 December 1892 (which lists "The Latest Additions to the Westminster Show")—that their images were included in the show. In three cases (Balfour, Goschen, and Smith), there is enough information to identify the image Furniss probably used in his show. The eleven other sketches reproduced here represent people who are mentioned by name but without any description of the images Furniss used. For some of those named, Furniss's published work offers several possibilities. Because there is no way to know which ones Furniss used for his lantern slides, we have selected those that in our judgment are the most attractive or clearest. In one case (Lecky), we have been unable to locate any Furniss sketch, published or unpublished, for inclusion here.

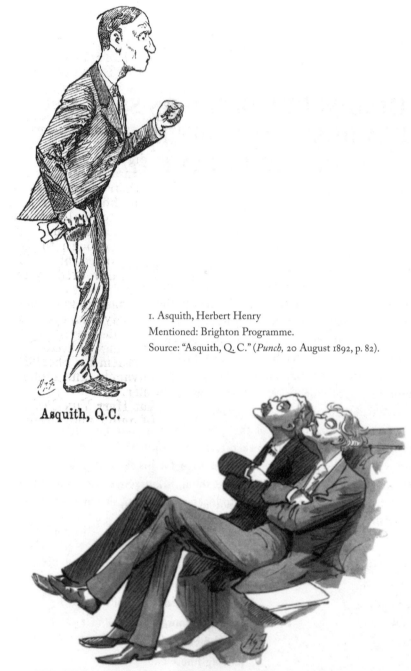

1. Asquith, Herbert Henry
Mentioned: Brighton Programme.
Source: "Asquith, Q. C." (*Punch*, 20 August 1892, p. 82).

Asquith, Q.C.

THE IRISH QUESTION: ATTITUDE OF THE BROTHERS BALFOUR.

2. Balfour, Gerald
Mentioned: *The Age* (Melbourne), 24 May 1897, p. 6.
"Mr. A. J. Balfour . . . aesthetically sprawling; also, Mr. Gerald Balfour in like position."
Source: "The Irish Question: Attitude of the Brothers Balfour" (*PPP*, p. 183).

3. Burns, John
Mentioned: Brighton Programme; *The Age* (Melbourne), 24 May 1897, p. 6.
Source: untitled (*PPP*, p. 151 and *Lika Joko*, 27 October 1894, p. 18).

4. De Worms, Baron Henry
Mentioned: *Belfast News-Letter*,
1 September 1891.
Source: "Baron De Worms.
'That's The Diet For Worms'" (*Punch*, 5
March 1887, p. 11; rpt. in *MPS*, p. 32).

BARON DE WORMS.

" THAT'S THE DIET FOR WORMS.

William Field, Esq., M.P.

5. Field, William
Mentioned: Brighton Programme.
Source: "William Field, Esq., M. P."
(*Punch,* 27 August 1892, p. 96).

6. Goschen, George Joachim
Mentioned: *Belfast News-
Letter,* 1 September 1891.
Described as being "in the
act of making his financial
statement."
Source: "Mr. Goschen, First
Month" (*PPP,* p. 184).

MARQUIS OF HARTINGTON.

"STARTINGTON."

7. Hartington, Marquis of
Mentioned: *Glasgow Herald,* 21
and 24 November 1891.
Source: "Marquis of Hartington.
'Startington.'" (*Punch,* 13 February
1886, p. 77; rpt. in *MPS,* p. 11).

8. Hicks-Beach, Sir Michael
Mentioned: *Belfast News-Letter,* 1 September 1891;
Scarborough Evening News, 16 September 1891.
Source: "The Budget, 1898" (*Fair Game,* May 1898, p. 2).

THE BUDGET, 1898.

9. Labouchère, Henry
Mentioned: *Belfast News-Letter*, 1 September 1891;
Scarborough Evening News, 16 September 1891;
The Age (Melbourne), 24 May 1897, p. 6.
Source: untitled (*Lika Joko*, 17 November, 1894, p. 79).

10. Lawson, Sir Wilfred
Mentioned: *Dundee Advertiser*, 26 November 1891;
The Age (Melbourne), 24 May 1897, p. 6.
Source: "Sir W. Lawson. 'I Rise to Order'" (*Punch*, 22
September 1888, p. 133; rpt. in *MPS*, p. 48).

Lecky, William Edward Hartpole
Mentioned: *New York Times*, 24 November 1896.
Described as one of HF's "best" sketches.
No image located.

SIR W. LAWSON.

"I RISE TO ORDER."

THE-WEEK IN THE COMMONS: MR. JUSTIN McCARTHY.

11. McCarthy, Justin
Mentioned: *The Age* (Melbourne),
24 May 1897, p. 6.
Source: "The Week in the Commons:
Mr. Justin McCarthy"
(*Daily Graphic*, 31 July 1890, p. 5).

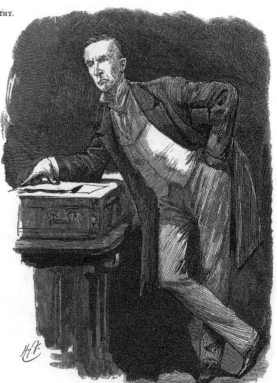

12. Morley, John
Mentioned: *The Age* (Melbourne),
24 May 1897, p. 6.
Source: "Mr. John Morley"
(*B&W*, 27 June 1891, p. 665).

MR. JOHN MORLEY

13. Naoroji, Dadabhai
Mentioned: Brighton Programme.
Source: "Bless me!"
(*Punch*, 27 August 1892, p. 96).

" Bless me ! "

THE CLOSE OF THE SESSION: MR. SMITH'S LAST SMILE OF THE SESSION.

14. Smith, W. H.
Mentioned: *Belfast News-Letter*,
1 September 1891; *Pall Mall Gazette*,
1 May 1891, p. 3. The sketch was reported
as showing the "smiling leader of the
House, Mr Smith"; and Smith "smiling
all round the back of his head."
Source: "The Close of the Session:
Mr. Smith's Last Smile of the Session"
(*Daily Graphic*, 21 August 1891, p. 5).

APPENDIX III

UK ITINERARY, 1891

A Note on Dates and Places

Those dates without a question mark (?) are confirmed from letters, advertisements, newspaper notices and reviews or have been calculated using a Reference Calendar which gives the dates and days for any year 1753 onwards. Those dates with a question mark (?) are deduced from available data.

The dates of publication of HF's accounts of the places visited in *Black and White* magazine (12 September 1891–20 February 1892) and republished in *Flying Visits* (1892) are, of course, later than when he went to those places and they can give only a rough indication of actual performance dates. Neither should we rely on the sequence of places visited as published (he visited Darwen near Manchester last but the final account in *B&W* and *FV* is about Scotland).

Various sources mention other places where "Humours" was performed but these are not listed below because not even rough dates can be surmised. These include: public schools (Rossal [Fleetwood, Lancashire], Harrow, Cheltenham), Banbury, Channel Islands, Chester, Doncaster, Halifax, Hampstead, Hatfield, Leicester, New Forest, Oxford, Salford, Sunderland, Warrington.

Where available, information on estimated seating capacity or audience size (assembled from a variety of sources) is indicated.

30 Apr	*London:* first performance at Prince's Hall, Piccadilly
30 Apr–1 Jul	*London:* various venues including Prince's Hall, Merchant Taylor's Hall (att. 1,100), Crystal Palace (cap. 1,500 in the concert hall), and St. James's Hall (cap. 2,127, but also two smaller rooms)
24–29 Aug	*Dublin:* The Antient/Ancient Concert Rooms (cap. 800)
31 Aug–4 Sep	*Belfast:* St. George's Hall
5 Sep	*Dublin:* The Antient/Ancient Concert Rooms (cap. 800)
8–9 Sep	*Llandudno:* St. George's Hall (cap. 700)
11–12 Sep	*Southport:* Pavilion Theatre
14 Sep	*Leeds:* Albert Hall (cap. c. 2,000)
15–16 Sep	*Scarborough:* Spa Theatre (cap. 3,000)
17 Sep	*Harrowgate*
18–19 Sep	*York*
21–22 Sep	*Sheffield:* The Montgomery Hall (large hall cap. 1,000; small hall cap. 350)
23 Sep	*Derby:* Temperance Hall
late Sep?	*Birmingham, Nottingham, the Potteries, Sunderland*
28 Sep	*Ipswich*
6 Oct	*Bournemouth:* Town Hall
early Oct?	*Tunbridge Wells, Southampton, Isle of Wight, Southsea, Eastbourne*
12–13 Oct	*Brighton:* Clarence Rooms, Hotel Metropole (cap. 300)
mid-Oct?	*Folkestone/Margate, Lewes, Godalming* (Charterhouse School)
late Oct?	*Ripon:* Newcastle
26 Oct	*Manchester:* Athenaeum
27 Oct	*Sale:* Public Hall
28–29 Oct	*Liverpool:* George's Hall (Great Hall cap. 2,500; concert room cap. 1,200)

30–31 Oct	*Wolverhampton:* Exchange Hall
2–4 Nov	*Birmingham:* Masonic Hall
6–8 Nov	*Manchester:* Gentleman's Concert Hall
16 Nov	*Newcastle:* Town Hall (cap. c. 3,700)
19–21 Nov	*Edinburgh:* Music Hall
23–24 Nov	*Glasgow:* Queen's Rooms
25–26 Nov	*Dundee:* Kinnaird Hall (cap. 2,500–3,000)
27 Nov	*Glasgow:* Queen's Rooms
30 Nov–1 Dec	*Aberdeen:* Albert Hall
early Dec?	*Troon, Hawick, Dumfries, Kilmarnock, Paisley, Greenock*
9 Dec	*Ayr:* Town Hall (current cap. 700)
14 Dec	*Preston:* Guild Hall
15 Dec	*Stretford* (Manchester)
17 Dec?	*Darwen* (near Manchester): final performance
18 Dec	On train back to London

APPENDIX IV

NORTH AMERICAN ITINERARY, 1896–97

1896

22 Oct. *New York:* HF arrives aboard steamer RMS *Germanic.* Stays at Holland House hotel.

3 Nov. Dinner in NY on eve of US election.

14 Nov. HF attends NY Horse Show.

23 Nov. "Humours" at Chickering Hall.

25 Nov. "America in a Hurry" at Chickering Hall.

10 Dec. HF attends dinner of the Society of Pointed Beards.

1897

4 Jan. HF scheduled to arrive from New York at 9:30 a.m., but delayed until 8:30 p.m. of the following day due to "urgent and unexpected business."

5 Jan. *Montreal:* HF arrives in Canada from New York.

6 Jan. "Humours" at Windsor Hall.

7 Jan. *Ottawa:* "Humours" at the Opera House.
[HF entertained at Government House by Lord and Lady Aberdeen?]

8 Jan.	*Montreal:* HF travels from Ottawa to Montreal in the morning, does sketches.
9 Jan.	Two shows at Windsor Hall: "Humours" in the afternoon; "America" in the evening.
10 Jan.	*Toronto:* HF arrives following "tedious twelve hours' railroad journey form Montreal," and stays at Queen's Hotel.
11 Jan.	"Humours" at Massey Music Hall.
12 Jan.	"Humours" at Massey Music Hall.
13 Jan.	*Ottawa:* HF visits Parliament and spends afternoon sketching.
14 Jan.	*Toronto:* "America in a Hurry" at Massey Music Hall.
18 Jan.	*Buffalo:* "Humours" at Concert Hall.
19 Jan.	"America in a Hurry" at Concert Hall.
21? Jan.	*Rochester*
23? Jan.	*Albany*
24 Jan.	*Washington, DC:* HF arrives to stay for a week and give four afternoon entertainments at the Columbia Theater.
26 Jan.	"Humours" at Columbia Theater.
27 Jan.	HF fêted at the Metropolitan Club with US cabinet members in attendance.
1 Feb.	*Baltimore:* "Humours" at Lyceum Theater.
3 Feb.	*Philadelphia:* "Humours" at Association Hall.
5 Feb.	"America in a Hurry" at Association Hall.
7? Feb.	*Boston:* HF arrives from NY to stay for a week.
10 Feb.	"Humours" at Association Hall.
12 Feb.	"America in a Hurry" at Association Hall.
late Feb.	HF returns to Britain.

APPENDIX V

AUSTRALIAN ITINERARY, 1897

9 April	HF departs London aboard P & O steamship RMS *Victoria* via the Mediterranean, Suez, Aden and India.
13 May	*Albany, Western Australia:* HF arrives, but unable to land because of quarantine restrictions.
19 May	*Melbourne:* HF arrives. Stays at the Menzies Hotel.
22 May	First performance in Australia of "Humours" at the Athenaeum.
24–26 May	Repeat performances of "Humours."
27 May	First performance of "America in a Hurry."
28–29 May	Repeat performances of "America in a Hurry."
31 May	Final performance of "America in a Hurry."
1 June	Final performance of "Humours."
2 June	First and only performance of "Harry Furniss at Home."
3 June	First and only performance of "Stories and Sketches." Final appearance in Melbourne.
10 June	*Sydney:* HF arrives via train from Melbourne.
11 June	Opening night of "Humours" at the Theatre Royal.
12, 14–15 June	Repeat performances of "Humours."
16–17 June	Two performances of "America in a Hurry."

18 June	First and only performance of "Heads and Tales." Final appearance in Sydney.
21 June	HF embarks RMS *China* for London via Adelaide.
28 June	*Adelaide:* "Humours" at Town Hall.
29 June	"America in a Hurry" at Town Hall. Last appearance in Australia.
30 June	RMS *China* sails for London from Port Adelaide
3 July	Docks at Albany and departs for Colombo.
mid-July	*Colombo, Ceylon:* Two "shows" ("Humours" and "America in a Hurry"?) at Colombo Theatre.
mid-August?	HF arrives in England.

APPENDIX VI

DRAMATIS PERSONAE

AIRD, JOHN (1833–1911). Civil engineer and Conservative MP (1887–1906). While Furniss was on tour with "Humours," Aird traveled from London to Bournemouth in order to tell him that W. H. Smith (see below) had died. Furniss quickly adjusted his script and, "as the papers said, 'in a few touching and eloquent words' broke the sad tidings to my audience" (*FV*, p. 188).

ASQUITH, HERBERT HENRY (1852–1928). A successful lawyer and Liberal MP (1886–1924), he served as Home Secretary under Gladstone and Lord Rosebery (1892–95), and in the next Liberal government as Chancellor of the Exchequer (1905–08) until he succeeded Campbell-Bannerman as Prime Minister (1908–16). After being effectively deposed on account of widespread dissatisfaction with the course of Britain's effort in the First World War, Asquith led a Liberal faction that sat as the opposition to the coalition led by his former Chancellor of the Exchequer, David Lloyd George. He was ennobled as the Earl of Oxford and Asquith in 1925.

BALFOUR, ARTHUR JAMES (1848–1930). Nephew and protégé of Lord Salisbury, Balfour entered Parliament in 1874. He served under his uncle as Secretary for Scotland (1886–87) then Chief Secretary for Ireland (1887–91), in which capacity he earned the nickname "Bloody Balfour." Writing in 1890 of Balfour's parliamentary style, Furniss observed: "One only gets half the effect by reading Parliamentary reports; he must be seen to be admired. The free-and-easy and thoroughly composed manner is delicious after the stereotyped official manner of answering questions. However members on the Opposition side of the House may differ with Mr. Balfour, all are agreed that his demeanour is most polished and his treatment of 'hecklers' most artistic

and effective, and he has no more sincere admirers in this respect than the Irish members." (*Daily Graphic,* 19 June 1890, p. 8). From 1891 Balfour led the Conservatives in the Commons both in government and in opposition, and on Salisbury's retirement became Prime Minister (1902–5). He continued leading the divided and increasingly demoralized Tories through the Liberal landslide of 1906 and the two general election defeats of 1910. His strategy of using the Conservative majority in the Lords to block Liberal legislation produced a constitutional crisis that resulted in the Parliament Act of 1911, which deprived the Lords of their veto. After resigning the party leadership, Balfour became a ubiquitous elder statesman, accepting the office as First Lord of the Admiralty (1915–16) in Asquith's wartime coalition, Foreign Secretary (1916–19) in Lloyd George's wartime coalition, and Lord President of the Council (1919–22, 1925–29) under both Lloyd George and Stanley Baldwin. Created Earl of Balfour in 1922.

BALFOUR, GERALD (1853–1945). Younger brother of Arthur Balfour, and Conservative MP (1885–1906). Served as Chief Secretary for Ireland (1895–1900), President of the Board of Trade (1900–1905), and President of the Local Government Board (1905).

BRIGHT, JOHN (1811–89). The son of a Lancashire cotton mill owner, Bright became one of the Victorian era's most prominent Radical politicians. He gained national prominence in the early 1840s in the campaign to repeal the Corn Laws (agricultural tariffs), and was first returned to Parliament in 1843. Although not naturally a man of government, Bright's symbolic value was high and he agreed to serve in Gladstone's first two ministries as President of the Board of Trade (1868–71) and then the largely ceremonial post of Chancellor of the Duchy of Lancaster (1873–74, 1880–82). Known as the "Tribune of the People," he was considered by many to have been the greatest orator of his time. According to Furniss: "To appreciate Mr. John Bright fully, one must have heard him. Really to comprehend his power and greatness, one must have heard him at his best. Yet the greatness of his oratory lay not so much in what he said as in the beautiful way he said it. . . . Statesmanship was not so much to him as speechifying" (*CCI,* p. 196).

BURNS, JOHN (1858–1943). Labour leader and one of the first working-class MPs (1892–1918). As President of the Local Government Board (1905–14), he became the first cabinet member from the working classes. He briefly became President of the Board of Trade (1914), but resigned at the outbreak of the First World War.

CAMPBELL, SIR GEORGE (1824–1892). Scottish Liberal MP (1875–92). According to Furniss, he "was the most eccentric bore we have ever had in the House of Commons. Sir George has acknowledged that he could not resist the temptation to speak. . . . He was well aware that he was a nuisance in the House, and he resolved as he walked down Whitehall not to open his mouth. But as soon as he crossed the Palace Yard and entered the corridors of the House he sniffed the odour of authority and the fever of debate. He, the Great Sir George of India—silent! Never!" (*CCI*, p. 198).

CAMPBELL-BANNERMAN, SIR HENRY (1836–1908). Scottish Liberal MP (1868–1908). After holding office as Chief Secretary for Ireland (1884–85) under Gladstone and Secretary of State for War (1886, 1892–95) under both Gladstone and Lord Rosebery, he became Liberal leader in the Commons in 1898. In 1905, he became Prime Minister at the head of a minority government, and then led the party to a great landslide victory in 1906. Ill health forced his retirement two years later. While conceding that he was "a man of common-sense and tact, rich, and universally popular," Furniss thought Campbell-Bannerman "a mere understudy for the real leader. . . . He is in a leading part without being a leader. He is certainly not the Head of the great 'Liberal' Party; he is simply its Chairman" (*Fair Game*, March 1899, p. 21).

CHAMBERLAIN, JOSEPH (1836–1914). Birmingham industrialist turned municipal activist, reformer, and political organizer. After serving as mayor of the city (1873–75), he was returned to Parliament in 1876 and became one of the leaders of the Liberal party's Radical wing. He served as President of the Board of Trade (1880–85) and President of the Local Government Board (1886), but his personal and political relations with Gladstone were always difficult. Chamberlain broke with Gladstone over Home Rule and helped split the party, becoming a leader of the Liberal Unionists allied with the Conservatives. He served as Salisbury's Secretary of State for the Colonies (1895–1903), but resigned to campaign for abandoning free trade in favor of a tariff system to privilege commerce within the Empire—an issue that then split the Conservatives. A stroke in 1906 ended his public career. In 1895, Furniss opined "There is no doubt that Mr. Chamberlain is the most interesting figure in Parliament to-day" (*PPP*, p. 120), but found that "It was impossible to make Chamberlain heroic. From the tuft of hair on the top of his head, to the point of his toe, he was in the artist's eye the very antithesis of all that is picturesque and heroic. His nose alone made it impossible; but his whole figure, dress and general bearing were those of a pushful shop-walker

in a provincial establishment" (*SVM*, p. 203). Hence, in light of a paucity of caricaturable politicians at the turn of the century, HF could write in 1901 that "Mr. Chamberlain alone interests the caricaturist" (*CCI*, p. 233).

CHURCHILL, LORD RANDOLPH (1849–1895). A younger son of the 7th Duke of Marlborough, Churchill entered Parliament in 1874 as a Conservative. A tempestuous and vocal internal critic of the party, he advocated progressive policies designed to capture the allegiance of the masses for the Tory party. In 1886, he became Chancellor of the Exchequer in Lord Salisbury's government, but after resigning in a failed bid to force the prime minister's hand he never held office again. He continued to sit in Parliament, but his rapidly declining health diminished whatever standing he retained prior to his early death. Furniss recalled that "the first picture I drew for *Punch*'s essence of Parliament was a portrait of Lord Randolph Churchill," and confessed "to being the cause of giving an erroneous impression of Lord Randolph's height. He was not a small man, but he *looked* small; and when he first came into notoriety, with a small following, was considered of small importance and, by some, small-minded. It was to show this political insignificance in humorous contrast to his bombastic audacity that I represented him as a midget" (*CCI*, p. 185). But he also wrote that Churchill was "one of the most extraordinary men of our time," if "an impulsive political opportunist and nothing more." He observed Lord Randolph not only in Parliament but also on social occasions, where he "found that puzzling personality the life and soul, and I may add the egotist, of the party, Mr. Gladstone not excepted" (*SVW*, pp. 151, 191). The "most interesting figure in the House since Disraeli," Churchill "was a political Don Quixote" (*CCI* 186).

CROSS, RICHARD ASSHETON, VISCOUNT CROSS (1823–1914). Conservative MP (1857–86). Home Secretary under Disraeli (1874–80) and Salisbury (1885–86). After receiving a peerage, he also served under Salisbury as Secretary of State for India (1886–92) and remained in the cabinet in the elder statesman roles of Chancellor of the Duchy of Lancaster (1895), and Lord Privy Seal (1895–1900).

DE WORMS, HENRY (1840–1903). Conservative MP (1880–95). He held junior office under Salisbury. Elevated to peerage in 1895 as Baron Pirbright.

DISRAELI, BENJAMIN, 1ST EARL OF BEACONSFIELD (1804–1881). A noted author of the 1830s and 40s, Disraeli entered Parliament in 1837 as a Conservative. Ambitious, restless, and talented, his flamboyant style and

Jewish origins inhibited the recognition of him as a serious figure in politics. By the later 1840s, however, he benefitted from the splitting of the Conservatives on the issue of agricultural tariffs and emerged as a party leader. Briefly Prime Minister in 1868, he returned as the head of a majority government from 1874 to 1880 and left a lasting imprint on the idea and concerns of British Conservatism. Furniss recalled that, in his early days of parliamentary work, he made a special study of Disraeli, who had recently been elevated to the peerage as Earl of Beaconsfield. Coming into the Gallery at the end of an all-night sitting, Disraeli looked, to the cartoonist sitting close by, "the perfection of an old dandy, scented, oiled and curled." (*SVM*, p. 220)

Dowse, Richard (1824–1890). Irish lawyer and Liberal MP (1868–73). Solicitor-General for Ireland before his elevation to the Irish bench. Known for his wit and common sense.

Farquharson, Dr. Robert (1836–1918). Scottish Liberal MP (1880–1906), and one of the small number of medical professionals to sit in the Commons. Although not a very active member, he was well-liked. As Furniss wrote in 1896: "He has been sitting on the back bench, with his feet up on the bench in front of him, as long as I can remember. Very seldom does he take part in the debates; few in his time have heard more and added less to them than the popular doctor" (HF, "The Best Club in England," *Pearson's Magazine*, vol. 2, no. 7 [1896], p. 25). Later, the "chairmanship of the Scotch Party in the House falls to Dr. Farquharson—who, like his predecessor, Sir Henry Campbell-Bannerman, is a universal favourite, and the Party in his hands will no doubt benefit largely, as it wants a great deal of doctoring to strengthen it just now" (*Fair Game*, March 1899, p. 24).

Field, William (1848–1935). Successful butcher and Irish Nationalist MP (1892–1918). Described by Furniss as a "peculiar and eccentric" but "genial Member of the Irish Party" (*PPP*, p. 140).

Fraser, Lieutenant-General Sir Charles Cauford (1829–95). Conservative MP (1885–92). He was awarded the Victoria Cross in 1858 for heroism during the Indian Rebellion.

Gladstone, William Ewart (1809–1898). Beginning his political life in 1834 as (in the words of Thomas Babington Macaulay) a "stern and unbending Tory," by the late 1850s he had become a key member of the Liberal party leadership. In Parliament for more 60 years, he held a succession of offices,

most notably Chancellor of the Exchequer in the 1850s and 60s, and was four times prime minister (1868–74, 1880–85, 1886, 1892–94). Nicknamed the "Grand Old Man," or "GOM," from the 1880s, Gladstone pioneered a style of political campaigning "out of doors" using the force of his oratory and personal charisma to appeal to the public over the heads of Parliament and his own party. For an account of Furniss's views on Gladstone, see Introduction section III.1.

GOSCHEN, GEORGE JOACHIM (1831–1907). Financier and MP (1863–1900). He entered Parliament as a Liberal and held cabinet office under both Russell and Gladstone, but sided with the Liberal Unionists when the party split over Home Rule and later on joined the Conservative Party. He served as Salisbury's Chancellor of the Exchequer (1887–92) and First Lord of the Admiralty (1895–1900), after which he was raised to the peerage. In Furniss's opinion, "Mr. Goschen's speeches are better when read than when listened to. His manner of speaking is constrained and uncomfortable. . . . Another circumstance which militates against his success as an orator, is his weakness of sight, which compels him to hold his notes close to his eyes" (*B&W,* 2 May 1891, p. 392).

GRANVILLE, GRANVILLE GEORGE LEVESON GOWER, 2ND EARL OF (1815–1891). Liberal statesman, nicknamed "Pussy" for his amiability. He sat for a decade in the Commons (1837–46) before succeeding to the peerage on the death of his father. He served as Foreign Secretary during three governments (1851–52, 1870–74, 1880–85) and twice as Colonial Secretary (1868–70, 1886), and was Liberal leader in the Lords from 1855. A close associate of Gladstone, Granville was one of the few great Whig peers to support Home Rule. Even so, Furniss was unable to deny "the grace and charm of his finished style" (*B&W,* 7 March 1891, p. 139).

HALSBURY, STANLEY GIFFARD HARDINGE, 1ST EARL OF (1823–1891). A leading barrister who appeared in several of the Victorian era's most famous cases, and author of major legal reference works (*Halsbury's Laws of England,* and *Halsbury's Statutes of England and Wales*). Conservative MP (1877–85), he served as Solicitor General (1875–80) under Disraeli, and then as Lord Chancellor (1885–92, 1895–1905) under Salisbury and Balfour. Furniss was a great admirer: "The Inns of Court . . . are aware that your knowledge of law is exceptional, and that, had you been a Gladstonian Lord Chancellor, you would have been acclaimed by the Radical press as the greatest, as you are the

soundest, lawyer of the day. . . . You are not too proud to go down into the Courts and do journeyman's work when the inadequate stock of judges we possess has run short owing to the assizes or the influenza. This is an admirable trait in your character. . . . An exaggerated sense of your own importance has never been a marked sign of the disease. . . . Your Lordship has been saved from a severe enlargement of the head by an excellent sense of humour" (*Fair Game,* May 1899, pp. 8–11).

HARCOURT, SIR WILLIAM GEORGE GRANVILLE VENABLES VERNON (1827–1904). A barrister and political commentator, Harcourt entered Parliament in 1868 as an advanced Liberal. His strengths as a debater and public speaker soon established him as a leading figure in the party, though throughout his career his generally belligerent and overbearing manner made him a difficult colleague and limited his ability to cultivate widespread personal support. In Gladstone's governments he served as Solicitor General (1873–74), Home Secretary (1880–85), and Chancellor of the Exchequer (1886, 1892–95), and became Liberal leader in the Commons (1894–95) under Lord Rosebery. In 1896, Harcourt became the opposition leader after Rosebery's resignation, but quit unexpectedly two years later although he continued to sit as a private member until 1904. Of his parliamentary style, Furniss wrote: "In debate you have contrived to unite the methods of the bully with the special pleadings of the police-court attorney. Over and over again you have shown that, though you can strike a heavy blow, you take your punishment badly" (*Fair Game,* June 1898, p. 5). But Harcourt was clearly a great subject and, "With the exception of Gladstone, I do not think I have caricatured any politician more often than Harcourt, and yet, strange to say, he did not like it!" (*SVM,* p. 11). When on tour in Sunderland, Furniss reported that "the much worshipped member and orator received me with open arms, and bestowed upon me all the hospitality in his power, but he drew the line at coming to the hall in the evening to hear 'The Humours of Parliament.'" (*FV,* p. 104)

HARDIE, (JAMES) KEIR (1856–1915). Lanarkshire miner and trade unionist, Hardie entered Parliament in 1892 as one of the first two Independent Labour MPs. A convert to socialism, he rejected working-class reliance on the Liberal party and became the central figure in the founding of the Labour Party. The fastidious Furniss snobbishly mocked Hardie's dress: "Mr. Keir Hardie, who made his entry into the House in the manner of a circus proprietor entering a village, got his reputation there by wearing a brown deer-stalker hat" (*PPP,* p. 144). He also charged Hardie with a kind of reverse snobbery in describ-

ing the MP's aversion to the Commons Terrace where he finds "the bloated aristocrat here wasting his time with his fair friends in the enjoyment of strawberries and cream, and tea and cakes" (*PPP*, p. 64).

HARTINGTON, SPENCER COMPTON CAVENDISH, MARQUIS OF (1833–1908). Liberal, then Liberal Unionist MP (1857–91), until succeeding his father as the 8th Duke of Devonshire. Nicknamed "Harty-Tarty" in reference to his recreational interests (the other was the turf), he served under Russell as Secretary of State for War (1866), and in Gladstone's first two cabinets as Postmaster-General (1868–71), Chief Secretary for Ireland (1871–74), Secretary of State for India (1880–82), and again as Secretary of State for War (1882–85). During what turned out to be Gladstone's temporary retirement of 1875–81, Hartington led the Liberals in the Commons. Rejecting Home Rule, he led the Liberal Unionist opposition to Gladstone and sat in Unionist cabinets under Salisbury and Balfour as Lord President of the Council (1895–1903), and succeeded Salisbury as Unionist leader in the Lords (1902–3). As befitted a scion of one of the great Whig families, politics was a responsibility not a profession; on three occasions he declined offers to become Prime Minister.

HICKS-BEACH, SIR MICHAEL (1835–1916). Conservative MP (1864–1906), he held office as Chief Secretary for Ireland (1874–78) and Secretary of State for the Colonies (1878–1880) under Disraeli, and as Chancellor of the Exchequer in Salisbury's 1885 caretaker ministry. After the fall of Gladstone's own brief administration of 1886, during which he led the opposition in the Commons, Hicks-Beach resumed the Irish secretaryship (1886–87) so that Lord Randolph Churchill could be Chancellor. Resigning office for health reasons, he subsequently served as President of the Board of Trade (1888–92), and in the next Conservative government returned to the Exchequer (1895–1902). His temper earned him the sobriquet "Black Michael."

KEELEY, MARY ANN (1806–1899). A leading stage actress from the 1830s through the 1850s. She reappeared periodically for special benefits through the 1880s.

LABOUCHÈRE, HENRY (1831–1912). Following a stint in the diplomatic service, from which he was dismissed, Labouchère briefly entered Parliament as a Liberal in 1867. After losing his seat, he embarked on a career as a theater owner and journalist, earning him notoriety in both fields. In 1869,

he inherited a sizeable fortune from his uncle, Baron Taunton, and financial independence only fueled his general rebelliousness. In 1880, he reentered Parliament and became a leading voice in the Radical section of the party. Through his writings, politics, and unconventional private life (for many years living out of wedlock with an actress), Labouchère made many enemies. Disappointed in his expectations for a seat in the cabinet in both 1892 and 1906, he resigned his seat and lived out his remaining years in Italy. Furniss rated Labouchère as perhaps "the most typical Bohemian [in Parliament], never conventional, never orthodox, frequently using the House as the dog upon which to try some new departure of his in public affairs. His excursions into debate were seldom taken seriously; in fact, Labouchère never intended them to be, they were simply 'good copy' for the benefit of his next issue of *Truth*" (*MBD*, p. 261).

LAWSON, SIR WILFRED (1829–1906). Liberal MP (1859–1906), he supported a wide range of radical reform efforts. Temperance, however, was Lawson's principal cause, and he tirelessly, though unsuccessfully, introduced bills for "local option" in permitting the liquor trade. To "that veteran of Teetotalism," Furniss wrote, "the Tea room is the brightest spot" in the Commons (HF, "The Best Club in England," *Pearson's Magazine*, vol. 2, no. 7 [1896], p. 27). Known for his winning sense of humor and personally well-liked in the House, Lawson was also highly regarded as a public speaker.

LECKY, WILLIAM EDWARD HARTPOLE (1838–1903). Irish historian and Liberal Unionist MP (1895–1903). Furniss wrote of how Lecky "delighted the House with his lady-like manner, and gave further illustration that Professors in Parliament are either out of place, or not a success" (*PPP*, pp. 185–6).

MACNEILL, JOHN GORDON SWIFT (1849–1926). Irish Nationalist MP for Donegal South (1887–1918) and known as a vocal member of the House. Called to the Irish bar, he became professor of constitutional law at King's Inn, Dublin, and the National University of Ireland, where he was also dean of the Faculty of Law. For the story of Furniss's imbroglio with Swift MacNeill, see the Introduction, note 97. Ever one to bear a grudge, Furniss's hostility towards MacNeill remained unabated. Nearly six years after the "assault" in the Lobby, the artist continued to mock the volatile MP: "Great Heavens! Mr. MacNeill a champion of the dignity of public life! What next? Mr. MacNeill, unfortunately, when most anxious to be serious, is generally funnier than when he is supposed to be humorous" and was the subject of the "loud and long laughter" of the House (*Fair Game*, March 1899, p. 24).

MCCARTHY, JUSTIN (1830–1912). Irish journalist, novelist, popular historian, and Home Rule MP (1879–1900). Vice chairman of the Home Rulers under Parnell, after the party split McCarthy led the anti-Parnellite majority until 1896. His reputation for affability and political moderation set him apart from the mostly unruly Irish members. Furniss thought that "the accomplished member for Londonderry city" was "an example of Parliamentary manners" (*Daily Graphic*, 31 July 1890, p. 5).

MATHEWS, CHARLES (1776–1835). Comic actor and theater manager. Husband of "the beautiful and accomplished" actress, Madame Vestris (*SVW*, p. 48).

MORLEY, JOHN (1838–1923). Noted Liberal journalist and writer from the 1860s, and MP (1883–1908) before being raised to the peerage. A loyal Gladstonian, he served as Chief Secretary for Ireland (1886, 1892–95) during the two attempts to achieve Home Rule. Later, he sponsored important reforms as Secretary of State for India (1905–10). His official life of Gladstone (1903) did much to shape the great man's reputation for generations thereafter. Furniss thought that Morley was "always too much in earnest, and lacks the indispensable attributes of humour and lightness of touch" (*B&W*, 27 June 1891, p. 664), and, of course, disapproved of his support for Home Rule and other efforts at "breaking up the Empire" at the India Office. Beyond the difficulties of his politics, "Lord Morley was one of the most difficult subjects for the caricaturist. His clean, cold intellectual features were almost impossible to represent—or rather misrepresent. He was more easily 'drawn' by conversation than by pencil. He always looked the picture of solemnity in the House of Commons." (*SVM*, pp. 1–2). Ultimately, Morley was not, in Furniss's view, "what an artist would call a black and white man" (How, p. 304).

NAOROJI, DADABHAI (1825–1917). A successful academic, businessman, and politician in India, he became Britain's first Indian MP (1892–95). After a previous, unsuccessful, electoral bid in 1886, Naoroji gained some notoriety from Lord Salisbury's unbuttoned remark during a speech that, "however great the progress of mankind has been, and however far we have advanced in overcoming prejudices, I doubt if we have yet to go to that point of view where a British constituency would elect a black man." Lucy's text that accompanies Furniss's sketch refers to him as "Lord Salisbury's Black Man" (*Punch*, 27 August 1892, p. 96).

PARNELL, CHARLES STUART (1846–1891). Protestant Anglo-Irish land-owner and Irish nationalist MP (1875–91). Leader of the Irish Home Rule MPs from 1878, he drew attention to Irish grievances through tactics of parliamentary obstruction, while also outside of Parliament presiding over the extra-legal Land League. The violence occasioned by the movement to withhold rents from targeted landlords led to Parnell's arrest in 1881, although he was released a year later after agreeing to curb the unrest in exchange for further concessions from the government on land issues. After Gladstone took up Home Rule in 1886, Parnell gave his support to the Liberals. Once described as the "uncrowned king of Ireland," his career was destroyed after being named co-respondent in the divorce suit brought by the (formerly complicit) husband of his long-time mistress, Kitty O'Shea. Parnell resigned from his party's leadership in 1890 and died a disgraced figure the following year. As Furniss recalled: "In my time Mr. Parnell was the most interesting figure in Parliament, and, after Mr. Gladstone, had the greatest influence in the House. . . . I doubt if even Mr. Gladstone ever hypnotized the House by his personality as Parnell did. There was a mystery in everything connected with the great Irish leader. . . . He guided the Irish ship just as he liked over the troubled waters of a political crisis, and not one of his men knew what move would be his next. By this means, so foreign to the Irish character, he held that excitable, rebellious, irrepressible crew in thrall" (*CCI*, p. 178).

PEEL, ARTHUR WELLESLEY (1829–1912). Son of the Conservative Prime Minister, Sir Robert, and named after the Duke of Wellington (under whom his father had served in government), Peel entered Parliament in 1865. He was elected Speaker in 1884, and in 1895 was raised to the peerage as Viscount Peel. Furniss wrote that "No Speaker ever left the Chair more respected or admired than was the last. His rulings were characterised by great firmness and decision; indeed, I am using no extravagant terms of laudation when I say that, notwithstanding the illustrious names which adorn the long roll of his predecessors in the high position which he filled, it is universally con-ceded in the House that there never has been, and there is never likely to be, a more popular and accomplished president than Speaker Peel" (*PPP*, p. 18).

REDMOND, JOHN (1856–1918). Irish nationalist MP (1880–1918) and, follow-ing Parnell's resignation in 1890, leader of the Home Rule faction still loyal to the fallen leader. In time, he succeeded in reuniting the divided nationalists. Furniss placed Redmond in the "apostolic line of Irish Patriots" in succession

to Parnell (*Fair Game,* March 1899, p. 8), and rated him a fine orator whose "defence of his chief" was a speech of "power and genius" (*CCI*, p. 183).

ROSEBERY, ARCHIBALD PHILIP PRIMROSE, 5TH EARL OF (1847–1929). Succeeded to the title at 21, and entered political life as a Liberal in the Conservative-dominated House of Lords. He played a major role in reform of party organization in Scotland, though refused minor offices on several occasions. Served as Gladstone's Foreign Secretary (1886, 1829–94), before being chosen to succeed the Grand Old Man as Prime Minister (1894–95). Although known for his intellect, speaking ability, and charm, Rosebery was an unhappy and not very effective leader. Furniss wrote that "Lord Rosebery is a veritable Crichton. A statesman, an orator, a historian, a wit, a society *raconteur,* a sportsman, an organizer, a thousand and one things. It is not to be wondered at, therefore, that he gives many a chance a less versatile man could not to the captious critics and the caricaturist. . . . I have had the honour of Lord Rosebery's acquaintance for some time, and, like all who come into contact with him, however slightly, have found him a most delightful and accomplished man" (*PPP,* p. 81).

RUSSELL, CHARLES ARTHUR, BARON RUSSELL OF KILLOWEN (1832–1900). Lord Chief Justice from 1894 to his death, and previously Gladstone's attorney general in his 1886 and 1892 governments.

SALISBURY, ROBERT ARTHUR TALBOT GASCOYNE-CECIL, 3RD MARQUIS OF (1830–1903). A Conservative MP from 1853 until succeeding to the peerage in 1868, Salisbury held office as Secretary of State for India (1866–67, 1874–78) and Foreign Secretary (1878–80) before leading three governments (1885–86, 1886–92, 1895–1902). With a deeply conservative outlook on most matters, Salisbury adapted only grudgingly and out of necessity to the advance of mass democracy. Furniss was a great admirer: "Of course, Lord Salisbury is the most important figure in either House. He is the greatest Parliamentarian both to look at and to listen to, and is every inch a statesman. . . . Everyone must admit that Lord Salisbury's is an impressive figure, and that his deep, sonorous voice and majestic manner when speaking are highly attractive. He cannot resist his old love of satire, and sometimes he has a chance of showing that his powers of sarcasm are as trenchant as ever . . . " (*PPP,* pp. 126–132).

SEXTON, THOMAS (1848–1932). JOURNALIST AND IRISH NATIONALIST MP (1880–96). Furniss wrote that "Mr. Sexton, no doubt, is one of the

cleverest men in the House. He 'orates,' as Americans say, and deserves his nickname, 'Windbag Sexton.' He is a little man, with a curiously shaped head, small in stature, and wears short trousers. He has a strong belief in Thomas Sexton, and it is no secret that he is anything but popular with his own party" (*PPP*, p. 48).

SMITH, WILLIAM HENRY (1825–1891). Successful newsagent and business-man, and Conservative MP (1868–91). Served as Financial Secretary to the Treasury (1874–77) and First Lord of the Admiralty (1877–80) under Disraeli, and later, under Salisbury, as Secretary of State for War (1885–86, 1886–87), Chief Secretary for Ireland (1886), and Leader of the House of Commons (1887–91). Nicknamed "Old Morality," Smith was a courteous and conscien-tious parliamentarian and ever sought to be the voice of good sense. Furniss praised Smith's devotion to his work, for "always showing the greatest atten-tion to business, [he] lived and almost died on the bench" (*PPP*, p. 176). During the first tour of "Humours" he died, but Furniss continued to show Smith's image even after his death (see above, under Aird).

SPENCER, CHARLES ROBERT (1857–1922). Liberal MP (1880–95, 1900–1905). Served as a party whip, Vice-Chamberlain of the Household (with the duty of reporting daily to the Queen on activity in the Commons), and Lord Chamberlain (1905–12). He became the 6th Earl Spencer on the death of his childless elder brother. Furniss described him as "the beau *par excellence* of the House" (*B&W*, 28 February 1891, p. 104). "He has risen from the front Opposition bench, his dress the pink of perfection—the perfect collar, neat attire, and nattiest of boots. He holds a roll of paper in his left hand, resembling those orators of old in Rome. This classic effect is modi-fied by his holding a modern gold pencil in his right hand" (*Daily Graphic*, 26 June 1890, p. 8).

STOREY, SAMUEL (1841–1925). A successful newspaper publisher and Liberal MP (1881–95). Although a Radical for most of his political and publishing career, Storey broke with the Liberals in 1903 to support Chamberlain's tariff reform crusade. Furniss described Storey as a tedious speaker: "he is a heavy man, with a heavy beard, heavy eye-brows, and a heavy voice" (*Daily Graphic*, 7 August 1890, p. 4).

STUART-WORTLEY, CHARLES (1851–1926). Conservative MP (1880–1916). Under-Secretary of State for the Home Department in Salisbury's first two governments.

TANNER, DR. CHARLES KEARNS DEASE (1850–1901). Noted Irish surgeon and Nationalist MP (1885–1901). An active participant in debates, Tanner's career and life were cut short by consumption. Furniss's dislike of Tanner, whom he saw as an uncouth, rebel-rousing Irishman with little concern for common courtesies, is often in evidence. For example Tanner "put in an appearance at the House, apparently with the stock-in-trade of a cast-off-hat merchant. A short time ago the volatile doctor practically broke into the larder of the House of Commons and brought up to the dining-room joints and any eatables he could get hold of" (*PPP*, p. 34).

TEMPLE, SIR RICHARD (1826–1902). Conservative MP (1885–95). Formerly an Indian civil servant, Lieutenant Governor of Bengal and Governor-General of Bombay. His authority on Indian subjects aside, he was not a great success in the Commons, although he was much caricatured. In contrast to the depiction used in "Humours" of Temple running at full speed (image 94), Furniss elsewhere gives him as an example of an MP who is "most careful in making the obeisance" in saluting the Chair: he "must have taken lessons from a professor to perfect himself" though the artist still found his "style of bowing . . . low and slowly from the knee" "rather funny" (*PPP*, p. 21).

BIBLIOGRAPHY

I. Manuscript and Related Sources

British Library, London

HF to H. E. Rensburg, 27 October 1891, BL MS Mus. 309, ff. 227–28.

HF to G. B. Shaw, 28 April 1888, BL Add MSS 50512, f. 31.

HF to G. B. Shaw, 9 April 1895, BL Add MSS 63183, f. 1.

J. Paul Getty Trust, Los Angeles: Getty Research Institute, Special Collections.

Harry Furniss Letters, Accession Number 861048.

HF to Dorothy F, 15 December 1896.

HF to F. C. Burnand, 3 January 1898.

HF to Mr. Cornish, 17 January 1891.

HF to Mrs. Capper, 12 February 1891.

HF to H. Lucy, 9 May 1891.

John Rylands Library, Manchester

Spielmann Collection, English Manuscript 1302.

HF to M. H. Spielmann, 28 December 1891, item 215.

HF to M. H. Spielmann, 31 December 1891, item 217.

National Portrait Gallery, London

HF to Sir J. D. Linton, 8 March 1888, 86.WW2.

Parliamentary Archives, London

Sketches by HF, HC/LB/1/112.

Program for Francis Carruthers Gould's "Lords and Commons from the Press Galleries: Illustrated with Caricature Portraits, Shown by Oxy-Hydrogen Light," performed at Westminster Town Hall on 24 June 1892, PRG/5/14.

HF correspondence with Sergeant-at-Arms Erskine, 2–18 January 1895, HC/SA/SJ/5/18.

Private Collections

Cordery, Gareth, Christchurch, New Zealand.

Lectures:

> "A Caricaturist in Colombo: Written and Illustrated by Harry Furniss," typescript, n.d.
>
> "Cartoon," typescript, n.d. [c. 1914–18].
>
> "The Carnival," typescript, n.d.
>
> "The Humours of Parliament," typescript, n.d.

Letters:

> HF to Dorothy F, 1 December 1896.
>
> HF to Guy F, 15 December 1896.
>
> HF to Guy F, 8? November 1896.

Goodacre, Selwyn, Woodville, South Derbyshire, England.

> HF to S. W. Richards, 29 June 1887.
>
> HF to S. W. Richards, 7 January 1888.

Wood, Rosemary, Doncaster, England.

> HF to Frank F, 24 January 1892.
>
> HF to Frank F, 14 February 1892.
>
> HF to Frank F, undated [October 1896].

World-Wide Web

> HF to Editor of the *Boston Herald,* 1 March 1897, catalog description at Kennedy's West Books, http://www.kennedyswest.net/ap_furniss_harry.html//. Website no longer active. Transcription in possession of Gareth Cordery.
>
> HF to J. B. Pond, 1 September [1891?], quoted on catalog website of David J. Holmes Autographs [from 8vo letter inserted into a copy of *Flying Visits*], http://www.holmesautographs.com/cgi-bin/dha455.cgi/scan/mp=keywords/se=FURNISS,%20HARRY. Item no longer available on website. Transcription in possession of Gareth Cordery.

II. Published Works by Harry Furniss

Furniss, Harry. *Parliamentary Views "From Punch."* London: Bradbury & Co., 1885.

———. *M.P.'s In Session: From Mr. Punch's Parliamentary Portrait Gallery.* London: Bradbury Agnew, 1889.

———. "Parliamentary Illustration." *Black and White,* vol. 29 (August 1891), pp. 312–13.

———. *Flying Visits.* London: Simpkin, Marshall, 1892.

———. "The Best Club in England." *Pearson's Magazine,* vol. 2, no. 7 (1896), pp. 25–29.

———. *Pen and Pencil in Parliament.* London: Sampson Low & Co., 1897.

———. *P & O Sketches in Pen and Ink.* London: Studio of Design & Illustration, 1898.

———. *The Confessions of a Caricaturist.* 2 vols. London: T. Fisher Unwin, 1901.

———. "Divisions." *Cassell's Magazine,* vol. 32 (June 1901), pp. 285–88.

———. "The Parliamentary Hat." *Cassell's Magazine,* vol. 37 (December 1903), pp. 10–16.

———. *Harry Furniss at Home.* London: Unwin, 1904.

———. "The Caricaturists and the Politicians." *Weekly Scotsman,* 7 January 1905, p. 7.

———. "The Press in Parliament." *Cassell's Magazine,* vol. 40 (June 1905), pp. 142–47.

———. "Ladies in Parliament." *Cassell's Magazine,* vol. 41 (December 1905), pp. 80–89.

———. "To Succeed in Parliament." *Cassell's Magazine,* vol. 42 (June 1906), pp. 85–90.

———. "Standing for Parliament: Its Humours and Toils." *Cassell's Magazine,* vol. 45 (May 1908), pp. 586–90.

———. "My Reminiscences." *Strand Magazine,* vol. 38, no. 223 (1909), pp. 186–93.

———. *How to Draw in Pen and Ink.* London: Chapman and Hall, 1914.

———. "The Magic Hand; Or, Lightning-Sketching for the Cinematograph." *Strand Magazine,* vol. 48, no. 278 (1914), pp. 667–71.

———. *More about How to Draw in Pen and Ink.* London: Chapman and Hall, 1915.

———. *My Bohemian Days.* London: Hurst & Blackett, 1919.

———. *Some Victorian Women: Good, Bad, and Indifferent.* London: John Lane, 1923.

———. *Some Victorian Men.* London: John Lane, [1924].

———. *The Two Pins Club.* London: John Murray, 1925.

III. Printed Primary Sources

Baudelaire, Charles. "Some Foreign Caricaturists" (1857). *The Painter of Modern Life and Other Essays,* ed. and trans. Jonathan Mayne. London and New York: Phaidon, 1965.

A Brief & Authentic Account of Harry Furniss. Complied by Those Who Know Him. [Pamphlet, no publisher indicated], 1896.

Catalogue of a Collection of Drawings, Political and Pictorial by Harry Furniss. London: Fine Art Society, 1894.

Dickens, Charles. *The Letters of Charles Dickens: The Pilgrim Edition: Vol. 7, 1853–1855.* Ed. Graham Storey, Kathleen Tillotson, and Angus Easson. New York: Oxford University Press, 1993.

———. *Sikes and Nancy and Other Public Readings.* Ed. Philip Collins. Oxford: Oxford University Press, 1983.

———. "The Uncommercial Traveller." *All the Year Round,* vol. 3, no. 62 (1860), pp. 274–78.

Furniss, Harry [HF's grandson]. *Family & Friends: Memoirs: Three.* Victoria, BC: Trafford, 2003.

Hammerton, J. A. "The Art of Mr. Harry Furniss." *The Charles Dickens Library, Vol. 17: The Dickens Picture Book: A Record of the Dickens Illustrators.* London: Educational Book Company, 1910.

Hanham, H. J., ed. *The Nineteenth-Century Constitution 1815–1914: Documents and Commentary.* Cambridge: Cambridge University Press, 1969.

Harper, Charles G. *English Pen Artists of To-Day.* London: Percival, 1892.

Hentschel, Carl. "Process Engraving" [and responses, including from HF (p. 472)]. *Journal of the Society of Arts,* 20 April 1900, pp. 461–74.

How, Harry. *Illustrated Interviews.* London: George Newnes, 1893.

Kinnear, Alfred. "The Trade in Great Men's Speeches." *The Contemporary Review,* vol. 75 (March 1889), pp. 439–44.

Lucy, Henry W. *A Diary of the Salisbury Parliament, 1886–1892.* London: Cassell, 1892.

———. *A Diary of Two Parliaments: The Disraeli Parliament, 1874–1880,* 2nd ed. London: Cassell, 1885.

May, Thomas Erskine. *A Treatise on the Law, Privileges, Proceedings, and Usage of Parliament.* London: Charles Knight, 1844.

———. *A Treatise on the Law, Privileges, Proceedings and Usage of Parliament,* 9th ed. London: Butterworths, 1883.

Parliamentary Debates, 6th series (Lords).

Pendleton, John. *Newspaper Reporting in Olden Time and To-Day.* London: Elliot Stock, 1890.

Pond, J. B. *Eccentricities of Genius: Memories of Famous Men and Women of the Platform and the Stage.* London: Chatto & Windus, 1901.

Redlich, Josef. *The Procedure of the House of Commons: A Study of Its History and Present Form.* 3 vols. London: Constable, 1908.

Reid, T. Wemyss "Mr. Gladstone and His Portraits." *The Magazine of Art,* vol. 12 (1888), pp. 82–89.

Russell, G. W. E. *Collections and Recollections.* New York and London: Harper & Brothers, 1898.

Sala, George Augustus. *The Land of the Golden Fleece: George Augustus Sala in Australia and New Zealand in 1885.* Ed. Robert Dingley. Canberra: Mulini Press, 1995.

Shaw, George Bernard. *Bernard Shaw on the London Art Scene, 1885–1950.* Ed. Stanley Weintraub. University Park and London: Pennsylvania State University Press, 1989.

———. "How I Became a Public Speaker." *Sixteen Self Sketches.* London: Constable, 1949.

Spielmann, M. H. *The History of "Punch."* London: Cassell, 1895.

———. "Our Graphic Humorists: Harry Furniss." *Magazine of Art,* vol. 23, (1899), pp. 345–50.

Thackeray, William Makepeace. *The English Humourists of the Eighteenth Century* [part of the 20-volume "Harry Furniss Centenary Edition" of *The Works of Thackeray*]. London: Macmillan, 1911.

———. *The History of Pendennis.* 2 vols. 1848. London: Smith, Elder, & Co., 1898.

Twain, Mark. *How to Tell a Story and Other Essays.* Ed. Shelley Fisher Fishkin. New York and Oxford: Oxford University Press, 1996.

Van Gogh, Vincent. *Complete Letters of Vincent van Gogh: With Reproductions of All the Drawings in the Correspondence.* 3 vols. Greenwich, CT: New York Graphic Society, 1958.

White, William. *The Inner Life of the House of Commons.* 2 vols. London: T. Fisher Unwin, 1897.

Whorlow, H. *The Provincial Newspaper Society, 1836–1886.* London: Page, Pratt, & Turner, 1886.

Wilson, P. W. "Reporting Parliament and Congress." *North American Review,* vol. 214, no. 3 (1921), pp. 326–33.

Woodall, William. "A Night in the House of Commons." *Good Words,* vol. 29 (1888), pp. 104–13.

IV. Newspapers and Periodicals

Aberdeen Weekly Journal.

The Age (Melbourne).

Argus (Melbourne).

Atchison [Kansas] *Daily Globe.*

Australasian.

Belfast News-Letter.

Birmingham Daily Post.

Birmingham Post.

Black and White.

Boston Daily Advertiser.

Boston Daily Globe.

Brighton Gazette.

Bulletin (Sydney).

Chums.

Country Gentleman.

Daily Chronicle.

Daily Citizen (Ottawa).

Daily Graphic.

Daily Inter Ocean (Chicago).

Daily Mail and Empire (Toronto).

Daily News.

Daily Telegraph (Sydney).

Dart: The Birmingham Pictorial.

Dundee Advertiser.

Era.

Evening Post (Wellington).

Fair Game.

Freeman's Journal & Daily Commercial Advertiser.

Gazette (Montreal).

Glasgow Herald.

Globe (Toronto).

Graphic.

Herald (Melbourne).

Illustrated London News.

Irish Times.

Leeds Mercury.

Lika Joko.

Liverpool Echo.

Lloyd's Weekly Newspaper.

Manchester Guardian.

Melbourne Punch.

Montreal Daily Star.

New York Times.

Newcastle Weekly Courant.

North American (Philadelphia).

Optical Magic Lantern Journal.

Pall Mall Budget.

Pall Mall Gazette.

Philadelphia Inquirer.

Preston Guardian.

Punch.

Reynold's Newspaper.

Saturday Review.

Scotsman.

Sketch.

St. James's Budget.

St. Paul Daily News.

Stage.

Strand Magazine.

Sydney Morning Herald.

Taranaki Herald (New Zealand).

The Times.

Washington Post.

Weekly Scotsman.

World.

Yenowine's Illustrated News (Milwaukee).

V. Secondary Works

Anderson, Patricia. "Illustration." *Victorian Periodicals and Victorian Society,* ed. J. Don Vann and Rosemary T. VanArsdel. Toronto: University of Toronto Press, 1994.

Applebaum, Stanley, and Richard Kelley, eds. *Great Drawings and Illustrations from* Punch, *1841–1901.* New York: Dover, 1981.

Banta, Martha. *Barbaric Intercourse: Caricature and the Culture of Conduct, 1841–1936.* Chicago: University of Chicago Press. 2003.

Bevis, Matthew. *The Art of Eloquence: Byron, Dickens, Tennyson, Joyce.* Oxford: Oxford University Press, 2007.

———. "Ruskin, Bright, and the Politics of Eloquence." *Nineteenth-Century Prose,* vol. 27, no. 2 (2000), pp. 177–90.

Biagini, Eugenio F. *Gladstone.* Houndmills: Macmillan, 2000.

Blake, Robert. *Disraeli.* London: Eyre & Spottiswode, 1966.

Bordieu, Pierre. *Distinction: A Social Critique of the Judgement of Taste.* Trans. Richard Nice. Cambridge, MA: Harvard University Press, 1985.

———. *The Field of Cultural Production: Essays on Art and Literature.* Ed. Randal Johnson. New York: Columbia University Press, 1993.

Bowley, A. L. *Wages and Income in the United Kingdom since 1860.* Cambridge: Cambridge University Press, 1937.

Bradley, Ian. *The Call to Seriousness: The Evangelical Impact on the Victorians.* London: Cape, 1976.

Braudy, Leo. *The Frenzy of Renown: Fame and Its History.* Oxford: Oxford University Press, 1986.

Brown, T. Allston. *A History of the New York Stage, from the First Performance in 1732 to 1901.* 3 vols. New York: Dodd Mead, 1903.

Burns, Alan, ed., *Parliament as an Export.* London: George Allen & Unwin, 1966.

Cannadine, David. *National Portrait Gallery: A Brief History.* London: National Portrait Gallery, 2007.

———. "Parliament: The Palace of Westminster as a Palace of Varieties." *In Churchill's Shadow: Confronting the Past in Modern Britain.* London: Penguin, 2002.

Cohen, Morton and Edward Wakefield. *Lewis Carroll and His Illustrators.* Ithaca, NY: Cornell University Press, 2003.

Collins, Philip. "'Agglomerating Dollars with Prodigious Rapidity': British Pioneers on the American Lecture Circuit." *Victorian Literature and Society,* ed. James R. Kincaid and Albert J. Kuhn. Columbus: Ohio State University Press, 1984.

Cordery, Gareth. "The Book Illustrations of Harry Furniss." *Imaginative Book Illustration Society Journal,* vol. 3 (2009), pp. 52–77.

———. *An Edwardian's View of Dickens and His Illustrators: Harry Furniss's "A Sketch of Boz."* Greensboro, NC: ELT Press, 2005.

———. "Furniss, Dickens and Illustration, Part I." *Dickens Quarterly,* vol. 13, no. 1 (1996), pp. 34–41.

———. "Furniss, Dickens and Illustration, Part II." *Dickens Quarterly,* vol. 13, no. 2 (1996), pp. 99–110.

———. "Harry Furniss: A Bibliography." *Imaginative Book Illustration Society Newsletter,* no. 20 (Spring 2001), pp. 28–48.

———. "Harry Furniss and the 'Boom in Boz,' Part I." *Dickens Quarterly,* vol. 21, no. 2 (2004), pp. 90–103.

———. "Harry Furniss and the 'Boom in Boz,' Part II." *Dickens Quarterly,* vol. 21, no. 3 (2004), pp. 143–157.

Cunningham, Colin. *Victorian and Edwardian Town Halls.* London: Routledge & Kegan Paul, 1981.

Cunningham, Hugh. *Leisure in the Industrial Revolution, c. 1780–c. 1880.* London: Croom Helm, 1980.

Dames, Nicholas. "Brushes with Fame: Thackeray and the Work of Celebrity." *Nineteenth-Century Literature,* vol. 56, no. 1 (2001), pp. 23–51.

Davis, Paul. *The Lives and Times of Ebenezer Scrooge.* New Haven: Yale University Press, 1990.

Field, Christopher. *Ibbs and Tillett: The Rise and Fall of a Musical Empire.* Aldershot: Ashgate, 2005.

Foster, R. F. *Paddy & Mr. Punch: Connections in Irish and English History.* London: Penguin, 1995.

Garrard, John. *Democratisation in Britain: Elites, Civil Society and Reform since 1800.* Houndmills: Palgrave, 2002.

Gunning, Tom. "The Cinema of Attractions: Early Film, Its Spectator, and the Avant-Garde." *Early Cinema: Space, Frame, Narrative,* ed. Thomas Elsaesser and Adam Barker. London: British Film Institute, 1990.

Hamilton, Lisa. "The Importance of Recognizing Oscar: The Dandy and the Culture of Celebrity." *The Center & Clark Newsletter,* no. 33 (Spring 1999), pp. 3–5.

Harrison, Brian. "Women in a Men's House: The Women M.P.s, 1919–1945." *The Historical Journal,* vol. 29, no. 3 (1986), pp. 623–54.

Hewitt, Martin. "Aspects of Platform Culture in Nineteenth-Century Britain." *Nineteenth-Century Prose,* vol. 29, no. 1 (2002), pp. 7–12.

Hill, Draper, ed. *The Satirical Etchings of James Gillray.* New York: Dover, 1976.

Hollis, Patricia. *Ladies Elect: Women in English Local Government, 1865–1914.* Oxford: Clarendon Press, 1987.

Holroyd, Michael. *Bernard Shaw, Vol. I: 1856–1898: The Search for Love.* New York: Random House, 1988.

Howard, Jill. "'Physics and Fashion': John Tyndall and His Audiences in Mid-Victorian Britain." *Studies in the History and Philosophy of Science,* vol. 35, no. 4 (2004), pp. 729–58.

Hughes, Edward. "The Changes in Parliamentary Procedure, 1880–1882." *Essays Presented to Sir Lewis Namier,* ed., Richard Pares and A. J. P. Taylor. London: Macmillan, 1956.

Kent, Christopher. "Gentlemen's Fashions in the *Tailor and Cutter,* 1866–1900." *The Lure of Illustration in the Nineteenth Century,* ed. Laurel Brake and Marysa Demoor. Houndmills: Palgrave Macmillan, 2009.

Kift, Dagmar. *The Victorian Music Hall: Culture, Class, and Conflict.* Trans. Roy Kift. Cambridge: Cambridge University Press, 1996.

Lawrence, Jon. "The Transformation of British Public Politics after the First World War." *Past and Present,* no. 190 (2006), pp. 185–216.

Levine, Philippa. *Victorian Feminism, 1850–1900.* Gainesville: University Press of Florida, 1994.

Lightman, Bernard. "Lecturing in the Spatial Economy of Science." *Science in the Marketplace: Nineteenth-Century Sites and Experiences,* ed. Aileen Fyfe and Bernard Lightman. Chicago and London: University of Chicago Press, 2007.

Londré, Felicia Hardison, and Daniel J. Watermeier. *The History of North American Theater: The United States, Canada, and Mexico: From Pre-Columbian Times to the Present.* New York: Continuum, 2000.

Low, David. *British Cartoonists: Caricaturists and Comic Artists.* London: William Collins, 1942.

Lucas, E. V. *The Life of Charles Lamb,* 3rd ed. 2 vols. London: Methuen, 1906.

Marshall, David P. *Celebrity and Power: Fame in Contemporary Culture.* Minneapolis and London: University of Minnesota Press, 1997.

Marshall, Debbie. *Give Your Other Vote to the Sister: A Woman's Journey into the Great War.* Calgary: University of Calgary Press, 2007.

Matthew, H. C. G. *Gladstone, 1809–1874.* Oxford: Clarendon Press, 1986.

———. *Gladstone, 1875–1898.* Oxford: Clarendon Press, 1995.

———. *The Nineteenth Century.* Oxford: Oxford University Press, 2000.

———. "Portraits of Men: Millais and Victorian Public Life." *Millais: Portraits.* By Peter Funnell et al. London: National Portrait Gallery, 1999.

———. "Rhetoric and Politics in Great Britain, 1860–1950." *Politics and Social Change in Britain: Essays Presented to A. F. Thompson,* ed. P. J. Waller. Hassocks: Harvester, 1987.

McKenzie, Judy. "G. A. S. in Australia: Hot Air Down-Under?" *Australian Literary Studies,* vol. 15, no. 4 (1992), pp. 313–22.

Meisel, Joseph S. "Palmerston as Public Speaker," *Palmerston Studies,* ed. David Brown and Miles Taylor. 2 vols. Southampton: Hartley Institute, University of Southampton, 2007.

———. *Public Speech and the Culture of Public Life in the Age of Gladstone.* New York: Columbia University Press, 2001.

Monypenny, William Flavelle, and George Earle Buckle. *The Life of Benjamin Disraeli, Earl of Beaconsfield.* 6 vols. London: Murray, 1910–20.

Morris, Frankie. *Artist of Wonderland: The Life, Political Cartoons, and Illustrations of Tenniel.* Charlottesville: University of Virginia Press, 2005.

O'Brien, R. Barry. *The Life of Lord Russell of Killowen,* 2nd ed. London: Smith, Elder & Co, 1902.

O'Gorman, Frank. "Campaign Rituals and Ceremonies: The Social Meaning of Elections in England 1780–1860." *Past and Present,* no. 135 (1992), pp. 79–115.

Ovendale, Ritchie. *Anglo-American Relations in the Twentieth Century.* Houndmills: Macmillan, 1998.

Parry, Jonathan. *The Rise and Fall of Liberal Government in Victorian Britain.* New Haven: Yale University Press, 1993.

Perry, Lara. "The National Gallery and Its Constituencies, 1858–96." *Governing Cultures: Art Institutions in Victorian London,* ed. Paul Barlow and Colin Trodd. Aldershot: Ashgate, 2000.

Plunkett, John. "Celebrity and Community: The Poetics of the *Carte-de-Visite.*" *Journal of Victorian Culture,* vol. 8, no. 1 (2003), pp. 55–79.

Popple, Simon, and Joe Kember. *Early Cinema: From Factory Gate to Dream Factory.* London: Wallflower Press, 2004.

Port, M. H., ed. *The Houses of Parliament.* New Haven: Yale University Press, 1976.

Pugh, Martin. *The Tories and the People, 1880–1935.* Oxford: Blackwell, 1985.

Quinault, Roland. "Westminster and the Victorian Constitution." *Transactions of the Royal Historical Society,* 6th series, vol. 2 (1992), pp. 79–104.

Roach, Joseph. *It.* Ann Arbor: University of Michigan Press, 2007.

Robinson, David. *Magic Images: The Art of the Hand-Painted and Photographic Lantern Slides.* London: The Magic Lantern Society, 1990.

Rockett, Kevin, and Emer Rockett. *Magic Lantern, Panorama and Moving Picture Shows in Ireland, 1786–1909.* Dublin: Four Courts, 2011.

Rose, Jonathan. *The Intellectual Life of the British Working Classes.* New Haven and London: Yale University Press, 2001.

Royle, Edward. "Mechanics' Institutes and the Working Classes, 1840–1860." *The Historical Journal,* vol. 14, no. 2 (1971), pp. 305–321.

Schlicke, Paul, ed. *Oxford Reader's Companion to Dickens.* Oxford: Oxford University Press, 1999.

Shillingsburg, Miriam Jones. *At Home Abroad: Mark Twain in Australasia.* Jackson and London: University Press of Mississippi, 1988.

Skilton, David. "Contemplating the Ruins of London: Macaulay's New Zealander and Others." *Literary London: Interdisciplinary Studies in the Representation of London,* vol. 2, no. 1 [2004]. http://homepages.gold.ac.uk/london-journal/march2004/skilton.html.

Smiley, Jane. *Charles Dickens.* New York: Viking, 2002.

Straus, Ralph. *Sala: The Portrait of an Eminent Victorian.* London: Constable, 1942.

Street, John. "The Celebrity Politician: Political Style and Popular Culture." *Media and the Restyling of Politics: Consumerism, Celebrity and Cynicism,* ed. John Corner and Dick Pels. London: Sage, 2003.

Taylor, Antony. "Palmerston and Radicalism, 1847–1865." *Journal of British Studies,* vol. 33, no. 2 (1994), pp. 157–79.

Thompson, F. M. L. *The Rise of Respectable Society: A Social History of Victorian Britain, 1830–1900.* Cambridge, MA: Harvard University Press, 1988.

Thompson, James. "'Pictorial Lies'?—Posters and Politics in Britain c. 1880–1914." *Past and Present,* no. 197 (2007), pp. 177–210.

Vernon, James. *Politics and the People: A Study in English Political Culture c. 1815–1867.* Cambridge: Cambridge University Press, 1993.

Walasek, Helen. "*Punch* and the Lantern Slide Industry." *Visual Delights-Two: Exhibition and Reception,* ed. Vanessa Toulmin and Simon Popple. Eastleigh: John Libby, 2005.

Waller, Philip. *Writers, Readers, and Reputations: Literary Life in Britain, 1870–1918.* Oxford: Oxford University Press, 2006.

Wilson, Angus. *The World of Charles Dickens.* London: Secker & Warburg, 1970.

Windsheffel, Ruth Clayton. "Politics, Portraiture and Power: Reassessing the Public Image of William Ewart Gladstone." *Public Men: Masculinity and Politics in Modern Britain,* ed. Matthew McCormack. Basingstoke: Palgrave Macmillan, 2007.

VI. Reference Works

Australian Dictionary of Biography. Online edition: http://adb.anu.edu.au/.

Barrère, Albert, and Charles G. Leleand. *A Dictionary of Slang, Jargon & Cant.* 2 vols. London and Edinburgh: Ballantyne Press, 1889–90.

Brewer's Dictionary of Phrase & Fable. 17th ed. London: Weidenfeld & Nicolson, 2005.

Dictionary of Canadian Biography. Toronto and Quebec: University of Toronto/Université Laval, 2003–. http://www.biographi.ca/.

Encyclopedia of Music in Canada (incorporated into the online edition of the *Canadian Encyclopedia*). http://www.thecanadianencyclopedia.com.

House of Lords. *Companion to the Standing Orders and Guide to the Proceedings of the House of Lords.* London: Stationery Office, 2007.

Matthew, H. C. G., and Brian Harrison, eds. *Oxford Dictionary of National Biography.* 60 vols. Oxford: Oxford University Press, 2004.

Mitchell, B. R. *Abstract of British Historical Statistics.* Cambridge: Cambridge University Press, 1962.

Osborne, Harold, ed. *The Oxford Companion to Art.* Oxford: Oxford University Press, 1970.

Robinson, David, Stephen Herbert, and Richard Crangle, eds. *Encyclopedia of the Magic Lantern.* London: Magic Lantern Society, 2001.

Wilding, Norman, and Philip Laundy, *An Encyclopedia of Parliament.* 4th ed. London: Cassell, 1971.

INDEX

Note: Page references in regular type are to the Introduction, notes, and appendices. Page references in **bold** type are to HF's "Humours of Parliament" text (pp. 141–265). Page references in *italics* indicate illustrations.

Cromwell, Oliver (1599–1658), **164**, 164n38

Cross, Richard Assheton, Viscount Cross (1823–1914), *202*, 294

Cruikshank, George (1792–1878), 2, 27, 27n14

Derby, Edward Smith-Stanley, 14th Earl of (1799–1869), 88–89

Devonshire, Georgiana Cavendish, Duchess of (1757–1806), **233**, 233n124

DeWorms, Baron Henry (1840–1903), *277*, 294

Dickens, Charles (1812–1870): celebrity, 14, 34; HF re-illustrates works, 7n13, 65; illustrators, 7; on lectures, 47; and magic lanterns, 70; public readings, 46, 49, 49n103, 65–66, 66, 66n3, 70, 91, 98, 106, 108, 119–20, 134, 141n1. See also *A Christmas Carol, Oliver Twist, Our Mutual Friend*

Disraeli, Benjamin, Earl of Beaconsfield (1804–1881), 26, 38, 39, 42, 53, **164**, 164n36, **167**, 178n52, 200n84, **242**, 242n135, 294, 294–95, 296, 298, 303; and caricature, 35, 36, 52. See also *Endymion.*

Dolby, George (1831–1900), 92

Doré, Gustave (1832–1883), 223n110

Dowse, Richard (1824–1890), **161**, 161n32, 295

du Maurier, George (1834–1896), 46, 50

Ducrow, Andrew (1793–1942), 143n3

Eccentricities of Genius (Pond), 111

Edgar, James (1841–1899), 116

Edison, Thomas (1847–1931), 82, 134

Edward VII (1841–1910), 137, 200n83, **202**; as Prince of Wales, 83, 83–84n77

Elgar, Edward (1857–1934), 91–92n119

Elliot, Sir George (1814–1893), 92

Endymion (Disraeli), 197n79

Erskine, Henry David (1838–1921), 145n6

Europe, great power tensions, 63, 112

Every Man in His Humour (Jonson), 90

Fabian Society, 48

Famous History of the Seven Champions of Christendom, The (Johnson), 180n54, **181**

Farquharson, Dr. Robert (1836–1918), **254**, 295

Fawcett, Millicent Garrett (1847–1929), 60

Fawkes, Guy (1570–1606), **238**, *239*, 272

Field, William (1848–1935), 30, *278*, 295

Fildes, Luke (1843–1927), 38

Fitzgerald, Percy (1834–1925), 92

Forbes, Archibald (1838–1900), 121

Forster, Sir Charles (1815–1891), 254n153

Forster, Josiah, **254**

Foster, Roy, 54

Fourth Party, 51

Fox, Charles James (1749–1806), **220**, **233**

Fraser, Lt. General Sir Charles Crauford (1829–1895), **227**, *227*, 227n115, 295

Furniss, Harry (1854–1925):
 abroad: Australia (1897), 1, 3, 68, 126–34; Ceylon (1897), 122, 132–34, *133*; New Zealand, abandons planned tour (1897), 120; North America (1896–97), 1, 3, 68, 111, 112–120; South Africa, abandons planned tour (1897), 122; United States, recreational visit (1892), 29, 92, 98, 109, 109n3, 111, 112, 113; visit to Edison (1912), 82, 134
 on art: advice to cartoonists, 10; on caricature, 6–7, 11, 12, 35, 36, 38, 39, 41, 42; on photography, 39, 42; on political posters, 28, 28n18; on portraiture, 38–39; on technical process, 21, 21n68
 as artist: ambition to be a serious artist, 12; book illustrator, 7n13, 11, 117n49, 65; compared to other artists, 2, 5n5, 7, 17n53, 44, 127, 193n76; criticism and controversy, 7–8, 12, 31–32, *33*, 57, 88; depiction of physical disabilities, 8, 10; filmmaker, 82–83, 134; graphic satire tradition, 6–11; methods, 15, 17–19,

Van Gogh, Vincent (1853–1890), 38n48

Vaughan, Kate (1852–1903), 95

Venezuela, 112

Vert, Nathaniel (Narciso Vertigliano), 91–92

Victoria (1819–1901), 126, 202n86, **227**, 227n116, **264**, 303; Diamond Jubilee, 126; HF's aborted performance of "Humours" for, 101, 106

Votes for Women (Robbins), 43n74

War Office, **210**

Ward, Edward Matthew (1816–1879), **220**, 220n104, 254n153

Ward, Sir Leslie, "Spy" (1851–1922), 17n53

wars: First World War, 29n18, 58, 60, 63, 291, 292; Second World War, 2; Spanish-American War, 112

Waste (Granville-Barker), 43n74

Weber, Max (1864–1920), 53

Wellington, Arthur Wellesley, 1st Duke of (1769–1852), 302

Wells, H. G. (1866–1946), 46

Westminster Bridge, **218, 252**

What Every Woman Knows (Barrie), 43n74

Whistler, James McNeill (1834–1903), 38

Wilberforce, Albert Basil (1841–1916), 184n60

Wilde, Oscar (1854–1900): lectures, 46, 114. See also *An Ideal Husband; The Importance of Being Earnest*

Wilson, Philip Whitwell (1875–1956), 44

women: changing status, 25, 58, 60–62; HF's views of, 59, 61, 62–63, **242–44**, 242n136, *243*; as MPs, 60; and Parliament, 58–59, **228–30**, **232**, 232n123, **233–40**, 233h125, *234, 235, 236, 237, 240*, 240n133, **242–44**, 242n136, *243*; suffrage, 9, 61

Woodall, William (1832–1901), 92

working classes, 6, 8, 45, 46, 101–2, 106; working-class MPs, 30, 63, *213*, **241**, *277*, 292, 297

Yates, Edmund (1831–1894), 92

Studies in Comics and Cartoons

LUCY SHELTON CASWELL AND JARED GARDNER, SERIES EDITORS

Books published in Studies in Comics and Cartoons will focus exclusively on comics and graphic literature, highlighting their relation to literary studies. It will include monographs and edited collections that cover the history of comics and cartoons from the editorial cartoon and early sequential comics of the 19th century through webcomics of the 21st. Studies that focus on international comics will also be considered.

The Humours of Parliament: A View of Victorian Political Culture
 Edited by Gareth Cordery and Joseph S. Meisel

Redrawing French Empire in Comics
 Mark McKinney

.